A CURIOUS KIND OF WIDOW

Also by Ann Davidson

Alzheimer's, A Love Story:
One Year in My Husband's Journey

A Curious Kind of Widow

~

Loving a Man with
Advanced Alzheimer's

Ann Davidson

2006 · FITHIAN PRESS, MCKINLEYVILLE, CALIFORNIA

Published by Fithian Press
A division of Daniel and Daniel, Publishers, Inc.
Post Office Box 2790
McKinleyville, CA 95519
www.danielpublishing.com

LIBRARY OF CONGRESS CATALOGING-IN-PUBLICATION DATA
Davidson, Ann, (date)
 A curious kind of widow : loving a man with advanced Alzheimer's / by Ann
Davidson.
 p. cm.
 ISBN 1-56474-454-X (pbk. : alk. paper)
 1. Davidson, Julian M.——Health. 2. Alzheimer's disease——Patients——Biography.
3. Davidson, Ann, (date) I. Title.
 RC523.2.D384D40 2006
 362.196'8310092——dc22
 2005030981

for Julian

"...together we were learning the same things: how to hold on, how to let go."

—Jeanne Lohmann
Dancing in the Kitchen

Contents

Part III: January 1996–May 1996

Part IV: May 1996–April 1997

Part V: February 1998–November 2000

Foreword

IT HAS BEEN exactly one hundred years since Dr. Alois Alzheimer first described the case of a woman in his care at a mental hospital in Frankfurt, Germany. Her relatives had brought her there because they could no longer provide the full-time supervision that she required. Her symptoms included memory loss, fractured speech, and disorganized thinking. She could no longer do simple things for herself. Upon her death, Dr. Alzheimer examined her brain and described the tiny abnormalities that are the hallmark of the disease that now bears his name. Still today the exact causes of Alzheimer's disease are not known, although progress is being made in unraveling its mysteries.

Over the last century, especially the last twenty-five years, Alzheimer's disease has become a growing public health problem. There are now five million Americans with the disease and that number is expected to double in the next twenty-five years. Families are the main providers of care, and most people with the disease live at home, requiring ever-increasing help. The disease is progressive, lasting two to twenty years depending on the age of onset. It is not surprising that providing long-term care is so taxing for family caregivers on many levels: physical, mental, emotional, spiritual, and financial.

What is surprising is the resilience of so many family caregivers in the face of such adversity. Despite the stress over many years, many caregivers not only survive but thrive in the midst of hardship. They feel hope where others might feel despair. They see possibilities instead of limits. They find the inner resources to make sense of seemingly senseless circumstances. They adapt to the changing needs of their loved ones. Their stories are worth sharing because they provide inspiration to others along this difficult journey. Ann Davidson's *A Curious Kind of Widow* is one such story.

Ann first chronicled the early stages of her spouse's disease in

Alzheimer's, A Love Story. In this sequel, she describes her beloved Julian's decline into the late stages and her struggle to cope with his moods and behaviors. At times Ann is beside herself with anger and sadness while at other times she is full of joy and kindness. At all times, however, she is honest about her thoughts and feelings. She uses her journal to sort through her confusion and focus on what is important. She eventually discovers that she can still love Julian in spite of his severe impairments.

Although a unique account, this book will give strength to others on their own journey into Alzheimer's disease. With clarity and insight, Ann describes many markers on her long journey: enlisting the help of others, enrolling Julian in an adult day-care center, moving him into a residential care facility, and visiting him regularly until he dies peacefully. Each transition is marked by losses that she faces courageously. Ann credits her family, friends, and care providers for enabling her and Julian to live fully in spite of his decline and her grief. However, she chose to face the loneliness of caring for her husband and found personal meaning amidst countless challenges. This is an exquisite story that demonstrates that love is truly a challenging verb.

— Daniel Kuhn
Mather LifeWays Institute on Aging, Evanston, IL
author of *Alzheimer's Early Stages: First Steps for Family, Friends, and Caregivers*

Acknowledgments

ON MY LONG JOURNEY with Julian, I met many people with Alzheimer's and their families. I would like to acknowledge, first of all, Julian's companions at the residential care center: Newell Aldous, Doris Hoffman, Mina Fields, and Blanche Rochmes, to name a few. Others with dementia wander through these stories, some named, some fictionalized. They taught me about dignity at the end of life and it was a privilege to know them.

I want to also salute fellow caregivers Verna Aldous, Sandy Korges, Deborah Hoffman, Ed Fields, Michael O'Reilley, and Adam Rochmes, among others, for showing me devotion and resilience in its many forms.

Heartfelt thanks to Carol Denehy and the wonderful staff at Peninsula Volunteers Rosener House, Julian's day care center. Everlasting gratitude to all the staff at Oak Creek Alzheimer's and Dementia Care Center, whose names are fictionalized in these stories and whose countless acts of kindness are condensed into just a few scenes. These scenes stand for the 2082 days in which Julian received their kind and cheerful care.

To Beth Logan, of Family Caregiver Alliance; and to Elizabeth Edgerly and others at the Northern California and Northern Nevada Alzheimer's Association, my deepest thanks for your support.

I am forever grateful to many friends who supported Julian and me during the twelve years of his illness, in ways large and small. Some appear in these stories; others don't due to storytelling constraints, but their friendship is no less appreciated.

Special thanks to Bernie Roth, Rosanne Strucinski, Marcia Stefanick, Danusia Szumowski, and Irv Zucker for their repeated visits to Julian—for opening their hearts, connecting with him, and continuing to see his charms. And to Daniella Prag for her many trips to Oak Creek, bringing Julian chocolate, singing Hebrew songs and massaging his feet. Thank you to Charles Familant for his enduring support over many years.

Appreciation to Julian's brother, Kenny Davidson, and Linda Davidson, who traveled many times from Glasgow to visit. To Julian's family in Scotland and Israel, for their bountiful affection and cheering us on. And to my sister Jean Colvin and brother-in-law Bharat Rawal for their devoted attentions to our father, while I cared for Julian.

Sincere thanks to Monday Writers Henri Bensussen, Helen Bigelow, Connie Crawford, Maureen Eppstein, Amanda Kovattana, MaryLee McNeal and Chloe Scott for listening to early versions of these stories. To Dorothy Wall, who helped shape the stories into this book. Thank you to editors John and Susan Daniel for bringing this book to life.

Deep appreciation goes to my family who traveled this journey with Julian and me. To my daughter Karen Davidson de Sá and son-in-law, Ronaldo (Beiçola) de Sá; my son Ben Davidson and son-in-law, Greg Riley; my son Jeff Davidson and daughter-in-law, Katie Neilson; and grandchildren Antar, Celina, and Rasa de Sá, my profound thanks for the countless ways they nourished and comforted us.

Finally, new baby Julian Nitai Davidson de Sá would surely have loved to play "horsey" with his grandfather.

Introduction

MY HUSBAND SITS on the bedroom floor surrounded by a pile of socks. He picks up a gray one, then a black one, and starts to cry. Deciding which to wear is overwhelming.

At age sixty-four, Julian can't remember the location of his underwear, out of sight in the dresser drawer. He can't butter toast, wash his hair, brush his teeth. Perhaps, on a good day, he can read my note printed in large letters, taped on the wall: "ANN GONE. HOME SOON." The only words he can still write are "Julian Davidson," his name.

In 1990, when Julian was fifty-nine, he was diagnosed with Alzheimer's disease. At the height of his career as a Professor of Physiology at Stanford Medical School, his days were filled with lectures and research in neuroendocrinology. He wrote journal articles, traveled to conferences, reviewed funding grants for national agencies. Healthy and strong, he jogged daily and biked to his lab on the Stanford campus.

Now, five years later, he speaks mostly gibberish.

"We need the mavis and the beenie in the laboris," Julian declares first thing in the morning.

"Also the game of the muria—that's maree ellee, the side of the murry ellia," he tells me switching off the light at night.

But Julian's gibberish is sophisticated: his words multi-syllabic. His intonation sounds authoritative, observant, thoughtful.

On clearer days, he makes insightful comments.

"Please. Let's enjoy our life together while I can still talk." He tells me, "I understand it all, but let's be happy in the rest of our life." "I used to be intelligent," he says. "Now I'm just a free and simple man."

When Julian was diagnosed with Alzheimer's, I was fifty-three. I had stopped working as a speech pathologist, recently recovered from breast cancer and chemotherapy. The last of our three chil-

dren, in their twenties, had just left home. At Julian's diagnosis, my triumph over cancer plunged into grief.

For months we hid Julian's problems, struggling to disguise the mounting chaos. I covered for him when he made mistakes speaking, prompted him when he forgot friends' names. Because he neglected to sign checks, we began paying the bills together; I went with him to the car mechanic and learned about Toyota engines. Trying to be cheerful, supportive, brave, I hid my anguish from Julian.

But it grew harder to keep up appearances: Julian's forgetfulness, language problems and ineptitude glared ever more apparent. He substituted words, spoke in vague, rambling circumlocutions, and couldn't follow directions or conversation.

First he lost his keys, his wallet, his coat, his bicycle, which, as a typical absent-minded professor, he had always done. But then he lost the car, bungled his once-excellent lectures. He got lost returning from the library at Stanford where he had worked for thirty years.

I fell into mourning over losing Julian and our normal life. Married thirty-five years, my existence seemed inextricably bound with his. At night, I couldn't sleep, imagining my smart husband "totally helpless, requiring constant care," as the Alzheimer's pamphlets warned. Pictures flooded me: Julian curled in a fetal position in a hospital bed, staring mute and unknowing. Where would I find the strength to care for him or to manage alone? Terrified, I feared I would "go down" and disappear with him.

Then, during that first year after the diagnosis, in an hypnosis session with a psychiatrist, an insight came. As I lay stiff with anxiety on the doctor's couch, that wise man asked me what I wanted. Suddenly a flash appeared: I wanted to "go down" in a spirit of love, not fear and anger, no matter what happened. I glimpsed myself as separate from Julian. He was going down, but I was not. The possibility emerged that I could grow stronger, stand by him and continue a satisfying life.

That transforming moment guided me as I struggled to extricate Julian from Stanford, urged him to tell his colleagues, take early retirement, and let his staff handle difficult work. Gradually I told family and friends and invented ways to handle the chaotic days.

During the second to third year of Julian's illness, when he was in

the "mild to moderate stage," I transformed my journal writings into *Alzheimer's, A Love Story*, describing this precarious time when dementia forced us to dismantle our former life and start adjusting to living with Alzheimer's. Then I called myself a stumbling beginner who recorded what I was learning about commitment, loss, acceptance and love.

Five years later, I am a pro. Alzheimer's blasts me with loss after loss, requiring acceptance of the latest fiasco, challenging me to bounce back. This disease is a fierce teacher, continuing to transform Julian and me.

But Alzheimer's is full of paradox, surprising me also with tiny gifts. While Julian is drastically changed, in many ways, he is still the same. His intellect is gone, but his body feels warm, familiar lying next to me in bed at night. He can't read, but he listens to Mozart and Jewish music with delight. He seems not to notice a sunset, or ten Canada geese honking and gliding around a lake, but he stops before a poppy beside the trail and exclaims, "Oh, lovely!"

Julian's confusion confuses me. Unable to read, write, make coffee or shave, he nonetheless looks intelligent, with his curly gray hair and beard, his wise, rabbinical-looking face. Learning to communicate with my husband who cannot talk requires patience and ingenuity far beyond what I ever learned as a speech therapist. Impaired as he is, his essential affection and tenderness endure. Often, he looks into my eyes, hugs me and calls me his "big chief."

Recently I hiked up a dusty trail through a redwood grove with a friend, after dropping Julian off at his adult day care center. She told me about the hikes she takes on weekends with a singles group. "You want a schedule?"

"Oh, I'll do that after Julian dies." The words shot out of me. I couldn't believe what I just said.

"Do you think he'll die soon?" Her voice softened.

"No! I'm amazed I said that. He's sixty-four, healthy and strong. We're still fiercely attached. But I guess I'm beginning to think about my life once he's gone from the house."

Stopping, she touched my arm and stared at me with compassionate eyes.

"I could never have said that a year ago," I confessed. "Five years

ago, when Julian was diagnosed, I wouldn't even have thought it."

We fell into silence. My tennis shoes turned brown with dust. Thick redwoods shaded the trail, manzanita covered the hillside.

I am alone and not alone, I thought. Like my single women friends, no capable man shares my house. Sometimes I long for an intelligent companion, someone to lean on. But I am still connected to Julian, the strands between us not yet severed. Although he is now in the moderate to severe stage of Alzheimer's, his presence is strong. He can't read, write, talk clearly, make a plan or think, but he is intensely present: funny, affectionate, still capable of pleasure.

I have lost my intelligent, competent Julian as surely as widowed and divorced friends have lost their mates. I must repair the roof, maintain the car, prepare the taxes, like all once-coupled women suddenly alone.

But, unlike them, each night Julian sleeps beside me, his warmth fills my bed. His breathing on the pillow sounds the same as a normal man. Yet, daily he grows less able, more restless, anxious and confused. His needs demand and consume more and more of my time.

Alzheimer's course is unpredictable: it can last from two to twenty years. The rate of decline varies from person to person. Much as I love him, I often feel frightened, furious, full of despair.

How much longer will I be able to care for him? What will happen when I no longer can? How do caregivers manage? How can I communicate with my husband who cannot talk? How will I bear it when he no longer knows me? Is it possible to maintain intimacy and closeness with someone so damaged? What will my life be when he is gone?

My friend waited beside me while I tied the laces of my boot. She pulled two apples out of her backpack and wiped them with a napkin. "What are you thinking?" she said.

"I am thinking," I answered slowly, "that Alzheimer's has made me a curious kind of widow."

A Different Kind of Harder

"Only Mellaril and day care stand between Julian living at home and the placement decision I dread."

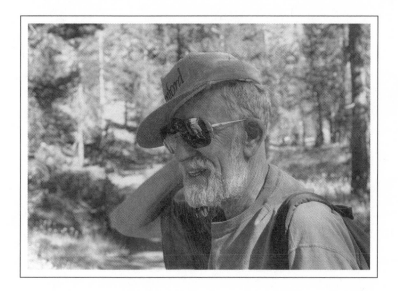

Two Small Orange Tablets

A LATE-NIGHT MOVIE blaring from the television wakes me—cold and uncomfortable—curled on the family room couch. Linen pants rumpled, sandals still on, I struggle to remember why I'm not in our bed.

Images emerge from the fuzzy zone between sleep and awareness...chocolate éclairs...snuggling on the couch with Julian watching "Mystery." Then he stumbled off to our room to sleep. During the ten o'clock news, I must have dozed off.

Now silver hands on my watch declare three A.M. Suddenly my heart thumps fast: Julian fell asleep without the drug his neurologist prescribed. Julian must take these pills. Without them, he will wake up headed for a terrible scene. I roll off the couch, lurch groggily towards our room.

In the bathroom, I shake two orange tablets from the plastic container and set them on the tile counter. My plan is to wake Julian and give him his pills. But as I undress, he appears in the hallway in his blue striped pajamas, curly gray hair tousled, looking like a mix of a mad scientist and the befuddled cartoon character Mr. Magoo. With his glasses off, Julian's eyes are the color of a milky morning sky; he has the sweet smell of a sleepy child. Smiling, he pats my bottom and goes to pee.

Glancing at the counter, I see that the orange tablets are gone. Good. He must have swallowed them. So I slip into bed, relieved that he has taken the Mellaril.

Julian returns from the bathroom and slides under the covers. His body spoons around me: chest pressing against my back, beard tickling my neck, knees fitting perfectly into the curve mine make. I relax into his familiar heat as he strokes the soft spot where my collar bones meet; my breathing slows, I sink into sleep.

But soon I am wakened by Julian, up and talking. He stomps from the bedroom, then reappears; he clumps to the window, slides open

the curtains. Outside the glass is pitch black night: red numbers on the bedside clock glare 4:30.

"Go to sleep, Julian. It's still night."

"The animus is on the foddering," he mutters, "the ishy needs the idderil and the uddering on the oddle."

"Go to sleep, Julian."

"The oddicoddle needs the oody and the osherall." His voice grows louder, shriller.

"Julian. Be quiet. Stop talking."

He begins unbuttoning his pajamas. Perhaps if I take him to the bathroom, he will quiet down.

"The animal is in the meevay," he declares, standing naked before the toilet, pajamas in a heap on the linoleum floor.

I help Julian back into his nightclothes and give him a drink. But he paces anxiously around our room, clearly not ready to get in bed. So I slip a Scarlatti cassette into the tape recorder; still he won't settle down.

"We've got to get the meandering off the oshe. And then the otteral goes in the idderil." Words rush from him.

Back under the covers, I try to ignore his muttering and focus on Scarlatti's violins, but I can't. Frantic now, I cover my ears with the pillow and yank the blanket over my head, afraid to sleep in another room for fear Julian might go outside or hurt himself. I haven't the strength to do anything but just let him pace and jabber.

Around 5:30, he starts talking about food.

"Go get a banana," I growl. "Go in the kitchen and eat a banana."

He stares at me blankly as if he has no idea what a banana is.

"A banana!" I snap.

He wants me to get up and start the day, I know, but I am too weary to move. Suddenly I see one orange tablet on the sheet, another on his pillow. Of course! He never took the Mellaril; this is what happens without the drug. Snatching up the pills, I hand them to Julian, who pops them in his mouth and swallows, but by now sleep is out of the question.

Despite the Mellaril, Julian grows more agitated. If I get up and make breakfast, he might settle down. But I have slept less than two hours, so I lie in bed watching him fuss. Finally I push myself from the blanket's warmth to face the gray day.

The minute I begin our morning routine, Julian's anxiety eases. I shower first, then call him. While he showers, I lay out his clothes, the usual steps. He whistles as he puts on the items I placed on the bed, hums while deftly tying his shoes, buttoning his shirt. Julian seems fine, as if last night never happened. Cheerful as he is, my eyeballs sting; dark shadows hang under my eyes, my legs feel as heavy as redwood logs.

"Don't talk to me," I snap as we drive to day care. "I'm cranky. Tired."

He seems to understand, but he cannot stop talking. "Look at that big one!" he cries as we pass Stanford's stadium. "Oh, let's go there!" he shouts, finger aiming at the new tennis bleachers.

Pointing out landmarks comprises our daily driving ritual. I punch on the radio, but the morning news adds more confusion. Besides, I can't hear it over Julian's chatter. So I switch to the cassette player and Jewish music bursts forth—a fiddle, a balalaika.

Finally Julian stops talking and begins clapping in rhythm, swinging his head from side to side, slapping his thigh, humming "Tumbalalaika"along with the tape.

At Rosener House, the social worker, Carol, calls out cheerily, "Good morning, Julian," as we walk in the door. It was Carol who, just a few weeks ago, hearing about our frantic nights, suggested I call the doctor and ask him to prescribe some "sedating medication."

This morning, seeing my glum face and bleary eyes, Carol grasps Julian's arm and whisks him from me. Her gray-blond pony tail swishes as she leads him to the dining room for his morning coffee. I toss her a grateful look. My hunched shoulders relax as I drive home.

Back in the kitchen, I putter around, put jam in the fridge, water the African violets. Each time I blink, my eyelids feel grainy and my body moves like a snail inching up a cliff. I am too tired to go out and do my errands.

Sleeplessness is a major reason caregivers put loved ones with Alzheimer's in residential care, Carol told me. Exhaustion pushes caregivers to eventually look for placement. Friends may wonder why Julian is still at home. But I am not ready to place him, not yet. I believe home is the best place for Julian to be and I am the best person to care for him.

After cleaning the kitchen, I collapse on the same couch I slept on last night. Though my body aches with exhaustion, I can't relax enough to let myself doze in the bright summer morning. Lying stiff, muscles tense, I fear Julian's agitated nights may not disappear, even with the Mellaril. Feelings about Mellaril swirl around. Reluctance: Julian is taking a powerful, mind-altering anti-psychotic drug, even though it's the minimum dose. Relief: when he takes it, he often sleeps until dawn.

But how long will the Mellaril work? When I asked the neurologist if Julian should take it nightly, or just when needed, the doctor said it must build in his system.

"But he isn't agitated every night," I protested. "I hate for him to take such strong medication all the time."

"If you want to stop and see the effect, go ahead," the doctor warned.

Last night I got my answer about Julian needing the two orange tablets. Only Mellaril and day care stand between Julian living at home and the placement decision I dread.

Realizing that I must sleep or I can't care for Julian, I close my eyes, let weariness drain from my limbs and give myself over to the soft nest of the sofa cushions. In blessed silence, I inhale deeply, exhale slowly and slide into a brief, delicious morning sleep.

Framing Things

THE JANGLING TELEPHONE wakes me at noon. It's my son, Ben, calling from Boston airport to say goodbye. His excited voice tells me in two hours he and Greg will fly to Spain. They packed shorts and sandals for the hot sun, laptop computers for Ben's thesis and Greg's novel. Ben's case is heavy with books; Greg lugs the printer. During summer vacation from graduate school, they will spend three months in Cadiz working and writing.

Lying here on my family room couch, pictures emerge of them on a balcony with geraniums spilling from clay pots, mugs of *café con leche* on a tile-topped table, moving from glare to shadow as the day's heat grows. I envision their silent mornings, struggling to bring words onto inchoate thought. Then lunch—tomatoes, olives,

bread, cheese—and a hot sleep on the *cama de matrimonio*. Later, over beer and *tapas* in the local bar, they'll discuss the day's work, what each is trying to express. In cool darkness, they will hold each other in that faraway Spanish night.

Their planned summer of writing together was Julian's and my idea of a perfect time. My mind floats across thirty years of our mornings in bed—mugs on nightstands, toast crumbs on rumpled sheets, papers strewn across blankets. I remember the warmth of Julian's arms, chest hair against my cheek, smells of sweat, sounds of breathing.

Thousands of cups of tea we drank—on beds and balconies, here and abroad. I read early versions of stories to Julian, or handed him a draft for his penciled remarks. He might show me a talk he was preparing on testosterone levels in aging men, or a chapter on the relation between hormone levels and sexual behavior, for my response.

When I honed a draft, searching for a word, Julian supplied the perfect phrase, closer to my intention. With Julian around, I needed no dictionary: he knew the correct spelling and meaning of any word, the product of his excellent Scottish education.

Before his Alzheimer's diagnosis five years ago, our dream for our future was both of us writing. Once I stopped work as a speech pathologist, I planned to write articles and stories; after my mastectomy in 1988, followed by six months of chemotherapy, I was free to travel with Julian to conferences in foreign cities. When he retired from teaching and research at Stanford, Julian planned to write about the philosophy of science or physiology for the general public. Our plan was to pursue our favorite things: walk, talk and write together. But we didn't start soon enough; now I write, but alone.

Glancing at the family room clock, I see it's time to get Julian from day care.

When I enter Rosener House, twenty elderly folks sit on blue vinyl chairs in the activity room before a huge television monitor, watching a travel video of Ireland. The only person standing, Julian paces the back of the room. As I approach, he glares at me, staring at his watch, frowning.

"I can't just sit around here," Julian used to mutter when he could

still verbalize feelings. Now his body language tells me: he grabs his jacket, puts it on upside down, fumbles with the zipper.

"The ittering is on the ancrosis," he snaps. "I want the ordolly and then we can do it…the offeree, the oodapee…the…well…you know."

Hugging him hello, I look into his eyes, listen to him, search for the gist of what he is trying to say.

"The ardoo-oli is going on the afiosis," he says. "And then we can eeger the adi…you understand?"

But I don't. I feel remorseful leaving him for long hours at day care, but once he gets in the car and starts talking, I remember exactly why he must go there. My heart sinks; I inhale deeply trying to stay calm.

"Yes," I tell Julian, driving to my dad's retirement home. "Okay…we can do that…okay."

With Julian jabbering beside me in the car, I pull up to Woodacre Knolls, where my father has lived for the past nine months, ever since his surgery to improve circulation in his leg. Heading down the hall towards dad's room, Julian stares at large oil paintings with southwest themes: cowboys on bucking horses, Hereford steers grazing near sagebrush. Their solid wood frames contrast strangely with the frail, elderly residents who shuffle the halls and slouch on couches.

Julian likes coming to Dad's retirement home. He gawks at a stuffed peacock sitting on the hutch in the hallway and fingers the silky feathers of its turquoise tail.

"Julian, come back here," I call, as he wanders through an open door into a bedroom where two white-haired women rest on pink bedspreads under afghans.

Ironic that this home would never accept Julian, nor would other "assisted living" places my dad has been; Julian is too physically active and more cognitively impaired than the residents here, even several who have early-stage Alzheimer's.

My eighty-four-year-old father is frail but competent. My sixty-four-year-old husband is healthy and strong, but mentally like a brain-damaged three-year-old.

Suddenly I realize how my current job description might read: providing three shifts of full-time care, constant supervision, recre-

ation, maintenance of building and grounds, cooking, cleaning, love and support for Julian. Yet, when people ask, I answer, "No, I'm not working."

Julian and I enter Dad's room, where my dad lounges in his leather recliner, feet crossed on the extended footrest: one wearing a brown tennis shoe with Velcro straps; the other a blue medical boot, worn for three months now, which protects his gangrenous toes. Poor circulation and diabetes prevent his open sores from healing. In the corner, the television flickers; on screen, Phil Donahue, Dad's weekday favorite, strolls through the audience clutching his microphone.

Papers and folders are stacked on the arms of Dad's recliner. He is cleaning out drawers, sorting memorabilia he has saved for years.

Last week he returned a note I wrote when I was twelve—thanking him for two goldfish. My childish handwriting shocked me, as did the 1950 postmark and the three green one-cent stamps. Most surprising was the letter's innocence. My three children, Ben, Karen and Jeff, now in their twenties and early thirties, wrote like that at six or seven. By twelve, Ben was already demonstrating against sending arms to El Salvador and protesting registration for the draft, Jeff was playing in a rock band and Karen was learning Capoeira, an African-Brazilian martial art.

Today Dad gives me his report cards from elementary school and a 1931 program from high school in Los Angeles, where he sang in the glee club, performing Gilbert and Sullivan's *Yeoman of the Guard*.

Proudly he shows me his name in the long list of the chorus. Then he gives me a second *Yeomen of the Guard* program from the Stanford production I took him and Julian to last month.

My father goes on living, but in clearing out his treasured files, throwing out papers held onto for fifty years, he is also letting go. In the past decade, he moved from a 5,000-square-foot, elaborately furnished town house (where he lived with his second wife after my mother died) to a small condo (which he shared with his third wife, Myriam, after his second wife died). Ever since he crashed his car and broke his leg three years ago, he has lived separate from Myriam, who works and lives across the bay. Since his circulation problems began, he has lived in studio apartments in two retirement homes.

Now, he is down to one room at Woodacre Knolls, his smallest, most restricted space, yet somehow he accepts it with spirit and grace.

~

"I'm fine." Dad answers my inquiries, as Julian plops down on the couch. "Food's okay. Place is good. I've plenty to do, sorting papers."

My father is a man of few words, but I get what he's saying. He has accepted his lot. Gone are schemes and dreams for the future business possibilities he has always had. Now he lives in the simple present, day by day.

Today he wants me to take him to have another picture framed. Recently he has begun framing mountain scenes cut from a calendar, as well as pencil sketches he drew in high school, his walls now covered with newly-framed drawings.

As my dad shows me what he wants framed, Julian snores on the sofa, his mouth open, his head tilted to one side. He leans so far over, I am amazed he doesn't fall.

Lowering the foot rest on his recliner, Dad rocks back and forth gaining enough momentum to finally stand up and out of the chair, his cane helping him balance. "Damn seat's too low," he says, then shuffles to the closet to get his blue disabled parking sticker.

My hand on Julian's shoulder, I shake him awake. He jumps up and runs out the door to finger the peacock's tail and look again at the cowboy pictures. Then we drive to the frame shop, the pharmacy, and lastly to a bakery, the climax to this tedious afternoon.

There, I hold Dad's arm as he shuffles towards our table in his tennis shoe and medical boot. He hooks his cane on the back of the chair. Once he's settled, I walk Julian to the bathroom, opening the door marked "M", not "W", which if alone, he would confuse; at this point he can still manage the bathroom by himself. Then I get three Danish pastries, two coffees, and a diet Coke for my father.

"I can't have sugar," Dad says, checking to see if the Coke label says "diet," yet cutting with gusto into his Danish. I haven't the energy to ask him to be consistent. Julian's face is soft and relaxed as he eats, pouring three packets of sugar into his coffee.

My dad and my husband eat silently, while I comment on the decor, the pastries, the bakery's new counter.

Exhausting, these outings. My body aches to walk fast, stride up some rocky trail high into hills, push myself physically until I tire. My chest bursts with the frustration of listening to Julian's gibberish and my dad's trivia, or enduring their silence. I long for a meaningful, intelligent conversation, like Ben and Greg are having.

To restrain myself like this, creeping at my dad's pace and running around after Julian, is not relaxing. To release tension, I breathe deeply, try to tell myself this outing takes only a few hours, and Julian and my father deserve a small treat. Besides, I chose an excellent bakery with great pastries.

Finally it is time to drive Daddy back to Woodacre Knolls.

"We've got to get that animal onto the gittering," Julian says as my dad gets out of the car.

"Bye, Julian," my father says, the first words he speaks directly to him.

That evening, as Julian and I prepare for bed, I picture Ben and Greg landing in Madrid, stretching their legs after the trans-Atlantic flight, exchanging traveler's checks for *pesatas,* as Spanish words buzz around them. Just two years ago Julian and I flew to Spain, when Julian received an honorary degree from a university in the Canary Islands, our last big trip. Now our traveling days are over.

Lying under the covers beside a sleeping Julian, I wish I could jump a jet and fly to Cadiz…meet Ben and Greg on the balcony, sip *café con leche* from a blue and yellow hand-painted mug, read aloud to my lover my latest writing.

But what I really want is for Julian to hold me and hear me, caress me, talk with me on balconies, between sheets, in cafes, in sunlight and moonlight. Like before Alzheimer's, I want us to stroll, arms slung around each other's waists, hips moving side by side, beneath a starry Cadiz sky.

Showplace

THE NEXT SATURDAY EVENING, Julian and I drive to San Francisco all dressed up. Sitting straight next to me in the passenger seat, Julian wears his good black trousers, a white shirt, charcoal tweed jacket, and a red tie. He looks like a well-groomed academic,

instead of the Einstein-like aging hippie who walked into the barber shop this morning for a beard trim and haircut, and not at all like an Alzheimer's patient in the "moderate" stage, who can't even write his name.

We are headed for the Designer's Showplace, a remodeled brick warehouse in the city's fashion center—to a fancy fundraiser for Family Caregiver Alliance, an organization that helps families with brain-injured adults. Not the kind of event I usually attend. I probably won't know anyone there, but Beth Logan, director of the respite camp Julian went to last year and a board member, urged me to come.

"The food will be great." she said. "I'll take you around. Come. You'll both enjoy it."

With Beth's urging in mind, I forced myself into Macy's after a desperate search through my closet produced nothing appropriate to wear. Now, in my new tomato-colored rayon tunic—long, soft-flowing, mercifully covering my expanding derriere, with loose black pants and a long Israeli string of silver and amber beads, I feel quite acceptable for this cocktail party. Elegant, by no means, but dressed up enough for me.

Julian and I join other well-dressed couples streaming towards the door of the brick warehouse, with its exposed pipes and huge glass windows. I feel slightly nervous; not only will I not know anyone, but I worry about how Julian will behave. I hook my arm around Julian's elbow where I vow it will stay for the next two hours.

Oddly enough, once in the warehouse, I grow increasingly at ease, not usually how I feel taking Julian to public gatherings. This is a fundraiser for brain-injured adults, after all. Surely Julian, with his strange, unpredictable behavior, will be accepted here.

Inside, small tables dot the room with four white chairs around each one, each table covered with a white cloth and vase of flowers. Along three walls, famous San Francisco restaurants serve specialty sandwiches—smoked salmon on toasted sourdough, *dimsum* in white flour buns, *spanakopitta*, sliced chicken breast, and wild boar. Bar tables offer unlimited wines. A man with a brown beard plays classical guitar.

My arm linked through Julian's, we stroll around the well-dressed crowd. No one would ever guess from looking at us that

earlier this morning Julian defecated in the shower and that I had to shave him and lace his shoes. We find a table near the restrooms, just next to a Greek buffet of *spanakopitta*, stuffed grape leaves and creamy garlic-flavored yoghurt, where I often return.

There we sit—happily eating *dolmas*, listening to Villa-Lobos, enjoying the scene. A man in a black suit and two women in silk dresses sit down at our table and introduce themselves—a doctor, his wife, and a friend. Julian does not look at their faces as they speak, does not see the hand the doctor extends to Julian as he tells us his name. Momentarily I slip back into feeling sad that we cannot have an intelligent, normal conversation, as we used to at professional parties.

In the more recent past, I would have winced, might have said, "Shake the man's hand, Julian," or told the doctor, "He doesn't understand." But I bite back these impulses and let things take their course. It is easier this way. It is stressful staying on guard, anticipating social awkwardness and always being concerned about what people think.

Our little round table is gradually covered with wine glasses. But Julian keeps drinking other people's red wine instead of his mineral water. After making several attempts to remove their glasses from Julian's hand and handing him his own, I give up. By now, I figure our table companions "get it" and can hang onto their own wine glasses if they want.

Julian wags his head back and forth in time to the music, and applauds loudly with the audience following introductions and the award presentations. One award honors filmmaker Deborah Hoffman for her prize-winning documentary about her mother with Alzheimer's, *Complaints of a Dutiful Daughter*, which I have seen seven times, a touching, informative film about placing her mother in a home for dementia patients.

Julian is fascinated by the auction that follows, focusing on the auctioneer appealing for higher bids on donated art items, as if he were in an orchestra seat at an opera. He beats his hand on the table in time to the auctioneer's rhythm. "Two hundred and fifty, do I hear more, two hundred seventy, who'll make it eighty?" Julian laughs and laughs. His eyes shining with pleasure, he looks at me and says, "*Ooda booda oodle ohdle . . . ,*" capturing perfectly the auctioneer's intonation.

I hold Julian's hand and we laugh together. Julian is enjoying himself thoroughly and so am I.

Suddenly Beth appears, slim and elegant in a short black skirt, her long trim legs in dark stockings, straight blond hair framing her face. She greets Julian with a big hug.

"Hi, Julian. Remember me? It's Beth, from camp. I want you to meet some folks."Taking Julian's arm, with me following, she steers us through the crowds and introduces us to Family Caregiver Alliance board members.

"This is Julian," she repeats. "Dr. Davidson, the one I told you about." Sometimes she says, "Julian's been to our camp." Julian smiles and laughs; sometimes he shakes an extended hand, sometimes not.

It seems that Beth has told people about Julian. "He is so sweet," she tells me and the others. "He's so charming."

As we cruise around the crowded room, I spot some women I recognize from the couples' support group at the Veteran's Hospital Julian and I attended four years ago, and wave.

"Let me take Julian for a while," Beth says suddenly. "Go. Enjoy yourself. He's fine with me."

I throw her a questioning glance, but she is already leading him away, winking at me over her shoulder. Joining the women I know, I exchange up-dates with them on our situations since we last saw each other.

"My husband's in a nursing home," one says. "He can no longer feed himself. It's been twelve years...."

"Mine's still home," says another. "But he's failed his fourth day care."

Once when I went to visit an acquaintance at the Jewish Home for the Aged, I saw this woman and her husband. Seeing him cling to her hand as she led him down the slick polished corridor towards the day care room, I remembered them vividly from the Alzheimer's couples' group. He was the man who had paced restlessly muttering only "*dibika, dibika.*" Suddenly I gasped. That was *four* years ago, and he is still home with her.

"How do you manage?" I whisper, filled with awe at what she has done.

"I have a team of Russians," she says matter-of-factly. "Three Rus-

sian immigrant Jews take care of Arthur round the clock. They're used to living in extended families. The house is full of people. They love it." Nonchalantly she throws out these lines. My heart leaps up at her bravery, her strength. I would love to hear more.

"How do you do it?" I want to ask. "How do caregivers do it?," the question I have been asking myself and others for nearly five years.

"I'm working now," says the first woman, smart and fashionable with close-cropped black hair and a pale pink blouse. "I'm in my sixties and I've gone back to work," she declares proudly, "in marketing at an Alzheimer's residential care center. I'm good at it. I know what people are feeling."

My eyes take in her new enthusiasm, her perky manner.

"And I'm writing a book—on how to take care of yourself," she says. "For me, it's been twelve years."

My question persists—how do caregivers do it? Although there is no time for a detailed answer, before me stand long-time caregivers who seem okay, who appear to be going on with their lives. The auctioneer stops his chant, and a string quartet begins to play. I mill about, sip Chardonnay, nibble a wild boar sandwich, then begin searching for Julian. Maybe he is missing me, or giving Beth trouble? Maybe Beth is tired of him?

Pushing through crowds, I head towards the music. Near the cello player, I spy Julian's curly gray hair bobbing up and down: he is dancing. As the quartet plays a lively Vivaldi concerto, Julian prances about holding the hands of a little girl, who looks about ten, wearing a fluffy pink dress. I am aghast. No one else is dancing. This is a cocktail party. And who is this child whose hands Julian holds? But no one seems concerned. Julian is grinning, shifting his weight in time to the music; the child seems happy. I glance around and spy Beth nearby, who motions for me to join her.

"Isn't Julian great?" she whispers. "Just look at him enjoy himself. He is so darling! That girl is the granddaughter of the woman who founded Family Caregiver Alliance."

Tears fill my eyes. Beth puts her arm around me and gives me a hug.

Together we watch my handsome husband, dancing his heart out, immersed in pleasure. I think back to last night's episode of cleaning feces from the shower, remember the gibberish and confusions of

the previous day. As bad as things sometimes get, good times are not yet over. I am happy Beth invited us here, glad to share with her this moment, grateful that she appreciates Julian and sees his charms. I vow not to turn away from possible pleasures, even if they involve extending myself and taking risks. I am learning to enjoy myself even with Julian so far from normal.

"You two are terrific," she says.

"And so, dear Beth, are you!"

Capoeira

THIS MORNING, my daughter Karen calls and leaves a message on my answering machine: "Hi Mom. It's me. Just want to let you know the new Capoeira class starts tonight."

Karen and her Brazilian husband live with their three children an hour away, across the bay. But this summer Beiçola will teach a Brazilian martial arts class just ten minutes from our house.

The flyer advertising his class hangs on our refrigerator door. Held up by magnets, the pink paper shows Beiçola head to the floor, one leg kicking high in the air. All week my eyes spot Beiçola on the Capoeira flyer every time I open the fridge.

Overweight and out of shape, I weigh as much as when I was nine months pregnant with my first child, Ben. When I feel stressed these days, I shove crackers in my mouth. Alone, on long evenings with Julian, after silent dinners or hours of listening to his gibberish, I make toast and lather it with jam. A year of uncensored carbohydrate craving has thickened my thighs, hung a roll of flesh around my waist, given me "kimono arms." Getting Julian to day care has eliminated my early morning walks. Now I pant just walking around my block.

I will certainly never stand on my head or walk on my hands, like Karen and Beiçola, but could I, at fifty-seven, learn to do a respectable Capoeira kick? For years I have watched my daughter doing Capoeira, ever since she was twelve, and watched Beiçola's students doing cartwheels, back flips and kicks. Imagining myself doing the same, maybe even losing some weight and keeping fit, I decide to take Beiçola's class.

I phone several friends to ask if anyone can stay with Julian, but

no one can. If Karen lived closer, I could drop Julian at her house when I needed to go out. As it is, I feel confined, trapped. Suddenly I feel desperate to take the class. Risky as it seems, I decide to leave Julian alone at home, just this once, and then find someone to stay with him for the coming weeks.

Julian has had a long day. It is hot, he is tired. I run him a shower, get him in pajamas, hide his shoes in the closet so he won't put them on and go outside, then turn on the television which faces our bed. Great: an opera is playing *Tosca*. Julian will like that. I turn down the covers. On a big paper by the nightstand, I print: "ANN—CAPOEI-RA. HOME—9:15."

"I'll be home at nine fifteen, Darling," I say for the twentieth time. "Have a nice rest. I'll be home soon."

Not the most responsible decision to leave him alone, perhaps, but I am ninety percent sure he will go to bed and drift off to sleep listening to *Tosca*.

Pulling on my white Capoeira pants, I glower at my reflection in the mirror, the tee shirt clinging over my wide hips. But I censor this image and replace it with a fantasy of myself doing my best cartwheel. Pretty darn good, I think, for a fifty-seven-year-old overweight, out-of-shape Jewish grandma with one breast, even though the cartwheel is a residue from my athletic childhood, not something I learned in the few Capoeira classes I took last year.

Walking into the large recreation room at the cultural center, I see Beiçola adjusting a tape recorder with eight new students standing nearby. He bends over the sound system, dressed in his white Capoeira uniform, his waist encircled by his yellow and white braided *maestre* belt. Beiçola has been a Capoeira master over ten years.

The students wear a motley mix of colored shirts, sweat pants and tights. Only two uniformed men are stretching out, wearing the regulation white pants and white shirt with Beiçola's logo on their chests. Good. Nearly the whole class is new; I can learn elementary moves with other beginners.

His brown eyes smiling, Beiçola faces us, stretching his dark muscled arms high over head. I position myself in the back row as we warm up. Slowly, he repeats the basic step, *ginga*, starting from a wide stance, swinging one leg back, rocking on his foot, shifting weight to the back foot, then forward.

The class awkwardly copies his movements. The two advanced students move to one side, practicing more difficult kicks. I haven't done Capoeira for over a year and even then did it only briefly, though I have watched it many times. My *ginga* is stiff, jerky. I keep my eyes on Beiçola's rhythmical, fluid movements, willing my body to look like his.

Music from the tape recorder drums out the beat. The new students practice their *gingas* while Beiçola moves among us, straightening someone's leg, repositioning a foot. Slowly my movements loosen and flow; body memories wake up. But already I am panting. Sweat drips down my face. I must stop after every few kicks.

Then Beiçola demonstrates *bencao*, the simplest forward kick. I remember this and am doing it well when Beiçola motions me to join the advanced students. I protest, wanting to stay with beginners. But Beiçola puts his arms around my waist and leads me to a corner where he shows me a new kick he wants me to learn. Wiping sweat from my forehead, I catch my breath.

"I've lost my stamina," I pant. "I've no endurance."

"Julian's taken all your energy," Beiçola says in his thick Brazilian accent.

Suddenly tears stream from my eyes. Words of kindness make me cry.

"Yes, yes, he has," I sniffle.

"I'm sorry. I shouldn't have said that." Beiçola looks at me with compassion, as the class practices their *gingas* and the advanced students their complicated kicks.

"It's okay...it's true."

Beiçola draws me into his arms, presses me to him. I feel his strong arms around me and rest there a moment enveloped in his strength.

"We all have our crosses to bear," he says gently. Pulling a chair near me, he shows me a new kick: right foot forward, pivot left, hands on the floor, swing the left leg high over the chair and make a turn. I don't get it at first. He shows me again and leaves me to practice.

Soon he calls everyone to form a circle. It's the class's first *roda*, the Capoeira game. Beiçola moves to the center and shows off his skill: leaping, twirling, kicking, standing on his hands, balancing on

his head, doing an effortless back flip. Soon he gestures for the two uniformed students to "play Capoeira," to come inside the circle to spar, kick, twirl, dodge, do hand stands and flips.

The two young men, one wearing a green belt and the other a yellow, show the class how Capoeira is done. Beiçola "plays" with each in turn, encouraging them to attempt ever harder kicks, pushing them to their edge.

Then he beckons me to play. I hesitate and shake my head, but he pulls me to my feet and leads me to the head of the circle. Squatting in the starting position, I shake my partner's hand and focus on the music, absorbing into my body the pulsing beat.

I cartwheel out into the game and establish my *ginga* in time to the drum. Dodging my opponent's moves, I squat to avoid his kick, turn another cartwheel as he walks on his hands. I stop thinking about how to do it or how I look and just move—kicking, turning, dodging, twirling, until I have no more breath. My face drips sweat; my breathing comes in gasps; my legs will not do one more kick. Smiling, I shake hands again with my partner and collapse on the floor.

A woman in turquoise tights smiles at me. Clapping my hands to the beat, I feel pleased. But soon Beiçola calls me again.

"I did it already," I protest, but I manage another round, tiring more quickly this time, but pushing until my body screams stop.

Afterwards, as we sit in our circle, Beiçola tells the history of Capoeira, a two-hundred-year-old African-Brazilian martial art. He explains its origins from when the Portuguese held slaves in Brazil. What slave-owners thought were songs, chants and dances were actually the slaves developing forms of self-defense.

"Capoeira is a game, a fight, and a dance," Beiçola says, "still done all over Brazil."

What am I doing here, I ask myself, gazing at the other students, most in their twenties and thirties. I am decades older than anyone else and it is probably not good for my sciatica and arthritic back.

But I feel great! My heart beat returns to normal; my breathing slows down. Wiping sweat from my forehead, I smile back at the woman in turquoise tights who keeps staring at me. Beiçola grins as he teaches us to clap the rhythm and sing a simple Capoeira song: "*Parana ueh...Parana ueh, Parana...*" which I've heard Karen and Beiçola sing for years at countless classes and events. I sing loudly

and clap the beat. I know I will be stiff tomorrow, but losing myself for an hour into wordless movement and pushing myself to my physical limit seems exactly what I need to do.

At the class's end, each person shakes hands with everyone else. Beiçola grins as I clasp his hand in the secret Capoeira grip.

But as I walk to my car, anxiety floods me about leaving Julian. Is he all right? Will he remember where I went? Will he have lost my note and become scared? Would he, God forbid, have gone outside to look for me? So far, he has never left the house.

I drive home quickly, dash from my car, and rush into the dark house. Running down the hall, I hear opera music still coming from the bedroom. Light flows from our room. And in our bed lies the familiar lump of Julian under the blankets. He is curled on his side facing the television, hands under his cheek, sound asleep.

Sighing with relief, I go straight to the phone and arrange for a friend to stay with him next week. Then I sit on the bed beside him filling out the cultural center form, signing up for Beiçola's class, imagining myself doing a perfect *ginga*.

Heat Wave

THE NEXT SUNDAY, Julian is red-faced and sweaty as we enter the house from a morning walk. Peeling off his shirt and shorts, he deposits them on the kitchen floor, drops his shoes on the family room rug, then collapses in the recliner.

It's not even noon and the temperature has reached an all-time high: nearly one hundred. For three days, the air hasn't moved. Each room feels like the furnace is on full blast.

Sweat rolls down my arms and drips off my forehead. Julian refuses to eat the simple lunch I set before him, pushing away salad, ignoring iced tea.

"Don't you want lunch, Julian? Aren't you hungry?"

"You have a reguery on the meeveris," he mumbles. "The osheree is there."

"Don't you want to drink?"

"Remember the scherning of the moini? I'll come up on the oshee. It's worth doing."

His cheeks are hot pink.

"Drink this, Julian." I hold the iced tea to his lips and he takes a sip.

"Julian. Let's rest."

Taking his hand, I lead him to our bedroom where he flops down on the quilt. Sprawling on his back in his underpants, he's asleep in a minute. Sighing, I return to the kitchen desperate for my iced tea, when suddenly the phone rings.

It's my father. The battery on his "One Touch" diabetic blood monitor is dead and he can't take his blood sugar, which he checks daily.

Fighting the desire to say, "Daddy, I can't come over; I'm too hot, too tired," instead I say, "Okay, Daddy. I'll get you a new battery." I worry about my father living alone. My sister and brother-in-law, who live in San Francisco an hour away, help Dad a lot, but they are busy today. Maybe I can do this errand quickly and then rest.

Leaving Julian asleep, bringing my cold drink into the car, I drive to dad's retirement home and pick up his "One Touch." Then I drive to the drug store, where the pharmacist declares they don't sell batteries. But the woman in the checkout line shouts they *do* have batteries…and she puts one in place.

Back at my dad's, he tries the "One Touch," but it doesn't work. We take out the battery and replace it in every position, to no avail.

"Maybe this battery is dead," I suggest, trying to stay patient. "I'll return it."

At the pharmacy, the saleswoman and I try three more batteries, but no numbers appear on the monitor's screen. At three P.M., the heat is at its highest. My feet stick to my sandals; I'm longing to rest. But I drive back to my dad and tell him that three different batteries failed to make the "One Touch" work.

"Fucking bastards," my father says.

I ignore his remark. For years my dad has sworn in response to the slightest frustration, but he's been mellow lately. In recent months I've stopped reacting to the curses which used to flow during every visit. Today, however, he's hot and irritable.

"There's an eight hundred service number on the back of the monitor," I say. "Let's call and see what else could be wrong."

We have to solve this. My dad must check his blood sugar to

know how much insulin to take. I dial the number, listen to the re-corded message and push the number of my desired option; I am thanked for my patience while they put me on hold.

What patience, I wonder. Or, by thanking me, are they trying to ensure that I am?

"What'd they say?" my dad asks.

"I'm waiting for the next available service representative."

"Fucking bureaucracy," my father says.

Finally I straighten out the problem; it's not the batteries: the "OneTouch" itself is faulty. The company will send a new machine in two days. My father takes the phone and gives his address in a friendly, pleasant voice. How polite he is to any stranger, showing his anger mainly to his closest family: my sister and me. Apparently he is willing to wait; he doesn't *have* to take his blood sugar, he tells me.

"Oh great," I think. "So why am I here?"

It's now four thirty. He pushes himself out of his recliner, leans on his cane and totters down the hall to his supper.

"Bye," he says.

A thankless way to spend a sweltering July afternoon.

In the car, I switch on the air conditioner and tape deck. Cool air and a cheerful Brazilian samba burst forth, and for twenty minutes I drive home, listening to tambourines and drums beat a new rhythm from Rio, trying to calm down.

～

Back home, I open the kitchen door to stifling heat. Harsh sun glares through the western window. Julian appears in his underpants, his chest sweaty, his face red and glum; damn it, now it's too late to nap.

"I looked...where...thought you'd died...never..." He gropes to explain.

"I went to my father, Julian. I was helping my dad."

"That's mory elly," he says. "The side of murry ellia."

Though I doubt he can still read, I left a sign taped to the wall by our bed: "ANN GONE TO DAD. HOME—4." I'm not going to be able to leave Julian alone with these little notes much longer.

"Well, I'm back now," I say. "I'm here. I'm sorry you worried."

"But the game of the muria," he persists. "The mavis...the beenies...the laboris..."

No longer able to guess what he means, I putter about the kitchen, trying to appear calm, which is not how I feel. What to do next?

"Let's have a cold drink," I suggest, pouring apple juice into two glasses and sitting across the kitchen table from him in the hot, still air. "Let's drink this juice."

Looking straight at my face, he declares, "You need to report on your shol before it is rimmer!"

Having no idea how to answer his statement, I look at my watch: five P.M. The library closes at six; I have overdue books to return. Hot as it is, at least a trip to the library will take up time. Only four hours till bedtime. Maybe I'll rent a video and crash on the couch, or perhaps we'll go to an air-conditioned movie?

Evenings alone with Julian are hard. He can't do what normal people do at night: amuse himself, talk, watch television, read, sort papers. He can't do puzzles, make anything, fix anything, *do* anything. He is way beyond all that.

"Let's get dressed," I say.

"The oddering's on the radiole."

"Come, where's your shirt?"

We traipse through the house together, find his shirt in the kitchen, shoes in the family room. Before we leave, I lead him to the bathroom where he stares at me blankly.

"Pee," I say. "Go pee-pee. Go to the toilet." I never know what to call it these days. Julian bends over and unties his shoes.

"No, no!" I yell. I undo his belt and lower his pants, but he pushes me off. This is going nowhere; my patience is spent.

"Forget it," I grumble. "Let's just go." I grab his hand and drag him to the door as he pulls against me. "Get in the car. We're going to the library."

Julian mutters under his breath. I don't understand, so I ignore him, maneuver him into the car and start to fasten his seat belt.

"I'll do it!" he shouts. But he can't even find the belt. Turning the opposite way, he fumbles with the door knob. I lean over him to snap the belt in place. As the buckle clicks, he states clearly, "You think I'm no good. You think I can't do anything."

I feel terrible: how painful for him to feel so inept. I begin to explain, but I haven't much strength. "I don't, Julian..."

Unintelligible words pour forth, and despite my compassion, by

the time we hit the first stop sign, I am yelling, out of control. I screech to a stop, then slam my foot on the accelerator. The car jolts forward.

"You better watch it!" I shout. "I'm hot. Cranky. Don't talk!"

But Julian can no more stop talking than a baby could stop crying when shouted at. He mutters on; I can't bear it. "Be quiet!" I yell. "Please be quiet!"

He keeps muttering.

"I can't stand this anymore!" I scream. "Go live by yourself. Go find a nurse to take care of you!"

As the words leave my mouth, I am flooded with shame. Julian glowers at me and leans forward trying to open the door, but he's strapped in, and can't find the seat belt release or the door handle. I must calm him—and myself—down.

"I'm sorry," I blurt. "I'm sorry I shouted. I'm hot and cranky. I'm truly sorry."

One good thing about memory problems is that fights aren't re-membered. If I calm down and let go of my anger, if I sound pleasant for even a minute, Julian quickly comes round.

But this time, I can't. We drive in silence to the library where I return my books. Then I drive home; Julian disappears in our bed-room while I collapse on the family room couch. It's still hot. I lie limp in the stifling air until shadows lengthen in the courtyard and the drawn drapes darken from white to gray. Finally I drag myself into the kitchen, play Vivaldi tapes and scramble two eggs. I bring Julian to the kitchen table. His face is soft; he is quiet; I am exhaust-ed, full of shame. Violins and cellos chase each other as we silently eat eggs and toast.

I can finish the day now; soon we will go to bed. The evening news forecasts that the heat wave will break tomorrow. And Bay Area temperatures will be cooler.

Baby-Man

JULY SUN STREAMS through our bedroom window making pools of light on the rust-colored carpet. A squirrel runs up the lo-quat tree, wind chimes tinkle in the breeze, the heat wave broken.

Julian wakes up, rolls towards me, smiles and announces, "It's a rab of the mineriol."

"Hi, Sweetie," I say. "Good morning."

The sheets feel cool against my bare legs. We had a full night's sleep, improving my mood, leaving me rested and calm, unlike those dreadful mornings when he wakes me after only a few hours sleep, for three or four rounds of bathroom chaos.

I get up, dress myself quickly and begin helping Julian.

"We need the iddering on the oshee," he says sweetly. "I'm assuming there'll be time for the miniol."

"There will be time. I agree."

I hand Julian first his underpants, then his socks.

"Baby-man," I tell him. "You're my baby man."

It is going well this morning: Julian and I are at our best. Today things feel calm, but how long will it last? When he is like this, I think placing Julian in residential care is way off in the future, unlike during the heat wave, when I could barely manage.

Once Julian is in his underwear, I take his hand and lead him to the bathroom sink.

"Let's brush your teeth now." I squeeze toothpaste onto his brush. He takes it, walks to the toilet and begins brushing his teeth, bending over the toilet bowl to spit.

"Come here," I say turning on the water at the sink. "Here, here."

He looks at me quizzically, as if asking what difference it makes.

From his point of view, sink, toilet, bathtub and shower are equivalent. Each is a white ceramic bowl with water controlled by pushing or turning a silver faucet. He pees in each. He doesn't know the difference; I often catch him unzipping in front of the bathroom sink or spitting toothpaste into the toilet.

"No, here," I'll say one minute, guiding him, penis out, from sink to toilet. "No, here," I'll say pulling him back from the toilet, toothbrush in hand, to the sink to spit. If there's tenseness or impatience in my touch, he resists being pushed, but he lets himself be guided when I am calm, cheerful and speak lovingly.

In my brighter moments, I think what does it matter really where he spits or pees. How confusing this is to a deteriorating brain.

Public restrooms are even more complicated. My brother-in-law said that once, at a fancy restaurant, Julian peed in the sink, then

washed his hands in the urinal. Who knows what Julian does in airports and movie theatre complexes with rows of sinks and urinals, when I can't go in with him. He must make a weird sight fumbling about large men's rooms doing the wrong thing in the wrong place. But what can I do about that, except wait for him patiently outside the door?

This morning, I find once again Julian's daily brown load in the toilet bowl; in the past few weeks he has forgotten how to flush the toilet. Today, I just flush it down with no emotion at all. When he first began not to flush, I recoiled in shock and fear. In vain, I tried to "teach him." "Here's the handle, Julian," I explained. "Push this handle. Flush the toilet after you use it."

What a waste of breath. If he could, he would. He doesn't want to *not* flush the toilet. If he has forgotten such a primitive habit, he is not going to re-learn it now. Just as a baby gradually learns to use the toilet appropriately, Julian is un-learning. Understanding this makes life much easier for us both. But how long I took to understand, how many hassles we endured before I learned.

This morning, even though I know it makes no difference where he spits, I still call him to the sink and he spits correctly in the bowl. "Mm—good," he says.

Next, I smooth cool, fragrant shaving cream over his cheeks, pull the razor down to his jaw, tilting his chin to catch whiskers on his throat. With warm water, I tenderly rinse the white cream off his face and we both enjoy it.

In earlier, angry days, I fumed when he put shaving cream on his toothbrush, and toothpaste on his cheeks. We have come a long way: Julian in his decline, me in acceptance.

This morning I nick the mole under the left side of his jaw. It is awkward angling the razor over his Adam's apple; I never quite know whether to go from his ear towards his chin following the line of his beard, or whether to pull the razor straight down from his beard line towards his neck.

A tiny spot of blood spurts out and I dab at it with a wash rag.

"Ow," Julian says, but he doesn't seem to mind.

His cheek feels smooth, his skin satiny, as I pat him dry. He smells of Palmolive. Not so long ago, this clean smell would have drawn me towards him in the womanly way I rarely feel anymore. A pang of sadness hits me for our lost lusty love.

Julian follows me back to our bedroom where I hand him his shirt, but he puts on his shoe before I manage to hand him his trousers.

"Take your shoe off," I say calmly as he looks at me, puzzled. "Shoe off," I repeat, tapping the top of his Nikes. He takes off his tennis shoe and I hand him his pants, then his socks. The rest flows easy.

In the kitchen, I set his granola before him, slice a banana and pour milk, then serve him coffee, spread marmalade on toast. I hand him part of the morning paper, which he examines as if he could read, while I settle down for a few minutes to drink my coffee.

As soon as I open the kitchen door to leave for day care, he unzips and pees again, on the pink impatience in the redwood box. So what, I think.

"Where's...where's..." he asks, pointing to his bare arms.

So I hand him his khaki windbreaker and a rolled up section of today's paper, two security items he takes to day care, and off we go. In the car, I open his door, fasten his seat belt and close his door, as even these simple tasks confuse him; then I push the tape deck button and out flows Brandenburg Concerto Number Four.

Julian claps his hands, whistles, and wags his head from side to side in time to the music as we drive towards Rosener House. Mornings like this I count among my blessings; how many more will we have? Just past the Stanford Shopping Center, he stops whistling.

"Mommy," he says, "You know, Mommy...."

He pauses. "That's funny," he observes. "Why'd I call you 'Mommy'?"

"I don't know. Why did you?"

"I guess 'cause you're like my mommy," he answers, clear as can be.

A rush of tenderness floods me as I reach over to ruffle the curly gray hair of my baby man.

"You had a wonderful mother," I say, remembering our many trips to Scotland, where Julian grew up. "She was a lovely woman. I really loved her."

A wistful look washes over him and he is silent.

"She's gone...strong now...."

"Yes, she's been dead a long time."

"Where's the iddering?" he says. "The radiol for the oodley."

For now this subject is closed.

"In-out" is what Carol Denehy, the Rosener House social worker, calls it. "People with dementia go in and out of lucidity," she told me. "They have moments of great clarity. A surprising joy can come from being with demented people if you recognize and catch these fleeting moments."

Julian and I are poised precariously on the edge of the Alzheimer abyss. Emerging from chaos, his moments of insight startle me, and I marvel at them, knowing they do not last long. Driving to Rosener House, I glance at Julian, eyes closed, tapping his fingers in time to the music, both of us concentrating on the fourth Brandenburg Concerto.

Considering Ashes

THE NEXT MORNING over breakfast, as I try to read the newspaper, Julian chatters cheerfully.

"We've got to get those animals...you know...the movie. That iddering into the osheree...." He jabbers on while I drink my coffee, but I tune him out, struggling to get through an article on mid-life women, estrogen, breast cancer, and heart disease.

Suddenly he points to a postcard of a Scottish bagpiper wearing a red plaid kilt hanging on the refrigerator and says clearly, "I may die soon. Let's go there."

Dropping my paper, I look straight at him, eager to connect with this lucid moment.

"We will go to Scotland," I say. "But soon your brother is coming here."

"When? You always say he's coming, but when is he?"

"In three weeks," I say. "Kenny will be here in three weeks." Then I return to his first comment about dying, a topic we didn't talk enough about before his Alzheimer's. I feel an urgent need to talk about everything important before it's too late.

"Do you sometimes think about dying?"

"I don't like to think about it."

"I don't mind thinking about death," I say. "I think dying is like going to sleep. You rest, and you don't know anything." My agnostic, spiritual beliefs are fairly simple.

For years, even with Alzheimer's, Julian has thought about death,

as many people do reaching fifty or sixty, but we never reached any conclusions about how we wanted our affairs handled. He never told me clearly what he wants after he dies. These days, he sometimes raises the subject, but always backs off if I try to pursue it.

"When I had cancer, I thought about death a lot," I continue, pointing to my left breast where my prosthesis fits snugly over my flat chest. "Remember when I had cancer?"

But he is gone again, muttering away, no longer processing what I am saying. Nevertheless, I feel grateful for this fleeting connection. I know death is often on his neurally-tangled, plaque-filled mind, though he probably doesn't remember that seven years ago I had breast cancer.

A scene from a few weeks earlier pops into my head: a hot day, I sat naked in bed with Julian beside me, staring at my chest—at the white full breast on my right side and at the flat skin on the left. Suddenly his face took on a puzzled expression; then he turned to me. "Well, honey," he said clearly, "what happened to that other one?" What was there to do but laugh.

Then my mind jumps to last night when we sat on the couch watching "Mystery." Julian was rubbing my back, pressing hard, the way I like it. Soon his hand came around to my chest and he continued massaging, but pressing my chest just as hard as he did my back. It hurt. I winced and reached for his hand to stop him.

"Is that okay?" he asked, eager to please.

I removed his hand and put it again on my shoulder. "Do it here," I said, just as I must take his hand in bed at night and place it on my back or shoulders. "Rub here," I say.

No, Julian probably does not remember my cancer. But even in this advanced stage of Alzheimer's disease, when his language skills are so impaired, he does think about dying and I am glad he tells me when he can.

After breakfast, driving to day care, Julian cheerfully swings his head from side to side, clapping his hands in time to the Yiddish tape. A Baptist church is located across from Rosener House, and as I park the car beside the church, he points and declares, "Let's go there." After day care, driving to my dad's retirement home, we pass a cemetery; again Julian says, "Let's go there."

"All those people are dead." I laugh. "Everyone in there is dead."

But I grab the opportunity and ask, "When you die, do you want

to be buried in a cemetery, or cremated and have your ashes scattered in the mountains?"

I doubt he can answer, since he can't answer even the simplest either-or question. "Do you want coffee or tea? Do you want strawberry or chocolate?" "Whatever," he will say, or "that's fine." In response to my question about burial versus cremation, Julian says nothing.

Passing the cemetery, it suddenly occurs to me that I have few regrets with Julian about things unsaid. Often when loved ones die, relatives are left with "unfinished business," things they wish they had done or said.

Over the past five years, especially since Julian's Alzheimer's, I have told him many times I love him, that I appreciate our comfortable life and the security his hard work has given us. The main lingering regret is that I hadn't loved him more and quarreled with him less. But we have talked, too, about these dark parts of our marriage: my disappointments over how unavailable he often was to me and the children, how preoccupied he usually was with his work, our many fights. Even after Alzheimer's, we had these discussions. Our relationship now feels pretty complete.

One topic he always brushes aside, however, is what he wants done after his death.

My wish is to be cremated and have my ashes scattered in the Sierra Nevada, on my favorite trail, high at 10,000 feet. I told Julian and the kids years ago, even wrote the directions. I showed Ben the exact trail when we hiked there three years ago, and when Jeff comes from New York in a few weeks, I will show him too. My mother's ashes were scattered at sea. My dad, especially now with the sores on his foot refusing to heal, tells Jean and me clearly he wants his ashes scattered at sea, too.

But Julian always joked away this discussion.

The topic matters because in Julian's family tradition, Jews are not cremated. Orthodox law, in fact, forbids it. But Julian is not religious. In thirty-five years of marriage, he never once said he wanted a traditional Jewish burial.

Still, I ask him. Who knows? Maybe in some lucid moment, I will catch him just when he can tell me. If not, I will make the decision about cremation, knowing deep in my heart he would have agreed.

From the tape deck comes a familiar Yiddish tune, a song from his childhood.

Suddenly Julian removes his glasses and wipes his eyes. At the same time he laughs, as he often does when he is embarrassed about crying.

"It is okay to cry, Julian," I say. "It's good to cry."

"Gone," he says. "All gone."

Because of the Yiddish music, I guess that he is thinking of his father and mother. "Your mom was a wonderful woman," I tell him. "I loved her a lot."

He chokes up and laughs again.

"You must miss her."

He takes my hand, raises it to his lips and kisses it.

All this coming from the same man who sometimes doesn't remember how to use a toilet, shave, or put on his belt.

Rosener Support Group

ON TUESDAY, after lunch, I phone my dad to check on this morning's visit to the doctor.

"How're you doing, Daddy?"

"Okay...," he says slowly, but I can tell from his tone that something is wrong.

"What's going on?" He rarely volunteers much information, so I press for more. "What did the doctor say?"

"He wants to keep watching my foot...."

"And...?"

"The damn sores aren't closing."

"And...?

"I may need more surgery."

"Oh dear...I'm sorry to hear that." Immediately I regret not taking Daddy to the doctor myself so I could ask more questions. He never asks questions or presses for details. "I hope not, but we'll keep our fingers crossed. Maybe your leg will get better. Let's take it day by day."

Then I tell him I must go as I am late for the support group meeting at Julian's day care, and I'll come by this afternoon.

"Okay, honey. Bye...," he says. "Don't worry." But of course I worry. If Daddy has more surgery, will this one work? Will his foot ever heal? Will he be able to return to his present semi-independent living?

Driving to Rosener House, I fret over Daddy's precarious health and the effect his growing dependence has on me. If he has another operation, I'll have to spend more time with him, meaning more hours away from Julian and even less free time for myself. How much longer will Julian be at home? The Alzheimer's clock is ticking away our last days together. I feel squeezed, pulled, torn and smothered between my father and my husband and all that they need.

~

At one fifteen, late to the meeting, I open the door to see all the chairs around the room filled with people, already talking. As I slip into the one vacant seat, my head bursts with mounting anxieties about my father and Julian.

The woman sitting to my right introduces herself, saying her husband has been at Rosener House two months.

I'm an old-timer. Julian has been here eight months, since last November.

My turn now: all eyes look at me. Today, I feel tense and stressed. Worries about Daddy and Julian flood me. Only Rosener House, and Mellaril, allow me to keep Julian at home.

"My name is Ann. My husband's been coming eight months." I recite the ritual beginning.

Then, instead of following with some burning question, or some new problem, or some behavior I can't handle, I blurt, "I'm so grateful to the staff at Rosener House. If Julian didn't come to this wonderful place, I couldn't manage. And I appreciate you, Carol." I smile straight at the clear blue eyes of the energetic social worker who leads these meetings.

Carol, sitting across the circle wearing a bright magenta blouse, smiles quietly back at me. Carol is the person who spoke so gently with Ben and me last fall when we first visited Rosener House, "just to look." She has talked with me for hours...when I was a basket case over Julian's night time agitation, when I felt trapped and desperate to hire someone to get relief. She is the one who noticed Julian's brother and sister-in-law standing outside weeping the

morning they saw Julian in day care for the first time; she went right over and stood on the sidewalk comforting them, even though she had never met them. That's the kind of place Rosener House is, the kind of person Carol is.

"It's often harder on families adjusting to day care than it is for the participants," Carol told Julian's brother, explaining that I was her longest pre-enrollment visitor. I was so reluctant to have my sixty-four-year-old husband come to an adult day care center that I visited five times before making up my mind. I thought he was too young, too capable, not impaired enough. She patted my sister-in-law's shoulder and said, "Julian's happy here. We all love him. He's such a sweet man."

Kenny and Linda, who were visiting from Scotland, where Julian grew up, hadn't yet seen Julian, so bright, strong and intelligent-looking, sitting in a room with eighty-year-olds, some slumped in wheelchairs, some crouched over walkers. They hadn't gotten used to Julian here, fitting in, appropriate, just as confused and needy as the others.

"I can't say enough about how Rosener House helps us," I continue telling the group, "what a difference it makes. It keeps me sane. Gives me free time. Lets me keep on going. I get so much encouragement and help from the staff."

Looking around the circle, I see other caregivers nodding. Many continue this theme as they introduce themselves—saying how long their loved one has been in day care and praising the staff.

Then they reel off current concerns: one man's wife refuses to get in the shower. Another insists on wearing long-sleeved blouses and two sweaters even on hot days. A husband is suddenly unable to get up from his chair.

A soft-spoken woman wearing faded jeans and a denim shirt, named Verna, says her husband, Newell, constantly paces in a circuit between the couch, refrigerator, and toilet for three hours each night. She is exhausted and is considering asking the doctor for sedatives for Newell.

Halfway round the circle sits a well-groomed, gray-haired woman in a mauve silk pants suit, with handsome silver earrings and heavy Navajo beads. Despite the elegant outfit, she looks sad today. Dark shadows hang under her downcast eyes.

"I had to place Woody in long-term care," she says haltingly. "The hardest thing I ever did. I felt like I sent him to prison, the jail doors closed behind him...and I put him there."

All eyes are riveted on her. My heart bangs in my chest, wondering how I would feel if I sent Julian away.

"I just couldn't handle him anymore," the woman continues. "I couldn't lift him out of bed. He'd fall and I couldn't get him up. I couldn't bathe him. I was exhausted cleaning his bathroom messes."

The group stares at her, hanging on every word. Most of us will have to do this one day, but I am filled with fear. What would make me decide to send Julian away? What would push me over from managing to not being able to manage any longer? But I'm not like her. Julian doesn't wear diapers. He happily takes showers. He can easily rise from his chair.

Like others in this room, my heart and ears are wide open. I need to learn all I can. The woman tells us what a good place she has found, and then reads a letter her thirty-year-old son wrote just after his father was placed in the nursing home. In it, he praises his mother for her valiant job caring for his dad for such a long time, giving his blessing for the choice she made.

The letter brings tears to my eyes and I ask for a copy to give to my children. When my turn to place Julian eventually comes, perhaps this letter will help Ben, Karen, and Jeff. Will my children criticize me for "institutionalizing" their father? Or support me as Sandy's son has done?

A gray-haired man with a bristly white moustache says he does everything for his wife...cooking, shopping, driving, laundry, dressing her, bathing her, laying out her clothes. Yes, yes, I think. While he wrestles with food preparation, which he's not used to, I must wrestle with house repairs, insurance decisions, and taxes, which I'm not used to. Everyone here runs someone else's life besides their own.

The man continues: she confuses her children and can't remember anyone's name. Of course. All of us here are on the same dementia road, albeit in different places. But, he thanks God every day that his wife is so cheerful. She took care of him for years; now it is his turn to care for her. That's how he sees it. Only he doesn't cook so well. The group chuckles.

His wife always greets me when I come for Julian, a slender,

well-dressed, smiling woman who stretches her hand towards mine and calls out, "Hi, Barbara. How are the children? How's that beautiful baby?" I must remind her of someone she knows.

"Fine." I shake her hand, not minding that she calls me Barbara, just entering into her view of the world. "They're doing just fine."

Slowly I am learning how to have a satisfying exchange that has no logic or meaningful content. I feel no need to correct her and we both leave our fleeting encounter satisfied.

"Yet sometimes," the mustached man continues, "my wife and I can have a short meaningful talk."

Carol nods vigorously, her gray-blond pony tail swishing behind her, reinforcing his words. This is a message she wants us to hear.

At the session's end, the woman in the mauve suit announces she is donating a tree to Rosener House in her husband's name. "A Japanese maple. After the meeting, we'll plant it. Please join us," she says.

As most people take their loved one out the front door, I go to the woman and clasp her hand.

"It must have been hard to place your husband." My voice trembles as I say, "You've done such a good job. Thank you for sharing your son's letter with us."

During our support group hour, the Alzheimer's participants have been eating snacks and watching a travel video on Alaska. As soon as I enter the dining room, Julian spots me and bounds over. His face breaks into a wide grin. "There you are, there you are!" he shouts, and I get a hearty hug followed by two strong kisses.

A small group gathers in the garden to plant the maple, resplendent with perfect, tiny, star-shaped leaves. The Rosener House director says we will remember Woody whenever we are in the garden.

Standing close to Julian, my arm slips around his slender waist. His body feels young, strong, normal. Who would ever know by looking at him that he can't sign his name or shave himself? How long before he becomes incontinent and can't rise from his chair?

Verna, in her jeans and cowboy boots, holds Newell's hand, standing just beside us. Like Julian, Newell is another vigorous man, among the youngest at the day care center. A retired engineer, Newell retains number and visual-spatial abilities, unlike Julian. Newell

still plays Solitaire and balances his checkbook. He is the only par-
ticipant at Rosener House who is allowed to go out for walks by
himself because of his excellent sense of direction.

The director says what good care Sandy has taken of Woody and
how they will miss him. Carol adds that one of her hardest jobs is
telling families their loved one has declined too much to remain at
Rosener House.

Will Julian, one day, be asked to leave day care? How could I pos-
sibly manage then? My screaming at Julian during the heat wave
jumps to mind: yelling at him that I can't stand his gibberish, that he
should go live somewhere else. I can't imagine deciding to put
Julian out of our home, but I know I can't go on much longer. Still, I
can't imagine life without him. Gazing at the staff in the garden, I
feel grateful for their support enabling me to manage.

A tall, lanky, staff member, Dave, who is about my age, tosses a
basketball into the hoop. Skipping towards him, I extend my hands.
He throws me the ball and I shoot three baskets in a row, hear the
satisfying swish as the ball drops through the net. Then I dribble the
ball and sink a hook shot.

Surprised, Dave looks admiringly at me.

"I played varsity basketball in high school," I explain. "Only in
1955, girls weren't allowed to dribble the ball."

Dave hooks one in, then jumps to push in the re-bound. When
Julian ambles towards us, Dave tosses him the ball. Julian stands fac-
ing him with both hands open ready to catch, like a three-year-old,
laughing proudly when he catches the ball, then throwing it to me. I
pass it to him and he heaves the basketball the opposite direction
into the bushes. Dave laughs and retrieves the ball, my little diver-
sion from troubles over.

Time to take Julian and visit my father before going home. Like a
spectator watching a ping pong match, my mind flits back and forth
between concerns over Daddy and Julian.

Verna and I exit the Rosener House garden together, arms slung
around each others' waists, our handsome husbands following be-
hind. For a few seconds it feels as if we are two normal middle-aged
couples leaving an ordinary party, headed for our cars. I feel a cer-
tain bond with this blue-jeaned woman, a stranger, really, but clearly
a fellow traveler on this relentless Alzheimer's journey.

Doing All Right

"DID YOU DO ANYTHING with your emil micamp?" my husband asks.

Opening my eyes, I turn to see Julian's face close to mine on the pillow. Without his glasses, his eyes sparkle so blue. A new July day begins; what kind will it be? Bearable? Or a day when I barely manage to cope?

"It's the finnish—change for gonchin."

Until he speaks, lying in bed with Julian seems for a moment deliciously normal, a fast-disappearing feeling I treasure.

"Hi, Sweetie," I say, squinting at the summer light streaming in through the split in the curtains across from our bed.

"The miscockle mussed the fit very well." He smiles. "We have to get up and see that McCraffee. It's the elly melly—in the coody moody."

For thirty-five years I have lain beside him. Despite his gibberish, I can't imagine sleeping without Julian. Reaching out, I lay my hand on his cheek, pat his beard and savor the sunlight, the cozy warmth of the sheets. These fleeting moments in bed together resemble life before Alzheimer's.

"It's the ardis plysis in the tissas," he says. And, suddenly, clearly, "I'm hungry. What's for breakfast?"

"I'm hungry too. Let's get up now." I hop out of bed.

Julian waits beside me, not knowing what to do; I hold out his jockey pants while he unbuttons his pajama top.

"Take *these* off." I tug at his pajama bottoms. "Off. Down."

Staring at me blankly, he has no idea what I mean.

"Take your pajama bottoms off." I pull at the turquoise cloth.

Standing naked, he fumbles with the jockey pants. Even though I handed them over in the proper position, he puts them on backwards, squirming, uncomfortable, before pulling them off and studying the white material with a serious look. Finally he locates the label, orients himself and steps in correctly.

Dressing is getting harder. Because Julian's visual-spatial abilities are severely damaged, positioning himself in reference to objects, even his clothes, requires enormous effort.

But seconds later, when I return from his closet, he is back in

pajamas, which I neglected to hide after he took them off. He forgets which process he is in, dressing or undressing, and puts on whatever clothes are in sight.

"Take these off." Again I tug at his pajamas, dangle his khaki Dockers. My voice sounds a little harsh, but we have plenty of time. We don't have to leave for day care for another hour.

This time when he removes his pajama top, I whisk it away and shove it in the dresser, before handing him his shirt and shoes. Then I head for the kitchen, calling, "I'm going to make breakfast."

Soon Julian appears, dressed properly, but fumbling at his crotch, unzipping his fly as he walks towards the sink.

"No, no!" Dropping the peach I am cutting, I dash over and grab his arm. "Here. Pee in here." He follows me obediently, as I lead him to the nearest bathroom.

Positioning Julian before the toilet, I lift the seat and return to the kitchen to wash my hands and finish slicing the peach. When Julian reappears, I wash his hands, lead him to the table.

"Sit down, Julian. Here's breakfast." Already I'm tired. These wearisome slow-motion actions eventually grind me down.

"Mm...lovely, lovely, lovely." He spoons cereal into his mouth. "The first time is the azeea," he says cheerfully. "Where's the easier pie that fergondi? Mm...lovely—a fudda pillea. Lovely."

He looks at me sweetly, munching granola.

Despite the difficulties, part of me enjoys the intimacy of caring for Julian. It's like taking care of a toddler, expressing love and connecting through hands-on, daily, concrete tasks. On easy days like this, I feel strong enough to care for him alone at home.

Images from last week's support group drift past: the dark shadows under Sandy's eyes, her tearful face saying she placed her husband in residential care. But Julian is not like Woody, unable to rise from a chair. He doesn't fall; he doesn't wear diapers. I am not like Sandy, at my breaking point; I can still manage.

"It's the plysis in the tissas," Julian announces. "Amercrays. We've seen him in the toller."

I have no idea what he means. A few months ago, I could decipher his sentences; he gave enough cues, used enough real words sprinkled with gibberish, so I could guess. But Julian is changing. His basic sentence structure is still intact, but most nouns are his

inventions. Now the ratio of gibberish to actual words is so high, I hardly try to understand.

Today, oddly, Julian isn't frustrated, as if he doesn't realize he doesn't make sense. He just needs me to respond from time to time in a kind, chatty way. It no longer matters *what* I say. He mostly responds to *how* I speak, the tone of my voice, the mood he senses in me.

"Uh huh," I say. "That's interesting." Or, "No, I didn't know that."

An autistic child I once worked with pops into mind, an isolated, withdrawn boy who never initiated speech, never asked a question. Working as a speech therapist with children having severe language problems, I learned the importance of questions. They bring not just information, but emotional contact.

So, when Julian asks me a question, which he often does, I try to respond. Even if it's, "Well, I'm not sure," or, "I'll have to think about that," he usually seems satisfied.

This morning, Julian has lots to say.

"What happened to the wanch?"

When I don't answer fast enough, a puzzled look crosses his face.

"Oh, you should know that!" He explains, "An old, old, old person that never came." I wonder if he might be thinking of my father.

Tedious as these breakfast chats are, I value the ordinary rituals of morning married life.

Setting part of the newspaper before Julian, I prop the front section by my coffee and try to read about the California activist Harry Wu's release from a Chinese prison.

But Julian is in high spirits, talking non-stop.

"I'm getting such good animals in this place. When you were there, you were talking about orli—remember? She had a big coaf. I wonder about the animal with the rine."

I manage to read two sentences about Harry Wu before the bagels pop out of the toaster.

"Great," Julian continues. "We've got great things—like the king. I can't make the pay of the gishen."

"That's interesting," I say, looking at Harry Wu's picture, his smiling wife beside him. The Wus have just returned to the Bay Area, after Wu was tortured in prison.

"I don't like to take the toyfous with toyra. Let's go see if there's anything in the taf. And then we'll go—okay?"

"We'll leave in a few minutes, Julian," I say, grateful that in half an hour he'll be at day care. I can handle Julian's jabbering, knowing in a short time he'll be gone.

But Julian is changing fast. I used to tell him each morning at breakfast what would happen that day, printing a list which he kept in his pocket, and writing the day's schedule on a chalkboard; but now he can't look where I point, and even if he does, printed words no longer have meaning.

Julian picks up his bagel smeared with a thick layer of his favorite Scottish marmalade.

"It would be lovely to have the rigor with draysh. They should be put in the laber," he explains. "It's amazing how you get zherzi muskovie...the coor to the muskie animals. I don't want to waste my mabey."

Words pour from him. I sense no frustration or anger at not being understood. For this I am grateful. He has so much he wants to say; his flood of words must be his desperate attempt to stay connected.

Julian sips his coffee. I have given up on Harry Wu.

"I'm so happy poppy poppy," he declares. "It's so coldy woldy woldy."

A wave of tenderness washes over me. Silly and exasperating as he is, Julian's cheerfulness is a blessing, in sharp contrast to my father's irritability. It makes being with Julian rewarding; it keeps us connected, balancing the sleepless nights and dreadful confusion. Outsiders may think I'm denying the severity of Julian's decline. But outsiders, and even our children, don't see these good times which encourage me to keep him home a while longer.

Julian points to my coffee. "Screen this for the groin." He smiles sweetly, takes my hand and kisses it three times.

"It's so calky for frayda," he says. "I feel good."

"Julian, I'm glad you're happy."

"Is the stoll mostler for the thing? It's the norrey storrey. How're *you* doing?" he suddenly asks.

Without waiting for my answer, he says, "the nilly stand. I'm happy things are going good. The chivlier stay. I feel so good!"

Is this the lovable man I may have to put away? But Julian and I are not like Sandy and Woody. It's not time yet to think of placement. Neither of us is ready!

Grabbing the garden section of the paper for Julian to take to day care, I open the kitchen door. He bounces out whistling "If I Were a Rich Man," and all the way to Rosener House hums tunes from *Fiddler on the Roof*.

In the car as I'm driving, he reaches over twice, lifts my right hand off the steering wheel and kisses it.

Suddenly Julian stops humming.

"Sometimes you get to be nasty and bad," he announces clearly. "But today you're doing all right."

Answering Machine

RESTLESSLY I WAIT for my father's doctor to return my call about the condition of Daddy's foot, anxious to know if he'll need more surgery. And wouldn't you know it, but my damned answering machine makes weird beeps and won't record messages, an expensive Panasonic I have had only a year.

I poke buttons and check the battery. Two days pass. I am missing important calls; maybe the doctor has phoned and I missed his message.

After dropping Julian at day care, I haul the unit down to Fry's Electronics. Maybe they can make it work. Of course not. They don't do repairs, the salesman says, even though I bought it there.

"Couldn't you just look at it and give me some idea what's wrong?" I plead. "I need this machine!"

"We only know the specifications of different models, not how to fix them." He turns to help a waiting customer.

"Well," I persist. "Where can I get it repaired?"

He hands the customer a cellular phone to examine and says, "You could send it to the manufacturer, but that will take two or three months...."

"Two or three months? I need it now!"

"Or, there's a place in Palo Alto that will look at it and tell you immediately what's wrong and give you an estimate on the repair." He writes down the number and hands it to me.

"Great," I say looking at my watch. The morning isn't over. I go straight to the public phone and call.

"Yes, we do on-the-spot estimates," a man's voice says. "But we're booked for three weeks."

"You can't even look at it till then?" I whine.

"That's right."

I hang up and look again at my watch. This is not how I planned to spend the morning. I want to get to my writing and any time now Daddy's doctor might phone.

Damn, I think, I'll just buy a new one. Indulgent. Wasteful. You should spend more time getting it fixed, declare imagined voices of frugal, resourceful, competent people criticizing this decision. I need to be careful with money. Julian's day care costs eight hundred dollars a month, and we are still paying for Jeff's living expenses in New York during his last year of college.

"Do things the easiest way." Suddenly I remember my wise friend Charles' advice. While I need to be careful about money, I also must solve this answering machine problem fast.

So I march back to the answering machine aisle, find the salesman and, after listening to him rattle off model specifications, decide to buy a new cordless answering machine unit. Not the more costly Panasonic, but a cheaper Korean model, because for $15.95 extra they will give you a new one if anything breaks within two years. Sounds good. It is nearly noon as I drive home, proud of myself for taking action.

Back in the house, I plug in the machine, but it doesn't work. I open the instruction manual. "Read this before operating your machine," it says in bold face type, followed by seventy-five pages of directions, seventy-five more in Spanish.

I just want the damn thing to work, to record messages so I can get on with my writing. I have to pick up Julian from day care in a few hours. I pay $40 a day for him to be there and need to use my time carefully; this isn't that.

I hate machines. I hate instruction manuals. I hate figuring out how to operate appliances. Thinking of all my friends with husbands who would set up the machine and show them how to use it, I feel sorry for myself, just a little.

"It's okay to ask for help," Alzheimer's books advise caregivers, so I begin thinking whom I might call, but our friend Bernie is in Poland and my neighbors went to the mountains.

Then I think of women friends who live alone, and there are many. The list is growing: divorced, widowed, and lesbian friends.

All of them set up their own answering machines. I watched one capable friend assemble a new barbecue by herself. Two lesbian friends learned how to operate their computers, including complicated programs, on their own. As I recall friends who have lived for years without men to do things for them, my heart floods with renewed respect.

Opening the instruction manual to "Preparing to operate," I read it three times, drawing yellow lines across the main sentences with a highlighter.

"It takes ten hours for the battery to charge," the manual says.

Getting my notebook, I settle smugly down to my writing...I've done it. Now all I have to do is wait ten hours.

But that night when I go to "record my outgoing message," nothing happens. I read and re-read the manual memorizing the yellow-lined steps, doing exactly what the manual says. Julian is asleep. I have bills to pay. This isn't how I planned to spend the evening either.

Finally I realize there is no battery in the receiver. Dummy! I search through the packaging and find the battery wrapped in plastic nestled in a Styrofoam pocket I hadn't noticed. But then I can't figure out where the damn battery goes. When I do, I can't open the little compartment. I push, pull, lift...it won't open. Fighting the impulse to pry it open with a knife, or smash the damn thing altogether, I look in the instruction manual index under "Battery—how to install."

Fifty-seven-years-old, and I'm just learning how to do these technical things by myself! Imagine! What a helpless, unmechanical, bird-brained incompetent I have been! But I am doing it. I open the compartment, insert the battery pack, connect the tiny plug and slide back the cover, my klutzy fingers proud. In another ten hours I'll be in business.

~

The next morning I leap out of bed, rush to my answering machine. Reassuring red lights glow from the top. As instructed, I record an outgoing message. "Hello. You've reached Ann and Julian...." I check the message and my own voice comes back.

"You've reached Ann and Julian. Leave a message and...."

Then I run to the second line in our house, the P-FLAG phone,

the answering machine for the organization I work with: Parents, Families and Friends of Lesbians and Gays. I have answered their information and helpline from my house for over ten years. From that phone I dial my home number and hear a lot of beeps, the whir of a tape rewinding, a long drawn-out tone...and...then....

"Hello. You've reached Ann and Julian...."

After the tone, I leave my message: "Hooray! It works! Ann, you did it. You are a smart, competent, self-reliant woman. No more missing important calls. I love you!"

Minutes later, my friend Jan calls from Berkeley. She is getting divorced after thirty-five married years.

"You know what I did?" she declares. "Fixed my watering system! Myself! It took three hours to figure out how to screw the heads on to the little black hoses. I felt so empowered."

"Congratulations!" I say. "Let me tell you my new feat. The only thing wrong is there are too many beeps. But I'll look in the manual tomorrow and fix it."

"Aren't we doing great!" Jan says.

Later that morning, my dad's doctor calls and leaves a message saying he has been trying to reach me. My father's foot is not healing as fast as the doctor expected, but he wants to wait a while to see if it might still improve before taking the next step of further surgery. He will keep me informed, he says. For, now we just have to wait.

Funny, I think, as I erase the doctor's message. An answering machine is a simple, mechanical device I can fix or replace, unlike a husband or a father.

Swimming

THE FIRST TWO WEEKS of August are roasting hot. On Saturday afternoon, the air hangs heavy and still in the house. Julian alternates between lying in the recliner by the fan or restlessly milling about the family room shuffling papers.

All day I've been fretting about the letter that came from Stanford Library on August first, declaring that "Professor Davidson must either request his faculty study for the fall term, or clear it out by the end of the month." It's obvious the time has come for Julian to leave his study. He doesn't go there anymore. But it's another

ending, another loss. This time he doesn't even know about it, but I feel pain for him. After this weekend I must stop procrastinating and call the library. But for today I must get out of this hot house and go swimming.

I decide to take Julian with me to the campus pool, but to wait until after six, when fewer people will be there. I am not really ashamed of Julian's odd behavior...well, to be truthful, I guess I am.

He can't go alone in the men's changing room anymore. Even last summer, when we swam regularly, he would emerge wearing some other man's shorts, carrying a towel or wet bathing suit that wasn't his. Children play in this pool and I don't want them laughing at Julian's weird ways.

So I wait until the pool becomes less crowded. We put on our bathing suits at home so he won't need to go in the dressing room. But, as Julian always insists on removing his wet suit immediately after swimming, I bring along underwear and long pants for when he gets out, planning to go to an inconspicuous corner of the grassy area, hold up a large towel and help him change.

When we get to the pool, the lap lanes are full and five kids are splashing around in the diving section. A few adults sun themselves on white lounge chairs. As I strip off my clothes and kick off my sandals, Julian heads automatically for the men's room nearby.

"No, no, Julian." I grab his arm. "Come here. Take off your shirt. Take off your shorts."

Puzzled, Julian stares at me. Any dressing or undressing that is not part of our daily routine escalates into a fumbling fiasco. He cannot understand why I am asking him to remove his clothes out here by the pool, not in the men's room and not at home.

Finally down to his swimsuit, he doesn't know what to do next. He stands anxiously looking about, so I take his hand and lead him to the edge of the pool. After patting the cement, saying "Here, here, Julian, sit here," and sitting down myself, Julian finally lowers himself to the concrete edge and we dangle our legs in the cool blue water.

Every activity with Julian creeps in slow motion and must be broken down into component steps. I swish my feet in delicious water, relaxing a minute, waiting for a lap lane to be free.

When two swimmers climb out, I encourage Julian to jump in. He stands, bends over, executes a half-leap, half-dive into the water,

looking like a small child with his arms overhead pretending to dive, but really jumping. Three boys near us in the diving section snicker and poke each other.

Once in the water, Julian breast-strokes across the lane instead of down it, paddling over the rope into the next lane. Quickly I retrieve him before the lap-swimmer reaches us.

Back in our lane, I kick on my back luring Julian down the watery strip between the two ropes. "Here, Julian," I call softly, hoping people won't look at us. "Follow me. Swim after me."

Julian moves through the water, a slow sort of breast stroke, making no attempt to lower his face or swim crawl.

"Hi, Julian," I smile. "Isn't this great?"

When we reach the other side of the pool, Julian starts to climb out.

"Julian, let's go back. Let's swim to the other end." Again I swim on my back slowly in front of him and when we reach the tile wall, I tug on his leg, wrap my arms around his neck and press him close.

Memories float to the surface: all those hugs while swimming, the sensuous feel of our bodies, skin against skin, caressed by water. Today his body feels the same, but it is not the same. The feeling doesn't go anywhere, has no future. "Another lap," I say. "Let's swim some more."

A woman, forty-ish, reclines nearby in a white lounge chair watching us. Not staring exactly, but definitely listening, she looks away whenever she sees me notice her.

Finally Julian gets the pattern: reaching the cement edge at the lane's end, turning and swimming back. So I pass him doing a fast crawl, pausing at times to wait for him and urge him on. I manage five or six laps, a fraction of what I like to swim, but the water feels velvety across my skin and a gentle breeze bends the birch trees, makes them nod their branches.

"Enough, enough," Julian says, reaching the end. Coaxing him to do one more lap, I climb out first, then help him, while the kids in the diving section giggle and stare. The woman in the lounge chair watches us too.

"Oo, oo, cold, coldy, cold!" Julian crosses his wet arms across his chest, so sensitive to the slightest chill or breeze. As I wrap him in a towel, I avoid looking at the giggling boys and rub Julian dry, hand-

ing him his shirt, waiting while he buttons it. Then I hold up the towel level with his waist and hand him his underpants which, of course, he puts on backwards.

"No, no." He pulls them off, tries again. When he successfully maneuvers himself into his shorts, I lower the towel and hand him his socks and shoes. "Put on your shoes," I say. "I'm going to the bathroom. I'll be right back. Stay here."

As I walk away, the woman on the lounge chair shoots me a sympathetic look. And when I return, she is standing near Julian, who is wearing his shoes, but on the wrong feet, his beige socks limp on the table.

"Something's wrong," he observes.

"I was going to help him," the woman says softly, looking puzzled.

"Thank you." I remove Julian's shoes and hand him his socks. "He has Alzheimer's disease."

"I thought so," she replies. "My father had Alzheimer's too. He died a year ago."

"I'm so sorry," I say.

"My dad was diagnosed when he was fifty-eight. He was a lawyer," she explains. "My mom took care of him until she could stand it no longer. Then she put him in a home, an Alzheimer's unit. He was there for twelve years. It cost sixty-five thousand dollars a year."

"Sixty-five thousand dollars a year for twelve years!" I gasp, too shocked to multiply twelve by 65,000 or to divide 65,000 by twelve months. Without knowing either sum, total or monthly, I am stunned. We could never afford that!

Seeing Julian fumble lances the woman's boil of painful memories. Out pours the tale of her mother's struggle with her father, how her dad had been a successful attorney cut down in his prime.

"When he lost his first case," she tells me, "he realized something was wrong." Just like when Julian goofed up his lectures, I think, and began getting poor evaluations from medical students. Julian is no longer a smart Stanford professor, like the other men at this campus pool; I clearly identify with this woman's mother, married to a once-competent, prematurely declining man.

"Then he got diagnosed and his client sued him. The nightmare started after that."

"It's a cruel illness, long and hard," I commiserate.

The woman has an urgent need to talk. She asks a few token questions about Julian, which I answer briefly, but she continues pouring out her father's story. Each time she mentions sixty-five thousand dollars, my stomach knots up.

Julian struggles into his socks and shoes and we're ready to leave.

"He was so young, my dad, only fifty-eight. His life and my mother's life were ruined."

"My husband was fifty-nine." I nod quietly, frightened by the tale she has told, hit by the blast of her sadness and fear, her anxiety spilling over me.

~

The next day when our friend Bud comes to take Julian to lunch, I tell him about the woman at the pool.

"Why did she tell me all that?" I ask Bud. "It scared the hell out of me. She said nothing positive or encouraging. I wanted her to tell me something helpful she learned."

"She wasn't out to help you," Bud says. "She's been traumatized and needed to talk. Telling her story was helping her."

"Sixty-five thousand dollars a year! I can't even fathom it."

Financial fears gnaw in my gut. I must call the Stanford benefits office, go over the retirement plan again. Even though I hate to think of Julian moving into a nursing home, I must begin thinking about it now. But even before that, I must call the Stanford Library and tell them Julian will no longer need his faculty study.

Bud takes Julian by the arm. "Come on, laddie," he says. "We're going for a hamburger and a walk. We'll be back around three."

After they leave, I prepare to go swimming, this time alone. I can't get that woman out of my mind. She kept talking about "two ruined lives." How is my life different from her mother's?

In the pool swimming laps, I realize my life isn't ruined, even though it is drastically constrained. I refuse to let my life be ruined. I wonder if my kids think it's destroyed. Do Ben, Karen, and Jeff anguish over Julian and me as that woman does for her parents?

I will learn how to get through this: how to keep on loving Julian, letting him go, and preserving a life for myself. I hope I can show my children that my life won't be ruined.

My legs kick harder, my heart pumps faster, cool turquoise water sliding like satin over my skin.

"O Sole Mio"

ON MONDAY MORNING, after dropping Julian at day care, I return home resolved to call the Stanford Library.

A woman's voice briskly answers the phone. "Green Library."

"This is Dr. Davidson's wife. Professor Davidson will not be renewing his application for his faculty study next term." The words come out simple and clear.

"Oh...." The voice pauses, softens. "How's he doing? We're so fond of him here. I'm so sorry about his illness."

Surprised by this stranger's compassionate words, I manage, "He's okay...thank you...," not knowing quite what to say.

No matter how awkward the moment, whenever Julian and his problems are acknowledged, instead of ignored, comfort comes. But then, feelings of loss erupt: no more bright Julian, no more Stanford professor, no more travel to scientific conferences, no more camaraderie of his colleagues and professional friends. This simple call to the library cuts us off from thirty years of academic life, propels us forward another step into the vast Alzheimer's unknown.

"The library has been so important to Julian. Thank you for your kindness...." I struggle to express the kind support I feel.

~

Later that night, the house still hot, Julian and I sprawl on our family room couch watching television. The three tenors—Jose Carreras, Plácido Domingo and Luciano Pavarotti—are singing at Los Angeles' Dodger Stadium.

When Pavarotti opens his mouth and belts out his high notes, Julian stares at the television and laughs.

"There's that big guy," Julian says, handsome in his blue tee shirt and loose cotton pants, oblivious of my call this morning cutting him off forever from his beloved library study, his last Stanford connection.

Dressed in black tuxedos, the three tenors bunch together on stage for their last number, "O Sole Mio," and they really ham it up. Each singer puffs up his chest and lets loose with all he's got, while the other two look at each other and wink. Operatic bravado: can you top this? When it is finally Pavarotti's turn, Carreras and

Domingo nudge each other. Pavarotti is twice their size, his voice booming out of his broad, black-bearded face…"*O sole mio…*" It is like three boys doing skateboard tricks, each trying to outcroon the others.

Julian perches on the sofa's edge intently focusing on the concert's climax. Rarely these days does he watch television. He usually moves restlessly about, picking up and setting down objects, fingering books, shuffling papers. But this time the singing's passion draws his attention.

The audience grows wild, standing and clapping. "*O sole mio.…*" All three tenors belt out the final chorus.

Julian and I stand up to get ready for bed. "*O sole mio…,*" I croon. I am no singer and can hardly stay on pitch, but the end of this concert is so intense I can't help singing. "*O sole mio…da da te da.…*"

Julian chimes in. No words, but he has the tune. "*Ta da da…ta da da da…o sole mio…te da da da!*"

Prancing about the family room, we fling wide our arms, opening our mouths trying to form that big round "O" that singers make. We gesture and gesticulate, sing louder and louder. In between phrases we howl with laughter. Julian takes me in his arms and pulls me to him. We giggle and belt *out* "*O sole mio…*" again and again as we head down the hall.

Still singing in our bedroom we stand side by side before the dresser mirror trying to imitate Pavarotti. We sing, laugh, horse around, then fall onto the bed laughing and playfully punching each other.

Suddenly I am struck with how much fun we are having, despite Julian's vanishing intelligence, despite cutting loose from the library today, despite the placement decision looming ahead. Genuine, right-here-now delight fills us. I feel flooded with awe: Julian can't put on his underpants correctly yet he can play around, still so connected.

My mind flashes back to last night, lying on the sofa watching a video I rented to get us through a long Sunday evening. Julian wandered off and puttered around, but when it finished, I felt wistful, full of yearning…provoked by a young couple in the film making love. I called Julian to the couch, patted the cushion to get him to sit beside me, pulled his hand onto my shoulder.

"Would you rub my neck, Julian?" I wiggled my shoulder and lay my hand on top of his to get him going.

Once he starts a familiar movement, he can usually continue. If the toothbrush is on the counter and I say "brush your teeth," he may look at me with a puzzled look on his face with absolutely no idea what he is supposed to do. But if I put the toothbrush in his mouth, he can brush. So it is with rubbing my neck at night. He can massage my neck in a mechanical way if I get him started.

So last night, moved by the film, I put his hand on my arm, on my leg, first my foot, then my thigh. Wherever I put his hand, he rubbed, gently, keeping the movement in the same place until I moved his hand. Then...finally...something familiar, something basic, took over. He gradually knew what to do. I lay on the couch in the family room while the video rewound, and we made a fumbling sort of love. When it was over, we looked at each other and grinned. A warm peace spread over me. We hadn't been this intimate for months. Our days together are precious and numbered; how many more shall we have?

Still humming "O Sole Mio" and remembering last night, I pull Julian's pajamas from the closet.

"Take off your shirt," I say, handing him his pajama top. "Take off your pants, your pants." I gently tug at his trousers. "Put on your bottoms." He brushes his teeth, takes two orange Mellaril pills, pees and climbs into bed. Waves of tenderness wash over me. How odd that given all his impairments, we can still be happy together.

An acquaintance pops into mind, a woman in the prime of life, with an intelligent, competent, attentive husband, and the woman is mostly miserable and depressed. Even with Julian's decline and all our problems, I spend many more happy hours than does this woman.

I remember the friend who called yesterday. "And are you thinking of placing Julian in a residential facility?" she asked after I complained how hard it was to talk on the phone when he follows me around talking gibberish in my other ear. Others may think my life intolerable, but I am not ready to let go of him yet. It's hard to explain the richness and complexity of life with Julian.

While he sleeps, I tidy up, do the dishes, then slip into bed beside him. It's been a good day. I pick up my novel, read for a while, then sink into delicious sleep.

But at 3:30 A.M. Julian wakes me, agitated, confused, muttering gibberish. Gone is the playful fun of just hours ago.

"Tomastoo is the time of godoo—right?" he asks. "Is this a lot of otomol?"

I drag myself out of bed, accompany Julian to the bathroom and give him a drink, listening and nodding. I play a Vivaldi tape, but still Julian's gibberish pours out.

"I'll have to make machione of the raydel," he declares. "The roderol...takomee...."

Two hours later, I try giving him another Mellaril. Too exhausted to sleep, I pick up my novel and bury myself in Natalie Goldberg's *Banana Rose* as Julian lies beside me, still muttering. Gradually the Mellaril takes effect and his talking slows down...he falls back asleep. At 5:30, I switch off the light. It's only been a few hours since our hilarious "O Sole Mio" exchange. It doesn't feel hilarious now.

"*Sole mio...*," I think. Now what does that mean exactly? I don't know Italian. Does it mean something about the "sun?" Maybe it means..."my only one?" Perhaps a man singing to his beloved?

Well, it's "*sole mio*" for me, all right. Julian is my beloved, my only one, and I'm the only one, alone, here to do it.

Breakfast at Joanie's

"SOMETHING SPECIAL TODAY," I tell Julian when we wake up the next morning. "We're going out to breakfast. Your old friend Ray is here. He wants to see you."

We are cuddled in bed, Julian's curly gray hair wild and tousled on the pillow. His eyes grow wide as he listens to me. I say it over and over, hoping each time one more piece of the message might sink in.

"Your friend Ray is here. We're going to a restaurant."

Julian struggles to understand.

"He's tall," I explain. "Jewish, South African, British accent. You worked with him."

Julian looks puzzled.

"You'll remember him when you see him."

"We could go for the gungaree of annimer," Julian says, sprawled

beside me, his smiling face close to mine. "How much time on the ungish? It'll be warm," he says.

"It'll be fun," I say. "We're going to see Ray. We'll eat in a restaurant."

Julian jumps out of bed, jabbing his index finger at his crotch. "I'll take away my pee."

As I hand him his shirt, underpants, socks, and trousers in that order, he asks, "Are you going to merryjedge? Am I going gungshoo and movee-gitten novelle?"

He happily jabbers away as I prepare to leave. He understands what is happening; he just doesn't know whom we will see.

"Today we're going to get potting to given the ging," he says as we get in the car. "So I suppose we're going to getter the nobile. Would you even want to thousand the foos?"

Julian is cheerful and excited as we pull into a parking spot in front of Joanie's Cafe, just as Ray's rented car pulls in beside us.

"Look, there's your friend. There's Ray." I point to tall, lanky Ray Rosen, wearing beige trousers and a brown sport jacket, dressed for his lecture at Stanford Medical School later this morning. Ray is a colleague of Julian's, who six years ago spent his sabbatical in Julian's lab. We became good friends; he still calls from New Jersey and visits when he is in town.

"Hey, Julian," Ray calls. "Hi, my old friend." He gives Julian a big hug and strides into Joanie's Cafe, his arm slung around Julian's shoulder. "Good to see you."

"Ah...yes. Yes, yes...you," Julian says.

As we settle ourselves in a booth around a table covered with a yellow and blue flowered cloth, a waitress with a French accent brings menus and coffee.

Our conversation starts easy before moving on to what I really want to ask Ray about.

"So how are the kids?" Ray and I query each other, recounting the antics of our respective children. Julian smiles and grins. From time to time he inserts himself into the conversation with unintelligible gibberish, and Ray and I stop and listen to him.

"You're right," I say. "I think so too."

Ray nods, sitting across from Julian, watching him intently— partly trying to understand what he is saying, partly assessing him, I

suspect. Ray is a psychologist, researching sleep disorders and sexual dysfunction, and running a university clinic. He cares about Julian. When he calls, I always feel a compassionate ear on the other end of the line.

It has been a year since we last got together. Last August Ray, his wife, and kids had drinks in our garden, and we ate dinner in a Chinese restaurant. Then, Julian was able to enjoy a simple, connected, albeit primitive, conversation. This August I warned Ray on the phone that Julian has changed since he last saw him.

"I knew he would have," Ray said simply.

"It's not more bass," Julian now declares. "It's the moodjie. Remember?"

"I don't remember that exactly, Julian," I say. "But you remember."

"You don't remember?" Julian looks at me quizzically.

"We have different heads," I say. "You remember some things. I remember other things."

Julian laughs. "You don't remember?" He finds this very funny.

"It's good to see you, buddy," says Ray.

I resume telling Ray about Karen's new job as a journalist in Fremont, an hour's drive from their house north of Berkeley, and how I worry about her long commute and that the children stay in an unsafe neighborhood with drug problems.

Then I interpret for Julian, "I'm telling Ray about Karen's work."

"I know she's a normal gong," he says. "But where's the porry?"

"Karen's working on a newspaper," I repeat.

"You did the whole re-fuming. Did you look at that riffia?"

Three way conversations with Julian are tricky. I want to include him, yet there is no way he can follow. While he struggles to understand, and we must acknowledge his attempts to contribute, I am starved for normal adult contact. I want to ask Ray how Julian was in 1989, the year Ray worked in his lab, just one year before Julian's diagnosis. Ray skillfully maneuvers through these conversational dynamics, correctly sensing that we cannot talk about Julian in his presence. What Julian does and does not understand is never clear.

The French waitress brings our food. I cut Julian's waffle into bite-sized pieces and pour on maple syrup.

"Eat this?" Julian pokes at the parsley garnish with his fork. I move the green sprig on my plate near my poached egg.

While Julian grows quiet eating his waffle, Ray and I talk rapidly about his work and his family's recent trip to Johannesburg.

I feel safe with Ray—comforted and supported, not just through words, but by his continuing affection for Julian. Julian is no longer the man he was, the man people think of as Julian. Dr. Julian Davidson, the scientist. Dr. Davidson, the Stanford professor, researcher, lecturer, excellent writer.

But I live with and love the core, the very essence, of Julian. While most of Julian's professional connections have fallen away, a few remain. Ray's respect for Julian hasn't declined. Without words, I feel Ray cheering us on.

Our breakfast is finished. We have already had three coffee re-fills and I am sorry our visit has ended. With Julian present, we couldn't talk about Julian, which I sense we both want to do. We never got to what I most wanted to talk about.

"Julian is cheerful most of the time," I say as we settle the bill. "He's only unhappy when I get irritable or impatient."

As Ray and I stand outside near our parked cars, Julian wanders away peering in Leaf n' Petal, a dress shop window. So I quickly ask Ray, "Did you notice signs of Julian's memory problems when you worked with him that year before he was diagnosed?"

"Yes," he says, carefully choosing his words. "I saw that Julian was often anxious and distracted. In our discussions he sometimes lost his train of thought. He edited writing in odd ways, but then he'd get back to it."

"You know," I blurt. "I recently read Julian's journal, from 1990, just before his diagnosis, the year after you worked in his lab. Scribbled pages filled with misspelled words, fragments of uncompleted phrases. I was shocked at how hard he struggled to keep up his professional activities, nobody yet realizing what was wrong."

"But I attributed all this to Julian being depressed," Ray explains, "over the recent deaths of his two older brothers. And the '89 Loma Prieta earthquake which demolished his office and lab."

"That year at Stanford before the diagnosis was so hard for him," I say. "He suffered most when he was slipping and trying to conceal it. He tried so hard to hang on to his life. And then after his diagnosis came those terrible two years…giving up all he'd been…letting go of his lab, ending his research, trying to extricate himself from Stan-

ford in a responsible way…in slow motion, loss after loss, adjustment after adjustment."

"I had no idea all that was going on at the time," Ray says. "Julian was still one of the leaders in our field."

"He covered it up well," I say. "It took so much energy to keep on going."

"It's clear in retrospect, isn't it?" Ray says.

"Yes…insidious, they call it. Alzheimer's has an insidious onset. That's what it means. It just sneaks up on you in thousands of tiny ways. I was often angry at Julian in the two years before his diagnosis. We'd make a plan to meet and he wouldn't show up. He was always late; he forgot appointments. I accused him of being rude, selfish, inconsiderate. I didn't get it then, but it's clear in hindsight."

Ray nods silently, complex feelings hang unspoken between us.

"I remember so well the award ceremony for Julian you helped organize at the Asilomar conference in '93," I add, "and the wonderful speech you made praising Julian. It meant so much to us both. And Julian was aware enough then to appreciate that he was being honored."

Standing by his rented car, Ray says, "I'm relieved to see you both looking so well."

"Somehow, miraculously, Julian's pretty happy now," I say.

"And how are *you*, Ann? How's your health?"

"You mean my breast cancer? I've been lucky…I'm fine. I hardly think about cancer these days," I say. "One way to stop fretting about cancer is to live with Alzheimer's."

"But the latest loss," I add, "is that I just canceled Julian's faculty study in the library. Soon I have to go there and clear out his books. Maybe you'd like to have a few?"

"I'd like that," he says, looking at his watch, then retrieving Julian from the dress shop window to say goodbye.

"Thanks for breakfast, Ray," I say as we hug, feeling more appreciation than these small words express. Ray kisses my cheek. "You're looking so well," he says. "I'll give your love to my family and we'll keep in touch."

Ray folds his lanky frame into his rented Toyota and drives away to give his lecture.

Watching Julian amble aimlessly along the sidewalk, looking con-

fused and forlorn, I stand by Joanie's Cafe a moment, full of yearning for our lost life, wishing the old Julian were back. But I don't dare let myself sink into the pit of longing for things to be different. This morning with Ray reminds me of the importance of friendship, and I'm glad Julian is remembered. Emotional connection is now what matters most.

~

Late that night, lying in bed, just before turning off the lamp, I nestle in Julian's warm arms thinking of this morning's breakfast with Ray.

"Do you miss being a scientist at Stanford?" I say. I have no idea if Julian will understand, but why not ask?

"That was a long time ago," he answers softly.

"Are you okay, Julian?" I whisper, anxious over what he might respond.

"I'm okay," he says, looking straight at me with clear blue eyes. "I'm really okay. Now you be okay too."

Tears well up, spill over. How can this terribly damaged man sometimes still be so connected. "Yes, my darling," I sniffle. "I'll try...to be okay too."

Green Library

AUGUST THIRTY-FIRST: the last day that Julian's faculty study at Stanford remains in his name. Today I must clear out his things and vacate the room. After today, his official presence at Stanford will be erased.

But for a few minutes I linger in his small study, six feet wide by ten feet long, bookshelves lining the western wall, and sit in his tomato red chair facing the large gray desk.

Swiveling right, I gaze out the wide window to an open view of the Stanford campus: across lawns shaded by pepper trees, olives, and California live oaks, students on bicycles pedaling past dorms with red tile roofs, Julian's professional home for thirty years.

Quiet, so quiet.

Every morning for fifteen years Julian came here, to Green Library, Room 373-C, on the third floor. He began each day in this

silent refuge—away from ringing telephones and the questions and problems of secretaries, research assistants, post docs and students. All of that he handled in the afternoons. Mornings were sacred times for his reflective work: writing research grants and journal articles; preparing lectures, editing textbook chapters.

~

Julian loved this study, free from requests and distractions, his place to concentrate and think.

After his Alzheimer's diagnosis in 1990, and the traumatic shutdown of his office and lab, Julian still came to this study. It consoled him after he "retired." We moved some books and journals here, the few I kept. This became *his space*, his place to be himself, giving him a focus, a pivot around which to organize his day, the last place he went to by himself.

"At least I have my study in the library," he said. "I can always go there."

He did go there, for five years after his diagnosis...before the serious fiascos began: lost keys, lost bike locks, lost bikes. Before he started getting confused trying to return home from Green Library where he had bicycled for decades. Before the phone calls started coming: from the Stanford police who found a "disoriented man wandering around campus"; from a kind commuter who found him on a main, heavily-trafficked road; from library personnel at the reference desk.

Perhaps I waited too long to decide Julian could no longer go alone to the library. But I couldn't stop him. Green Library represented his last shred of independence.

Also, fearing what my life would become if he stayed home all day, I was reluctant to forbid him to go, knowing that act would simultaneously imprison me.

In the end, I didn't *decide* to stop him; it just happened. I made excuses for why "this wasn't a good day to go to the library," why he should "go tomorrow." As the weeks slipped by, he gradually forgot about going. I never had the courage to forbid him.

Now, the bookshelves are empty, four cartons of books piled on the desk. Soon I will get library personnel to help me move them to my car. But, I want to sit here a few minutes before turning in his key.

Entering Green Library an hour ago, I was shocked at the force

of emotion that hit me. Suddenly I felt as if I were Julian walking through the heavy glass doors, past the turnstile where he showed his identification card. Of course, these last years, he rarely had it, but the library staff knew him and let him in without I.D. They replaced his lost keys. They phoned me often to say they found his briefcase, his jacket, his bike. I remember the kind voice of the woman who answered the phone when I called to say Julian no longer needed his study.

Sitting now in Julian's red chair, memories come of two years earlier, when I once accompanied Julian to his faculty study, amazed how many staff people waved, calling, "Hi, Dr. Davidson"—a man at the reference desk, a woman at the check-out table. No wonder he loved coming here after his lab and office closed. This familiar, comforting place made him feel like the man he had been.

Ironic that Julian, who could no longer read nor write, sought a library's solace. He walked towards his study through narrow stacks—past rows of books by Krishnamurti, past black volumes of the *Journal of Symbolic Logic*, past philosophy books in French and German. He loved being surrounded by books.

What he did here I can only imagine. Probably he leaned back in this red swivel chair, put his feet on the desk, and "read" the paper. Cleaning out the study, I found twenty or thirty yellowed sections of the *San Francisco Chronicle*. Scattered across his desk were old copies of the Jewish magazine *Moment*, the Stanford Hillel newsletter, brochures of Stanford's music programs, solicitations from the Jewish Peace Lobby and Amnesty International, two favorite charities.

Little notes lay everywhere—scribbled on scraps of torn paper, corners of newspapers, half pieces of stationery. A line here, two or three phrases at most, words misspelled, unintelligible written gibberish. Gathering the sad little notes, I read them and wept. I threw most in the trash bag, but then retrieved them, shoving them in a brown folder, wondering if I'd ever have the strength to read them.

On a yellow Stanford phone memo pad, he wrote: "Plesr enge with wipe wte of BE=E, Pl I give H Pine, BlEER J or."

How stubbornly this lover of language clung to literacy as words fell from him. Philosophy tomes and the *Journal of Logic*? Julian can't open a can with a can opener or put on his belt. He can't figure out how to roll down the car window. He can't even sign his name. How

long he struggled to write down his befuddled thoughts, trying to hold together his failing mind.

One note, dated July 1991, said, "I knew so many beautiful words which are no longer available to me."

I marvel at his tenacity. Futile as it sounds to sit in the Stanford library with moderately advanced Alzheimer's, I understand how he comforted himself with books.

Seeing his desk strewn with books and papers, stepping over reprints tossed on the floor, reading the sad little notes—a lump rose in my throat. But as I sorted through the mess, fascination mixed with sadness.

Curiosity took over. I could have looked at the mess, the chaos, these tangible signs of Julian's decline, and despaired. In the past I might have. There is a bitter sweetness in giving oneself over to the sadness of loss. At times it's nice to sink into it, feel the full impact of all that is gone. I have done that plenty.

But, oddly, I do it less and less. I don't cut off from my feelings or deny hard truths, but I try to stay present and deal with what is happening now. Today, I'm sentimental, yes, but not sad.

My friend Charles tells me that sadness comes from not truly accepting the present. Letting go, accepting reality and not hanging on to the past will lead to less grief. Sadness comes from hanging on, from needing.

Every minute I can choose, Charles says. If I choose to think about what I have lost and how Julian has changed, then I will be sad. Or I can choose not to do that. I can decide to stay focused in accepting the present and move ahead with my life. Staying sad for too long Charles calls self-indulgent.

In the first years after Julian's diagnosis, I felt overwhelmed by shock and grief; I was just beginning to learn to let Julian go. I floundered in depression for days on end. Now I dwell much less on what we have lost.

Sure, I still have moments of sadness. I can sink further down into nostalgia, and sometimes I do. Or I can choose to come up quickly and get on with whatever is happening at the moment. I feel in charge of how I feel. Sadness no longer floods me, like an engine flooding with gas; I am less stalled by sadness. I live with the paradox of staying connected to Julian while simultaneously letting him go.

When I placed books from Julian's study shelf into a box, I scanned the titles: *Psychobiology of Reproductive Behavior, Human Sexuality and Its Problems, Mind and Brain.* Maybe Ben, Karen, or Jeff might like some of these books. Memories wash over me of Julian's long, fruitful scientific career.

Soon, the boxes will be moved to the trunk of my car. Three garbage cans filled with waste papers sit outside the door. I have thanked the library staff for their kindness to Julian.

In Room 373-C, I linger a few more moments, sitting in his red swivel chair looking out on the tile roofs and olive trees that he gazed on for so many years. Now the shelves are bare, the desk empty, Julian's presence at Stanford erased. He has nowhere now to go but the dementia day care center.

It is quiet…so quiet. I, too, crave this blessed silence, and must have peace to sort out my thoughts. Here in Green Library, I feel close to Julian and the academic, professional life he has lost. But soon I must leave to take my father for blood tests before the surgery that will happen next week, and pick up Julian at day care. This Stanford era is done, and today's tasks are pressing.

Someone named Davidson, but not Julian Davidson, closes the study door of Room 373-C for the last time.

Oh Ley Ley

THURSDAY NIGHT the surgeon phones to say my father is scheduled to enter the hospital in four days for more vascular surgery.

"The operation is risky," he tells me, "in a man his age, with longstanding diabetes. There's always the possibility of complications."

"What complications?"

"Well, he is eighty-four, and his heart is weak. We never know how he'll withstand the anesthetic and shock of the operation."

"Yes, but my father's a fighter," I say. "He's eager to improve his condition."

"The problem with diabetes is that the blood flow is compromised," the doctor continues. "Healing is slow. That's why his foot hasn't healed from the previous surgery. His toe is necrotic. But

there's a pretty good chance that this time we might prevent gangrene in his toes and save his leg from amputation."

"It's his decision," I say. "He's perfectly competent. Surgery is what he wants."

"I want you to know where we stand," the surgeon says.

Hanging up the phone, I am flooded with fear for Daddy: for the surgery failing, for him dying on the table or becoming an invalid, for losing what little independence he now has, for having to move to a nursing home, for not having any more happy times in his life.

Then, the phone rings again: it's Beiçola.

"The kids' musical is in three days," he reminds me, in his thick Brazilian accent. "The children choreographed dance numbers and made their own costumes. I've reserved your tickets. Be sure to come!"

All this August, Beiçola worked at a children's performing arts day camp in San Francisco, taking our two oldest grandchildren, Antar and Celina. For four weeks they've rehearsed a musical production of the story of Persephone, using Brazilian mythological characters. Beiçola taught sixty kids Brazilian dance, songs, drumming, and Capoeira, the African-Brazilian martial art, that a month earlier they never heard of.

"Of course, I'll come! And I'll bring Julian, even though he won't understand the story," I tell Beiçola. "Julian loves music and dance. Besides, where would I leave him?"

Then the idea comes to also take my father. Every evening he sits alone in Woodacre Knolls where dinner is served at 4:30. He endures long lonely evenings, though he never complains. Now, scared about the surgery, he has updated his will and taken out his power of attorney for health care, stating emphatically to my sister and me "no life support, no heroics."

"My dad's surgery is scheduled four days from now," I tell Beiçola. "Get another ticket. I'll try to bring Daddy too."

It won't be easy to get Daddy to San Francisco, as he can walk only a few slow, wobbly steps. But he has so few pleasures, I resolve to bring him. "I don't want to be hooked up to some damn machine," he mutters often to me and my sister. Increasingly crabby and short-tempered, he swears a lot, his way of showing that he is scared.

Imagining myself trying to park the car, get Daddy into a wheel-chair and hang onto Julian on a busy San Francisco street, I enlist my sister's help and she readily agrees.

~

The afternoon of the performance, I drive to an orthopedic supply company to rent a wheelchair. Collapsing the chair, I heave it into my Toyota, fetch Julian from Rosener House, strap him in the car, then drive to Woodacre Knolls for my father. While my dad shuffles down the hall, Julian escapes into bedrooms where I must barge in to retrieve him. Finally at the car, I buckle Julian in the back seat and settle my father in front. As I drive to San Francisco, I tell Julian over and over where we are going while attempting cheerful conversation with my irritable father. Only one hour into this outing and I am exhausted.

I'm so relieved to see my sister waiting outside the school as I double park.

"I couldn't do this without your help," I whisper to Jean, who brings fresh energy to our tense little group.

Leaving Julian strapped in his seat, Jean and I maneuver Daddy out of the car and into the wheelchair, then haul the heavy contraption up six steps. While Jean pushes Daddy into the theater, I drive with Julian on crowded rush hour streets to search for a parking place. Three blocks away, I finally find one and we race into the auditorium just as the lights grow dim. Karen, who has dashed in from her newspaper office across the bay, sits in the front row, arms folded around Rasa, who curls on her lap.

"*Oh ley ley, oh la la...,*" children's voices sing. "*Carnival is here... celebrate the year.*"

Onto the stage prance twenty little five-year-olds, including Celina, wiggling their hips and shaking their shoulders in a samba so adorable tears mist my eyes. Celina, a butterfly, wiggles with ten other butterflies dressed in pink tights and yellow leotards, waving the gauze wings they made themselves. My eyes stay riveted on my granddaughter, seeking out her long black braids in the dancing crowd. Older children beat conga drums and pound huge xylophones with wooden mallets.

In the Capoeira number, Antar cartwheels on stage in a red and gold sun god costume—executing a round of back flips while the

audience claps and cheers. A burst of red energy tumbling, flipping, kicking, Antar, who has watched Capoeira since he was born, flipped and kicked since he was two, dominates the stage.

Drumming, singing, dancing, the gala costumes—I love it all, and peer intently into every crowd scene to glimpse sun god Antar and butterfly Celina, giving myself totally to these joyful moments, glancing occasionally to see how Julian and Daddy are doing.

My father slumps in his wheelchair craning his neck to watch his great-grandchildren whenever they appear. White-haired, sagging, he looks so frail, but he laughs and claps. Seeing him happy makes me glad we made this effort. How many more outings, if any, will he have? I don't know then that this is his last.

"Let's go," Julian keeps muttering, for he cannot identify his grandchildren in the fast-moving blur of children on stage, nor can he follow the plot.

"Enough, let's go now," he hisses in the middle of the brilliant Carnival scene. I am disappointed; I thought he would like the music and costumes. But apparently there is too much noise, too much confusion. He squirms on the hard bleacher seat tugging at his trousers. Just as Antar whirls on stage, Julian needs the bathroom. Risking his discomfort, worse yet, an accident, I hiss, "We'll go to the bathroom later." Fortunately, he quiets down.

In the grand finale, Persephone marries black-cloaked Omoloo, God of the Underworld, who turns out to have his charming side. Her mother sings and sambas again while skipping flowers and squirming butterflies once again fill the stage.

Carnival is here...and sixty kids wiggle their hips in a samba that melts my heart. Children of the sun god twirl about. Drums, xylophones and singers fill the room with samba music and fill the audience's hearts with an infectious joy.

Persephone will spend six months on earth with her mother and six months in the underworld with Omoloo. Balance returns to the earth: darkness and light, the harmony of seasons.

The audience whoops and applauds. Shouting "Bravo, bravo!" I leap up, searching for our wiggling butterfly and our red sun god in the Carnival finale.

"*Oh ley ley, oh la la...,*" the children sing. "*Carnival is here, celebrate the year...,*" the crowd sings back.

My dad in his blue wheelchair is smiling and clapping. Julian stands beside me clapping, but his face is twisted into a grimace. "Let's go now," he snaps. Karen clicks pictures as my sister steps down the bleachers towards Daddy's wheelchair. Leading Julian by the hand, I take him to the men's room, then back along the busy street to get our car. My heart is joyful. It was worth the schlep to get everyone here.

"*Oh ley ley, oh la la...*," I sing in the car driving back down the peninsula.

Both Julian and my father sit silently as the car speeds through the black night. Asleep, Julian slumps in the back seat, head hanging to one side, while Daddy sits beside me staring ahead, answering in monosyllables as I attempt conversation. He won't respond when I try to open up the topic of his medical uncertainties. Of course he worries about the days ahead, but he won't discuss it, nor will he engage in chit chat, nor say much about the performance.

Conversation blocked, I decide to prolong this evening's respite of merriment, and sing loudly all the way home, extending the pleasure of this gala evening, hoping Daddy won't mind, and might actually enjoy, my tunes. Closer to home, driving down the dark freeway, I shift into quieter songs, Appalachian ballads and lullabies, my melodic attempt to acknowledge Daddy's somber mood and perhaps, even, to soothe him.

Moving In

TWO NIGHTS AFTER the children's performance, rapping at the bedroom window wakes me. Karen stands outside the sliding glass door in the dark beside black bushes, an anguished look on her face, tears rolling down her cheeks.

"My God, what's happened?" Images of car crashes, a child in the hospital, Beiçola hurt, spring up. I leap out of bed and open the door to let her in.

"I'm okay, Mom," she blurts. "We're all okay." She falls into my arms. "My children aren't safe," she sobs. "We can't stay there. My children aren't safe."

I have heard this before. Three years ago there were robberies

and shootings in her neighborhood and one scary night she and the children actually fled.

"Tell me what happened."

Her cries soften. "A drive-by shooting…at our babysitter's. Someone drove down the street and shot into the house…the kids could have been there…they could have been shot…" Karen's voice trembles and fresh tears roll down her cheeks.

I hug her tightly and draw her to our bed. Julian sits up rubbing his eyes, concerned, but useless in any crisis. Three of us sit under the quilt while Karen blurts out her story. Three rounds of shots were fired into the sitter's house just thirty minutes after the children left.

"They could have shot our house too," she says. "We could be dead."

Some teen-agers were after the sitter's friend, Karen explains. Something about drugs. And the husband rushed out the door with his own gun to find them.

"Where are the children? Where's Beiçola?"

"The kids are asleep in the car. Beiçola's coming. I had to leave, Mom. I had to leave."

Julian gets up and goes to the bathroom, oblivious to what Karen just said.

"Let's get the children and put them to bed," I say.

Karen and I go to the car and carry three blanketed bundles into the house, lay them down in one of our two spare bedrooms and tuck them in. Antar is heavy, but it's too hard asking Julian to help. With the children and Julian fast asleep, I make a pot of tea and Karen and I meet in the kitchen. Her brown hair is mussed, her blue eyes wide with fright.

"This is it," Karen repeats. "We have to leave. But what'll we do?"

My heart swells with feelings of protection for this little family. They work so hard pulling their life together. Karen loves her new job as a newspaper reporter, but it is far from her house, nearer to our house than to hers, and Beiçola's main teaching is now concentrated here in Palo Alto, an hour from their Richmond home.

"Antar and Celina start school next week in Berkeley," Karen rushes on. "This is already Labor Day weekend, and the school district said they might have to go to two different schools—each one far from our house."

Beiçola was to care for the baby most days, she explains, as he works mainly at night, but the linchpin of these complicated logistics was the neighborhood sitter. Without her, their hectic schedules couldn't happen. And now the shooting.

My mind spins with this newest dilemma before us.

"Karen, honey, let's go to sleep. We can't solve this now. Go to sleep. Everyone's safe. We'll work things out in the morning."

Karen phones home and talks to Beiçola, who is coming soon. Heart thumping, I return to bed, possible solutions tumbling around in my head. One thing is clear: they can't go back.

Lying in the dark beside a snoring Julian, I think of our safe life here in Palo Alto, where I have never known physical fear, never been in danger. How privileged I've been. Though Julian and I worked hard, our economic life has been relatively easy, without great struggle.

Now it is hard for young families starting out. Julian and I bought our first house easily as a young couple, never needing our parents' help. Our children led a comfortable life, in safe green neighborhoods, good schools nearby. Picturing Antar or Celina getting hit by a bullet in some drug-related, crazy cross-fire, I shudder and yearn for them to be healthy and safe.

In the morning I drop Julian at day care, then drive quickly back home. While the children sprawl on the couch watching *Sesame Street* in the family room, Karen, Beiçola and I prop our elbows on the kitchen table and talk.

Still in pajamas, Karen pours out the story of exactly what happened. Listening to her frightening tale, I frantically scan the possibilities as to where they might live.

"What about moving further south, closer to your new job?" I suggest. "You'd have less commute and Beiçola would also be closer to his Capoeira classes here in Palo Alto."

"Yes, but live where?" Karen asks.

"We could sell our Richmond house and buy a new house across the bay," Beiçola says.

"Yes, but school starts in a few days," I say. "You can't sell and buy a house that fast." The logistics of finding a house, moving and setting up child care while working overwhelms me.

"We could rent in the meantime," he says.

"How about renting in Berkeley, maybe, where we have friends to help us with babysitting?" Karen proposes.

No one mentions their living here, as least not in this initial discussion. But for years Beiçola has said that we could help each other if we lived together. Families do that in Brazil, he says. "No way," I've told him on many occasions. "That would never work. I can't imagine our households merging!"

Realizing we need more information before we can make decisions, Karen leaps into action, phones school offices and real estate agents across the bay. She and Beiçola arrange to look at houses in Fremont where her job is located. That night in our next discussion, they describe two homes they saw and would love to live in. Excitedly we imagine a new life across the bay, until reality hits. You can't buy and sell a house overnight and school starts in four days. They consider renting, but financially, it just won't work. Our hopeful fantasies deflate like a leaking balloon.

The next day, they set forth to check out Berkeley. Fresh ideas pour forth, but that night we each realize that won't work either.

On day three, Beiçola tentatively verbalizes what so obviously lies before us: "What about staying here?"

A blast of conflicting emotions hits me, but I remain silent mulling over what this might mean. Already I feel squashed between the needs of Julian and Daddy and now, possibly, this entire family.

For days we discuss living together. We talk about it in our garden on sunny mornings and in the kitchen late at night, hash it over as the children play happily on the grass and as they run through the house, shrieking and quarreling; as Julian whinnies like a horse, crawling around with Celina riding on his back, and as he, with sudden irritation, pushes the baby.

Would it, could it, work...our living together? It would solve their immediate housing crisis; the kids could go to school behind our back fence, the one their mother attended. I could help Karen and Beiçola care for the children and they could help me take care of Julian, freeing me especially in these next weeks to spend time with my father after his operation.

In morning sunlight it seems possible, even positive. Tired, late, after the hassle of the getting the children to bed, doubts rise up.

Julian and I try to lead a peaceful, orderly life. Our house is tidy, no noise, no clutter. This wasn't our style when our kids were little,

but it is now. Julian's dying brain brings enough chaos and I can't tolerate more confusion. Julian needs quiet. The children's loud noises annoy him and he can't respond appropriately. I need solitude. Each hour that Julian is at day care is my precious time. Karen works long days, not returning home until seven. I already know how exhausted I get after just a day with the kids.

But then our large empty house springs to mind, the spacious home where we raised our children. Antar and Celina could walk to an excellent school on a peaceful street. What a boost living here for a while could give them financially, what a haven it could provide. I think of refugees escaping war zones, staying with relatives in a safe town, families who helped each other during the depression. My mother's parents took in a family of six cousins who went bankrupt in the 1930s. In most of the world—Mexico, China, Brazil—families in our circumstances probably would live together. Beiçola grew up with many relatives in his mother's house.

"But I need my space," I warn them clearly. "I have enough to do between Julian and my father. I'm barely managing as it is. I can't add on taking care of the children."

Feeling already crushed by family demands, I lay out my reservations to Karen and Beiçola.

"Let's think about it for a day," I say. "Consider pros and cons. There are definite advantages, but there'll be hard spots too. Let's lay it all out."

"We're adults," Beiçola says. "We can talk about what's not working and tell each other what we feel."

Looking into his reassuring face, I want to believe his words. Deep in her own conflicted thoughts, Karen stays silent. She loves their house and their family's independence, but her children's safety comes first. Her demanding new job and the impossible logistics of their schedules exhausted her, even before the drive-by shooting; I know she worries about adding to Julian's confusion and stressing me.

"Dad deserves a quiet life," she says. "It's a big invasion of your space. But I just don't know what else we can do."

That afternoon, Karen, Beiçola and I sit on the grass by the faculty pool in the hot Labor Day sun as the kids splash in turquoise water and Julian sleeps in a lounge chair.

Breaking a long silence, I suddenly say, "Let's go for it. Let's just

do it. Living together is not ideal. But it's got advantages for each of us despite the drawbacks. Let's do it with the best spirit we can!"

Beiçola, Karen and I look quietly, resolutely, into each others' eyes and then jump into making plans. I'll clean out closets in the two spare bedrooms; Beiçola will bring their clothes and the baby's high chair; Karen will phone schools and arrange child care for the interval between when Beiçola leaves and she gets home. We'll let the family room get messy but the living room will be off-limits to kids and will stay clean. I make it clear that I can't take on caring for three children on top of Julian. They must be totally responsible for the kids. Of course I imagine myself reading stories and taking them on hikes. Karen will watch Julian in the evening if I want to go out; when I go to the hospital to visit my father, I won't have to hire a sitter for Julian as I planned. I'll have adults to talk to, others to help.

Living together might just work.

~

The night after our decision, Julian wakes up at three A.M., mumbling gibberish.

"Oh, it's terrible! The gavin and the gibbins. Did you go to see the aberiz?" he mutters. "Remember last night, the mindian attendance? He's not a person given the meracus offindus—kind of rendy bonavult on the ground."

He hops out of bed, pads to the bathroom and reappears, jabbing at his pajamas. When I finally lead him to the toilet, we're thick in the muddle of whether to sit or stand, whether to take off his pajama top or the bottoms, whether to face the toilet or back on to it, while he jabbers non-stop.

"Oh, oh, it's terrible," he says.

Back in our bedroom, he panics over how to lie down, unable to position himself correctly in bed, or to figure out how to lay his head on the pillow. For months I haven't seen this much confusion.

I've only slept three hours. Frantic with fatigue, I try soothing him, holding him, ignoring him, shushing him.

"I have to sleep. I *must* sleep." Finally I hiss, "Just stop talking!"

"Oh, oh...," he repeats. "I'm going to die. I don't want to die. Oh, oh...it's bad, bad."

He bolts up holding his head, pointing to his chest. Is he in pain? Having chest pains, a heart attack, maybe? Shall I call the doctor,

take him to emergency? Or is he just in another middle of the night muddle?

Not knowing quite what to do, I rush to the kitchen hoping for the best, pad back with two mugs of peppermint tea, his sweetened with sugar, and punch on a tape by Albinoni. Julian reclines in bed, leaning on pillows sipping his tea.

"Oh, thank you, thank you," he says, kissing my hand. "You're wonderful. You're so good. You're so wonderful."

Sitting in bed, I sigh, drink my tea, relax and browse through "Sex After Sixty," an article in a magazine I grabbed from the night-stand. "A wife must stimulate, take the initiative and experiment with new positions in order to maintain an active sex life after menopause in a long marriage," it says, "or sexual boredom will set in." Any kind of boredom sounds good to me.

Julian quiets down, drains his tea, settles into silence. I switch off the light, put "Sex After Sixty" on the floor and stroke Julian's bristly cheek.

"Thank you, thank you," he murmurs.

The alarm buzzes me awake an hour and a half later. I planned to take Julian to day care earlier than usual today and, for the first time in two years, enjoy my yoga class without him. For years I took morning yoga by myself, but when I couldn't leave Julian home alone, I started bringing him with me. First he lay on the blue mat and attempted to follow the teacher's instructions, raising the wrong leg, not doing what others were doing; but gradually he did none of the movements, and last term just lay there and slept. Now there's no point bringing him.

Padding down the hall to the kitchen, I weave between heaps of plastic bags bulging with clothes piled outside the spare bedrooms. Beiçola's computer, printer, scanner and fax machine cover my desk, his metal file cabinet looms in the corner. In one bedroom, Beiçola rearranges furniture; in the second, the children curl under their *101 Dalmations* and *Little Mermaid* quilts.

In the kitchen, Karen is dressed for work in a navy pants suit and lavender silk blouse, already making coffee and phoning the school district office, the receiver pressed between her shoulder and chin. For a moment I think of skipping my yoga class and helping enroll the kids in school, but I don't. Letting them run their own lives and

preserving time for myself is what I need to practice for this new arrangement to work. I must budget my energy between Julian and Daddy, whose surgery is scheduled for Thursday morning.

Dashing out the door to drop Julian at day care before yoga, to be followed by a pre-op visit to Daddy, I leave Beiçola standing on a chair changing a light bulb in the kitchen, and Karen stirring a pot of pinto beans on the stove. Our new life together begins.

A Different Kind of Harder

ON THURSDAY MORNING, my sister and I sit in the surgical waiting room, the hands on the clock jerking slowly towards noon. Daddy's been in surgery over two hours. While Jean struggles to concentrate on work she pulls from manila folders, I sip coffee and try to read.

Will Daddy, at eighty-four, survive this surgery? What if something bad happens? What if they can't do the bypass? What if he later has to have his leg amputated? Daddy couldn't bear life as a permanent invalid. What if he has to live in a nursing home? Jean is probably flooded with similar thoughts.

Fighting to silence my "what if's," I jump up and pour more coffee as a woman volunteer in a pink coverall says kindly, "It shouldn't be much longer now."

Suddenly a lean man appears dressed in green cotton scrubs, mask dangling around his neck, Daddy's surgeon. Jean and I jump up.

"The surgery went well," the doctor announces. "We accomplished the vascular bypass with no complications. He went through the operation just fine; his vital signs are good. The bypass should bring a good blood supply to his foot."

Jean and I laugh with relief, then bombard him with questions. He patiently answers that Daddy will be in recovery a few hours; later we can visit in his room. He should be on his feet tomorrow.

"Thank you, thank you." Jean and I pump the surgeon's hand. Anxiety seeps from me as I drive to Rosener House to get Julian, anticipating telling the family Daddy's good news.

~

The next morning high energy fills our kitchen: the children's first day at school. Celina tucks a new blue shirt into flowered shorts, her shiny black hair hanging in a thick braid down her back.

But over her Cheerios she breaks down in pre-first grade angst, pouting, "I have no friends!"

When I promise she will have new friends very soon, she bursts into tears. I ask what else is bothering her.

"I know that two and two are four, four and four are eight, and eight and eight are sixteen," she wails. "But I don't know sixteen plus sixteen." Tears stream down her cheeks.

"Oh, honey, you don't have to know *that*." I hug her to me. "You'll learn it later in first grade."

Almost convinced, she marches off clutching her Pocahontas lunchbox, tightly gripping her mother's hand. As they head down the street towards the same school Karen attended, I remember walking Karen to first grade, amazed that twenty-five years flew by so fast.

Karen's and Celina's figures grow smaller, round the corner and disappear. Then I load Julian and Antar into my car and drive Antar to his school where he strides boldly into his new fourth grade class. Moving from Richmond so abruptly is hard on him. A confidant bravado covers his jitters and he tosses me a quick look over his shoulder. "Bye, Gramma," is all he says.

Driving to Rosener House, I sigh over achieving these goals: good schools in a safe place and a reduced commute for Karen and Beiçola. Rasa has her own kitchen drawer filled with plastic cups and wooden spoons, and Beiçola taught the kids to wash their dishes. Daddy's vascular surgery was a success.

An hour later at Sequoia Hospital, after dropping Julian at day care, I find Daddy sitting in bed wearing a blue-flowered gown, his left leg heavily bandaged, stretched out on the sheet. He waves hello and points to his foot.

"Still got it!" he grins triumphantly. "The stitches look like a zipper running the length of my leg." He tells me he already stood up and will start physical therapy tomorrow.

I stare at his foot, a nice rosy color, indicating good blood flow, just what we hoped for. "Look at that cute pink foot!" I gently wiggle his hairy big toe and hand him the vase of magenta chrysanthemums I brought.

As a nurse with a blond pony tail checks his blood pressure, he jokes around with her. How charming and good-natured my father is with strangers, especially women. "Your dad's a great guy," his nurse tells me.

Leaving my dad in good spirits, I treat myself to twenty laps in the Stanford pool, lingering to read a magazine before doing errands. Then I dash to pick up Antar and drive him to his after-school program, before hurrying back to Rosener House for Julian.

Breathless, pausing at Carol's office, I lean on her door jamb.

"Can I talk to you for a minute?" I say. "Big changes are happening...I think you should know."

Carol listens quietly as I pour out the story of the drive-by shooting; that my daughter, son-in-law, and three children have moved in; that we've decided to live together and help each other through this crisis.

"There are advantages for me." I rush on, anticipating her disapproval. "I'm not alone; other adults are around. They can take care of Julian when I go to the hospital to visit my father, who's just had an operation. I can go out at night."

I blurt it all out. "Whoa...," Carol interrupts my gush. "Come in, sit down."

"But adding five people is *not* good for Julian." I continue. "He doesn't understand why they moved in. He keeps asking, 'What are *they* doing here?' Of course he doesn't remember explanations."

Carol lets me finish.

"Last night Julian kept stepping on Legos, shouting, 'Too much, too many,' as the kids ran in and out of the kitchen."

Without criticizing our decision, Carol grasps the important issues in our present reality and calmly suggests, "Minimize contact between Julian and the children. Eat separately; have just a few special meals together. Spend time alone with Julian, and give him an extra Mellaril, when things get hectic before bedtime. He can't handle the commotion."

Carol reminds me I must preserve my solitude when Julian is at day care, and resist caring for the kids; I must not take on more responsibilities, especially now that my father's had surgery.

"Caring for Julian is a demanding, full-time job! He needs constant, one-to-one supervision," Carol reminds me. "Julian looks

healthy and well, but living with dementia is overwhelming. You must take care of yourself," she warns, "or you'll break down, and get sick too!"

"Thank you, Carol." I look gratefully into her eyes. "You're one of the few people who understands, really, what it feels like to be me."

Back at the house, I drag Julian with me to pick up Antar and Celina from their after-school program, the dress-up corner, science alcove, reading nook and organized soccer reminding me again what a safe, privileged world we live in. Even though it is hard handling Julian *and* the children, I have agreed to pick them up and watch them briefly until Karen gets home.

"Gramma, Gramma," Celina calls. "Come see the bunny." Together we stand before the rabbit's cage, admiring its whiskers, its quivering black nose, a life-affirming change from watching demented seniors in wheel chairs and shuffling at a snail's pace beside my father's walker.

Back home, I find Karen already at the cutting board chopping broccoli, her navy suit jacket and briefcase slung on the table. Whack, whack…the knife slices thick green stems.

"Hi, kids; hi Mom," she calls out. "How'd it go today?"

While Beiçola unclogs the kitchen sink, Karen shows me her front page story in today's paper. Cartoons blare loudly from the family room where the kids have collapsed, after this long first day at school. Julian bumbles about the kitchen picking up and setting down newspapers.

The new energy in our house is far from restful. But I have exchanged loneliness and tedious exchanges with Julian for the noisy bustle of family life. Our merger, with all its drawbacks, brings joy, at least in this honeymoon period. Rasa's huge black eyes and bubbly laugh fill me with gladness, as does watching Celina roller skate on the driveway, feeling her six-year-old power with each circle and spin.

After dinner, Julian and I walk out the front door for an evening stroll when the bed-time hassle begins, as Carol suggested. At midnight, after our four "kids" are asleep, Karen, Beiçola, and I sprawl on the family room sofa, feet on the coffee table, exhausted, folding the laundry heaped on the floor.

"It'll take planning and patience from us all," I warn Karen and Beiçola as we discuss how to handle the coming week.

Reviewing today, Beiçola praises our bold new adventure while Karen lists tomorrow's tasks.

"Living together may be harder than taking care of Julian alone," I say, folding Antar's shirt. "But, for me, it's a lively, different kind of harder."

Moon Dream

SEPTEMBER ELEVENTH is our friend Connie's birthday and she includes Julian and me in a small dinner party—to celebrate her sixty-fifth birthday and the rising of the full moon. I am thrilled to be invited, as our social life has plummeted; only a few friends invite us anymore, and I need some celebrating after all the pressures and tensions of the kids' moving in and Daddy's operation.

An avid sky gazer, Connie apologizes that her birthday actually falls one day before the truly maximum moon.

"It's okay," I reassure her. "I won't even notice."

She plans for us to eat supper in her beautiful new garden, which she has planted with white flowers, intended to reflect silver moonlight.

A week before, I find a great birthday card, a picture of a coyote howling at a yellow moon, and a perfect gift, a bronze wind-bell from the garden center, a large bronze bell hanging from a metal moon crescent. Last month, I bought a similar wind-bell, a round sun with spiky bronze rays which I hung in my courtyard. I liked so much the cheery ding it makes in the breeze that I bought a second sun chime to hang on the back side of the house. My two sun wind-bells feel cheerful and optimistic, powerful and positive, in both directions.

At Connie's party, Julian is welcomed and hugged by the small group of guests. Thankfully, everyone knows his problems so I am spared embarrassing moments and awkward explanations, and can relax for a few hours in the freeing space of acceptance.

Sitting on Connie's redwood deck, surrounded by ceramic pots overflowing with geraniums and begonias, we sip Chardonnay,

munch sesame crackers with crab dip and brie. My dad's medical problems seem far away. I feel safe among these friends, chatting away with Connie's daughter while Julian muddles about with different friends who take generous turns trying to talk to him.

When supper is served, Julian immerses himself in the pleasure of grilled salmon and spinach salad, while I immerse myself in intelligent conversation that is not about domestic arrangements.

After dinner the guests move to Connie's new "moon garden" on the south side of her house, to toast the full moon's rising. Perched on a wooden bench, Julian and I raise glasses of champagne and watch the slim white arc appear, rising up over the bushes, swelling until the huge white disc looms over the fence, revealing its full round beauty. We watch it float upward, making Connie's roses and chrysanthemums glow a luminescent ivory.

"To the moon...to the moon," we shout, clinking our glasses, followed by rounds of "Happy Birthday, Connie." Lanky Connie, laughing in her long flowered skirt, tears opens envelopes, pulls out cards, exclaims over gifts. She reads out loud what I have written on the coyote-howling-at-the-moon card: "To Dear Connie. May the waxing, waning, quarter, half, harvest, blue and full moon shine on you always."

Holding up the crescent wind-bell, the only gift in the party's moon theme, she hugs me and Julian. "Thank you, Julian. Thank you for my birthday present." Julian seems to understand it's a birthday party, grins and hugs her back.

After sponge cake smothered with kiwis and raspberries, Julian and I walk hand in hand the six blocks home, full of champagne and good cheer, peaceful and content.

~

But the next morning I wake with a jolt...anxious, agitated from a troubling dream. Fuzzy-headed, I lie in bed groping to remember, as shimmering dream fragments slowly slide into focus....

I have done something terribly wrong! I bought two sun windbells for myself, instead of one sun and one moon! It's disruptive! Unbalanced! Not in the natural order.

My heart thumps. What have I done? Of course. I haven't honored the moon. It was outrageous to buy two suns and ignore the moon.

Suddenly the importance of life's dark side hits me: sun *and* moon…light and darkness…day and night…summer and winter. Joy and terror. Love and loss. It's so obvious. The inevitable power of opposites smacks me full force, the paradoxical need to embrace both sides.

My friend Charles' words float to awareness: if I truly accept things as they are and live in the present, I will be less sad. Sometimes I get this and often I don't. I pass through moments of understanding, then fear and self-pity, as though swimming through warm and cold currents in a mountain lake. But sadness isn't just "self-indulgence," as Charles says. Sadness is the flip-side of joy, an integral part of life…the moon-side.

Just as Persephone, bored in eternal sunlight, traveled to the underworld and embraced Omoloo, the Brazilian god of darkness, in the children's musical last week, so I must learn to look my demons straight in the eye, embrace them as an integral part of life: fear, exhaustion, sadness, doubt, dread.

My father's medical crisis with its uncertain outcome includes the possibilities of continued life, permanent disability, and approaching death. Nothing lasts or stays the same. Everything is in flux, part of a cycle, like the moon waxing and waning, making up the full range of being human, completing the world with all its seasons.

~

Ever since Connie's birthday, I've been paying more attention to the moon, watching it shift from a thin curved sliver of light to a thicker quarter crescent, growing to a flat half pie, then swelling into the full, shiny round disc. At night, I fold Rasa Lila in my arms and carry her outside into darkness.

"See the moon," I point. "The beautiful moon."

Since my moon dream, I have taken down the second sun bell that hung from the mulberry tree in my back garden; I am going to the garden center to exchange it for a crescent moon. I must ask Connie when I see her whether that left-facing crescent is waxing or waning. It's important to notice.

Bad Night

THE NEXT WEEK, around eleven, I slip happily in bed beside a sleeping Julian. We've had a good day. I watch the news, read a little, turn off the lamp. But, shortly after I drift off to sleep, Julian's muttering wakes me. He's jabbering non-stop, nothing makes sense as I fight my eyes open.

The bedroom is dark. In the night light's dim glow, I see Julian sitting on the end of the bed, tugging the blankets. He has un-tucked the sheets and is trying to get in at the bottom, crossways, his newest problem, like when he swam across the lap lanes at the pool.

"The gingase is in the resticle...gotta go...." He speaks faster and faster. "...where's the fiddering...oh no...the ardorlee...."

When he gets agitated, I know he needs me. He is losing the sense of how to move his body in space, how to position his body in bed between the sheets. Our king-size bed forms a square, not a rectangle, which would signal more clearly how to get in. Forcing my eyelids to stay up, I push away my warm covers. The bedside clock says 1:45. Damn! I slept less than two hours.

Stumbling around to Julian's side of the bed, I grab his arm, not too gently, tug on his pajama sleeve and lead him to the bathroom, at least we'll get the bathroom part over first. Positioning him before the toilet, I yank down his pajamas.

"Pee," I order. "Pee here. Wee wee. Pee pee. Whoosh whoosh."

He stares at me with a frantic bewildered look and I twirl him around, push him down on the seat and leave him there, then stagger back to bed.

Soon he reappears, puzzled again about how to get under the covers, something he could do easily just two months ago. I never should have lain down before him. Stupid me. I force myself up and go over to his side of the bed.

"Here," I order, thumping the pillow. "Put your head here." Then I whack the middle of the mattress. "Sit down here."

Julian has no idea what I mean, my words and gestures confuse him more. He looks at me with wild eyes as I push him down.

"Please, please," he pleads. "Be nice...I love you...I'll do anything for you...."

"Go to sleep," I shout. "Put your head down and go to sleep!"

Shoving his shoulders down towards the pillow, I already know this won't work…but I am so tired. He resists, pushes back up.

"Down, down," I hiss. "Stupid idiot," I mutter under my breath, hoping he hasn't heard me.

"Please," he says. "I'll do anything…tell me what I should do."

I try forcing him to lie down, but he keeps sitting up. When he does get his shoulders down, his neck juts forward, his head held high off the pillow, so I push my hand against his forehead.

"Down. Put your head down." I rarely command him this sharply, but I am desperate to sleep. I can't bear many more nights like this. Maybe a stern, clear order might sink in?

Finally I give up, leave him sitting and return to my side of the bed. Yanking the blankets over my face, I lie rigid while Julian keeps muttering. I just leave him be, try to relax.

Rolling my eyeballs up to the count of one and down to the count of two, I imagine myself floating on a high Sierra mountain lake in warm bright sun, a self-hypnosis technique I learned years ago. But it doesn't work.

"The iddering…the oroville…the udderlee in the lenible…."

I roll my eyeballs and count again. Julian keeps muttering. I hug the pillow tight over my ears, feeling him get up, but trying to ignore him as he leaves the bed and then returns. He jerks and fiddles with the blankets, gets up again, mumbles and jabbers. Then he makes sucking noises and smacks his lips. He is thirsty. It won't work to ignore him; many times last month I tried and failed, so I jerk up, stomp to his nightstand and lift the green plastic water glass to his lips. These night fiascos are getting worse, much worse than just this past spring. How much longer can I bear this?

"Drink," I command, pouring too much water into his mouth. He gulps and swallows. "Drink again."

I am not being nice; I hate being like this. My friend Betty, an ombudsman for the elderly who defends and protects elderly victims of abuse, pops into mind. Of course elder abuse exists; of course it is wrong. But, God knows, caregivers get desperate, pushed to the edge.

Suddenly I remember Carol's advice: maybe more Mellaril will calm Julian down. After he swallows the little orange pill, he climbs

back in bed, finally quiet. But it's only temporary. As soon as my head hits the pillow, his muttering resumes.

"Be quiet," I yell. "Just be quiet. I must sleep!"

"The osheree...the valable...oh the endering...," Julian jabbers.

"Shut up!" I screech and then hear Karen's door squeak open and her footsteps padding down the hall. We have woken her up. Though I tried to be quiet, to just ignore Julian and let the storm pass, this time he has worn me down.

As Julian tugs at the blankets, muttering, I leap up and flee into the dark kitchen, lean my elbows on the tile counter and prop my head in my hands as soundless sobs jerk from me.

Karen appears in her loose white pajamas, her long brown hair tousled on her shoulders, her face pale and worried.

"Oh, Mom," she says.

"I'm sorry," I cry. "I never meant to wake you up. I couldn't help it, but I can't stand this."

Karen looks at me with solemn, compassionate eyes. "When Harry Wu was released from a Chinese prison, he said the guards tortured him by repeatedly waking him. Sleep deprivation is a form of torture."

She pours milk in a saucepan and warms it, the stove's electric coils glowing red. Suddenly Julian arrives in his dark blue pajamas, puffy-eyed, shuffling towards me, his body bent forward, a forlorn expression on his face.

"Oh, it's you...." He points his finger at me. "Thank God I've found you. I love you. I love you. You're my big chief," he says, wrapping his arms around me, kissing my neck.

Weird snuffling noises emerge from my mouth, hard to tell if I'm laughing or crying.

"Hi, Dad," Karen says, giving him a hug.

The three of us stand in the dark kitchen near the range coil's red glow as the milk heats.

"I love you so much." Julian kisses my hand. "You're my oogle-oogle, washy-washy. My only one."

"Beiçola should be as affectionate as this," Karen smiles.

"My oddy-raddy. Oh, I found you!" Julian says, and we laugh together.

Karen pours steamy milk into two mugs, hands one to me, the

other to Julian. Listening to his love declarations, I simultaneously laugh and cry, as the milk slides down, sweet and soothing.

"G'night, Sweetie." Julian strokes Karen's hair. "You're the big one."

"Goodnight, Dad." Karen tosses me a wide-eyed look that says it all. The kitchen clock reads three A.M.; my alarm is set for 6:30.

The three of us pad down the carpeted hall to our rooms.

"Thank you, darling." I pat Karen's shoulder.

"Call the doctor tomorrow, Mom," she says, but I already decided I would. This can't go on. We must find some way to quiet Julian at night or I can't manage.

Back in our bed, Julian and I fall into exhausted sleep. By six thirty he again jabbers. "The resticle, the oshee...."

"I'm tired, very tired, Julian," I groan. "We had a bad night."

"We did?" he asks, looking surprised.

"You couldn't sleep. You woke me up. I'm very tired."

"Oh, I'm so sorry," he says clearly. "I'm a good person...and you're my big chief."

Back in our usual morning routine, we dress and go to the kitchen at 7:45 to find the table set with two green place mats under folded cloth napkins, bowls of granola with sliced peach, and coffee waiting in the thermos, even though Karen and I agreed that she would tend the children and I would take care of Julian.

"Oh, honey," I say.

Karen, in her navy pantsuit and the silk blouse I gave her when she got her new job, braids Celina's long, shiny hair as Antar gulps his cereal. Two lunch bags sit on the counter.

"Hi, Gramma," the kids chant in unison.

"Remember to call the doctor, Mom," my daughter reminds me. We both see that Julian is deteriorating, getting harder, if not impossible, to manage.

"About last night...," I begin. "I'm sorry...you also need sleep...you work all day. I didn't mean to wake you. The books say Alzheimer's can destroy whole families."

"Well, it won't destroy this one!" Karen scrambles for jackets and lunches and herds the kids out the door. "See you at six."

Julian and I sit down to our cereal, I hand him the garden section of today's paper. How much longer can I manage? I hoped Julian

moving to residential care was years away. Now I fear that day is getting closer.

Julian sits across the table, looking so normal, staring at the newspaper which I know he can't read. I can't imagine sending him away, can't imagine breaking up the family. He still knows me, loves me, calls me "big chief." He isn't incontinent, isn't combative. Unlike Woody, he can rise alone from a chair.

Forcing away these thoughts, I swallow my coffee and focus on the front page of today's paper—to learn what is happening now to Harry Wu.

Walking on the Ceiling

FROM DEEP IN A DREAM, from way down in a REM sleep trough, again I hear Julian mumbling.

"I don't know about the moozie majen. What about the shtem?"

I force open my eyes. Julian sits straight up in bed beside me tugging at the blanket, more fiercely than he did the night we woke up Karen.

"Shaf the gen...shaf in the safgen...it's very strange."

He lifts the sheet and messes the covers. I stare at him, shaking grogginess off.

"Masello mashia. *Oy gevalt!*"

"Julian, let's go to the bathroom. Let's go pee."

"Gopee?" he asks.

Trying my usual solution for quieting him, I lumber around to his side of the bed and pull his hand leading him to the toilet. As I stand him in front of it, he begins removing his pajama top.

"No!" I shout, then mutter to myself, "Stupid, stupid...you're so stupid!," hoping he won't hear.

Muttering, or even thinking, these words is the main way I know I am stressed nearly beyond control.

"I'm a good person, a good person," Julian pleads as I twirl him around, back him onto the toilet, yanking down his pajama bottoms. "Don't talk like that."

He obviously heard me. And, of course, he is right. I shouldn't talk like that.

"It's coming…it's coming…oh, it's almost here." He sits on the toilet, head propped in his hands. "There it is…I hear it."

Standing by the toilet watching him, I hear the soft splash of urine in the bowl.

"Ah, it's beautiful," he says.

He washes his hands and we return to bed. I switch on the lamp: two A.M. Julian sits on the bedspread, stiff and unyielding.

"Shooshen. Shashen," he says.

"Lie down, Julian, lie down." I push him over, not gently. I only slept two hours, had little sleep the night before. He bolts back up. I thump the pillow. "Down, down. Put your head here!"

"Fenders all perfan until you chance," he says.

"Julian. Go to sleep."

He sits rigidly in bed staring at me with clear blue eyes.

"Oh, it's myooka camar. Craikee…I've lost my bloody gun."

I punch the play button on the tape recorder and the fourth Brandenburg Concerto begins. We have heard it eight times in the past two nights.

"Let's sleep, Julian. Sleep." That magical, elusive state.

Wearily I lift the water glass from the nightstand to his lips and he gulps two swallows.

"I'm simply a yoodle pan," he says.

He has already taken three Mellarils, the maximum dose. Increasing his dose was what the neurologist suggested when I phoned him last week after that frantic night and my talk with Karen.

Now the clock reads 2:40. The increased Mellaril isn't working. I cannot face more rounds of toilet, tape recorder, thumping the pillow. From the past two weeks, I have already learned that lying motionless in bed with the covers over my face, ignoring his muttering and enduring his tugging the blankets doesn't work: it only drives me insane.

On a desperate impulse, as Julian fiddles with the blanket, I pick up my pillow and tiptoe past him. He never even notices. Padding quietly down the hall, I feel guilty sneaking away, the carpet soft under my bare feet. But exhaustion drives me.

In the living room, I collapse on the sofa, pull the mohair afghan over me. This is the first time in thirty-five years I left our king-size bed intentionally to go sleep somewhere else.

The living room is cool, dark, bathed in blessed silence. Moonlight illuminates armchairs and plants by the sliding glass door leading to the courtyard. Outside, star jasmine climbs the courtyard wall and white impatience spills from oak barrels, glowing in the moon's light in these last September days of their bloom.

As I sink into my pillow, muscles slowly release into peace. Overhead I study the inverted "V" of the vaulted wooden ceiling, the curious way the cross beams cut up the space, the dining room at the far end holding the wrought iron chandelier hanging over the table.

Any minute I expect Julian to appear looking for me. Our bodies are so used to sleeping side by side that it is hard to sleep without each other's warmth. But the house stays silent. I breathe deeply, my shoulders sinking with each breath. Tonight something new is happening. For the first time in over three decades, my body wants to sleep alone.

Looking at the ceiling, I imagine the room turned upside down. The ceiling becomes my floor and I walk across the wooden boards, stepping over crossbeams. I imagine moving around the chandelier which sticks up like a bush in a garden, with light bulb flowers: this is the upside down, walking-on-the-ceiling game I played as a child alone in my bed....

~

In the morning I awake to Karen's voice in the kitchen. "Antar, here's your toast. Celina, get your shoes."

From the living room sofa, the kitchen table is in full view: Karen, in a red skirt and Indian print blouse, is lathering peanut butter on bread. Julian, already dressed, hunches over a bowl of cereal. My watch says nearly eight, later than I have slept in months.

I get up slowly and enter the busy room. "Hi, everybody," I say quietly, wondering how Julian will feel.

Julian looks up from his granola. "Oh, it's you," he says with no apparent recrimination, no anger, no pout, no indication that he is aware that I didn't sleep beside him. "It's you, it's you!"

"Your alarm rang at 6:30," Karen says. "It woke Dad up. Otherwise he'd still be sleeping. I dressed him, gave him breakfast...he was fine. The kids are ready. I even drank some tea myself. We don't have to leave for five minutes. I must have forgotten something." She laughs, her morning departures timed down to the wire.

"Thanks, honey," I say as she gathers up lunches, kids, her brief-case and purse and disappears out the door. A pot of beans simmers on the stove, filling the kitchen with its spicy smell. Julian sits quiet-ly looking at the classified section of the newspaper viewed, like my last night's vista, upside down.

Rested and relaxed, I make myself a cup of tea. Beiçola and the baby are still asleep. The house is silent, except for faint sounds of children playing in the schoolyard beyond our garden.

For the first time in a week, I had an unbroken five-hour sleep.

But even though I slept, the solution to my desperate exhaustion feels naughty, disloyal, unspeakably sad. Not sleeping with Julian signals a terrible, unretrievable loss.

More than half my life I have slept beside him. Our bodies pressed together in bed is as natural as breathing, lying next to him has given me the most profound feelings of safety and rest. Sleeping with Julian is home, the place I belong. No longer sleeping with him makes me anxious. Despite losing a normal, active sexual life, de-spite all Julian's drastic impairments, we still had the deep comfort of sleeping in each other's arms. Now, this too is lost to Alzheimer's.

But sleep deprivation's frenzy forces me to accept this newest ad-justment: sleeping without him, alone on the couch. At least this postpones the dreaded placement decision.

Julian looks up from his inverted newspaper and smiles, obvious-ly innocent of this latest change in our life. His emotions rise from the present moment without abstractions, regrets from the past, worries over the future. He gazes at me with sky blue eyes.

"Oh, it's beautiful, wonderful, moonderball," he says.

Checking Places

"The decision weighs on me, presses in from all sides."

Traveler

ON A THURSDAY MORNING in early October, pulling up to Rosener House, I glance at Julian. His mouth droops. He looks worried.

"No...no...not again...not so long...so big...."

I stop the car and unbuckle his seat belt.

"Julian, this is where you go on Thursdays. I have work to do. You have friends here. There's 'sweeties' and music. You'll have fun. I'll pick you up. I always pick you up."

Too much talk, I know. Maybe part will sink in. Probably I launch into so many reasons because my anxiety shoots up when he objects to going. I need him to go. He must go, more days and longer. Otherwise I cannot take care of him.

"Too much...," Julian says.

He means he doesn't like when I pick him up late, and I have been coming later. Something has shifted. I need more time away from him. I pay less attention to what he wants, no longer make so many decisions favoring him. Out of a sense of self-preservation, I am beginning to attend to what is better for me.

I walk around the car and open Julian's door. He sits motionless, looking sad, making no move to get out as I chatter cheerfully.

"Your friends are here. There's music. It's time for coffee. Don't you want coffee? A sweet?"

Julian stares straight ahead. As I take his hand and pull him out, he resists slightly but he stands and looks sadly at me.

"You...where...?"

"Julian. I need you to go here." I appeal to his poor, diminutive, shrunken, little reason. "I have to work. I have to visit my sick father."

"I'll go with you...."

"Julian. It would be boring for you to come with me to visit Daddy." A lie, of course. He would love to hang around with me. "Everyone goes someplace each day. This is where you go on Thursdays."

I don't say this is now where he goes every day.

Taking his arm, I lead him into the dining room filled with folks sitting at round tables where juice and coffee are being served. We have arrived later than usual; I was so tired, I slept in. At 5:30 this morning I gave Julian a second sleeping pill so I could get a few more hours' rest.

Julian stands in the dining room looking at me, his eyes pleading, "Don't leave. Don't leave me." Then he begins patting his crotch.

"Let's go pee." I take his hand and lead him to the bathroom. Outside the men's john, he looks forlornly at me.

"When...how much...?"

"I'll be back. I'll pick you up this afternoon."

"When? When?" He moves towards me.

I kiss his cheek and say matter-of-factly, "Have a good day, darling. See you later," the same tone I use with Rasa when I leave the house. My heart is thumping as I turn and walk out, leaving Julian poised on the threshold of the men's room.

In the hall, I pass Carol, who smiles at me.

"We've an unhappy camper today," I blurt, nodding in Julian's direction.

"Go. He'll be fine. These moods pass. He's okay here, you know."

But I don't go. I stand in Carol's calm, reassuring presence, needing to talk. It has been a hard month: tormented nights; increased agitation and confusion by day; more help needed in dressing, eating, going to the bathroom. The dramatic shift in Julian's language: few coherent phrases now and the drastic increase in unintelligible speech.

"Do you have five minutes?" I ask.

Immediately she motions me outside, beyond Julian's view, looks at me and waits.

"How's Julian doing?" I begin. "Do you see changes?"

Carol nods. Her pale blue eyes look compassionately into mine. Around her neck a brown carved figure of a squat, pudgy man hangs from a soft silk cord with a brown tassel dangling below.

"Yes," she says slowly. "The staff has mentioned that Julian is different."

My face registers alarm. I am afraid they will ask him to leave just when I most need him here as long as possible.

Carol tells me what the staff sees: increased wandering and pac-

ing, more agitation, more anxious talking, little ability to focus or concentrate."

"It's the same at home," I murmur.

"But we can handle it," Carol adds. "It's not a problem here. He's not angry. The increased Mellaril improves his behavior; he doesn't try to leave. Lots of staff can listen and talk to him."

My shoulders sink with relief.

"I need him to be here." Then I tell Carol about my dad's surgery and that while Julian is at Rosener House, I must spend part of each day going to the hospital to visit my father.

"I can't visit my dad and chase after Julian too!"

"Julian is fine," she repeats. "You pick him up later and drop him earlier. Lengthen his day. You need this time without him. He's okay."

"If Julian weren't here, I'd have to send him away," I blurt. The words pop out. I have never said this out loud before. "Friends ask if I've looked at nursing homes and I always answer, yes, but it's not time now. But you know," I pause, "...not that I'm ready to do it, but I think about it more and more."

Carol stares at me, concerned.

"I'm glad we looked at nursing homes last summer," I continue. "I know what's out there and where to go when I need it."

Carol nods, her soft eyes widen as I add, "But I'm nowhere near ready to put him in one of those places."

"I've seen some other centers that might be appropriate for Julian one day." She chooses her words carefully. "Would you like to come with me and see some more?"

"Well...okay. I guess I should check out alternatives to Julian's living at home. Last summer when we looked, it seemed like abstract research." My voice wobbles as I murmur, "But now I'm closer." I am entering new terrain.

"I'll arrange for us to visit some Alzheimer's units next week," Carol says.

"I have better questions now," I tell her. "Last summer I thought I would never place Julian as long as he knew me, and wasn't incontinent or combative. But these may be the wrong criteria. I'm no longer sure I can wait until then."

My eyes tear up. "Carol," I say, quickly changing the subject.

"There's some good news too. Julian's going away next weekend to that Alzheimer's respite camp, the one you told me about. He'll be gone from Friday afternoon until Sunday."

"I'm glad for you," she says, opening her arms and giving me a hug. You deserve that break.

"Julian's fine here now," she reassures me. "You go and leave him today as long as you like. We can handle his problems."

Between Rosener House and Sequoia Hospital, I drive slowly along residential streets, gazing at lawns strewn with brown, crinkled leaves, at pumpkins set on doorsteps, at black cats and ghosts taped to front doors. Inhaling deeply, I slowly exhale, trying to calm my rapid breath, to relax myself and gather new strength before visiting Daddy.

Stepping out of the hospital elevator, I spot my father shuffling down the hall folded over a walker, a physical therapist supporting his elbow. Wearing a pale blue hospital robe and his own blue tennis shoes, my dad concentrates as the therapist coaches each step.

Overtaking them, I call out cheerily, "Hey, Daddy. Great to see you on your feet!"

"He's making good progress," the therapist says. "We walked all the way to the nurses' station."

Back in his room, my father settles into the high chrome bed. "Tomorrow we'll go to the rehab gym where they have carpet, gravel, curbs and steps," he says. "I have to learn to walk on different surfaces. Life's not all a smooth hallway, you know."

Is he being precise or philosophical, I wonder, pondering whether my dad intends his metaphor.

"No, it certainly isn't," I say, plucking dead leaves from his African violet, pouring fresh ice water into his glass.

~

It is nearly closing time when I finish swimming and return to Rosener House to pick up Julian. On the bulletin board by the door, a large flyer announces a memorial service for Woody, the elderly man who moved to residential care just a few months ago, the one whose wife planted the Japanese maple in his honor. My eyes mist over as I jot down the place and time of the service.

How quickly Woody slipped from Rosener House to nursing home to death. Will Julian slip this fast, too, I wonder. But Woody

was eighty-two and frail, Julian's only sixty-four and strong, I console myself.

Then I notice a bulky envelope pinned under the flyer, with my name on it. Puzzled, I take it down and tear open the seal.

Inside lies Carol's necklace, the pudgy carved man nestled in the brown silk tassel, the one I admired earlier this morning. A handwritten note on blue paper says:

"This is a Chinese traveler's good luck charm. I collect them. Take it and wear it. With love, Carol."

As I hold the carved figure, tears leak from my eyes. My finger traces the pudgy curves of the Chinese man and strokes the silk tassel. Carol's gift feels like her blessing, for this solitary traveler alone in a strange scary land.

Respite

TONIGHT, WHILE Julian sleeps, I print JULIAN DAVIDSON in bold black letters with a marking pen on sheets, towels, and all the clothes listed on the flyer, *"What to bring to camp."*

On the pile I toss his fluorescent pink baseball cap with "Stanford" on it, not because I want people to know he is from Stanford, but because its bright color can be easily spotted in the woods if he wanders off.

Tomorrow Julian goes away—to a special camp for Alzheimer's patients. For the entire weekend, he will be in someone else's care. Other people will deal with him at night and respond to his jabbering while I go with friends to the beach. How ecstatic I feel anticipating two days on my own, knowing Julian will also have fun and be safe.

At midnight I stuff his clothes in a duffel bag so he won't see them. If he sees any clothes on the bed, mine or his, he will undress and put them on, and if he sees a suitcase in the hall, he will open it and take everything out, so I must pack in secret.

At one A.M., I finally creep into the dark driveway to load our bags and jackets into the car, and by one thirty I climb in bed beside him, so excited I can't sleep, thoughts racing over which books to take to the beach.

Just as I'm falling asleep, at 2:15 Julian wakes up, muttering, jerking the bedspread, pulling the blankets this way and that. But I just leave him sitting in the dark.

"G'night Julian. See you in the morning," I say kindly and pad down the hall to my quiet study with the spare bed where I have slept the past few nights, ever since I first left to sleep in the living room. Leaving Julian is easier now. Often I begin the night with him, but once trouble starts, I simply leave. He doesn't seem to notice I'm gone and I fall instantly asleep between my own cool sheets.

The next morning, when I return to help Julian dress, he steps into his purple shirt and tries to pull it over his pants.

"Oh," he says, as I bend down towards his ankles, unbutton it, remove the crumpled material and hold the sleeves open for his arms. "Of course."

He follows me around as I try to pay bills and tidy up before leaving. He shows me dust plucked from the carpet, brings me three pine needles he picked off the grass. Always he is jabbering.

When Beiçola comes to the kitchen, I ask, please will he take Julian for a walk so I can get ready, and while they are gone, I whirl through my tasks: water the garden, fold laundry, call my father to tell him we'll be there soon. By the time they return, I am exhausted.

~

Before driving to camp, we visit Daddy, who is now home from the hospital, back at Woodacre Knolls. I haven't yet told Julian about camp, for if I tell him too soon, he will get confused. I can only tell him about one activity just before it occurs.

When Julian and I enter Dad's room, he is sitting in his recliner dressed in his navy jogging suit, his bandaged leg stretched out on the footrest, his thin gray hair combed neatly back.

"It's great to see you in your own clothes!" I am so relieved to find him out of the blue flowered hospital gowns, looking more like his regular self.

Tables on each side of his lazy-boy are piled with papers.

"I'm sorting Medicare forms," my dad says. "The damn bills beat me home from the hospital."

Julian wanders about fingering Daddy's jade snuff bottles, a ceramic parrot, his Chinese vase. Before Julian drops anything or disturbs Daddy's papers, I shove a *National Geographic* in his hands and

settle him on the couch. Keeping an eye on Julian, I tell Daddy about the Alzheimer's camp and inquire about his leg.

"A visiting nurse comes daily to check on me and change the bandages," he says. "And Jean and Bharat are coming tomorrow to take me to the drugstore and the bank."

Relieved that Daddy will have company while I'm gone, and that my sister and brother-in-law share in Daddy's care, I kiss my father goodbye and pull Julian to standing.

"Bye, Julian." My dad says simply, and waves. "Have a good weekend, honey."

Back in the car, I feel freer already, and finally tell Julian, "Something nice is happening soon. You're going to camp. Nice people… music…singing…hikes. You'll eat and sleep there. I've brought your pajamas. I'll come get you Sunday…you'll have fun."

Maybe from my barrage of words, some will sink in. He looks at me as I speak, smiling, his eyes wide open.

"You? You?"

"No. Not me. It's special for you."

He looks happy and apprehensive at the same time, knowing he is going somewhere different without me. As I follow the directions to camp, Julian's head drops forward into sleep. Driving along a winding road, past a reservoir, past brown hills studded with oak trees and madrone, I wish he were awake to enjoy the scene.

"Look, Julian…it's beautiful."

But his eyes stay closed. So I enjoy the drive alone. One of the hard lessons I've learned in living with Alzheimer's is to enjoy things by myself. Another tough loss—letting go of sharing special times with Julian.

Finally we turn past an open gate, cross a creek and pull into a parking lot where a sign declares, "Camp Costonan."

California live oaks spread heavy branches over low brown buildings set around a clearing with a volleyball net. Grasping Julian's hand, I head towards a crowd on the wooden porch hearing a cheery voice call out, "Julian, over here. Hi, Julian. I'm so happy to see you!"

It is Beth Logan, the camp director, the genius behind this amazing venture, the bouncy woman who loves Julian, the one who invited us to the cocktail fundraiser last spring. I can't imagine

organizing a weekend of "fun" for twenty demented people like Julian, but knowing Julian might have a good time eases my guilt over wanting to leave him.

Squashed in her hug, he giggles and grins.

"Oh, it's you, you, you." He points his finger, happy to see her, seeming to recognize her from when she interviewed him at our house and from the fundraiser.

Beth directs me to give his medications to the camp nurse, then take his belongings to the bunk house. Lugging his duffel bag, we enter a long building with ten blue- and white-striped mattresses on rusty iron frames, five on each side, like an army barracks.

"Pick a bed," says a woman standing by the door. Two beds nearest the bathroom have suitcases already on them, so I spread Julian's sheets on a middle bed as the woman whisks Julian off to the bathroom as if she has known him for years.

Immediately I stop worrying how he will find the toilet at night. He is in their hands now. I make his bed, hang his clothes on hooks, while a cool breeze wafts through window screens. I feel as if I'm a young mother, leaving a child at camp, except Julian has no idea where he is or what is going to happen.

Hand in hand Julian and I walk to the dining room where folks sit around a long table cluttered with papers, glue, yarn, paper punches, and staplers.

"Come join us," a young woman calls out. "Come make a wallet."

We watch her help a man with wispy white hair and arthritic hands punch holes in a paper square and thread yarn through them. Then the counselor turns to Julian. "Do you want to make a wallet?" she asks with a friendly smile.

He looks at her blankly. He has no idea what a wallet is, and anyway, nothing on the table resembles one. "Come," she continues. "Do you want blue paper or green?"

She holds out two papers, but when he doesn't choose, she hands him the blue piece. "Let's fold this in half." Julian looks wildly about, never focusing on what she is doing. But he sits down and as she tries to engage him, I slip away, hoping to make my departure casual, saying, "Bye Julian. I'll pick you up Sunday. Have a good time."

My heart thudding, I turn and walk out, feeling like I am abandoning my immature three-year-old at a pre-school overnight.

Driving down the dusty road to the freeway, an enormous mix of anxiety and relief hits me. Will Julian be okay? Will he wander off? Will they really provide a one-to-one buddy for each camper as the flyer described? Will he feel angry, scared, abandoned?

Suddenly I spy a yellow striped umbrella shading a small wagon with a sign "Hot Dogs."

It is 2:30. I already ate lunch and am headed to a beach-house with friends where I am sure to have a gourmet dinner. But a hot dog stand on this remote country road is so incongruous. Since leaving Julian, my stomach's been churning, anxiety or hunger, I can't tell which. Impulsively, I screech on the brakes and swerve onto gravel, feeling deliciously, crazily, free. I haven't eaten a hot dog in years. My mouth starts watering.

"I'll have a hot dog with onions, pickles, mustard, relish, the works," I tell the vendor. I want this hot dog. I need this hot dog. I must have this hot dog to silence my growling stomach. And, to celebrate the beginning of my weekend away.

As I bite into the steaming sausage, it bursts open, releasing its spicy flavor...comforting, silly, soothing. My weekend begins.

~

Driving back to camp on Sunday afternoon, my mind drifts over images of crashing surf, walking on wet sand as gulls flapped and screeched overhead, napping whenever I pleased, reading and writing. Best of all, talking with intelligent, interesting, articulate friends.

In the dining room where campers gather, the nurse reports that Julian was up both nights, pacing, muttering, unable to sleep.

"Just as he does at home," I explain. She gave him three times the usual Mellaril dose, but nothing quieted him. Only too well do I know what she means. The look on her face acknowledges that she understands how miserable our nights at home must be.

"Hi, Ann, Julian was great!" Beth calls out. "He's sure a character! Such a live-wire!"

An invincible optimist, she winks, and tells me that on Saturday morning he attached himself to her, following her around constantly jabbering in her ear. Then she hugs me and whispers, "I don't know how you stand this full-time!"

"But how was he?" I quiz her. "Seriously, was he really all right?"

"He certainly required constant individual attention," Beth explains. "But with our full staff, we managed him well. He seemed to enjoy the activities, especially singing and eating!"

At a long table seated with other campers, Julian appears engrossed in his afternoon snack. When I approach, calling, "Julian, Julian, hello darling," he turns, jumps up and hugs me. His eyes have dark circles under them from lack of sleep otherwise, he looks fine.

The campers' luggage is piled by the door. On top of Julian's duffel bag are a flower pot he painted; a blue paper "wallet" the counselor undoubtedly made; and a certificate with a gold seal. A decorated blue border surrounds Beth's handwriting:

"Awarded to Julian Davidson," it says. "The most *poetic* and *spirited* camper at the Family Caregiver Alliance respite camp."

"Poetic" is Beth's adjective for Julian's prolific, creative gibberish, "spirited" her word for his boundless energy and activity. What an expert Beth is at re-naming difficult behaviors and casting them in a positive, even humorous, light.

Poetic and spirited: certainly a unique way to describe Julian. If only I could view it this way in the middle of the night.

As I drive home, Julian immediately falls asleep exhausted from camp. The hot dog stand is still parked at the intersection, but I drive on by, anxious to get home to check on my father, put Julian to bed and ready myself for busy Monday. The weekend's calm recedes like a frothy wave sliding out to sea as my mind churns over all that I must do tomorrow.

Woody's Service

A FEW DAYS AFTER the respite weekend, as I dress for Woody's memorial service, the telephone rings. It's Daddy's visiting nurse.

"I'm calling about your father," she says. "His foot is badly infected. He may have to return to the hospital."

"But he was doing so well. I thought his leg was getting better."

"Yes…at first his foot was pink and healthy," she explains. "But now his toe is yucky…a gaping, infected wound. There's not enough blood flow to heal the hole left by the removal of his necrotic toe. His blood sugars are stable, his insulin's adjusted and he's

comfortable. But his foot is turning red. The doctors may have to amputate his leg."

"Amputate his leg?!"

We have faced this before, but twice already, vascular surgery saved us. "Amputate his leg?"

"Amputate at mid-calf," the nurse says. "I'm not supposed to tell you, but that's what the doctor said."

"Does my father know?" I ask softly.

"Not yet," she says. "They'll give it a few more days before definitely deciding. They'll try pouring intravenous antibiotics into him first. But I just wanted you to know what's going on."

My heart pounding, I hang up the phone. Oh no, I think, poor Daddy. Just as we think things are improving, another blow comes. Not amputation.

~

An hour later, I find myself slowly climbing the church steps behind a crowd of people in dark clothes, thinking of Woody, but mostly my father. Inside the church, stained glass windows reach towards a high beamed ceiling. Scanning the mourners, I spot Verna and Monica from the support group meetings and they motion me to sit with them in their pew.

I hardly know Sandy, Woody's wife, but I remember her wise, dignified presence in the meetings and admire her good common sense, her sorely tested loyalty and commitment, her humor.

Remembering her increasing exhaustion, the dark shadows under her eyes, her furrowed brow, I can hear her voice describing cleaning messes in the bathroom, how hard it was to pull Woody out of his chair, how she couldn't lift him when he fell.

Images of Woody spring to mind, a frail, stooped, white-haired man with thin pale skin shuffling about, just two years younger than my father. "Come sit down, Woody," the staff would say. A small figure slouched in a chair, his head dropped forward on his chest sleeping: that is how I know him. By the time Julian started Rosener House, Woody was beyond words.

Sitting with Verna and Monica, two other caregiver wives, I stare at the stained glass windows, watch light stream onto a ledge covered with flowers, wondering how close my dad is to the end of his life, how close Julian is to leaving home.

The minister, in royal blue robes, begins the service, saying that mixed feelings surround Woody's passing: sadness over the loss of husband, father, and friend, and relief that Woody's suffering has ended. He says that Woody is now in God's presence, up there in that "wonderful place," under the "sheltering wings of Jesus Christ." He speaks joyfully of Woody's being at peace, at eternal rest with God.

Even as an agnostic Jew with long-standing resistance to organized religion, I feel comforted hearing the minister's words. How soothing is this image of coming to rest in God's presence. I feel slightly jealous, as I resist embracing metaphors of comfort, Christian or Jewish. I don't, can't believe. I don't believe God planned Alzheimer's, or diabetic infected feet; I believe when you are dead, you are gone.

The minister asks the mourners to reflect on their relationship to God and I turn my thoughts to this, but I feel, as I often do in any religious setting, an outsider. As a Jew, I am forever outside Christian symbols. As an agnostic Jew, I am, for some unknown reasons, unable to embrace Jewish answers. From my youth, I have chosen to squirm in existential angst, willing to live with no answers, to exist in uncertainty and ambiguity. In some odd way, I am proud of this commitment to living without formal, structured knowing.

Still, I am comforted hearing the minister's words and know that Woody's wife, sons, family, and friends are comforted too.

When Woody's two sons come to the microphone, my eyes fill with tears. They speak of their father's life: his career in the Air Force in World War II, earning a teaching credential at Stanford after he retired. Hard to imagine the frail, stooped, mumbling white-haired man as a fighter pilot. But at the reception later, there is his photo: a handsome, young Woody wearing a helmet and goggles, grinning out of his plane's cockpit.

The sons speak of their father's integrity, his discipline, his helpfulness to others, his deeply held Christian faith. They struggle to get out the words without breaking down, saying what a wonderful model he has been. They praise their mother, who cared for Woody so valiantly over the long years of his illness.

I glance at Verna and Monica who are both crying. Like me, they have lived, for years, with agitated, confused husbands who, if they do speak, never make sense, husbands who need us to do everything for them: cook, dress them, wash and shave them, yet they are phys-

ically strong, healthy, handsome men. Tapping Monica's arm, I request a Kleenex.

In the pew behind us sits Ron, also from the support group, whose wife is now in a convalescent hospital. Every noon he goes to feed her. Ron also wipes his eyes.

What exactly turns on my tears? It isn't grief for Woody; I barely knew him. Unlike his family, I haven't lost a loved one. But, of course, I have lost a loved one: Julian. Probably, soon, I may lose my father too.

I am on this same journey of loss. Like Woody's sons, I may soon speak at a service for my father. He will probably return to the hospital, may have to have his leg amputated and Lord knows what will happen after that.

One day Julian may be stooped and vacant, like Woody, unable to rise from his chair. Like Sandy, I may have to put my husband in residential care, lock him away in a prison from which he will never return. One day, I, too, will be the widow at Julian's memorial service.

As the organ plays a final hymn and the crowd files out to a reception next door, I reach over and clasp Verna's hand, overcome with emotion.

"We'll be doing this one day, too," she says, dabbing her eyes, verbalizing my thoughts. As Monica leaves to sign the guest book, Ron says, "This was nice, but I'm not religious. I can't believe these words."

Standing in a long line waiting to pay respects to Sandy, Verna, Ron, and I talk haltingly, tears in our eyes, each of us thinking of our beloved spouse far along this Alzheimer's road.

Ron tells us his wife is bed-ridden and rarely speaks, but he feels she still knows him. Verna's husband, Newell, a strong handsome man in his early seventies, has been at day care five years, four more than Julian.

"Don't wait too long to place your husbands," Ron warns us. "Go look at places now, before you need it."

Verna and I exchange sad, wet-eyed glances.

Ron, who still attends the support group meetings, offering advice and suggestions, suddenly, now, looks tired and small.

"Are you lonely?" I whisper.

"I have friends," he says quietly. "Good neighbors to eat dinner with sometimes."

Of course he is lonely. I reach out and touch his arm.

"I'm thinking what kind of service I'll have one day," Verna says.

"Me too," I whisper, thinking, throat tight, about my father.

~

We reach the head of the line where Sandy stands beside her sons. I clasp her hands, look into her eyes; not knowing what to say, we hug.

"Thank you so much for coming," Sandy says in her gracious manner.

Somehow it doesn't feel quite accurate to say I am sorry; so I say how comforting the service has been, how movingly her sons have spoken. I tell her I admire her dignity, her good common sense.

"Woody's death was a blessing," she says. "It was what I prayed for. Woody is free. I feared he would linger for years like a vegetable. Now he's at peace."

I am learning a lot from Sandy, this good woman who goes before me. Verna, Ron and I examine photos of Woody placed on tables— pictures of him as a baby, a boy holding a fishing pole, the groom at his wedding, a soldier in the fighter plane. Then the three of us kiss goodbye.

Leaving the reception, I walk alone to my car, for unknown reasons, feeling calm and at ease. I have glimpsed the wide expanse of Woody's life. Alzheimer's consumed the long, slow end, but it did not define him.

I vow to hold onto the minister's words: this illness is only one part of a long life's meaning. So it is with Julian and me. Alzheimer's currently fills our days; sometimes it is all I see. But it is only part of Julian's story, only part of mine. My life will extend beyond my father's life and beyond Alzheimer's, though I don't know how. Woody's service nourishes and encourages the mourners, even a stubborn Jewish, agnostic skeptic, like me.

Back in Sequoia

THREE DAYS AFTER Woody's service, my sister calls to report on her visit with Daddy, who is back in Sequoia Hospital. She tells me that the surgeon laid it all out. "Amputate…or let nature take its course."

"Do it," my dad said, unwavering, choosing life, as he always has, despite his desperate losses of recent years.

Jean told Daddy what the doctor had said. "You'll have to leave Woodacre Knolls and move to a nursing home."

My sister understands, but tells me she doesn't think Daddy really heard the doctor, hasn't digested all he had said.

"It's Daddy's decision," I answer. "He has his wits about him. It's up to him."

"Yes, but what kind of life will he have in a nursing home?"

Images flood my mind, of convalescent homes my dad has spent months in, how eager he always was to leave. Would he adjust to living in a nursing home permanently? I think of him confined to bed or a wheel chair, sitting slouched over tied in a chair, left in some hallway with other chair-bound invalids staring at television.

"It's his decision," is all I can say. "I'm not going to talk him in or out of anything."

What would I choose if it were me, I wonder. A friend's uncle in a similar situation chose not to amputate and quickly died. Another friend's parents both chose to end their own lives in their late eighties, rather than decline in a nursing home. I think, too, of Julian's fate: perhaps spending years of his life in such a place.

"I can't choose for Daddy," I say again.

"He's already chosen," my sister says. "All he said was, 'When are you going to do it?'"

"Well, he can still have a life in a wheelchair," I offer meekly. "We could still take him out to dinner."

Immediately I imagine struggling to maneuver him in and out of a wheelchair and into a car, like when we took him to the Brazilian show. Weak as he now is and forever will be, I know his frail arms will never be strong enough for "independent transfer," those magic words, the ticket to a more normal level of living.

Here I go again...jumping ahead, I remind myself. Imagining a future which may or may not come is a waste of time. So well I know this: I have done it thousands of times. I am great at fantasizing life in a nursing home—bed-ridden, urine-smelling roommates; the monthly sing-along designed to cheer up the lonely depressed souls.

But one thing I keep learning is that what we imagine may or

may not occur. Much of what I lie awake worrying about never happens. Something else happens instead. So why waste good time fretting?

~

When I arrive at the hospital two days later, Daddy is sleeping, just as I saw him the day before, lying small and flat in the hospital bed, frail and diminutive, a wisp of a man.

His fine white hair is mussed up against the pillow. His glasses make his face owl-like, eyes staring out at the active world he is leaving. His arms thin: loose flesh hanging from the hanger of his bones. Hairless. What happened to the furry dark hair that covered the strong, warm arms which once held me?

Yesterday, when I tiptoed into his room, he also was sleeping, head rolled to one side, mouth open. I wrote a note on the white message board across from his bed, telling him I was eating lunch in the cafeteria and would see him later.

When I returned from lunch, he was sitting up, eating his. Not eating, exactly, but picking at a grapefruit wedge. He sat upright, propped by pillows, and waved when he saw me.

"Hi," he said.

I told him he had been sleeping when I arrived. Then I lifted the green plastic food covers, checking his plate and soup bowl. He had barely touched them.

We talked only chit-chat: the view from his window, his mushroom soup, what the kids were doing. After lunch he closed his eyes and wanted to sleep.

Today I write a similar note saying I will return shortly. Now, in the hospital cafeteria, I devour stuffed bell peppers, soft summer squash, bread pudding. Yesterday I ate Salisbury steak, spinach, and tapioca. I don't usually eat lunches like this. These are the comforting meals of my childhood. During these days of high stress and sleepless nights, tofu or salad simply won't do. I feed my anxiety as if it were hunger.

Back at the nurses' station on Daddy's floor, his nurse tells me, "Your father's foot has actually improved. The redness has receded from his ankle."

"Does that mean they might *not* cut off his foot?" I dare to ask.

"The doctors are still talking amputation," she says, "but they're

waiting to see what antibiotics might do." Maybe the weekend is coming, I think cynically, when nobody wants to operate.

Then suddenly I burst into tears. Tears roll down my cheeks as I ask if a social worker can see my dad to prepare him for surgery, for emotional support.

"Do you think he's scared?" I ask, wiping my eyes. "I'm sorry," I mumble.

"Don't say you're sorry," she says. "Do you want a tissue?"

Young, pretty, curly black hair, a maroon-flowered shirt. Soft-spoken and sensitive, she says, "You don't have to apologize for crying."

It is me who is scared. I am terrified of a fleshy stump. Do they just sew the skin together, like pulling the strings of a drawstring purse? What about pain? Real pain? And the phantom limb pain, of which I've read? Will he ever stand? Will he be a permanent invalid? "Permanent invalid"...what does that mean?

My mind spins off into whirlpools of projected fears.

The nurse hands me a box of Kleenex. "It's okay to cry," she says.

Wiping my eyes, I prepare to enter my father's room, resolve to be strong, positive and present, not to let my fears show. Or, maybe I will let my fear show; then, maybe, he could let his show too. But probably he doesn't want to give way to his fears. That's my way, not his.

I am old enough to understand he will do things his way, not mine. He probably won't explore, consider, vacillate and process decisions, like I do. He doesn't want to have deep meaningful conversations. He is eighty-four; I'm fifty-seven. It's time I knew this. He will make his own choices and die his own death.

Somewhere I read, "It's arrogant for any of us to think we know how anyone else should die. All we can do is be present for another to do whatever he must do."

Tiptoeing into Daddy's room, I look again at the big chrome bed. My father still sleeps—soundly, innocently, his head on the pillow. Now his white hair is neatly combed straight back off his forehead. I wonder if I should wake him, say hello, maybe tell him I love him. But I don't.

Deciding to let him rest, I update my note on the message board, telling him I have gone home and will come back tomorrow.

Daddy

SATURDAY MORNING around eleven, I call the hospital. The phone rings many times before my dad picks it up. Then he drops the receiver.

"Hello...hello...Daddy...Daddy...," I shout. The sounds of fumbling. Finally his voice answers, deep and slow.

"Daddy...hello...it's me, Ann. Did I wake you? Were you asleep?"

After a long pause, his soft voice says, "I'm so tired. I'm just so tired. Catching up on my sleep."

"Go back to sleep, Daddy," I say. "I'll come see you this afternoon. Sorry I woke you. Go back to sleep."

"Bye, dear," I think he says. I don't feel anxious. I just saw him yesterday morning and he seemed fine. My sister and brother-in-law visited him last night, too, and reported that he seemed stable. Jeff phoned him from New York, and reported that his grandfather told him, "I love you, God bless." The nurse even said his foot was better. I feel no sense of urgency.

So, Saturday afternoon, I amble in. Walking past the nurses' station en route to his room, I check the white board listing patients, room numbers and assigned nurses. "Suzanne" is written in large letters by my father's name. I decide to look for Suzanne and inquire about him.

As I head towards his room, a nurse steps out with a name tag saying Suzanne. "I'm one of Murray Gelber's daughters," I say, relieved to find her so easily. "How's he doing?"

"I'm glad you're here," she says. "I can't make out what he's saying. Maybe you can help me understand him."

With slight, but not overwhelming, hesitation, I enter the room. My eyes shoot immediately to his bed. There lies my father propped up, his small bony face against the pillow. His thin white hair sticks out on all sides. He looks dreadful: his eyes, wide open, stare fixedly up at the ceiling off to his right. His eyes are milky, the blue-gray color of his iris clouded over.

He isn't blinking. His mouth is open. He breathes easily, but he lies very still.

"Daddy, Daddy," I say gently. "It's me, Ann. Hi, Daddy. How are you?"

He mumbles something which I can't hear. I take his hand; it is limp and lifeless. I squeeze it, hold it, but feel no pressure of recognition, no squeezing back. I bend towards him and kiss his cheek, leaving my head near his lips so I can hear him speak.

"Daddy, how are you?" I ask calmly. "Are you okay? Are you in pain?"

Again he mumbles, a vain attempt to form some words. The nurse stands nearby watching him quietly. Then we go out and stand in the hall.

"What's happened to him?" I cry. "He looks awful. His eyes are glazed over. He isn't blinking or focusing. He's not really seeing. He doesn't respond. He looks just like my stepmother before she died."

The nurse looks at me and nods. "I see what you see," she says. "I'm glad you came. I was just getting ready to phone the family. Is there anyone else we should call?"

I tear down the hall to the public phone to call my sister. Jean's answering machine comes on. I leave a message describing Daddy's state and telling her to come or call, then call my dad's wife, Myriam, who picks up the phone. She was just leaving to come to the hospital; I say, "Make it quick."

Then I run back to my father's room. The nurse stands by his bed taking his pulse. His mouth is open, his lips look dry.

"Do you want water, Daddy?" I say. "It's hot. Are you thirsty?"

A mumbled, incomprehensible answer. I lift the water glass to his lips. He sucks, but the liquid rises only half-way up the straw.

"He can't suck it," I say, taking the straw out of the cup. The nurse holds his head and I raise the cup to his lips. He takes a swallow. On the second swallow, he coughs.

"Better stop," the nurse says. "It's going down the wrong way."

We settle him back on the pillow and step outside into the hall.

"How long has he been like this?" I demand. "Why didn't you call us earlier?"

Suzanne explains that she just came on duty at three o'clock. He was stable at two; the nurse on the previous shift noted nothing remarkable. He deteriorated in one hour.

"Can someone die so fast?" I hear myself ask.

"Yes," she says softly.

"How long can he be like this?"

"Hours or days."

"He's not having any operation," I observe stupidly.

"No, probably not," she says.

Panic rises in my throat like the mercury shooshing up the blood pressure gauge. Then it drops back down. I remember Elsie, Dad's second wife; Julian and I were with her when she died. I had been terrified before I entered her hospital room, summoned by a nurse in the middle of the night.

But an angel of a nurse, some anonymous nurse in the dark hours before dawn, paused a moment and sat with me, holding my hand, asking me what I was frightened of. She was Catholic, a nun. She wore a silver cross around her neck. "I've never been with a dying person before," I said. "I don't know what to do."

"Just be there," she said. "Just hold her hand; speak gently to her." This nurse gave me strength. Julian and I sat with Elsie as she died, looking exactly the way my father looked now. I learned something important the night Elsie died.

Now, alone in my father's room, I feel oddly resigned. Moments of fear, moments of grief wash over me. I wish my sister were here; she would want to be with him too. Mostly I feel calm. I will my father peace. With all my heart and all my soul, I will him a safe, easy passage.

I hold his limp hand, from time to time, speak softly to him. "It's me, Daddy. I'm sitting right here."

I keep worrying about my sister, hoping she will return home soon and get my message in time.

I squeeze Dad's hand, but he doesn't squeeze back. His cloudy eyes still stare fixedly off into space. His breathing is slower, but he breathes easy.

"Rest, Daddy, rest," I say quietly.

I sit with him about an hour, leaving the room only to go to the bathroom and anxiously phone my sister.

Two nurses return shortly before five to take his vital signs. They change his sheet. One props up his emaciated bony shoulder, while the other snaps on a clean blue-flowered gown.

"Mr. Gelber, we're changing your gown," one says. "Mr. Gelber...Mr. Gelber."

My father is motionless. No more mumbled response. His breathing grows slower: his breaths come farther and farther apart.

"Bring a stethoscope," one nurse says to the other. A nurse stands on each side of his bed; I stand at the foot. One takes his blood pressure, the other his pulse.

"Do you want us to do something?" a nurse asks.

"No," I say calmly. "No." I repeat what Dad told my sister and me many times, "No heroics."

The nurse presses the stethoscope against his neck. The other pumps the blood pressure cuff. I watch the mercury rise sharply, then fall fast. I don't know what the numbers mean; I only see the mercury sink. I watch my father's mouth which is now stretched wide open into the shape of an "o," like a choir boy singing. Maybe his mouth formed this shape when he was a lusty baritone singing "On the road to Mandalay...where the flying fishes play." I remember him standing by the piano with my mother accompanying him. "And the dawn comes up like thunder...."

He gulps for air. Then he inhales again. Then he is still. He just lies there, quiet, no longer sucking air in and out. His chest does not rise. The small lump beneath the pink blanket is still. He is gone. No pain...no struggle...no thrashing...no discomfort that any of us could see. He looks peaceful, like a tired old man asleep.

The nurse looks at her watch. "He's gone," she says. Tears well up and spill down my cheeks.

"I'm grateful...," I choke out the words, "...that he didn't suffer." It was the death I had prayed for, a gentle, easy passing. No agonizing death from neck cancer which he struggled with two years before. No amputated leg.

"One minute to five," the nurse says.

Then she asks, "Did you close his eyes?" I look at his eyelids. The thin delicate pink eyelids have closed. "No," I say. "He closed them himself."

The nurses go out leaving me alone with my father. I watch him...a tired old man asleep on the pillow. I fiddle with the bedding, smooth the blanket, fold down the sheet. I hold his hand and kiss it. I kiss his forehead, press my cheek to his. Motionless and warm still, he lies quietly, a tired old man asleep.

~

I sit in a blue chair beside my father's bed, watching him, watching over him. His hand, limp and lifeless, grows cool. I smooth his hair, pull up the sheet and fold it neatly down over the pink blanket. His face grows paler and whiter. His thin body lifts the blanket so slightly. How could his once-hefty body have grown so small?

Gratitude is what I feel, and relief. Gratitude that he died so easily, without pain or struggle. Relief that he won't have to deal with amputation and more deterioration after that.

I sit quietly with my dead father, seeing him at peace. Where is his soul, I wonder, where is "he," the age-old unanswerable question. Has his soul flown to the protective arms of the Lord, as the Presbyterian minister said just a week ago at Woody's memorial service? Is he in the "wonderful place—full of light and love," the comforting Christian images I just heard about?

I doubt it, especially as my father was an agnostic, non-believing Jew, like me. But, at this time of death, I see how profoundly appealing are these images.

Holding the hand of my dead father, I feel surrounded by enormous peace. An orderly comes in, a young man in a blue uniform, thick black hair, dark eyes. "I'm sorry," he says. "My condolences."

Then the hot tears spill from my eyes. "Thank you," I manage. "I'm grateful he died a gentle death."

The orderly stands respectfully, silently, at the foot of the bed, then leaves.

~

Around six, I hear voices in the hall and stand to greet Myriam and her son Alex. "He's gone," I say. "Peacefully. Gently. An hour ago."

Tears fill their eyes and we embrace. Silently I lead them into the room. "He's with your mother," Myriam says.

I tell Myriam I'm waiting for my sister to call. I know she would want to see him. I tell the nurse I have left messages, but that I don't know where she is, and that Daddy was stable when she phoned this morning. She has no knowledge that anything critical was going on. The nurse says we can stay until she leaves her shift. "No hurry," she says kindly. "Can I get you something?"

Myriam, Alex, and I sit in Daddy's room for nearly four hours. We sit in silence and in tears. They pray. I ask what Catholics pray and think. Memories flood us. We talk for three hours about my

father. Myriam tells me how much she loved him, how she will miss him, how much he helped her. Alex says what a fine man he was, how he respects him, how he thought of him as a father.

From time to time, I hold Daddy's hand. It grows colder and stiffer. I feel his forehead, experience a strong need to touch him, to check on him and see how he is, maybe, probably, to convince myself he is really gone.

His color changes slowly like a fading sunset. I can't really see the colors change, but when I look away and then look back, I see how his skin tone has shifted and muted. My father grows paler, yellower. The pink of life drains away and a waxy, yellow-white coats his forehead and cheeks. His forehead feels cooler and cooler.

I feel oddly comforted sitting in the presence of my dead father. Not ghoulish, not macabre. I feel I am the guardian of the shell of his body as his essence flows...where? A flash of something I read somewhere appears: Buddhists sit for many hours around a departed, believing it takes a long time for the soul to leave the body. True or not, it feels fitting to sit with him and not let him be whisked away.

Myriam, Alex, and I talk about my father, about things he did and said, about his good qualities and his difficult side. We tell each other how generous he was and how impatient; how devoted to family and how quick to anger.

We laugh at how he brought rolls of toilet paper to Myriam each time we went to her house for dinner. Always generous, but recently down to little money and no independent transportation, my dad brought her toilet paper collected from his board and care home, plus a stack of little plastic medicine cups she "could use in her beauty shop" whenever I drove him to see her. We speak of how much he loved my sister, brother-in-law, his grandchildren and each of us.

The nurse comes in and hands us cups of custard. "You haven't eaten anything," she says kindly. "Have you heard from your sister?" We have not. "I'm sorry, but you'll need to leave soon," she says, "...before my shift is over." We nod.

I want to stay until they take him away on a gurney, just as I have seen him being rolled away so many times for angiograms, X-rays, surgeries. Only this time he will not return.

"You leave first and we'll take him after you've gone," the nurse says. We nod again.

"I'm going out for a few minutes," I tell Myriam, wanting to give her time alone with him. When I return, she and Alex leave the room, my turn to say goodbye.

Tears fill my eyes. I lay my hand on his cold white brow and press my cheek to his. For the last time, I kiss his forehead. "Goodnight, Daddy," I say. Then I kiss him again. "This kiss is from Jean," I tell him. Then I add, "And this is from Bharat. And this from Julian." I kiss him twice more. Suddenly I find myself kissing him again and again...a kiss from Ben, Karen, and Jeff; from Beiçola, Antar, Celina, and Rasa. Tears sting my eyes. I squeeze his cold hand one last time and straighten the sheets.

Passing the message board across from his bed, I take the black felt pen and write: "Goodnight, Daddy. Sleep well. See you later... Love, Ann," just as I've written so many times when I've visited him in hospitals and he was asleep.

L'Chaim

THE NEXT SUNDAY, Ben opens our front door to let in friends and family for Daddy's memorial gathering. They squeeze onto the sofa, settle themselves on chairs and carpet while my sister bustles about, greeting folks. Bunches of carnations, chrysanthemums, and tiger lilies which Jean has brought spill out of buckets by the fireplace, awaiting the flower ritual we've invented to close our service.

I worry that Julian will disrupt the gathering, such as it is. It will be hard enough for me to orchestrate this afternoon and express my thoughts, without fretting about Julian. He has no idea what is going on; I'm not even sure if he understands that my father has died. Thankfully, Jeff, who flew in from New York, volunteered to take care of him while people speak.

With visitors packed around the living room, and Rasa and Celina in matching dresses sitting cross-legged at his feet, Ben clears his throat and welcomes people to our informal gathering. He explains that his grandfather, whom most know as Murray Gelber, but whom he calls "Coppy," was an informal man who would not have wanted a structured service. Listening to my handsome son, I'm impressed at

Ben's maturity, his poise, stepping into a new role, overtaking Julian as articulate spokesperson for the family.

"Coppy has always been in my life and always loved me," Ben begins. "As the oldest grandchild, I named him "Coppy," my baby attempts to say 'Grandpa.' 'Coppy' was a big improvement over the earlier version, 'Crappy,'" he says, and everyone laughs.

As Ben sits down, Julian begins clapping loudly, as if he is applauding a lecture or performance. Out of the corner of my eye, I see lanky Jeff, solemn-faced, grab his father's hands, gesturing him to shush, not an ordinary sight, watching your twenty-five-year-old son tenderly manage his father's disruptive behavior.

Then I stand, re-focus my thoughts and thank everyone for coming. Though my dad was not religious, nevertheless I read from Ecclesiastes. "For all things there is a season…a time to be born and a time to die.…" I tell them I chose this because my dad had a long life with many seasons: ups and downs, change and adjustments.

Sketching his life, I outline his career and tell of his three marriages, first to my mother, then Elsie, and later, Myriam.

"I learned many lessons from my father," I explain. "His career rose to peaks, which then fell. He lost two wives to cancer. Yet despite his many losses, he lived with courage, acceptance and resilience, looking optimistically towards the next task. I hope I've inherited some of this resilience from him.

"Daddy died peacefully without pain or struggle. He just stopped breathing and went to sleep," I tell them, and then quote Daddy's own line from the memoir he never finished: "'I'm not a famous person, just an ordinary guy.' "

Looking serious and handsome, my sister stands and introduces a Sufi quote from 1200 B.C. that Daddy read at our stepmother's memorial gathering over ten years ago, a quote that hung in her bedroom. Always needing to "frame things," Daddy framed copies for each of us after her death:

"Look to this day! For it is life, the very life of life…For yesterday is but a dream and tomorrow is only a vision, but today well lived makes every yesterday a dream of happiness and every tomorrow a vision of hope. Look well, therefore, to this day!"

Jean then explains that Daddy always wore a Navajo silver watchband and a silver and turquoise ring from his days in Arizona. Fight-

ing back tears, she reads a Navajo blessing, "In beauty he walked...,"
her words capturing Daddy's spirit. As she sits down, again Julian
bursts into applause, Jeff once again trying to silence the clapping
hands of his father.

Karen speaks next, her voice quavering, telling of Coppy's love
and generosity. "He gave elaborate gifts when he could. But these
last months, he gave us all toilet paper rolls and plastic medicine
cups taken from his retirement home." The visitors laugh.

"Coppy was open for a man of his generation," Karen continues.
"He accepted my African-Brazilian husband, when many grandfa-
thers of his age would not," she explains. "He always hugged Beiçola,
shook his hand and always said to me, 'Say hi to Beiçola.' Coppy was
a conventional man, though he did not have a conventional family.
He always showed generosity to the extent that he could."

While Beiçola gets up to speak of his father's death in Brazil this
summer, I am shocked to realize that our immediate family has no
fathers. Daddy's death comes shortly after the deaths of Beiçola's,
Greg's, and Bharat's fathers. Though Julian is alive, my children, too,
have essentially lost their father. My youngest son, Jeff, especially,
has no older man to help him, guide him into manhood. His father
has had Alzheimer's since Jeff was twenty, a crucial age when Julian
could have advised him and been a companion to him in ways I
cannot.

In his thick Portuguese accent, Beiçola describes his Hindu be-
liefs that while the shell of the body leaves, the spirit lives on, its es-
sence set free. Slightly self-conscious about his accent, he asks Antar
to help him read a prayer from the *Bhagavagita*.

Just as Antar begins, Julian shouts loudly and clearly, "No, you're
wrong!"

First I am embarrassed, but then amazed that, no matter how out
of it Julian appears, he still has flashes of insight, even though he can-
not express his thoughts appropriately. At some level, Julian under-
stands that Beiçola is expressing ideas that he does not, even with
advanced Alzheimer's, believe. People politely ignore Julian, though
I glimpse some smiles and hear a few chuckles as Jeff shushes Julian
and leads him away into the kitchen.

Still standing, Antar picks up a tattered *Robin Hood*, the book I
gave him for his tenth birthday, my father's copy, with dad's ten-year-
old signature on the title page: Murray Gelber, 1922. Beneath it is

my ten-year-old signature in 1948, then Ben's childish scrawl. At the bottom of the list, Antar wrote "Antar Davidson de Sá, 1994."

Taking us by surprise, not having asked permission, Antar suddenly starts reading the first page of *Robin Hood*: "In the reign of King Henry II, there lived on an estate near Locksley Village in England...." Oh dear, I think, how long will he go on?

"...like so many of the knights and nobles in that troubled age..." he steadily continues in a firm voice. But all the speakers so far have read; why shouldn't he? People smile, Coppy would be amused too. Mercifully, Antar stops of his own accord; his contributing *Robin Hood* seems somehow fitting.

Then Myriam tearfully says how much she loved him, how she will miss him, her sons adding that they admired and respected my father.

As they speak, my friend Betty, who works in nursing homes and knows many people with dementia, takes Julian by the arm, walking up and down the hall with him so Jeff can return and listen to what friends are saying about his grandfather. A woman from the travel agency where Dad last worked praises him, saying that he saved their business.

By the hour's end, a spirited picture of my dad emerges. His long, complex, rich, not-altogether-easy life is celebrated, including his anger, which many speakers acknowledge.

Gazing at photos of Daddy on the memorabilia table, I recall my father at different ages, not just the frail eighty-four-year-old who died.

Finally Ben invites guests to stand, choose a flower from the buckets, and create a bouquet on the dining room table. People surround the table, silently placing flowers in a huge green and red Chinese vase that belonged to my dad.

A bountiful arrangement emerges from the spontaneous placing of flowers: yellow and rust chrysanthemums, white tiger lilies, orange carnations. Then we bring cakes, cookies, and sandwiches that friends have brought, and reminisce about photos and mementos from Daddy's life: his beige Stetson from Phoenix, the black beret I brought him from Paris, a wooden gavel from when he was president of the Controller's Institute in Los Angeles.

The rest of the gathering goes by in a blur. I feel proud of my family for creating this occasion, for opening themselves and revealing

their feelings. I feel good, too, about my father. In our family's unique way, Daddy's long, rich life has been called forth, honored and brought into focus.

After the guests leave, Greg sets out a lavish dinner which he has prepared: turkey, stuffing, gravy, squash, collard greens, cranberry and pear relish.

I wish my father could be with us; he would like what people said, would enjoy seeing the friends who came. He would love eating Greg's dinner surrounded by his family, even though my father always "hated turkey."

"For Coppy," Greg says simply, raising his wine glass. "For Coppy," we echo, clinking our glasses one against the other.

"*L'chaim*," says Julian, clear as can be, touching his glass to mine. "*L'chaim*," we repeat Julian's words. "To life...*l'chaim*."

Yortzheit

MY FATHER'S BEEN DEAD two weeks already and the memorial candle has burned out. I miss the light glowing on the dining table as I pass, especially at night. A warm glow shone beside photographs of him at various ages that I placed on the table after the memorial gathering.

"Who's that?" Antar asks today as he whirls through the dining room, pointing to a large picture of Daddy in a cap and gown graduating from high school.

"Coppy, when he was eighteen," I say.

"It doesn't look like Coppy."

"People look very different at different times in their lives," I say. "It's hard to imagine how old people looked when they were young."

"My grandfather and my great-grandfather died," Antar declares. "One was sick and one was just old," he observes, running to the kitchen to get himself a snack.

Curled, crinkly flower petals lie on the tablecloth. It's time I removed them. Shall I buy another *Yortzeit* candle even though a week has already passed? No traditional rituals for this secular agnostic family. Yet, I still feel the need for comfort.

Julian now wears my father's shirts. Yesterday my sister and I

began going through Daddy's things. We couldn't bear to dismantle the pictures, artwork and knick-knacks that decorate his room, so we started with things that didn't show, leaving the appearance of his room intact. First we sorted clothes.

Old, worn items we put in bags for Goodwill; better trousers and jackets, I took to the American Cancer Society used clothing shop. But shirts, sweaters and coats that either Jean or I had given him, or we especially liked, we each took home. I chose six shirts and two wool cardigans I thought might look good on Julian.

For the past week, Julian has worn one of my father's shirts: a maroon, beige, and blue plaid; or a gray and brown checked; or a turquoise and blue flannel plaid that looks good with his jeans.

Odd seeing Julian in my dead father's shirts. At first, I liked it. But then it made me sad. Daddy should be wearing his clothes, not Julian. It suddenly feels wrong. Part of me feels comforted, but part of me feels now Julian is the old one.

Julian wears my dad's tan wool cardigan sweater, too, with cable knit stitch. My dad always wore cardigans as he didn't like to pull sweaters over his head because of his stiff arm and the tracheotomy opening from his neck cancer, which never closed. But Julian has never worn cardigans. He wears Shetland wool, solid color, simple pullovers.

"Dad looks old in Coppy's sweaters," Karen says this morning when Julian appears in the kitchen wearing the latest inherited out-fit. "He looks like an old grandpa."

"Well, he is an old grandpa," I say.

But she is right. Julian does look older, his hair and beard definitely grayer. He bends over now as well, shuffling when he walks. He has a tentative look about him, seeking me out wherever I am in the house and standing near me.

My friend Joan sent me photos of our last trip to the mountains just a month ago, in September—when Joan, Julian, Ben, Greg, and I went together to the Sierra. In each picture Julian hunches near me. In one, I'm holding his hand leading him up a trail while he hangs back looking hesitant. In another, he stands near me beside Lake Winnemucca, looking fearful while I grin broadly, feeling ec-static that he managed to hike here one last time.

"Yes, he is an old grandpa," I repeat, remembering Joan's photos.

Maybe I should let Julian wear my dad's shirts, but not his cardigans. Julian looks old enough as it is. His own pullovers suit him better.

But, of course, what clothes Julian wears is not the issue. Funny how I start thinking about my father and my thoughts shift over to Julian. It is all about loss. Accepting, losing, and letting go…of these two major men in my life.

"I've been working on letting go for a long time now," I told my brother-in-law on the phone last night. "Julian's had Alzheimer's for over five years. I've worked hard at saying goodbye, inch by inch. Maybe that's partly why I was already prepared for Daddy's death. Long ago I accepted his fragility; I already, mentally, let him go, even though I tried to stay present for him all the way to the end."

Still, I miss him. I miss him every morning when I bring in the newspaper. My breakfast ritual for several years began with opening the paper: rubber band on the doorknob, front section for me, Peninsula section for Julian to carry with him to day care, business sections on top of the refrigerator to take to my dad.

Now, I reach for the business section and my father appears before me: sitting in his brown recliner at Woodacre Knolls. He wears one of his plaid shirts and a matching wool cardigan. His thin legs are stretched out on the chair's leg rest, one bandaged foot in the blue medical boot with the Velcro straps. Dad always sat in that chair. I always walked in his room, looked immediately left to his chair in the corner, called out "Hi, Daddy" cheerily, and handed him the business sections.

This week I think of my father each morning when I sort the paper. As I put the business section directly in the recycling bin, a pang of sadness hits me.

Maybe I won't put my dad's cardigans on Julian. But I will keep them. Maybe I will wear them myself. Maybe I will buy another *Yortzheit* candle and keep the flame glowing a while longer.

John's Visit

IN EARLY NOVEMBER, the phone rings: a man with an English accent says hello. It is John Bancroft, a colleague of Julian's, calling

from Indiana, where he just moved with his wife and baby to head the Kinsey Institute. He and Julian were well-known scientists in the field of sexuality research.

A psychiatrist working for years in Scotland, John ushered Julian into human research in 1979 when Julian spent part of his sabbatical in John's lab in Edinburgh. Later this week their society—the "Quad-S," Society for the Scientific Study of Sex—will meet in San Francisco, and John is calling to ask if he can come see Julian.

"Sure, John, that would be nice...." I hesitate. "But I must tell you that Julian has changed."

"I know he won't be the same," John says kindly. "I expect him to be different."

"Yes, but he's gone downhill a lot in the past few months. It will make you sad to see him."

"It's okay. If it's all right with you, I'd like to come visit you both."

"He can hardly talk," I explain. "He processes very little. Most of what he says doesn't make sense."

During the silence on the other end of the line, I feel John quietly nodding.

"But I think he'll recognize you. He won't know your name, of course, but he'll sense that you're an old friend."

~

It is with some slight hesitation that I pick John up at a drug company near Julian's day care center where he has been consulting. Driving to meet him, a blast of sadness hits me. I don't often think these days of the man Julian used to be—my smart husband, my witty companion, my best friend.

A friend asked me recently if I still grieved over losing the man Julian was.

"Not anymore," I told her. "I was a basket case for the first year," I said. "But not now. I've already accepted that I have lost him."

Later, I realized I hadn't been completely honest. It is too painful to even think about, so I usually don't. Thinking of Julian's decaying brain, his lost language and evaporating intelligence is devastating. Staying involved in daily tasks and the events of living keeps me present. Just getting through the day is hard enough, but it is not true that I don't think about what I have lost.

John's phone call brings this all back. Knowing the Quad-S is

meeting in San Francisco and Julian is not there, knowing so many of our friends and professional buddies are gathering, awakens my feelings of loss. His old life, our old life, continues and we are out of it.

When Julian's students and colleagues phone or write, two feelings surface. I'm glad that they think of us, that they still respect Julian and care about him; I'm sad because I am reminded of the life that is gone. Getting postcards from friends at scientific meetings in Scotland, Majorca, and Cape Cod last year—all places where we would surely have traveled—is bittersweet.

~

John Bancroft stands outside the drug company in his dark suit and tan raincoat, looking professorial and British, his hair and beard a little grayer than when I saw him two years ago at the Asilomar conference.

There, Julian was honored at a formal banquet for his outstanding contributions to the field of sexology research. Three years into Alzheimer's Disease, Julian could still behave properly and appreciate the significance and sentiments of the event, even though I had to write his retirement speech and John had to read it for him. Now, John's eyes shine with emotion as we embrace.

Sitting in the car before driving to Julian's day care, John turns to face me and asks solemnly, "How much have you heard about Rosie?"

Rosie is his new baby daughter, born nine months ago, just before he and his wife moved to the Kinsey Institute in Indiana.

"Well, I got your beautiful birth announcement." I smile, trying to recall if I sent a baby present or not.

"She has a limb defect," John says.

My heart gives a thump. "A limb defect? What do you mean, 'limb defect'?" I manage to say.

"Rosie was born with a tiny partial foot hanging from just below her knee."

Tears spring to my eyes: images of this tiny girl with no foot, no lower leg. Then a vision appears: Rosie wearing an artificial leg and skiing, as Robert Kennedy's son, who had his leg amputated years ago, learned to do. Questions flash forward: will she have lovers? Will she marry? All this floods me in milliseconds following John's announcement as I stare silently into his face.

He explains that they learned about the limb defect when his wife

had an ultrasound examination four and a half months into the pregnancy. He describes their initial despair, their agonizing adjustment to this fact, their fear that something else would be wrong. He tells me that Rosie is beautiful, smart, wonderful, the joy of their life.

"We've learned a lot from Rosie," John says, "about how to be better people."

I look at John, a lump in my throat. "Rosie will be a marvelous girl," I say. "She has two sensitive parents to help her and give her strength."

John takes a picture from his wallet and hands me her photo: a grinning bright-eyed infant with wispy blond hair. "She's already crawling and pulling herself up to stand on her artificial leg," he says. "Her little foot just tucks right into the prosthesis."

As we drive to the day care center, our talk shifts from Rosie to Julian. "Seeing Julian here will make you sad," I warn again, leading John into the dining room, where three white-haired women stare out the window, one cradling a rubber baby doll. Julian is pacing around on the far side of the room as I walk over to embrace him.

"It's you, it's you," he says irritably. "Finally!" His forehead wrinkles into a scowl.

John stands quietly behind me. "Your friend John is here," I tell Julian. I told him this morning that an old friend would come to visit. "Good," he said then, though I don't expect him to remember that now. I step aside and John comes forward.

But Julian can't focus on John, can't seem to see him. Often these days, he cannot locate the face of someone standing right before him.

"Here's John. Here's your friend John," I repeat. "John's come to see you."

"Hello Julian, my friend," John says in his British accent. Just two years ago, John toasted Julian at the Asilomar international conference and Julian enjoyed it. Now Julian looks straight past John. He can't find his face. Sad and embarrassed that Julian does not respond, I unpin his name tag and we amble out to the car.

"It's easiest if we go for a walk," I tell John. "Walking is easier for Julian than sitting and talking."

We drive to Lake Lagunita on the Stanford campus. The lake is empty this time of year, honey-colored grass filling the shallow

bowl. We pass deep green California live oaks and bluish-gray euca-lyptus, colors sharp against a cloudless sky.

Together the three of us plod along the dusty path around the lake. Julian is silent. John and I chatter on, trying to acknowledge and include Julian, but he makes no response.

Julian is much less aware than just two and a half months ago when Ray Rosen was here. Then, Julian recognized Ray and tried to respond. Now John and I fall into awkward silences. I hold Julian's hand; sometimes John takes his elbow. Julian's face looks sad, his mouth set in a straight line. Does he even know John is here? Is he sad because he can't talk with his friend? Is he embarrassed having John see him this way?

"He used to be happy," I say. "Even two months ago, he looked happier. He smiled, sang, whistled and laughed."

I tell John about our current problems: the sleepless nights, the restless pacing at day care, the powerful medication Julian takes to decrease agitation and help him sleep.

"Some drugs affect facial expression," John explains. "These tran-quilizing-type drugs relax facial muscles and a person's face can lack expression. Julian may not really be feeling sad. His face may just look that way."

John's explanation makes me feel slightly better. After our walk, we drive home for a quick cup of tea before John catches the train back to the city. In our kitchen, Rasa Lila toddles about, bringing John a plastic cup, a toy cow, and her favorite mouse book. She must be just a few months older than his daughter Rosie.

John and Rasa sit on high stools at the counter looking at mouse pictures, while I fix tea and Julian wanders aimlessly, silently, about the kitchen.

Sadness floods me. I want Julian to pour over graphs with John, want their voices to talk animatedly about science—their next projects, the textbook chapters they each are writing. I long to hear the words "testosterone hypothalamic implants, posterior median eminence, supra-collosal chiasmic nucleus," words I've heard ban-died about my kitchen for thirty years.

Rasa perches on the stool at the counter munching a cookie, while John, Julian, and I sit at the table drinking Typhoo tea. Con-versation is minimal. I feel uncomfortable chattering on with

Julian's friend in Julian's presence when he can't join in. John and I exchange news about our children.

When it is time to go, John draws me in his arms, hugs me long and close.

"You're doing a wonderful job," he says. "I'm proud of you. Call me anytime you want to talk." He hands me a Kinsey Institute card on the back of which he writes his home phone number.

En route to the train station, we dash into a bookstore where I buy *Goodnight Moon,* a present for Rosie, and *Operating Instructions* for John's wife, a journal account of Anne Lamott's first year with her newborn son. I explain the title to John: "The baby came without operating instructions."

Driving home after dropping John at the station, I picture Rosie standing bravely on her new little artificial leg. She will go skiing; she will have boyfriends. Then come images of Julian's friends gathering at the Quad-S conference, delivering research papers, talking science, enjoying the camaraderie and intellectual exchange, and I feel again stabbed by longing and sadness.

None of us gets operating instructions, I think, nor any blueprint for what lies ahead. We have to invent them as we go along. Nowhere in my growing up and my education did I learn how to live with a demented man. John's saying he was proud of me perked me up like a shot of adrenalin; his hug sustains me as I drive back to cook Julian's dinner and put him to bed.

Hold

A WEEK AFTER John's visit, Carol calls from Rosener House. She wants to see me this morning when I bring Julian, to talk about his problems at day care.

My heart thumps hard as I dress Julian and drive him to day care, where he disappears into the dining room for his coffee and Danish. Hesitantly I walk towards Carol's office, afraid of what I will hear.

"Julian's been trying to leave in the afternoon," she states simply. "He's hostile when the staff tries to bring him back. He swung at Dave and hit him. And he's been touching other participants.

"That's the big concern," she adds gently. "He goes up to people

and squeezes their arms. Yesterday he gripped the elbow of an elder-
ly woman with a walker and bruised her. Her husband was very up-
set when he saw the bruise. We can't let this happen."

I sit stiffly in a chair by her desk, twisting a Kleenex.

"He touches our kids at home too," I confess. "Sometimes he puts
his hands around their throats. He doesn't really hurt them, but they
get scared. We can't leave him and the kids alone together in the
same room. The other day he suddenly swatted Celina on her
behind."

"That's a love pat," I told Celina who looked hurt and bewildered.

"How do you know it's a love pat, Gramma?" she asked, uncon-
vinced.

"The problem is," Carol continues, "we can't let him touch peo-
ple like that. I'm worried. I've thought about you for three nights. If
he does it again, we'll have to put him on 'hold.'"

"'Hold'? What's that?"

"It means he'll have to stop coming until you sort out medica-
tions with his doctor. Maybe the Mellaril could be increased. Or
you might try another drug."

"Not come to Rosener House?" I swallow hard.

Carol knows we're in a crisis. Julian has changed drastically in the
past two months. He understands little speech. Most of what he says
is unintelligible. He can't focus on anything. We never get a full
night's sleep. He needs more help in bathing, dressing, eating.

Carol knows that day care stands between living at home and
residential placement. Julian is not appropriate for in-home care; he
is too strong, active and mobile. I couldn't provide all the stimula-
tion and personal interaction he needs. I simply can not, will not,
care for him at home if he can't come five days a week to Rosener
House.

Tears sting my eyes.

"I'm not in good shape." The words tumble out. "I'm really
stressed. My weight has shot up. I've never weighed this much be-
fore. I stuffed a box of Ritz crackers in my mouth last night. Pure
anxiety. I wasn't even hungry. My blood pressure's up. I've never
had trouble with blood pressure before."

Carol nods.

"I'm worried about you and Julian," she says softly. "Get Julian's
doctor to adjust his medication. If he squeezes someone again—

especially a frail person on blood thinner who bruises easily—he'll have to go on 'hold.'"

My mind races to our recent weekends: long terrible days trapped with Julian, inventing ways to fill time. Trying to stay calm as he follows me around the house, standing a few feet away, constantly talking.

"I've tried to imagine myself in your shoes," Carol says. "I don't know what I would do."

Her words touch me like a giant pat on the back. She understands my despair. She is not afraid to linger with me for a moment in this terrible space.

I look into her soft eyes. "Thank you, Carol." A numb feeling creeps over me.

"But the good news is that I've seen people pass through similar crises and improve. They found drugs that helped them."

Carol tells me of a "particular gentleman" who was on the verge of having to leave. His wife was frantic. She wore a beeper for two months so the day care could call her to come get her husband if he became unmanageable. But they found the right drug; he is manageable now.

"This crisis may pass," Carol reassures me. "But I want to tell you what's happening so you can do something before anything worse occurs. If he goes on 'hold,' I won't be able to help you."

I hear her loud and clear.

Leaving Rosener House, I drive straight to the nearest pay phone to make an appointment with Julian's neurologist. Next week is the soonest he can see Julian. That done, I sit in a bakery drinking a hazelnut decaf, mulling over yesterday's support group meeting.

I didn't say one word, unusual for me. I felt overloaded. Too much is happening too fast. But others talked. One woman, who before has always been cheerful, said how sad and lonely she feels. She described the long, interesting life she'd had with her husband.

"I miss him so," she cried. "We were always excited about some new plan. We had so much to discuss. Now...nothing. I'm in my sixties. What do I have to look forward to? Only worse."

My heart nodded agreement.

Another woman said her husband put three socks on each foot. I remembered Julian last week putting eight, yes eight, socks on each foot. His swollen feet looked like they had been heavily bandaged

for terrible burns. Once these Alzheimer's brains start an activity, it is hard for them to stop. Perseveration is the technical word for this behavior.

Yesterday, Woody's widow returned to the group for the first time since his memorial service a few weeks before.

"He's in a happier, better place now," she said stoically. Good for her, I thought; she is lucky to have the comfort of faith.

After each comment at the meeting, I could have said "Ditto," could have related versions of my own. But I hadn't the strength. No energy to console Woody's widow or to encourage the wife longing for her husband as he used to be. I understood all too well.

Looking around the room at other spouses, mostly white-haired, in their seventies, I was struck again by the age difference between us. I am fifty-seven, surely too young to be here. What am I doing surrounded by these "old age" issues? What has happened to the active middle age years I expected? Twinges of self-pity gripped me. But what does age really matter? Sadness hurts no matter how old you are. Immersed in my own sorrow, I could summon no upbeat words to offer.

Now, sitting in the bakery, I can find no solace, no way to lighten my gloom. All I can think to do is finish my coffee. Plod on. Take Julian to the doctor next week and try to adjust his meds. Find help on weekends and some way to sleep. I put down my cup and exit the bakery; if only the doctor can improve Julian's behavior, quick, before Rosener House asks him to leave.

Thanksgiving

MONDAY MORNING before Thanksgiving, around eleven, just a week after my talk with Carol, she calls again, telling me to come get Julian. They can't handle him. He goes out the front door and is hostile and belligerent at staff who try to bring him back. Ironically, his neurology appointment is scheduled for this very afternoon.

Filled with dread, I pick him up and take him straight to the neurologist who, after hearing my story, changes his meds. That night at bedtime I give him the new sleeping pill, Ativan, hoping, praying that it will calm him down.

But all night I am up with him. He never sleeps. He paces around in slow motion looking like a gorilla, knees slightly bent, torso leaning forward, arms dangling straight down from his shoulders, head jutting out. He stands motionless in this posture in the middle of the living room. Or, he drifts in slow motion, as if he were walking under water, pushing against a great pressure all around him. At times he climbs onto the bed and crouches frozen on hands and knees.

He will not, or cannot, lie down. If I manage to get his body down on the bed, he holds his head stiffly up off the pillow. He will not/cannot lower his head. For twelve hours he doesn't speak a coherent word, only mumbles. He does not respond to anything I say. In horror I watch him shuffle about the bedroom like a stoned zombie.

Suddenly he takes out his penis and urinates in the middle of our rust-colored carpet. "No, no! Julian, no!" I scream, but he never hears me. There is no stopping him, no getting him to move to the bathroom.

Karen wakes up and comes to my room. Together we watch his rigid zombie dance.

"I can't believe this, Mom," she cries. "I can't believe this!"

For two minutes I lean against the door jamb and cry. Then I get a sponge and the Woolite carpet cleaner and spray sweet-smelling white foam over the dark spots on the rug.

"Are you sure you're okay, Mom?" Karen repeats. I nod and she goes back to her room. "I'm feeling weak," she says. I know she has to sleep or she can't work in the morning. I also know she can't bear seeing her father like this.

Realizing I can do nothing but let this dreadful "sleeping medicine" wear off, I climb in bed and lie stiffly on my back under the covers watching Julian. Tonight, I cannot go in another room and leave him alone. Ape-like, he alternates between standing motionless and shuffling in slow motion. Red numbers on my bedside clock creep slowly forward: two...two-thirty...three-thirty...four... five. Finally gray light peeps in through the split in the curtains.

The Ativan will eventually wear off, I am certain. But seeing him like this sends shudders up my spine. Unbelievable that Julian could become this silent, frozen, ape-like man. Deep down I imagine him like this forever: inaccessible, non-human. Maybe he will be like this in later stages of the disease.

Tuesday morning comes. I've been awake all night. Julian continues his zombie shuffle until the gray light eases through the curtain and through the narrow window above my bed.

To wash away this eerie night, I take a shower. Julian begins to respond to my voice, mumbling a few words which I can now make out. He allows me to undress him and help him into the shower, which refreshes him, too. We muddle through our breakfast routine.

Julian, my Julian, what there is of him anyway, slowly returns. In the kitchen he eats his granola and banana and at long last, he smiles. After finishing his tea, he nibbles at toast, then his head drops forward into sleep. No wonder. He has been in the grip of an Ativan demon all night. Finally he is released.

I phone Rosener House to describe what happened and to ask if he should come.

"He's exhausted; I think he'll just sleep," I tell Carol. I could keep him home, but I have a full day already planned.

"Bring him," Carol says. "But leave a number where you can be reached."

Sure enough, before noon she calls and says again, "Come get Julian." My heart sinks, but I am not surprised.

When I arrive, Carol meets me, averts her eyes and says briskly, "And don't bring him tomorrow. We have a hundred and thirty people coming for Thanksgiving lunch."

I feel banished. But I understand, of course; I know Carol hates saying this. Partly I am disappointed because I was looking forward to their holiday party. But mostly I feel terrified that Julian is being put out. Is this how it will be? No day care, sleepless nights?

Avoiding eye contact with the staff, I lead Julian to the car at high noon. Now what? What am I supposed to do with him for the rest of today, all day tomorrow, on Thanksgiving, and the long, unstructured weekend after that? Karen, Beiçola, and the children will be gone for four days. A black cloud envelopes me. Of course I can get through this, but I am afraid.

That night I phone several friends, saying that Karen and crew are away for the Thanksgiving holiday, Ben and Greg are visiting his family in South Carolina, Jeff is in New York. "You must feel abandoned by everyone," one friend says. Another says, "Call any time if you need me." A third says wisely, "It's okay if you feel depressed."

Hearing that I am alone with Julian, a young friend, Paul, imme-

diately invites us to his Thanksgiving dinner. Paul's father had Alzheimer's for many years and died recently in a nursing home; Paul knows what it's like.

I feel understood and supported even if I am alone. With the help of friends, I will get through this. Each day I plan an outing and each day take Julian for a long walk, looking forward to Paul's dinner on Thursday. We have abandoned the Ativan and increased the Mellaril, which calms Julian down. He is not as agitated, not so talkative. He doesn't stand by my side muttering constantly, "Come on, let's go. Come on, let's go."

Dragging Julian with me, I accomplish errands. Each midnight I leave our bedroom and retreat to my study. I don't know what Julian does at night as I hear him bumping around. From time to time, he opens the study door, perhaps looking for me, but I lie motionless, eyes closed, and he never bothers me. He probably never even sees me in the dark.

Each morning I see signs of his night prowling: our flowered bedspread heaped on the kitchen table; our beige afghan folded neatly on top of the toilet; the contents of my purse dumped on the coffee table. Julian has been up and active, but he has been quiet. He doesn't do anything dangerous. And I can sleep. Maybe this is how I will handle his sleeplessness, for now.

Perhaps in good nursing homes they let Alzheimer's patients wander at night, but they have nurses' stations and night staff to handle midnight prowlers. One woman in the Alzheimer's support group hired night attendants for three years. But she had a two-story house. Her demented husband and the attendant slept downstairs while she retired to her own space upstairs. If I hired an attendant, there would be eight people in our house. Where would an attendant sit? In our bedroom with Julian? In Julian's study?

I remember a chapter on sleeplessness that I read in an Alzheimer's book for caregivers: let them wander in a well-lit place, it advised. So, okay, that is what I am doing. I cannot make Julian sleep. And I cannot afford to stay up with him either. Maybe this solution, invented in desperation, will work.

Each day I try not to yell at Julian, or mimic him, or imitate his gibberish as I sometimes do when I am frantic and sleep-deprived and use that mocking tone that is so painful for Karen and the children to hear.

On Thanksgiving morning, Jeffrey phones from New York.

"How're you doing, Mom?" he asks.

Hearing that I am alone, and sensitive to the tone of my voice even across three thousand miles, he adds, "Maybe I should have come out?"

But Jeff was just here last month for my dad's memorial service, and plans to fly out again in January. "Thanks, Jeff, we'll muddle through," I say. "Dad and I will be all right."

I know he worries, yet there is nothing really that he can do, so I reassure him, walking that tight line between wanting to spare him my fears and protect him from my sad feelings, yet sometimes needing to speak my heart and get support. Sometimes I get weepy on the phone, which I know disturbs him. The balancing act between honesty and protection for my young adult children feels confusing sometimes.

Around noon, I maneuver Julian into the shower and dress him in clean tan corduroy trousers and his green velour shirt. With his freshly-washed, curly gray hair and his trimmed beard, he looks like a handsome, intelligent academic, not the needy, deteriorating Alzheimer's patient that he is. I suspect Paul will have alerted the other guests about Julian's illness.

At Paul's house, about twenty of his friends mill around the living room, while Paul bustles about the kitchen. The dining table is laden with bountiful dishes that people have brought; young men nibble guacamole and chat. Someone plays the piano. Pleasant young men I've never met before chat kindly with me and hand crackers to Julian. Over the buffet meal, no one seems to care that Julian eats with his fingers.

Julian and I are nurtured and accepted here in Paul's house, just as we are. Though I know no one but Paul, and feel somewhat alone, I am thankful to be surrounded by the bounty of accepting kindness.

Driving home, I give myself over to the gigantic task of caring constantly for Julian, alone and unaided for the coming two days and nights. How I respect the millions of isolated caregivers across this land who manage this gargantuan work. Mine will end when the kids return on Saturday night, so I fill the time as best I can.

Over this five-day period alone with Julian, the questions get clear. For the first time, I feel at the end of my rope. What kind of life is this? How much of myself do I give over to Julian? I can do it

for a few days, but not as a way of life. I feel pressed closer than ever before to the edge of the placement decision.

In bad moments, I think: this is it; I can't do this anymore. During tranquil periods, I think: this isn't so bad; I can manage. How can I put Julian away for the rest of his life? How can I commit him for years, maybe, to living confined to a shared room off a hallway in some nursing home, even if it did have a garden or courtyard and an activity schedule?

His world will shrink to that small sterile space. Now we walk daily—around our neighborhood and the Stanford campus, by the bay-lands and in the hills. We still eat Hunan noodles in our favorite Chinese restaurant, where the waiters who have been there fifteen years smile at Julian and bring him an extra egg-roll. We eat vegetable curry and samosas in a little Indian cafe near our house. Julian looks out the window at day care waiting for me to pick him up and asks after me constantly. When I arrive, he throws himself into my arms, hugs, and kisses me.

"Thank God you've come," he says. Over and over he kisses my cheek, my hand, my neck. How would he feel left in a nursing home when I didn't come each afternoon to take him home?

The other day as I emerged from the shower, he stared at me and said, "I just love looking at you. You're so beautiful."

Is this the man I am thinking of putting away? How could I? But as I pass hour after hour with him, leading him by the hand to the bathroom, pouring bleach onto his brown stained underwear, wiping his bottom, inventing errands to fill the day, counting the hours until bedtime, then, how could I not?

But I make it to Saturday night. Julian collapses in bed by his usual eight o'clock; Karen and Beiçola return after I go to sleep.

Sunday morning I awake to piles of dirty clothes, the churning of the washing machine, children's overturned backpacks, and sounds of quarrels, as they went to sleep late last night and are cranky.

Lively chaos fills the kitchen as Karen flies into action, cooking for the next three days. Four pots bubble on the stove: black beans, sautéing vegetables, lasagna sauce, tofu and leeks. Delicious smells emerge, steam sucked up into the overhead fan.

Rasa Lila runs across the linoleum, holding a toy cow in one hand and a plastic spoon in the other. Karen stands at the counter chopping carrots, while I sit at the table paying my bills.

Julian, who is ambling about aimlessly, suddenly walks to the stove and reaches his hand straight into the simmering sauce.

Before Karen or I can get to him, we hear Rasa's little high-pitched voice use three of the only twenty words she knows.

"No, Grandpa, no! Hot!"

Karen dashes to him, pulls him back to the sink and runs cold water over his hand.

Once more part of this noisy family team, I feel a wave of comfort and release. Tomorrow Julian can return to day care and I will have some time to myself, released from solitary confinement as both prisoner and jailer. For now, my Thanksgiving sentence is over.

Tired

UPSTAIRS IN THE coffee shop over Draeger's Market, I sip a *cafe latte*, waiting to pick up Julian. The miniature Christmas tree on the marble table fails to cheer me. Colored lights shining from a larger tree near the cash register and red tinsel strands looped from the ceiling only make me more depressed.

I am tired...so tired. My eyes burn in my sockets and all I want to do is sleep. In slow motion I move through a thick fog of sadness. Is this how Julian feels, moving like an automaton through his dreary days, a robot in Mellaril molasses? Is this how he feels ambling across the house, making his repetitive, snail-like, purposeless movements—picking at the straw place mat on the breakfast table, moving a paper from one counter to another, sipping air from an empty cup? Does he even know what he is doing?

For the first time in months, last night I slept six hours undisturbed. Still I am tired. Weariness hangs in my bones that one night's sleep cannot overcome.

The dreadful placement decision stares me right in the face.

So soon? So soon? Oh, please, not so soon. How did I suddenly hit this awful turning point I knew was coming? I am at it, I know. But not now. Not quite now. But if not now, then when?

This is why I am tired. The decision weighs on me, presses in from all sides. It will press until I decide. Maybe I'll feel better once the decision is made. Maybe this is the last struggle before giving up and resigning myself to placing Julian.

At seven-thirty last night, I helped Julian undress, shower, put on pajamas, brush his teeth, and take his pills; then I tucked him in bed. He seemed anxious to collapse, as well he should: he had been up most of the night before and had a full day yesterday.

Julian had a good day at Rosener House, the staff reported when I had picked him up yesterday afternoon. He was subdued, but awake. He hadn't hit anyone, made threatening gestures or squeezed any arms; apparently increasing the Mellaril works. He was in the television room when I arrived, actually sitting down, not pacing as he usually does. While he wasn't watching the Bing Crosby movie, at least he sat with the others.

When he saw me, he hugged and kissed me and jabbered happily as we walked to the car and then drove home. He seemed in such good spirits that I put Rasa in her stroller and we walked up to the playground behind our house with Celina and a neighborhood child. The two children pedaled ahead on their bikes while I pushed Rasa's stroller with one hand and led Julian up the path with the other.

At the playground, Celina and her friend rode around the school, while Rasa climbed up the slide, squealing with delight as she slid down. I gripped Julian's hand as we walked around the playing field, keeping my eyes on Rasa in case she fell. If I stopped to watch Rasa, or sat down, Julian would pull on my hand saying, "Come on, let's go."

Once home, I fed everyone black beans and rice and Celina and I sang songs in the kitchen until Karen returned. Then I started Julian's evening routine, thinking he would surely sleep.

At nine-thirty I disappeared into my study and shut the door. Climbing into a clean bed with the Lands End and Williams-Sonoma catalogues, I thought maybe with catalogue purchases I might manage holiday gifts, as I cannot bear to face a shopping center. I never saw or heard Julian until this morning.

But even though I slept, Julian did not. Karen told me this morning he had been up all night. She saw him at two-thirty, three-thirty, four o'clock and five. When she went to the bathroom she watched him amble through the house in eerie slow motion like a sleepwalker, bending over a table to pick at non-existent items, fiddling endlessly with the blanket he had wrapped around him.

In the morning I saw signs of his wanderings: toothbrushes on the kitchen counter, bedspread in the living room, my tennis shoes

on top of the toilet. No big deal to replace the items, but they showed me where he wandered and how confused he had been.

Karen drove him to day care after dropping the children at school, reporting that he had slept in the car, his mouth open, his glasses sliding down his nose. He leaned over so far, she said, that his head fell against her driving arm.

When they arrived at Rosener House, she couldn't rouse him. It took her ten minutes to get him out of the car and into the dining room. For the next ten minutes she sat in her Toyota alone and wept. I can only imagine her despair seeing her father like this, the father who adored her, who helped her through hard times.

Despite last night's sleep, I am still tired. My face feels frozen in a frown and I am shocked how sad I look when I pass a mirror. All I want is to go back to bed.

It is holiday time, Channukah and Christmas both. A gift list waits on my desk. I wrote a draft of a holiday letter which I will copy and send to far-away friends.

Heavy and weary, I have made appointments to visit residential facilities before the holidays. Last week I saw two and will visit two more this week, three the next. I must find a place, so when I'm ready for Julian to go, I will know where to turn.

How will I know when the time is right, I ask myself for the thousandth time, quizzing friends, social workers and staff in each nursing home I visit.

"You'll know," they say. "You'll know."

On bad days I think, yes, the time is near. On good days, I think I can do this a while longer. Eventually, bad days will outnumber the good, one social worker explained.

I am tired, so tired. My *cafe latte* failed to rouse me and these Christmas decorations just make me sad.

Now it is nearly time to go get Julian. Rosener House has asked me to take him away by three. But what to do with him for the next four hours? A baby sitter is at the house taking care of the children and Karen won't be home until nine. Raindrops slide down the windows of the cafe. Since he was up all night, Julian won't have energy to shop with me or do errands.

This much I know, the hours will pass until it is time to put him to bed. My *latte* finished, I spoon white foam from the edge of my cup, drag myself downstairs and out to my car to pick up Julian.

Checking Places

THE NEXT WEEKEND, Ben drives to our house from San Francisco. Though he phones often, his weekday job, the pressure of writing his Ph.D. thesis, and his heavy schedule make it hard for him to visit.

"Dad, Dad. Hi Dad. It's me, Ben," he calls to Julian, who ambles about the family room picking up newspapers and moving them about. Julian doesn't respond to the sound of Ben's voice.

"I'm over here, Dad."

Julian shuffles around, not acknowledging Ben, whose bright smile fades into sorrow. How it must hurt when his father stares right past him. Seeing Julian in this terrible state must make him feel helpless; it must tear Ben apart.

An hour passes before Julian focuses directly on his eldest son. Finally, a flicker of recognition flits across his face, the fleeting faint smile I knew would eventually come. I have learned to wait out these lapses of recognition. For Ben it came excruciatingly late.

"Dad looks terrible, Mom!" Ben says, appalled at the change in his father. Gone are the homecoming visits he's used to, when Julian delighted in his arrival, when two parents were joyful to see him.

"And...don't take this wrong, but you don't look so good either."

In low hushed tones, hoping Julian won't hear or understand, I tell Ben about the nursing homes I saw last week, how reluctant I am to send Julian away, how I worry about money, how exhausted I feel.

"It's not only time, Mom," Ben says emphatically. "It's past time."

He sits me down in the living room and we have a long talk.

"I've already lost my father," he declares. "I don't want to lose my mother too."

Tears cloud my eyes hearing his concern; I am not used to Ben advising me. He tries to convince me that Julian will be "better off in a simple, calm, structured, predictable environment," where he won't be "dragged off to day care, markets, errands, and outings." He feels it will actually be "*better* for Dad to live in a place designed for dementia patients, instead of at home," better for me and Julian too.

"Makes sense," I counter. "But that's all theory. You haven't seen these places. You've never seen what nursing homes are like."

And I describe the two I saw last week. Although the lobbies

were attractive and nicely furnished, the Alzheimer's patients lived behind locked doors.

"At the first home I visited, just inside a double locked door, a woman stood crying, 'Let me out! Let me out!' she yelled." I imitate her high-pitched cries. "'Why am I here? I don't want to stay here! Why have they put me here? I want to go home!'

"Nursing homes are like hospitals," I tell Ben. "Bedroom doors open onto long hallways with a nurses' station in the center."

I think of Julian on good days, when we walk together in the hills behind Stanford or along the marshes by the bay. Then I picture nursing home halls, with doors to a television room, a dining room, a small courtyard, maybe: Alzheimer's patients' entire world. Although Julian is obviously as impaired as many patients, at home he goes outside; he participates in shreds of "normal life." I *cannot* condemn Julian to living behind nursing home doors.

"I can't limit Dad's life to pacing a corridor behind a locked door!" I cry. "Pacing up and down like a tiger in a cage!"

Ben looks at me quietly with moist, sad eyes. He understands my dilemma, but his more dispassionate view sees, too, that it is time for Julian to go.

"Two other women stood in the hall crying," I add.

I remember talking with the admissions director in the lobby of one dementia unit, bombarding him with questions, which he answered thoughtfully while my heart wept.

"When I got home, I wrote down everything he said," I tell Ben. My gut reaction screamed out clearly. "At the bottom of my notes, I scrawled: 'NO!'"

"But you must keep looking, Mom," Ben says. "Dad can't stay here like this!"

"And I can't put Julian in the places I saw. I can't imagine him living in a dementia unit!"

Together we watch Julian moving slowly, aimlessly, silently about the room. I suspect Ben must feel guilty taking the position that it is time for Julian to go. He is the only one in the family to state this clearly.

How different my children are. Karen probably feels Julian should remain at home, despite the hardships. Like me, she has a strong sense of loyalty and believes that families need to care for their own. She helps daily in concrete, hands-on ways. Beiçola, com-

ing from his experience in Brazil, also believes responsibility lies with the family. Different relatives lived periodically in his mother's house when he was growing up.

But we three have slid gradually into our current living state. We have grown used to Julian's weird ways; maybe we don't see how extreme our situation is, whereas Ben sees it with fresh, outside eyes.

"I'll look at places with you, Mom," Ben offers. And we arrange to go together next week to see the Alzheimer's unit at the Jewish Home for the Aged in San Francisco.

A few days later, Verna and I make appointments to see two more dementia units nearby. Nearly at her breaking point, she is also looking at places for Newell. He is incontinent; he hasn't spoken for years; each night he paces constantly between refrigerator, bathroom, and couch. After supper, Verna guards the refrigerator, blocking him from compulsively eating and drinking everything in sight.

Yet he is a strong and healthy man. Like me, she feels her husband needs a large space in which to wander, but he must also be in a safe environment where he cannot escape.

Together Verna and I visit a local convalescent hospital with an excellent reputation. It is clean, well-staffed, attractive. They have several patients with Alzheimer's, the director tells us, and have set aside a room in which they organize special activities for their dementia patients. Inside, three frail, elderly women sit at a table crayoning in coloring books. No way could Newell or Julian participate in this. Neither of them sits down for more than a minute, nor would they engage in "crafts."

The second place we see resembles a comfy residence more than a nursing home. It is considered an "assisted living" board and care center, meaning that it has no medical or nursing staff. Residents tend to be higher functioning and more physically independent than in nursing homes.

At first, Verna and I are pleasantly surprised seeing the large living room furnished with upholstered arm chairs and couches. Lamps throw light on coffee tables with magazines and flower arrangements. But magazines and flowers hold no interest to Julian or Newell, even though they are a welcomed sight to Verna and me, and are no doubt comforting for the elderly residents.

Over tea at a bakery, Verna and I review our visits. "What's wrong with this last place," Verna says, "is that the front gate isn't secure. Our guys could escape easily and be off down the street before anyone knew."

"Yes," I agree. "And Julian would mess up that nice living room pronto."

"The first convalescent hospital wouldn't do either," Verna says. "Except for the main hospital corridor, there was no place for them to pace and wander."

"Julian would wander into people's rooms and dismantle nursing equipment," I add.

Exchanging impressions, we sort out the confusing terminology: "Convalescent hospital, nursing home, assisted living, board and care, three-tiered structure." We don't yet know what kind of place might work for Julian and Newell; but we're learning what to look for, what questions to ask.

Verna and I also discuss money, the huge cost of residential care. Neither of us has long-term care insurance, nor do we qualify for financial assistance. Medicare does not cover custodial care. Residential care facilities will cost around three thousand dollars a month, more than four times what we currently pay for day care.

⁓

The next day, while Julian is at Rosener House, I drive an hour to San Francisco to meet Ben at the Jewish Home for the Aged, which has an Alzheimer's unit well-recommended. Built years ago, the building is a tall stern structure, and looks "institutional." My heart sinks at the thought of "putting Julian in an institution."

But inside is a bustling, vibrant world, much like a large hotel complex. Julian would love the Jewish food, celebrating Jewish holidays, the familiar music and atmosphere of his youth. But how much would this cost? I haven't even discussed with Ben my financial worries. I think of the woman at the swimming pool, whose mother paid sixty-five thousand dollars a year. Would Julian die months after placement, like Woody? Or twelve years later, like the woman's father?

But what is not appropriate for Julian about the Jewish Home is that the Alzheimer's patients are on the third floor, secured behind locked doors. Julian would never go outside unless someone took him out the locked door, down an elevator, along corridors. Ben

agrees that the Jewish atmosphere is wonderful and that Julian would most likely respond; but he also agrees that living on the third floor in a large building simply won't work.

What I don't want is getting clearer. But I don't know what it is that I want.

Suddenly I remember the film I saw last summer at the Jewish Film Festival in San Francisco: a strong, moving, courageous film, *Complaints of a Dutiful Daughter,* by a local filmmaker, Deborah Hoffman, about her search for residential care for her own mother with Alzheimer's. Discouraged by many places she sees, Hoffman finally finds one that is designed especially for Alzheimer's patients.

Not knowing what exactly I am looking for, I decide to visit the facility in the film, the one Deborah Hoffman chooses for her mother. I want to see what a good Alzheimer's care facility looks like. Although Oak Creek is an hour's drive east across the bay, I make an appointment for the next day, just before the Channukah and Christmas frenzy descends.

This year, I have no heart for the holidays, though this is probably the last December Julian will be home. No one in my family acknowledges this sad fact. Everyone proceeds with holiday plans as if life were "normal," as if it were just another Channukah and Christmas, as if there will be more.

My wish is for our family to be quietly alone and to focus on our last holiday intact; I would like to cherish Julian and his ominous departure. In fact, the Alzheimer's Association newsletter suggests keeping holidays simple and cutting back on festivities. But I cannot get my family to understand my wish for simplicity. Instead, they invite visiting friends to our holiday meal, escalating the commotion which I predict will be too much confusion, if not for Julian, then for me.

Perhaps the pain of admitting this may be our last family holiday together with Julian is too great. Or, perhaps the children have already said goodbye to him and let him go. Or, perhaps they think a jolly crowd represents regular life continuing. Or, perhaps it is easier to just proceed as usual, as if nothing is wrong.

But I know Julian's days at home are numbered. I feel lonely and isolated when this isn't acknowledged, and crushed against this placement decision which is sapping my soul.

Doors

AS SOON AS I arrange to visit Oak Creek, I call my friend Betty, who evaluates board and care homes for the elderly. Betty has seen countless dementia patients in care centers and has offered to help. I value her experience and opinion.

"Of course I'll come," she says. And the next morning she cancels her Christmas shopping and picks me up for the hour's drive across the bay.

"I'd never want to put Julian so far away," I say in the car. "But the facility looked so good in Deborah Hoffman's film. I want to see what a good Alzheimer's facility is like, so I know what I'm looking for."

"There are many good homes," Betty explains. "But it's important to find the right place for Julian's particular needs. Julian's a wanderer. He's young. He needs freedom and space to wander safely."

"I just can't put him in a nursing home." I glance out the car window at brown hills studded with oaks. "At least not the ones I've seen."

"A nursing home is not the right place for Julian," Betty says. "It's not the right level of care for him now. He's healthy and doesn't need nursing. Many people in nursing homes are placed prematurely because there aren't other appropriate places for them to go.

"But small board and care homes aren't right for Julian either," she adds. "Most dementia patients live in small group homes. But he's too active for most of the homes I know."

Now we drive on the bridge crossing the bay, whizzing over gray, white-capped water extending north and south for miles.

"When we visit, it's most important to watch the staff," Betty continues. "See how they interact with residents. Listen to how they speak to them. Are they condescending? Do they talk baby-talk? Are they attentive, warm, friendly? Most families, at first, focus on the physical appearance of furniture and decor. But it's what life is like for the residents that counts. Look at what the residents are doing."

Exiting the freeway, we drive past grassy hills covered with trees. The approach pleases me, though I know Julian would never notice. Turning left down a steep driveway, I read the small white sign: "Oak Creek, Alzheimer's and Dementia Care Center," and my throat tightens.

Inside, a vivacious woman with curly blond hair introduces her-

self as Vickie. Unlike the marketing and admissions people I met in the larger homes, Vickie doesn't give a sales pitch; she simply shows us around.

"We have four different doors leading outside," she says. "People can go out one door whenever they wish and come in another."

Indeed, elderly people amble up and down the corridors, going in and out as they please. A patio-like garden wraps around the building. Residents can exit from several doors and wander to different sections outside: a paved courtyard area with tables, umbrellas, and garden chairs; an aviary filled with cooing doves; wooden flower boxes and a concrete walk. Beyond the fence, willows and oak trees covering the hillside bend leafy branches into the yard.

Inside, there is no long hospital hall. At the end of each corridor, a glass door opens to outside, which wouldn't leave residents feeling trapped. People mill about freely.

In the activity room, a cheery young woman tosses an orange balloon to white-haired people sitting at a table. Residents look clean, well-dressed. Some women wear make-up, lipstick, and jewelry; the men are clean-shaven and well-groomed. There are no unpleasant odors. Though many people are asleep, others laugh and smile. Caregivers, wearing blue tee-shirts, hug residents and joke around. Even though this is a residential facility for elderly people with dementia, the ambience feels light-hearted, jolly and friendly.

Back in Vickie's office, Betty and I settle into chairs facing her desk, which is covered with photographs of her children. A tall skinny man she calls "Grandpa" sprawls in the third chair munching a cookie. "Grandpa likes to hang out in my office," she says.

"How many people live here?" Betty begins. "And we're wondering about the ratio of caregivers to residents?"

"We're licensed for thirty-eight," Vickie answers. "Right now, we have thirty-six residents—one caregiver for seven people."

Knowing how exhausted I am taking care of just Julian, I can't even imagine getting seven people up, showered, toileted, and dressed before breakfast!

"How do you prevent people from going out the front door and wandering away?" I ask, remembering the times Julian escaped undetected from Rosener House and the two times we had to call the police to find him.

"A staff person always monitors the front door," Vickie says. "And

residents wear an ankle bracelet which triggers an alarm if they go out." She points to the small gray plastic strap around Grandpa's ankle. "Legally, this is not a locked facility. The alarm system works well. We haven't lost anybody," she says.

"Has the staff had special training in caring for dementia patients?" Betty asks.

Yes, Vickie answers, they are trained and skilled in distracting, diverting, communicating, and dealing with difficult behaviors. "We refrain from using strong medications to control behavior," she says, "unless it's absolutely necessary. Because this entire center is designed for dementia patients, we can handle behaviors that often can't be ignored at home or in day care centers."

The more Vickie talks, the better I feel about this place.

When Vickie asks me to describe Julian, I begin by saying, "He's healthy, strong, and young, only sixty-four. But he hardly talks sense. He jabbers constantly, he's up all night...and...and...." The words pour out. "I don't know how much longer I can manage."

"It's hard. I understand," Vickie says looking into my eyes.

I really only came to look, but it seems they have an opening, and Vickie offers me two weeks of "respite" to "try it out," beginning February first, just six weeks away. Julian can stay for two weeks while we see how it goes. This will let me rest, see how I feel and how Julian adjusts.

Betty and I exchange glances and, without even conferring privately with Betty, I find myself arranging with Vickie for Julian to come visit next week and stay for lunch. That way, Oak Creek can evaluate him and see if he is appropriate for their program.

"We also have a new facility near you, which will open soon," Vickie says.

"This seems like the perfect solution," I say. We can just try it; I won't have to "commit him." I can let them know later whether I'm ready for permanent placement.

Back in the car, Betty asks what I think.

"I feel pretty good about Julian going for two weeks to this place. In fact, I'm relieved."

"Oak Creek seems fine," Betty says. "I like what we saw: the physical environment, the stimulation and activity program, and, most of all, the attitude of the staff."

So, it seems I have a plan; in just over a month, Julian will go, at

least for two weeks. The respite offer lets me postpone the permanent placement decision.

"It's hard to say goodbye," Betty says in the car driving back from Oak Creek, voicing the thought that is sad beyond words.

At home, I mull over this new possibility. Am I really so near to "putting Julian away?" Doors closing, doors opening. The door of our thirty-five-year marriage may soon close; our life together is nearly over. Soon Julian and I may be separated by an institution's monitored door.

But closing this door also opens another. I glimpse a hazy freedom beyond: sleeping at night, going places I want to, doing things I'd like to do. A new life waits ahead. But fear swells up as I peek through: who will I be when I no longer care for Julian? Open doors, closing doors, locked doors: I am haunted by doors.

Of all the residential centers I have seen, Oak Creek, for Julian, is clearly best: four doors leading outside, caregivers laughing, joking, and hugging residents. Ron's advice at Woody's memorial service floats to mind: find a place before a crisis forces you to make a hasty decision.

To make sure that Oak Creek is as good as it looks, I phone Deborah Hoffman, the filmmaker who made *Complaints of a Dutiful Daughter*, which I learned has been nominated for an Academy Award for best documentary. When she returns my call, we talk for an hour, and she gives me a good report, saying her mother has been happy at Oak Creek for three years. She tells me to call her "Debbie," and to phone again if I have more questions.

Hanging up the phone, a burst of confidence hits me: I'll just do it. I'll find ways to pay for it; I can manage. But paying three thousand dollars a month means I won't be able to spend money in ways other families do in my position—a new car, trips abroad, helping children with downpayments on houses. Concerns over having enough money to pay for Julian indefinitely and leaving enough for my old age haunt me.

I phone Jeff in New York to tell him I've "found a good place for Dad" and that his upcoming visit is perfectly timed, as Julian will go there on February first. Jeff can spend a week at home with Julian before he leaves, which will also be helpful for me. Then I phone Verna to describe my visit to Oak Creek and my talk with Debbie Hoffman. Verna has also seen the Alzheimer's film and, encouraged

by what I report, says she will arrange to visit Oak Creek, too, after the holidays.

Where Julian will go for respite seems decided, but am I really saying, enough, I can't do this anymore? Am I really deciding he should live somewhere else? Am I declaring my life is intolerable and it's time now to think of myself? Is it really better for him to live in residential care? Better for whom? Better for Julian or for me?

The question hangs over me like a heavy cloud casting a black shadow: is Julian going to Oak Creek for two weeks of temporary respite or for permanent placement? Conflicting thoughts tumble around in my head like tangled clothes in a spinning dryer.

New Year

ON DECEMBER THIRTY-FIRST, at the last minute, our friends Bud and Judy invite us for an *early* supper.

"It'll be small," Judy says. "Just you and Julian, Paul and Ginny, and Eileen. We'll eat early. You don't even have to stay till twelve. Please come."

For decades, this little group of friends has gathered for New Year's Eve together. But this year, I told them I wanted to skip New Year's Eve. Julian crashes in bed by seven or eight. He could never stay up until midnight. Nor did I want to. I didn't feel festive; I couldn't bear to say, or hear, the words "Happy New Year," even though I know this is the last holiday that Julian will have at home.

So at our Channukah party ten days ago, I kissed them all and told them no New Year's Eve this year for us.

But Judy encourages me to come. The rearrangement of our usual plan, I suspect, is designed around Julian's needs. I'm grateful for her kindness. The food will be delicious, our friends jolly and gentle, so reluctantly I agree.

When Judy opens the front door, we are welcomed with hugs. Julian looks great, with his silver hair and freshly trimmed beard, wearing gray corduroy pants and his soft black and red alpaca sweater from Ecuador that my sister gave him. He looks handsome, professorial, intelligent, even. My heart weeps seeing him look so well and knowing what terrible shape he is in.

Before supper, Julian sits quietly by a crackling fire eating the water biscuits and brie I hand him. He never says anything, but he seems content here in Judy's familiar house in the company of friends.

At the dining table I sit next to him and place the soup spoon back in his hand when he reaches in the bowl to pluck out croutons with his fingers. No one stares at him. No one minds. After supper, as we linger over coffee and fruitcake, Julian retreats to the guest room and sleeps. This gives me a chance to relax and enjoy the party, but instead of feeling cheerful, I feel exhausted. Reserved and aloof, I curl my legs under me and lean into pillows by the fire, listening passively to the lively banter, lacking the energy to talk to anyone.

Around nine, when it's midnight in New York, we stand with champagne glasses in hand before Judy's television watching the glittery ball descend above the screaming crowd in Times Square.

Pretending we're there, we count down with the television: "Ten...nine...eight...seven...."

For the first time in thirty-five years, Julian's not with me. But he's nearby, just asleep in Judy's guest room, not far away. Next year where will he be? "Three...two...one...Happy New Year!" Then as the crowd in Times Square goes wild, we hug and kiss each other, as we always do. Everyone's hugs to me linger especially long.

Arms linked in a circle, we sing, *"...we'll take a cup o' kindness yet...."* My eyes fill with tears, especially as I watch Paul and Ginny, and Bud and Judy embrace, veteran couples, the way I always thought Julian and I would be. Tonight I feel uncoupled, standing next to Eileen, whose husband died two years ago. *"...for auld lang syne."*

When it's time to leave, Bud walks Julian and me out to the car, where Julian stands stiffly by the Toyota door. He hasn't the vaguest idea how to get in and sit on the seat. Eileen appears and the three of us shiver in the cold night trying to maneuver Julian into the car.

Each of us explains, demonstrates, cajoles, pushes gently, shoves...but Julian stands frozen, stiff, totally bewildered by the task of getting in. The night is dark, puffs of cold air escape from our mouths as we talk. After thirty minutes, Julian finally manages to crawl onto the back seat on his hands and knees. Bud and Eileen clap gloved hands together in muffled applause.

Once I start the engine, Julian's neurons somehow connect and he manages to flop over and sit properly. I have never seen car paralysis like this before, although I see a similar scene every night when he can't figure out how to get into bed, crawling on the blanket on his hands and knees, crouching, frozen, stiff, for several minutes trying to figure out how to lie down.

At home, as California's midnight approaches, I retreat into my messy study, which I haven't cleaned though I vowed I would. As January first, 1996, enters, I lie alone in my narrow bed, reading *The 36-Hour Day*, an Alzheimer's guide book for caregivers. It feels like the most appropriate thing I can do: facing the new year, reading the chapter on "nursing home placement."

~

January first: I awake in a lousy mood. Outside, the day is bright, sunny; inside, the house is a mess. Piles of newspapers and unpaid bills clutter tabletops. Julian wanders about picking up objects and moving them aimlessly from place to place. My whole life feels out of control. As I grumble around trying to decide what to do first, Eileen phones, asking if I would like to take a New Year's walk with her and our friend Jan. In the past four years, death, divorce and dementia have removed our husbands.

We meet at a coffee shop, greet each other with hugs. The two women kiss Julian, wish him "Happy New Year." He lets himself be hugged, but passively, standing subdued, joyless, stony-faced.

While my friends chat animatedly over *lattes* and pastries, I take Julian to the bathroom. He hasn't a clue how to use the toilet. Standing up, or sitting down, he is bewildered and does not pee. Unsuccessful, we return to the table, but as soon as we sit down, he jumps up and wants to go again. Five times I take him. The last time, he kneels down on the dirty restroom floor and begins scooping water out of the toilet bowl with his hands.

Outside, the sky is a cloudless blue, the air clean, cold and crisp. Jan and Eileen walk slowly, knowing Julian can't keep up.

He moves as slow as my father used to walk. Two paces ahead of Julian, holding his hand, I drag him along. "Walk faster, walk faster," I demand. But of course he can't.

The gap widens between us: Jan and Eileen are half a block ahead. I can't hear what they are saying. Julian's heavy weight pulls

on my hand, back to his maddeningly slow, shuffling pace. My legs long to walk fast, to stride into that bright day, to talk with my friends.

Instead, I haul Julian along by the hand as if he is a balky, recalcitrant, hundred-and-sixty-pound toddler. Just three blocks into our New Year's walk, I can't stand dragging this burden behind me.

Suddenly, I decide to leave, an out-of-character decision for me. I'm the kind of person who stays to the end of boring movies and finishes books I don't like. But today I holler to Jan and Eileen that this isn't working and I want to go home.

Tears stream down my cheeks as they hug me goodbye and say "Happy New Year," the words automatic, but I know they wish me well. Dragging Julian to the car, I glance back and watch my friends grow smaller as they stride quickly down the leaf-strewn streets.

～

At home I avoid Julian, hardly talk to Karen and the kids. I refuse to answer the phone when Ben calls to wish me happy new year. "Happy New Year"? What is that supposed to mean? I know everyone wishes me well, but all through the holidays, I've felt so alone, no one verbalizing the truth of what is happening: that on February first, in just one month, Julian will be gone.

The only positive thing I have to anticipate is Jeff's visit later in January. Throwing myself into cleaning my closet, I fill three bags for Goodwill and toss out two bags of papers while watching a stupid Danielle Steele melodrama about a young woman whose parents and fiancé drowned on the *Titanic*.

Miraculously, I don't feel depressed *all* day—just part of the day, and I ride right through it. I don't sink into gloom and despair—as I often did on New Year's, for what reasons I can't remember. In years past, I spent entire days in black, negative moods. Why did I waste all that good time? What was I depressed about back then when I had a bright, interesting, loving husband, however busy and distracted he was at the lab. When I had three exuberant teenagers, however exasperating and defiant they were. When I had a good job as a speech pathologist, however stressful and difficult it may have been at times. What was I depressed about then anyway, when from where I now stand, life looked simple and good?

It's curious how now, when the external realities of my life are so

bleak, I actually have learned how to pull myself quicker out of depression.

Cleaning closets helps me gain control of my wild house. I rejoice seeing each bag of unwanted clutter disappear. Instead of crying over my life, I weep for the people who drowned on the *Titanic*, jumping up to take out trash during commercials. There are so many commercials I can even vacuum the carpet between teary scenes.

By eight o'clock, the house is tidy and Julian sleeps. New Year's Day has passed, the new year begins. Alone in my bed, I relax into soft pillows and think of Jeff's pending visit, oddly ready for tomorrow.

Hare Krishna Shabbat

THE FIRST FRIDAY MORNING in January, the cleaning woman comes. As she vacuums the bedrooms, Beiçola and I work in the kitchen and talk.

He chops vegetables for a curry stew while I clean out drawers; my New Year's resolution is to reduce clutter. Rasa Lila sits on the floor by the cupboard removing saucepans and lids. Julian is at day care, the kids at school, Karen at work. Beiçola and I chat about what we think is important in marriage and how we feel these days in our new, big, extended household. I'm grateful for his company, feel part of a large family team, instead of being isolated with Julian.

The morning passes cheerfully. Work gets done. By the time Antar and Celina arrive from school, the house is tidy and clean: piles of papers and laundry are put away, a nice dinner cooked. After I fetch Julian, Beiçola and I take him and the kids to the park, where the children play on the slide and Julian wanders about until darkness descends and we return home.

On our Friday night table I place two Shabbat candles in the brass candlesticks and the braided challah on the breadboard, then go watch Beiçola and the children in the family room.

Beiçola has painted a pale yellow stripe down his forehead. He lights small candles in little brass oil lamps. Each child waves a stick of incense while Beiçola sings a refrain and the children repeat the verse. They laugh cheerfully—here with their Daddy in the darken-

ing room, the smell of incense mingling with the smell of curried vegetables coming from the kitchen.

Beiçola looks relaxed and happy. Antar sits on the floor, rhythmically beating a drum. Celina prances around ringing a bell. Rasa waves her incense and sings, "*Hare Krishna, Hare Krishna....*"

Beside me on the couch sits Julian, his head hanging forward, asleep. How sad his parents would be to see Julian, their once-brilliant, accomplished son, so impaired. Neither of his parents had memory problems, even at age eighty. They would also be saddened watching their great-grandchildren, Julian's grandchildren, chanting *Hare Krishna*.

The chain of Jewish practice has weakened with Julian and me. Our daughter has married an African-Brazilian man devoted to Krishna. I watch reluctantly, but respectfully, our grandchildren chanting in Sanskrit instead of Hebrew, listening to the Gita instead of the Torah, polishing brass deities instead of keeping the vow never to worship a golden calf. But they are Beiçola's and Karen's children, not mine.

A twelve-year follower of Hare Krishna, Beiçola takes his practice seriously: has not eaten meat or eggs for over a decade. He goes to the Krishna temple many Sunday nights, reads the *Bhagavagita* daily. Photos of his spiritual master hang in his bedroom and the kitchen. He chants special prayers and blesses food before he eats.

I respect his spiritual practice, having no formal spiritual path of my own. All my life I have rejected organized religion, though I still feel the ineffable yearnings that drew me to Bahai in my youth. But, unable ultimately to believe in God or prayer, somehow unwilling to make that leap of faith to believe in a God who sends holy words down through prophets, I remain an outsider to formal ritual, finding joy and transcendent feelings in the beauty of nature.

Yet, like people everywhere throughout time, I stand in awe of life's mysteries: who am I? How did I get here? How did the universe come to be? What happens after we die? How shall we live? There have been so many attempts to answer these age-old burning questions, to provide explanations and guidelines.

Oddly, tonight, I am comforted watching Beiçola show his children the gift of his faith. Julian and I didn't give traditional Jewish versions of faith to our children, because we followed no structured

belief ourselves. I couldn't because I never found a system I could follow; Julian didn't because he had rejected the Orthodox upbringing of his youth, though we both *feel* Jewish, and are Jewish, culturally and historically, and pay tribute to our Jewish heritage in our secular family life.

Watching Beiçola, I wonder about the similarity between laying Jewish prayer straps on your head and arms, and painting a yellow stripe on your forehead. Both seem to serve a similar purpose: expressing acknowledgement of a transcendent power. I also see Hebrew grace before meals, and Sanskrit offerings of food to the representation of a deity, as essentially about attending to spirit, being respectful of life's bounty, blessing food and living with appreciation and intention.

The television cartoons are turned off. The room looks beautiful in the candles' glow. The children sing and dance with their Daddy, who is joyfully teaching them practices dear to his heart. It makes me think of the ways Julian's father taught and shared his deeply held beliefs with his sons.

When Karen comes home, we move into the kitchen. I light the candles and say the blessing over light and bread, acknowledging our heritage, appreciating our beautiful family and the good fortune around us. Respectful of all spiritual practice, Beiçola encourages me to do anything Jewish.

A jolly meal in the light of Sabbath candles: laughter and talking, the kids mellow and happy. Julian eats quietly, seated at the head of the table, his family around him. He seems aware of the candles, the challah, the familiar symbols of Shabbat; I believe he enjoys them. My heart aches, knowing we have only four more Shabbats together, our family intact, before Julian moves to Oak Creek. Though I tell myself the plan is officially only for respite, deep down, I know he probably will never come home.

After eating pieces of berry pie, Julian and I drift off to our bedroom, looking forward to a restful morning. I love this Friday feeling…going to sleep in a clean, orderly house with tomorrow's open day before us.

~

On Saturday morning I wake to silence. Karen, usually up at 6:30, feeding and hurrying the kids to school, is still asleep, as are the chil-

dren. I creep out from my study to determine Julian's whereabouts. In bed? In the kitchen? Walking through the house, I survey his night's activity; six walnuts on the toilet and the bathtub plug on the living room couch don't even startle me.

This morning I find an unusually original arrangement of objects: his toothbrush stuck up the skirt of Celina's Barbie doll, the gray plastic handle sticking out like a third leg, the width and length of the brush almost identical to Barbie's thin plastic limbs. Clever, in an odd way.

I also find three long leaves picked from the spider-plant in our bathroom carefully placed parallel to each other on top of the television. Actually, I am mildly amused by these signs of Julian's night-time wanderings, and curious about his odd perceptions, arranging objects by shape and size rather than meaning.

But moments later, I do not find amusing what greets me. Tiptoe-ing into our room to see if Julian is asleep, I am aghast at what I see: bits of tan pillow stuffing scattered all over our bedroom. Stuffing material lies heaped on the freshly vacuumed carpet beside the bed. Remains of the pillow itself stand upright by the nightstand—one end ripped open, a wide, white gaping mouth drooling tan blobs of fluff. Stuffing strewn everywhere: on the bookshelves and dressers; over the carpet on both sides of the bed; up the hall as far as the bathroom.

In some sort of slow-motion confusion ritual, Julian removed the pillow slip, ripped open the pillow and scattered brown stuffing all over the room.

How disoriented he must feel at night in the dark, silent house. Is he scared? Does he want someone? How terrifying to be unable to shake off such confusion.

Now Julian stands hunched by the window in his light blue flannel pajamas, bent slightly forward, arms hanging straight down from his shoulders, in his new, characteristic Mellaril gorilla posture. He might have been standing there for hours. My heart aches for him, seeing him so desperately confused and alone.

Seeing me, he smiles and walks mechanically towards me.

"Oh, it's you. It's you." His voice is muted; the words come slow. He holds out his arms. Saying nothing about the mess, I reach to hug him.

"You've been very busy." I manage to swallow my shock.

"I'm a good man, a good man," he says, kissing my neck. I wonder if he realizes what he has done.

When I bring Karen in the bedroom to show her the scene, she leans silently on the doorjamb for several minutes, looking sad. Then I call Beiçola to see it too.

"Oh, Krishna." He smiles gently at me. "Krishna, Krishna."

I get a plastic bag and we begin picking up the tan bits. While Julian eats granola in the kitchen, I vacuum up fluff, pushing the vacuum cleaner over all the straight lines the cleaning woman made on the carpet not so many hours before.

Our Sabbath morning, only four more before us, begins.

Ashes

IN THE REDWOOD Cafe and Spice Co. I sit across from Betty as we order lunch: chicken Caesar salads and iced tea.

"So how's it going?" my friend asks, beautiful in a gray cashmere sweater which shows off her light, bronzy hair. I haven't seen her since December, when we visited Oak Creek together. Today she has dashed away from her ombudsman job to have lunch with me.

"What's happening with Julian?" she asks.

Betty has heard me vacillate for hours about pros and cons of residential care, patiently listening to my terrible ambivalence.

"Julian's scheduled to go to Oak Creek on February first," I remind her. "Since our visit, I've made the arrangements. Maybe two or three weeks of respite care…but probably longer." Even, still, I avoid the word "placement."

Sipping her tea, Betty lets me continue.

"But I've crossed over a bridge. As of this moment, I know it's not just for respite. In my heart, I know it's for good."

I have never said these words out loud.

Betty nods. She thinks Julian is ready to go, but she's not pushing. Four weeks ago, when we visited Oak Creek, she told me clearly it was time. She has seen countless dementia patients in care centers.

"It's definitely time," she repeats, explaining that people often make better adjustments if they are less impaired.

I tell Betty about the pillow stuffing all over the bedroom. And then refer obliquely to an even worse mess this morning, which I don't name.

"What?" she asks.

"Tell you when we're done eating," I say. But then I go right on and tell her anyway...in delicate terms.

She wrinkles up her nose and fans her face as if waving away an unpleasant odor.

"I've pretty well decided Julian should go. You're the first person I've told. I'm just starting to say it out loud."

I see from Betty's face that she is relieved to hear these words.

We know each other well, Betty and I. One of my oldest friends, we met at Stanford as freshmen in the same dorm. Our junior year, we spent a semester together in Paris, studying French at the Sorbonne, but mostly, wandering the streets of the fifth and sixth *arrondisements*, thinking ourselves "existentialists," carrying volumes of Sartre, Camus, and Henry Miller pressed against black turtleneck sweaters. We spent hours staring at Botticellis and Leonardo da Vincis in the Louvre, drinking coffee at *Le Deux Magots*. Walking along the *quais* of the Seine, down cobblestone alleys in the *Marais,* I longed for "intense experiences," but both Betty and I were too timid and unsophisticated for much to happen.

"You've been through so much," Betty tells me now. "You are so good to Julian. You have much more patience than I do."

"Yes...but I know three friends who cared for husbands ill with cancer, nursing them at home until they died. Part of me thinks I should hang on longer."

"Cancer is different," Betty says. "The mind is still there, the personality holds. People can talk and participate in decisions. The person is intact. Besides, the time period is shorter. People with cancer are terminal a relatively short while. Julian could deteriorate slowly for years."

I spear a chicken chunk with my fork. Betty's plate is empty; mine is half full, as I've been doing most of the talking.

"Mostly I know it's time. Still a tiny part of me remains ambivalent...when he's sweet, when he kisses my neck, when he tells me he loves me."

Tears fill my eyes.

"It's a terrible decision," Betty says. "I don't know what I'd do with Bob."

She told her husband, Bob, last week after reading my *Alzheimer's, A Love Story* manuscript, that he should put her right into a home if she got dementia. She wouldn't want to ruin anyone's life.

"Good for you. But did he tell you to be sure to put him away too?"

We laugh. As the waitress brings our check, Betty rises to rush back to her office.

"Bye, and thank you. Know where I'm going next?" I say outside the restaurant. "To the Neptune Society to pick up my father's ashes."

Betty knew my dad when we were students and always liked him. A memory flash of Betty at my dad's gathering last October, walking around with Julian while people spoke so my kids could listen without distraction. Now, she looks at me quietly. We hug each other and walk off to our cars.

~

After lunch, I drive up El Camino to the Neptune Society, scanning addresses, looking for a Spanish-style building with a red tile roof. Surprised that I don't feel more emotional—hesitant and fearful, or reverent, or sad—I pull into the driveway, park and open the mortuary door.

A Haydn concerto from the classical music station is playing as a pleasant-looking woman walks towards me.

"Can I help you?" she says.

"I'm here to pick up my father's ashes," I tell her. "I spoke with you earlier on the phone. Murray Gelber. He died October fourteenth." Hard to believe I'm saying so calmly these ordinary, yet awesome, words, as if I am picking up the dry cleaning.

"Just one moment." She motions me to sit in an upholstered chair by a round table and I sit alone in the quiet room waiting for her to return with my father's ashes.

Suddenly my heart pounds fast, my stomach knots up. An image of my dad sitting in his brown recliner watching Phil Donahue appears, the way I saw him on so many visits to Woodacre Knolls. Suddenly I miss him.

The woman returns, cradling a royal blue velvet bag which she places gently in my outstretched arms. Inside is a heavy box. The

weight doesn't surprise me this time; it's what I expect. I hug the bag towards my chest, folding my arms around the soft cloth, supporting the box.

Two years ago I went to the post office with my friend Eileen to pick up her husband's ashes, mailed from a mortuary in Florida, where Joe had suddenly died. Then, I'd been surprised at their weight; today, Daddy's ashes weigh the same.

"Can I keep the blue cover?" A stupid question, but I need to say something to break the awkward silence.

Carrying the bag to my car, I wish I had cleaned out the back seat. I meant to, but the morning was rushed. Rasa's car seat with mashed cheerios is strapped in the center, a bag of groceries on one side, a box for Goodwill on the other. One of Antar's soccer cleats lies on the floor.

It doesn't seem right; it's not dignified. John F. Kennedy's formal funeral procession pops into mind, and Yitzhak Rabin's recently televised funeral in Jerusalem. Ceremony accompanied their remains all the way to the grave. It feels haphazard, irreverent, sloppy to just put my father's ashes in my Toyota next to groceries and clothes for Goodwill.

But as I carefully set down the heavy blue bag alongside groceries, I think how suitable this really is. No prime minister, no president here. It's my dad, an ordinary man—as he put it—an "ordinary man with an ordinary life." In a funny way, he seems very alive, still part of the family, there on the back seat of my Toyota.

Moving Antar's cleat, I prop up the grocery bag full of fruit juice from Trader Joe's (my dad's favorite store) near Daddy's ashes, then look at my watch...nearly 2:15. There is time to dash to the market before getting Julian.

Odd that just minutes ago, I placed my father's ashes in the car. Traditional Jews ritualize death. A formal set of acts begins from the time of death to immediate burial through the week-long *shiva* which follows. During this mourning period, daily life stops. My father would want none of that. Instead, daily life goes on around him; he's in the midst of it; no fuss, no bother. Daddy would like that. At 2:50 I drive from the market to get Julian.

~

At Rosener House, Julian walks alone in the dining room when I

arrive. He seems to be behaving okay lately, though each day I'm fearful of getting a bad report, or another warning about needing to put him on "hold."

Through the windows I see him shuffling slowly around and around a table, one hand on the top...for leverage...for balance? His plastic name tag is pinned to the back of his shirt so he can't remove it. Other participants sit in the activity room on blue vinyl chairs watching a Gene Kelly video on the large television monitor; Gene Kelly's voice—"I'm singing in the rain..."—comes cheerfully from the next room. Julian never watches television; he's rarely in the activity room with the others.

As I walk towards the forlorn, solitary figure, Julian says predictably, "Oh, it's you." I hug him and remove his name tag. "Come on, let's go," he says mechanically, without smiling.

I grope in his trouser pockets for other people's name tags, which he likes to pick up. Sure enough: Dave's name tag is in one pocket and John's in the other. I help Julian into his sweater and zip up his jacket.

"Would you like to go for a walk? It's beautiful outside."

"Lovely, lovely," he says softly.

Once buckled in the car, his face drops forward and he sleeps, head hanging to one side. His neck must hurt, but I've failed many times to get him to lean back against the head rest. Turning on the car radio, I listen to National Public Radio's "All Things Considered" as I drive to Stanford and park the car near Lake Lagunita.

The lake is empty this time of year, just a dried hollow with stubbly grass and muddy ridges, where we walked with his friend John Bancroft two months ago. A smooth gravel path runs around the bank, lined with gnarled oak trees and soft beige and rust-colored bushes.

Unbuckling Julian's seat belt, I gently shake his shoulders, then walk around to his car door, open it and pull him out.

"Coldy, coldy," he says, pulling his parka hood up over his head.

Hand in hand we walk along the gravel path. Gnarled oaks lift heavy branches towards a steel gray sky. A pair of mallards waddle in the mud and three Stanford students in sweatshirts jog by.

Suddenly I stop and step in front of Julian, lay my hands on his shoulders, stick my face close to his.

"Julian. Julian," I say. "Are you okay? I want you to be happy." I stare deep into his clear blue eyes.

"I'm okay," he says slowly. "Okay."

"I don't want you to be unhappy."

"*Och*...away with you." In his cute Scottish accent, clear as can be, he says again, "*Och*...away with you," and grins.

Once more I take his hand and we walk slowly around the empty basin where we have walked for thirty years. In the graying light, his fingers feel warm, familiar, and especially precious, gripping mine.

～

Back home, I bring Daddy's ashes into the house and place the blue velvet box on the desk in my study. While the kids play and quarrel behind the closed family room door, I give Julian his dinner. Cartoon sounds blare from the television. Julian eats his pasta as I unload the dishwasher. Beiçola is in his bedroom working on his computer; soon Karen will be home. When Julian finishes eating, I lead him to our bedroom and undress him. As we do each evening, we tussle over buttons: he buttons each shirt button that I unbutton, forgetting which process he's in, dressing or undressing.

"No, no, coldy, coldy." He protests as I try to tug on his corduroy trousers.

"Sit down." I push him gently onto the bed. Shoes off...pajamas on...teeth brushed.

In just a few weeks, some strange caregiver will undress Julian and put him to bed and the intimacy of our thirty-five years together will be over. But he is not dead, nor are we divorced. My throat tightens, tears fill my eyes.

Finally Julian crawls on the bed, crouching on all fours for several minutes before slowly lowering himself onto the flowered sheet. With a sigh of relief, I pull up the covers, kiss him, turn off the light and tiptoe out. What will life be like when I have no Julian to care for?

In my study, I collapse onto the narrow bed, too tired to undress. Daddy's ashes, in the blue velvet box, face me from where I set them on the desk beside unpaid bills and piles of papers. It's eight o'clock; Julian and I are in bed before the children. Thoughts are too painful. All I want to do is sleep.

Talking with Carol

THE SECOND WEEK in January, when I come to day care to pick up Julian, Carol motions me into her office. Her butter yellow sweater hangs loosely over black pants, her gray-blond hair pulled back in a pony tail. Her blue eyes smile.

"We haven't talked for six weeks," she says. "I want to know how you and Julian are."

Carol and I haven't met since the Thanksgiving crisis when Julian disrupted day care and she warned me that they might have to ask him to leave. I haven't yet told her about my frantic search for residential care, how depressed I was seeing dementia units. I haven't told her I finally chose a center I liked, or disliked least is a better way to put it.

"I've found a place that might work," I say. "But I'm so ambivalent. Any worry I could possibly have about placement, I do have."

"Every caregiver I've talked to is ambivalent," Carol says. "Everyone hesitates, vacillates and feels guilty."

Julian is scheduled to go on February first, I tell her. "They offered me two weeks of respite care, to see how it goes. After that, I can leave him, or bring him back home."

"It's a terribly hard decision," Carol says gently.

"The hardest I ever made in my life."

Carol nods, encouraging me to continue.

"For months I've thought about it. Every day, I feel the whole range of emotions. Yes, the time is right; Julian's very impaired; my life is shut-down. No, I can manage; Julian still knows me; it isn't so bad."

"How are things now?" she asks as I settle down by her desk.

"I've lowered his Mellaril because I can't stand him like a zombie. I can't bear his silence, even though before the doctor increased the dose, I wasn't able to stand his constant jabber either.

"If he gets troublesome at day care, be sure to tell me," I blurt quickly. "It's critical that he come here. If he causes problems, I'll increase his dose again."

"People with Alzheimer's," Carol explains, "have long stable periods. They go weeks, months, even years, with few changes. But others are changing and unpredictable. New decisions have to be made."

I look at her questioningly, trying to read between the lines.

"Julian's okay now," Carol says slowly, "but he's in what I call *transition*. On the increased Mellaril he is not grabbing people or running out the door. He's quieter, but it's precarious. He is unstable. He could change any minute. We have to be prepared."

My face muscles tense up.

"Transition stages cause great distress," Carol adds.

"Well, I found Oak Creek," I say. "I'm glad I searched before a crisis. I have a place for him whenever I'm ready, and I'm greatly relieved."

"You've done good work. Now tell me about Julian at home."

I tell Carol about his restless nights, how he paces and wanders from midnight till dawn, how he drags the spread and pillows off the bed, dismantles the couch. I describe how nightly he pees on the bathroom floor. I'm simply used to finding bathroom rugs wet with urine. Part of my morning routine now includes throwing them in the washing machine and mopping with Pine Sol.

Carol looks deep in my eyes; I sense her judgment that I've already kept him home too long.

"But he doesn't wear diapers." I defend Julian. "He never wets or soils his clothes. He almost always defecates in the toilet." I think how grateful I am each time I spy it filled with his brown load. "If he soiled his pants or defecated on the floor, I couldn't stand that!" I say.

Then I describe how confused Julian gets in the bathroom. Some days he goes in alone, unzips, pees properly in the toilet and washes his hands. Other days he stands before the porcelain bowl totally bewildered as to what to do, or as terrified as if I've placed him before some weird, futuristic torture machine.

"Yesterday, for instance, I took him to the bathroom and he just stood there. Then he went to the kitchen door, stood on the stoop and urinated on the step."

I tell her how last week Julian urinated on the kitchen table. Beiçola cleaned it with Clorox and never told Karen or me because he didn't want to upset us. "Rasa's pee or Julian's pee...what's the difference?" he later said. "You see pee, you clean it up." After that, Julian peed in my dresser drawer where I keep my scarves.

"Well...," Carol pauses over her words. "Let me think how to put this. Compared to most people at Rosener House, Julian has some

very difficult behaviors. You have a lot to cope with. More than most caregivers here," she says.

"Yes, but Julian doesn't wander or run away. He isn't violent or combative."

"You've that to be thankful for, I agree," says Carol. "But there's also his very impaired language. Many here can chat superficially and carry on little conversations, however limited. We've forgotten to mention Julian's severe language problems. All this adds up to incredible stress," she says kindly.

"Yes, but," I hear myself say again, "many people here are difficult to care for. Half wear diapers which someone at home changes."

I don't realize at the time how resistant I am to Carol's words.

"Believe me," Carol flips strands of hair off her forehead, "Julian has some extremely difficult behaviors," she repeats. "His limited language, sleepless nights, bathroom confusions, dependence on you to wash and dress him, his need for total care, his inability to concentrate or focus on any task…you have a very hard job! Many caregivers place their loved one in residential care for much less."

While not telling me what to do, Carol is clearly working hard to give me permission. It is my decision, mine alone, that we both know. But, like my friend Betty, Carol is helping me gain perspective. She has a wider viewpoint. It helps me to hear her say Julian is "way out there on the continuum of difficult care."

"I feel like such a wimp," I say, "quitting while I'm still able."

"Oh my goodness." Carol shakes her head.

"I mean, I *can* still manage. I *can* do it. I'm not broken down or at my wit's end."

"That's harder in a way." Carol tells me that her father, who had Alzheimer's, finally went to a nursing home when he broke his hip. "That made the placement decision easier. My mother couldn't take care of him. He simply had to go."

Carol explains that most people go to residential care because "something happens: a fall, a broken hip, the caregiver can't lift the patient, the caregiver gets sick, the patient runs away…."

"I know," I say. "But I don't have an 'external event.' My choice feels 'deliberate'…'in cold blood'…'a premeditated decision' to 'put Julian away,' so I can have an easier life. It seems selfish. I feel I'm giving up caring for Julian too soon."

Carol sighs.

"Yes, and Verna," I protest, "is still caring for Newell at home, too, and he's more impaired. He's had Alzheimer's five years longer than Julian. She's also on the verge of placing him and is concerned that other people will criticize her for giving up.

"I don't think *others* will judge me harshly." Words tumble out. "In fact, my friends and relatives probably think I've cared for him *too* long. It's *me* who's judging my decision. Part of me says not to give up."

"It's so hard," Carol repeats.

"I'm trying to re-frame it," I continue. "I tell myself I'm not *putting Julian away*. I will not stop caring for him. I will just *care for him in a different way*. If he lived somewhere else, others would dress, bathe, and shave him…but I'd still be there. I wouldn't abandon him."

Then I confess that last Sunday morning I found two balls of feces in the bathroom sink and then discovered brown, smelly smears on our bedroom carpet.

Carol stares at me.

"I spent two hours cleaning and shampooing the rug," I say. "And that day Karen solemnly said, 'It's not sanitary anymore, Mom. I'm changing my mind about Dad's needing to go.'"

Carol keeps nodding. A participant shuffles past her door en route to the bathroom, followed by a staff member wearing white plastic gloves.

"Carol, can you help a minute?"

Carol looks at me apologetically, aware that this important talk is interrupted.

"It's okay. I need to get Julian. It's past his departure time, and I must go home and clean up my study for Jeff, who arrives from New York tomorrow. Thank you, Carol," I say, "for listening. Who else can I tell these things to?"

Carol gives me a long look over her shoulder as she leaves to help, and I put on my jacket and go to the activity room to find Julian.

There he is, grinning and adorable, in his sky blue sweater that matches his eyes. "Oh, it's you, yes, you," he says running towards me, throwing his arms around me and kissing my neck. "I love you. Oh, I love you so much," my husband says.

Bluntly Honest

LATER THAT WEEK, as Julian sleeps at the kitchen table, his head drooping over his breakfast cereal, Antar asks, "Is Grandpa coming in the car today?"

"Yes, he is," I answer. "It helps me a lot when your mom takes him to day care after she drives you to school."

"But I don't like him to come," Antar blurts, his brown eyes staring at Julian. "I like to sit in the front seat and listen to the radio." Still learning social graces, this nine year old is bluntly honest.

"Grandpa's very sick," I explain again. "It's hard to be with him, I know. But we have to be patient, and love him and help him."

"In the car everybody," Karen calls, scurrying around, grabbing lunch bags and jackets, herding Antar and Celina out the door.

No time to continue my talk with Antar. Not enough time to say: "Yes, Antar. It's hard living with Grandpa, I know. He pees on the floor. Sometimes the bathroom smells. It may seem gross. He may embarrass you in front of your friends. But Grandpa can't help how he is. He wouldn't want to be this way; he wouldn't want to cause us trouble."

I do say things like this in quick, short sound bites, as occasions arise. But I have never had a proper conversation with Antar, which I keep meaning to do. I want to confirm his feelings, not just override them with platitudes like "We have to help Grandpa," which I often say.

It is a tricky balance—allowing him his feelings of annoyance, embarrassment, fear, and disgust—while at the same time insisting on respect, and trying to model patience and love.

"I wish Grandpa would go live someplace else," Antar mumbles as he pulls on his parka and runs out the door. Only Antar dares say aloud what others in the family no doubt feel.

I bundle Julian into his coat and lead him by the hand to Karen's car, where Antar and Celina wait in the back. As I help Julian into the front, I say to Antar, "I know you like to sit in the front seat, Antar. But Grandpa needs to sit here now. He may be going to live somewhere else in a few weeks."

"You mean the 'home?'"

That boy doesn't miss a beat. Of course he overhears his mom,

dad, Jeff, and me discussing Julian—how he is that day, how much he wandered around at night, how we feel about Julian going to residential care.

The topic floats around Antar, as he makes toast in the kitchen or lies on the floor watching cartoons. He hears it all. I must make time to talk to him directly and invite him to tell me more about how he feels.

"Grandpa came in my room three times last night," he sometimes tells me. Or, "Grandpa came in the middle of the night and ripped off my blanket." Or, "Grandpa peed on the bathroom floor."

Yes, I need to talk more directly with Antar.

After Karen leaves with Julian and the kids, I putter around the kitchen and make a pot of good Peet's coffee to be ready for when Jeff wakes up. I'm looking forward to spending the day with him, hanging around Palo Alto, having lunch at La Azteca Mexican restaurant, maybe taking a walk in the hills behind Stanford, having open time to discuss all that is going on.

The baby's asleep; Beiçola is in the family room walking back and forth doing his morning meditations as I put on my rubber gloves and take the Pine Sol into the bathroom for my morning clean-up.

Jeff, here for a week during his university's winter break, wakes up and finds me crouched on all fours sponging the linoleum.

"Why don't you put newspapers down, like for a puppy?" my practical son suggests. He has recently housebroken two kittens in his Manhattan apartment.

"Brilliant," I say, spreading thick layers of newspaper all around the toilet. "Tomorrow we'll see how your plan works out."

~

Soon Jeff and I stride up the steep hill in back of Stanford, reaching the road that runs along the top. From there the Stanford campus sprawls below us, red tiled roofs, the beige spike of Hoover Tower, the elementary school where Jeff went. Beyond the school, we can almost see our house in a patch of trees. Staring at the panorama, my son grows silent, combs fingers through his sand-colored hair.

Finally he says, "You know, Mom, I've been reading some of Dad's books that you gave me, chapters he wrote on the physiology of consciousness, and meditation. I didn't know he wrote about that."

"Julian got fascinated with consciousness in the mid-seventies," I say, "and edited a collection of essays—*The Psychobiology of Consciousness*—and he wrote a chapter on the psychobiology of sexual experience. Is that what you're reading?"

"It's great, Mom! Dad's work on consciousness is really interesting! He wrote all this when I was a kid." Jeff pauses. "And I never knew, never got to talk with him about it."

My mind flips back to Jeff as a freckle-faced, adorable boy, wrestling with Julian on the bed, doubled over laughing at their favorite Monty Python. Then a flash appears of Jeff holding Julian's hand on last summer's trip to the mountains, leading his father down a rocky trail, another of Jeff shushing Julian at Coppy's memorial service.

"Dad got diagnosed with Alzheimer's soon after you left for college." Considering Julian's illness alongside Jeff's childhood makes my voice turn husky. Trying not to sound weepy, I say, "He's had Alzheimer's your whole adult life."

Jeff stares out at the campus below. "I never got to talk to Dad about anything serious. I wish I could talk to him now."

"I wish you could too. You'd have many things to discuss. I wish you could know each other now, man to man."

Together in silence Jeff and I stare down at the red-roofed campus below.

~

The next morning I peek in the bathroom to check on Jeff's newspaper plan. His plan works: the newspapers surrounding the toilet are soaked. This time I pull on my rubber gloves and simply throw the soggy load into the garbage.

"Great idea!" I congratulate Jeff after he wakes up. "Made the morning clean-up so much easier." I lay down more newspapers for the next night.

But the second morning when I go to inspect, the papers are all folded and stacked in a neat pile on the bathroom counter. Julian has picked them up and tidied them, the linoleum wet with its usual puddle.

"Ah me," I sigh, looking at Jeff who stands in the doorway in his pajamas smiling a funny smile tinged with sadness. He has given his blessing to Julian going to Oak Creek; he, too, understands that it's time.

"Oh, Krishna," Beiçola says when I show him the stacked papers. Antar listens, wide-eyed, as he enters the bathroom to brush his teeth.

"Whew! Gross!" Antar blurts seeing me on my knees again sponging the floor. "It stinks in here!"

You want the truth? Ask a nine year old. But the truth hurts. And I don't always want to hear it.

Wimping Out

"NO, I DON'T think you are 'wimping out,'" a psychologist at the medical clinic says thoughtfully.

I just told her I was sure—well, ninety percent sure—I wanted Julian to go to residential care. And not just for respite.

"But I still waffle around," I say. "Sometimes he's so sweet and I feel so tender towards him when I button his shirt."

"He looks innocent lying in bed at night." I start to cry. "I can't imagine not seeing his face on my pillow."

I reach for a tissue, blow my nose. "It's so sad," I whisper.

Dr. Norman sits across from me and nods.

"I know it's time," I blurt. "I've settled that really, since I last saw you. Yet I still have moments of doubt. Sometimes I think I'm a spoiled Jewish-American princess giving up too soon."

Dr. Norman sits in her leather armchair, re-crossing her legs.

When my blood pressure jumped up at my last physical exam, my internist, hearing the stress I was under caring for Julian, suggested I have a few counseling sessions. "To help you through this crisis period," he said.

I have seen Dr. Norman several times. It helps talking to someone who can help me sort through the maze of decisions, medication adjustments, and emotional hurdles.

"I've seen many families facing this tough placement decision," Dr. Norman says. "And I've developed a yardstick for when's the right time. You are NOT placing him too soon. You've gone on longer than most."

"Tell me about that," I say, desperate for reassurance.

Dr. Norman outlines the reasons, re-structuring the facts I have

told her. This is a dialogue with an experienced health professional, not just another internal dialogue with my conflicted self.

"The day care is really telling you it's time for Julian to go," Dr. Norman says, after I relate last week's talk with Carol. "Saying Julian no longer benefits from their program is a polite way of saying he needs to leave."

This time she speaks and I nod.

"Secondly, from all you've told me, it's clear Julian is severely impaired. Caring for cognitively impaired adults is a back-breaking, heart-rending task. There comes a time when it's unhealthy to keep doing it."

"Deep down I know this already," I say. "But I need bolstering from someone outside."

I pour out the latest in Julian's new behaviors: his jerky tremors and weird, twitchy, puppet-like gait. He gropes his way along walls and counters like a blind person. He gets rigid and stiff standing by a car door with absolutely no idea how to get in.

"Some of this indicates more deterioration," she says. "And some are side-effects from Mellaril. The tremors and jerky gait are from the medication, which can be controlled with complementary meds."

Experienced with psychotropic treatments, she explains various drugs and affirms my decision to call Julian's neurologist and push for optimal medication.

"Even small dose adjustments can bring significant changes," she says. It feels good having an ally, as I have so much to keep track of: Julian's medications, completing the admissions packet for Oak Creek, trying to find help for afternoons and weekends, learning about Medicare and how this affects my health insurance.

I tell Dr. Norman all that happened in the last two weeks, describe my aimless afternoons driving around with Julian, inventing errands, shuffling around Palo Alto sidewalks. I have gained ten pounds eating cakes with Julian in bakeries trying to fill long afternoon hours.

"I pick him up from day care at three...then check my watch every half hour to see how long till bedtime."

"You must get extra help," she says.

Together we brainstorm ideas for how to find help.

"That's not easy either." She confirms what I already know.

We flip from practical talk to heart talk and back again. While discussing medication side-effects, I flash on tender moments with Julian.

"As soon as he finds me each morning, he walks straight to me with open arms and tells me he loves me."

I start to cry. "These are not bad words for him to go out on. I'm lucky."

"So is he," Dr. Norman says.

Tears stream down my cheeks. Silent sobs shake my body. My heart full to bursting, I struggle for words.

"It's all about love," I manage. "The only way I can do this is with love. I can't explain. I'm grateful to feel so much still coming from him."

I check my watch: nearly time to go. My wide-open heart pulses shut. Dr. Norman writes down a phone number to call for insurance advice as I throw wads of Kleenex into the trash. Our hour is up.

She opens the door and smiles as I descend the stairs. I feel strengthened having her professional hand to hold, desperately needing to hear I am not wimping out.

~

The next morning, I wake up early, straight out of dream: Julian is lost.

I am at the airport with my friend Betty and another woman. Nicely dressed in high heels and tweed suits, they stand by their luggage at the check-in counter preparing to leave for London. I feel jealous; I want to fly off to London too.

Suddenly I look up and realize Julian is nowhere in sight. A rush of panic: he is lost in San Francisco International Airport. Frantically I look this way and that.

"Julian's lost," I shout. Betty and the woman head off in one direction, searching for Julian in the crowds; I tear off in the other direction. If I don't find him soon—my mind races ahead—I'll call the security guards and airport police.

I wake up before he is found. My heart thumps; my palms feel sweaty. Just a dream, but I'm flooded with the intense anxiety of losing Julian in the crowded airport.

Slipping out of bed, I pad down the hall to look for him. It is after

seven; he is usually up. The dressing room and our bathroom are empty. No Julian in our bedroom either. I look for him in the other end of the house. He is not in the kitchen, living room or family room. I rush back to peek into the children's bedrooms and Karen's and Beiçola's room. He's not there.

Then, foolishly, I run back through all the rooms checking again, just to make sure.

The front door is closed; that's a relief. So is the kitchen door. A good sign: he probably wouldn't wander out of the house and re-member to close the door too. Where is he? I imagine him wander-ing around the cold streets in his pajamas and bare feet in the early morning fog. My heart beats wildly. I'll have to call the Stanford po-lice.

Light underlines the door of Karen's bathroom. I hear water run-ning; she is taking a shower. I decide to knock and ask if she has seen Julian.

Just as I'm about to knock, the door opens and out walks Julian in his red plaid pajamas. A blue slipper covers one foot, the other is bare. One arm is slipped into the baby's blue jeans. He has shoved his arm into the leg of her tiny jeans, the second leg dangling down. His gray hair is disheveled, his glasses off. Seeing me, he smiles.

"Oh, it's you, you," he says.

Enormous relief washes over me and I rush towards him, give him a hug. As he puts his arms on my shoulders and kisses my neck, the dream's anxiety coupled with the shock of not finding him ebbs away.

"You funny man," I say, pulling Rasa's blue jeans off his arm and leading him back into our bedroom. "Let's go get dressed."

"Yes, yes," he says. "Oh, yes, yes."

A Fragile Ledge

"I print his name on his shirts with the marking pen, as if he's my big gray-haired kid going away to camp."

Phone Calls

THE CALL IS surprisingly easy to make, this call I've anguished over, debated, resisted.

"Hello, Vickie?" I say to the admissions director of the Alzheimer's and Dementia Care Center. "Is the bed at Oak Creek still available? If it is, I'd like Julian to go on February first...and stay there."

The words come out clearly, firmly. No hesitation or doubt. I don't even feel bad as I say them.

"What's going on?" she asks kindly.

In a rush of words I tell Vickie how fast Julian has deteriorated in the past two weeks. How his slow shuffling walk turned into a puppet-like gait, his legs jerking out from the base of his spine like a marionette dangling from a string. I describe how he walks up to walls and feels them like a blind man, groping along table tops and kitchen counters.

Swallowing hard, I confess that he sometimes drops to the floor and crawls, sometimes lying full length, face down on his stomach, then pushing up again on his hands and knees and crouching motionless on the carpet.

My tale gushes out. For the past two weeks I've watched Julian decline. Never in the six years since his Alzheimer's diagnosis has he deteriorated this fast. Right before my eyes he loses skills. Suddenly one day he can't do something he did before: tie his shoe, brush his teeth, eat with a fork.

"But he is not consistent," I tell Vickie. "One day he can. One day he can't. Then he can again." I have already learned that once a skill becomes inconsistent, it is on the way out. Things rarely improve in this awful disease: they only get worse. If he sometimes can't tie his shoe, then soon he won't tie his shoe at all.

Vickie listens quietly as my words pour out. "Yes, the bed's still open," she says softly. "Julian can probably come...but I'll need to

discuss the changes in his behavior with Oak Creek's owner, just to make sure he's still appropriate."

I don't dare think that he might not be able to come. Instead, I focus on details: buying tennis shoes with Velcro straps, an item on the clothing list she gave me in December. Professional caregivers don't want to keep bending over to tie and untie everyone's shoes.

Tying a bow is Julian's last remaining complex skill. Just last week he did it so well—deftly, normally. It amazes me that he can still tie his shoe when he can't cut food with a knife, stir sugar in his coffee, comb his hair, shave or wash himself, seemingly simpler tasks.

"What made you change your mind?" Vickie asks gently.

"Last night the day care called asking me to cut Julian back to only three days a week," I say. "He's too difficult for them to handle. And I can't manage him more days at home!"

Carol's phone call rushes to mind, the accompanying fear that choked my throat, the sadness that flooded me. "I understand," I told Carol, but I realized immediately I was at the end of my rope.

"I need more help, not less," I tell Vickie now. "Weekends alone with Julian are impossible. When the day care called, it became clear fast: it is time for Julian to go."

"I'll tell the owner about the changes in Julian," Vickie repeats. "Meanwhile, you phone Julian's doctors about a chest x-ray and TB test."

~

When Vickie and I finish our talk, a flood of relief hits me. No more hesitating: is this the right decision? No more vacillating: am I sending him too soon? Now is the right time and I know it.

My soul-searching dominated the past two months. Now it is clear. A profound sorrow replaces my terrible ambivalence, sadness that we have come to this place. It is not a final goodbye, but a separation from which there is no turning back.

Immediately I phone Ben in San Francisco. He is out getting groceries, so I talk a long time with Greg, the first person I tell. Maybe it is easier telling Greg; not being Julian's son, he is less emotional.

Greg tells me that when his father had cancer, his mom cared for him at home until six weeks before he died.

"After my dad went to the hospital," Greg says. "My mom was

free to love him, unencumbered by caregiving tasks. When you're bathing, dressing, and feeding, there's little time left for love."

Greg says his mother felt again a pure, basic affection that had been long buried.

Tears leak from my eyes; I know exactly what he means. Greg assures me I am doing the right thing and that he will help any way he can.

Later I phone Jeff in New York, call Karen at work, and eventually talk to Ben. All agree. Each encourages me to move ahead, which I hoped they would say. It is my decision alone to make; I don't need to consult them. But I need feeling their hands behind me, supporting me in case I slip. Like when we hiked a steep trail in the Sierra last summer and Jeff walked behind me with his hands on my back, pushing me forward.

"You're doing the right thing, Mom," each of my children declares. "It's the right time."

When I tell Beiçola later that night, he hugs me and rubs my shoulders. "Life's not easy," he says, as hot tears spill down my cheeks. I also phone Verna and leave a brief message on her answering machine, saying that Julian will probably be going soon to residential care at Oak Creek.

So by the time I phoned Vickie this morning, making the call came as relief, the instant release that comes after lancing a hot, near-to-bursting boil. No ambivalence or regrets.

~

Now I wait for Vickie's final answer. Will Oak Creek still accept Julian? Has he deteriorated too much since his evaluation in December? Will he really go to residential care?

He can't go to Rosener House tomorrow, that much I know. Since he'll be at home, I'll take him to Mervyn's to buy some tennis shoes with Velcro straps.

Hamster

THIS AFTERNOON at five I drive to our friend Tom's house, just blocks away from Julian's day care. Ever since Rosener House asked me to pick up Julian early, Tom, a colleague I worked with when I

was a speech therapist, volunteered to collect him, giving me the gift of two more precious, free hours.

When Tom opens his door, I see Julian crawling on his hands and knees around the living room, pressed close to the wall.

In silence I stare at the pathetic figure. "It's so sad," I murmur. "Can you believe this?"

Tom looks into my eyes and nods. Who else but this special Tom would dare to take care of Julian in his present state.

"What's he been doing?" I manage to ask.

"Pretty much the same as on Sunday," Tom says. We had been together at a friend's house where Julian crawled, lay on the floor, stood up, sat in a chair, stood again, walked jerky steps, sat down, got up, crouched on hands and knees, crawled...for five hours.

Tom and I gaze at Julian, watching as he repeats his eerie, slow-motion robot ritual.

Leaving Julian crawling about, we retreat to the kitchen where I report what has happened in the past two days.

"The day care asked that Julian stop coming two days a week," I say. "When they said that, I knew I could no longer manage."

Then I describe my last appointment with Julian's neurologist when I cried out my concerns: Julian's jerky gait, his groping like a blind man, his crawling, his rapid decline. The neurologist observed Julian closely in his office, flopped over like a limp rag doll in a chair, seemingly oblivious to our presence.

"The doctor and I talked at great length," I tell Tom. Was Julian "comfortable?" Was this the disease progressing or side-effects from Mellaril? Was the motor impairment permanent or would it improve if he stopped the drug?

I tell Tom all the doctor said—and that we decided to keep Julian on Mellaril so he could continue at day care.

Finally I summoned up courage and asked the neurologist: "Seeing him now, what can you tell me about the future?"

"It's a matter of months, not years," he said.

I stared at the impassive face above his white coat.

"You mean months...until he dies?"

"No. I mean months before he'll need nursing care. Beyond what a board and care can provide."

"But the place I found *is* a board and care facility," I said.

"So I've no idea what will happen," I tell Tom. "I called the residential care center this morning and said I'd like Julian to go as soon as possible."

"You're doing the right thing,"Tom says gently. "You can't care for him like this. He needs twenty-four hour, undivided supervision."

Tom hugs me for an awkward moment. If I relax into that hug, I know I'll break down and cry, so I straighten up and go to retrieve Julian from the living room floor. I put on his jacket and open the front door. Cold rain splashes on the driveway as I look deep into Tom's eyes.

"Thank you, Tom. Thank you," is all I can muster, but the words come from deep in my heart. I hope Tom understands how much I appreciate the gift of support he has given. Julian and I leave the warmth of Tom's kitchen and step out into the rain.

~

At home, the kids watch cartoons in the family room as we come in. I sit Julian down in his chair at the head of the table and place a bowl of pasta and veggies before him. He reaches into the bowl with his hands.

"Here's your fork, Julian."

I place the fork in his fingers but they don't grasp it, so I maneuver the fork into the proper position and lift it to his mouth. Then I lower his hand to the bowl, put pasta onto the fork and raise his hand again to his lips. Once he gets started, he continues eating slowly, silently, mechanically, managing to get most of the food into his mouth. Four noodles and some zucchini fall on the table.

While Julian eats, I press the message button on the answering machine and the admissions director's voice begins:

"Hello, Mrs. Davidson. This is Vickie...."

My heart thumps wildly, my mouth goes dry.

"We have a bed ready for Julian. He can come here tomorrow. I've faxed a physician's report form to the doctor requesting that he fax it back today. Once we have that, Julian can come. Call if you have questions. And phone tomorrow to tell us your decision."

Tomorrow? I gulp. No, not tomorrow. Too soon. I need at least one more day. I must buy Julian socks, a jogging suit, other items on the clothing list. But that isn't the real reason: I am not ready.

I lead Julian to the bedroom and take off his shirt. Slipping on his

pajama top, I drink in the sight of his shoulders, his chest, savoring slowly this task which I've done nightly for months.

Only two nights more. I spread Crest on his toothbrush and lift it to his mouth, then lead him to bed. On hands and knees he crawls onto the sheets and without too much difficulty slowly maneuvers himself into a sleeping position.

I pull up the blanket and fluff a pillow under his head. His tousled gray hair presses against it. I remove his glasses.

"G'night, Sweetheart," I say, sliding a Brandenburg concerto into the tape recorder.

Sweet sounds fill the air as I switch off his lamp and leave the bedroom, trying to pretend it is an ordinary night, only seven o'clock.

When I return to the dining room, the family is sitting around the table—Karen, Beiçola, Antar, and Celina. Rasa scoots along the floor dropping a black plastic gorilla in and out of a measuring cup. A heated debate about whether or not Antar should have a hamster swings in full force.

"A boy at school is giving it to me," Antar pleads. "Tomorrow. He has to give it away tomorrow. Can I have it? Please, can I?"

We have to decide that night. Antar has wanted a pet for years and never had one. A lengthy discussion ensues. Its cage will have to be cleaned; his mother refuses to clean it; so do I. Antar will have to take full responsibility. Where would we put the cage? How bad would it smell?

"What's your opinion, Gramma?"

All eyes turn to me. This doesn't seem the right time to tell them about Julian. The life force in our house pulses so strong. "Choose life," the Torah says. So I join the debate about Antar's hamster. Finally the adults agree: yes.

Antar leaps up, his dark eyes wide and bright, while Celina wiggles on and off her chair in the infectious excitement. Time enough later for me to talk about Julian. I give the hamster project my blessing.

It seems Julian is leaving the day after tomorrow...and tomorrow we are getting a hamster.

Last Day

JULIAN IS UP, dressed, fed, and put in the recliner by the window. While a Yiddish tape plays, his head falls forward, his eyes close. I cover him with the red and black mohair shawl.

Into the kitchen to make calls: the doctor to check on the chest x-ray; the admissions director to ask about the physician's report and to request one more day at home. Oak Creek received the doctor's fax and yes, Julian can come the next day.

It's done, settled. He is to come at half past ten tomorrow morning. Then I phone Carol at Rosener House.

"I know you said Julian shouldn't come on Wednesdays," I say matter-of-factly. "But he's moving to Oak Creek tomorrow. After you phoned me Monday saying we had to decrease his days, I knew immediately I couldn't manage. I decided fast."

Tears fill my eyes, my voice quavers.

"Do you think he could come today? It will be his last."

"Of course," Carol says quietly. "Come in and we'll talk."

I drag Julian by the hand to the car and buckle his seat belt. Driving up El Camino, a tape plays the cheery "*Tumbalalaika*" while Julian hums the last part of each phrase.

Last time…last time…throbs through my head. The last time I'll bring him to day care, as I've done daily for over a year. I glance at my watch: ten-thirty.

Tomorrow at this time he will be at Oak Creek—out of our house, most likely forever. Loudly I sing "*Tumbalalaika*" along with the tape.

At Rosener House, we enter as usual. I nod to Steve, Dave, and Nancy—this marvelous staff who, day after day, have given me so much help and support. They don't yet know Julian is leaving. I pin Julian's name tag on the back of his shirt where he can't take it off, leave him in the dining room drinking coffee, and head straight to Carol's office, where she sits at her desk covered with papers, wearing black pants and a soft white sweater.

Carol greets me with a solemn face and clear blue eyes, extending her hand.

"Say one nice word to me and I'll cry," I warn. "And I may never stop."

Then I blurt out what has happened since Monday: what the doctor said, how fast I decided, the tumult of feelings that churn through me.

"You've made a good decision." Carol's voice is slow and steady. "You had to do it. And it's very sad."

"Yes...yes." I pull out a Kleenex and blow my nose. "I'm not ambivalent. I had to. But it's so sad. So hard to let go. My life feels like a quilt held together by Scotch tape and it's ripping apart."

We discuss Julian's drug dilemma: should or shouldn't he stay on Mellaril? Is it wise to move him to residential care and change the medication at the same time? Carol explains the pros and cons of each decision, then leaves to photocopy pages of drug descriptions from the *Geriatric Pharmacology Handbook*. While she's gone, Nancy, one of my favorite staff people, walks by and greets me.

"Julian's going to residential care," I stammer. "Today's his last day."

"Oh, Ann...." Nancy's freckled face grows sober. "Come here for a hug." We stand with our arms wrapped around each other. "It's so sad...so hard," Nancy says. Pressed against her, my cheek against hers, we both cry softly. If I let myself go, I would howl and sob.

By the time I leave Rosener House, I have stopped crying and feel firm again, no regrets. But I can't look at the other staff. I just slip out, filled with gratitude for all the help I have received here, knowing I'll break down if I have to explain again. Later I will return to say thank you and goodbye. Passing the dining room I glance at Julian, his back to me, drinking coffee, unaware of the drastic decisions I have made.

The day speeds by...errands, laundry, phone calls. Once again Tom offers to take Julian from three to five. God bless this special Tom. Who else would take Julian into his house and hang out with him while he crawls and urinates on the floor?

But today, when I go get him, Julian is sitting sweetly on Tom's couch, hands clasped together in his lap.

"We both slept," Tom says. "Julian was fine. We walked to Safeway, came home and had a nap. He didn't crawl at all today."

I show Tom the pages from the drug handbook and ask his opinion. Though he is a pediatrician, he knows how to think about behavior and psychotropic drugs, and I feel clear after our discussion: no

Mellaril. His wife comes home, and I am comforted by hugs and kisses: the blessing of friends.

To the barbershop we go for a last haircut. I don't tell the barber Julian is leaving. But the haircut is harder this time. Julian can't figure out how to get into the swivel chair. He can't deal with the metal foot rest. I have to help him, push him in. I hold his hand when he gets restless and tries to stand up. But we get through it. Afterwards, he looks handsome and clean-cut with his smartly trimmed moustache and beard.

"See you next time," the barber says.

"Thank you." I give him an extra large tip, ignoring his remark about seeing us again.

"Would you like Chinese food?" I ask Julian as we return to the car.

"Oh goody, goody," he says.

We drive to our favorite Chinese restaurant, in a nearby shopping center, where the waiters know us, a place we have gone for years. They know something is wrong with Julian and don't mind that he stands up or eats with his hands.

Julian devours fried wonton and spring rolls, smiles as he licks red sweet and sour sauce off his fingers. With gusto he eats Lake Tung Ting chicken and Singapore *mai fun* noodles, our favorite dishes. We eat in silence, except for my occasional, "Isn't this good?" What else can I say?

Leaving Julian eating his fortune cookie, I dash to the bathroom. When I return, just minutes later, he is standing by the table next to ours, patting a woman's hair and reaching into her food with his hands.

"Oh, I'm so sorry, I'm so sorry," I blurt, rushing over. "Excuse us."

"It's okay," says her companion calmly. "Don't worry," says the woman. "We don't mind a bit."

How grateful I am for the kindness of strangers.

At home, I undress Julian, put him in the shower, wash his hair and bathe him...for the last time...for the last time. I rub the wash cloth slowly over his shoulder, up and down the bones of his back. My hands soap his chest, his arm pits, his legs, his groin, savoring the feel of his skin, the silky wet hairs. I brush his teeth...for the last

time. My whole being is open to the excruciating pain of this long-dreaded goodbye.

Julian lies in our bed, smelling of shampoo and shaving lotion, sweet, relaxed, peaceful. So innocent and unsuspecting.

I sit beside him and stroke his hair, my heart aching, wondering what I can say to him, whether or not to try to explain.

"You're a wonderful man," I begin. "A wonderful man."

Julian beams. "You too," he says, looking straight at me, his blue eyes clear and shining.

"I love you so much. You're my darling husband. I'll always love you." Tears trickle down my cheeks, the words catch in my throat.

Julian looks at me and smiles. "Yes, yes," he says. "Yes."

"I'll always take care of you, Julian." I choose my words carefully. "Only I may need some help."

How can he possibly understand? I have anguished over what to tell him. I can't give a long explanation, but I know too that I can't just dump him and leave without some truthful statement, whether he gets it or not. I must do this, as much for me as for him. I never took my toddlers anywhere without some simple statement about where we were going.

Wrapping my arms tight around Julian, I squeeze him close. My heart pounds as I feign an ordinary goodnight kiss, turn on a Bach tape and leave to prepare his things.

Ben has come down from San Francisco this evening to be with me during Julian's departure. On the dining room table we spread out his clothes. Together in silence we print his name on four shirts, four pants, four sets of underwear, four pajamas. That is all he will take away with him when he leaves tomorrow.

"Julian Davidson. Julian Davidson. Julian Davidson," I print with the marking pen, as if he is my great big gray-haired kid going off to camp. The last time I packed his clothes, he went away for the weekend, to the respite camp, but this time he is not going to any camp.

I know Julian will never come back. What will life be like for him in residential care? How will my life be when he is gone? His leaving feels like a death, but Julian is alive, breathing, loving me still. Grief floods me. Grief, and unspeakable sadness, pulse through my veins with each thump-thump of my heavy heart.

Moving Day

SEVEN O'CLOCK. I slide out of my narrow bed and pad down the hall to find Julian. No sign of his night's wanderings. No sink plug in the dining room, no bedspread on the kitchen table. Tiptoeing into our room, there he is—asleep in bed—head on the pillow, lying properly under the covers, like a regular man, blankets and spread neatly over him.

"Maybe he's getting better?" I stupidly think. "Maybe he should stay?"

Julian's eyes open; he sees me and grins. Approaching the bed, I suddenly feel pulled to lie with him. I open the sheet and slip under the covers. His body feels hot, familiar, but somehow smaller. He lies quietly and lets me press against him. Our bodies lie alongside one another—as we've lain for thirty-five years...as we haven't lain for months.

I soak in the feel of him, the shape of him, the heat of his body lying beside mine. My heart pounds and sad tears roll down my cheeks. My lower lip quivers. We lie together.

A knock on the door, and Karen's voice asks softly, "Can we come in?"

She stands by the bed in her black wool blazer, holding Antar and Celina by the hands. They wear parkas and backpacks, ready for school.

"We came to say goodbye to Grandpa," Karen says simply.

In bed, I soak in Julian's heat. He rests quietly, but gives no response to Karen or the children. How this must hurt her. The children press close to Karen, not knowing what to say. This scene is seared into memory: me lying in bed next to Julian, Karen with Antar and Celina standing before her, watching us wide-eyed from the side of the bed.

"Goodbye, Dad," Karen says. "Goodbye, Grampa; goodbye, Grampa," the children echo. Ordinary. Commonplace. What else is there to say?

My eyes fill with tears. I swallow. "Bye, kids," I manage. "Bye, Karen. I'll see you tonight." Understatements, for now, will have to do.

~

Later, I will relate to Karen a detailed description of this day. Sometime, when it's appropriate, I vow to talk about their grandfather's departure with each of the children. But now they disappear down the hall.

Silently I lie beside Julian, maneuvering his arm underneath my head, but he pulls it back. Turning on my side, I wriggle my body against him and he curls around me just as we have always slept. He is quiet, relaxed.

For months we haven't slept together. He can never get comfortable. He can barely figure out how to lay his own body down and get his head on the pillow, much less make sense of, or take pleasure in, someone else's arm or leg, even mine.

But, oddly, this morning we lie peacefully together...how many minutes...one, two, five, ten...? My whole body presses against his. I feel heat and pressure from his chest, his stomach, his groin and legs. Sad...so sad...how can I possibly peel myself from him?

"Julian, Julian. I love you so much. I'll always love you."

These are the words I want him to hear.

Julian smiles broadly, one hand lying on my breast. His hot breath blows in my ear. "Me too. You're a good girl," he says.

But this morning's departure has been carefully planned. We must be up and dressed by eight to leave by nine to get there at the appointed ten. In excruciating slow motion, like ripping off the surface of my skin in all the places where my flesh touched his, I leave our bed.

~

Slowly, I dress Julian in his rust-colored velour shirt and charcoal gray corduroy trousers. I brush his hair and shave his cheeks. He smells clean, soapy, from last night's shower.

Ben loads the duffel bag in the car as I pour Julian's granola and slice his banana. Toast pops up and I spread his favorite British marmalade thickly on it. Julian munches his toast as if it were any day.

"Remember we went to Oak Creek last week and ate lunch?" I ask. Of course he doesn't remember. "We're going back there today, to that nice place with nice people. You're going to have lunch."

Julian smiles. I don't say "stay there."

Nervously I sit at the table beside him. "Julian, we're going to Oak Creek for lunch." I must tell him a shred of the truth.

In the car, Ben sits next to me in the front seat. Julian is buckled

in the back and I glance at him in the rear view mirror. He is asleep in three blocks, his head hanging awkwardly to one side.

"You've handled it all so well, Mom," Ben declares. "You've taken such good care of Dad. Now you are free."

I keep my eyes on the road, nodding silently.

"Now you should do whatever you want. You deserve anything...stay in bed for a week. Cry. Go out to eat. Go to movies. Fly to the Bahamas. You're free. You deserve to do just exactly what you want."

My eldest son lectures me on not filling up my new free time with household tasks and babysitting. Knowing Karen and Beiçola's hectic life, their daily scramble to work and care for the children, he knows it will be easy for me to slip into more housework and child care.

"This is your time, Mom," Ben warns. "You've been deprived for so long of a normal adult life."

A tumult of feelings churns in me as I listen to Ben and drive steadily across the bay. Mostly sadness, deep sadness. It is less than an hour since I peeled myself from Julian and forced myself out of our bed. Relief that the departure has gone smoothly so far. A trembling eagerness for my new life, whatever it might be. Anxiety over the final separation ahead.

Turning off the freeway, I drive down East Castro Valley Boulevard, winding through steep rounded hills bright green with spring grass. A pinto horse grazes in a corral; black goats butt each other by a fence. Soon we are there. A small white sign on the left reads "Oak Creek" in large turquoise letters, "Alzheimer's and Dementia Residential Care."

Ben grows silent. I turn left down a steep driveway where low tan buildings nestle against a hill covered with oak trees and willows.

"Julian," I say. "Wake up. We're here."

I get out my car door, then open his. I unbuckle his seat belt, leaning across his chest, forcing myself to focus fully on these concrete actions.

"Julian. We're at Oak Creek. We're at the nice place. There's lots of nice people here."

Julian stumbles out and walks in with me, hand in hand, so unsuspecting, so trusting. My heart pounds. I will my voice to sound natural, will belief in the rightness of what I am doing.

Inside the front door I hear the cheery sounds of a stand-up bass and a man singing. Most residents sit in the activity room—some slumped over dozing, some clapping, a few singing. Ben stands nervously. Vickie, the administrator, is on the phone behind the front desk. She waves at me but keeps talking, as a young woman in a blue shirt comes to us.

"Hello, Julian," she says, just like in *Complaints of a Dutiful Daughter*, when Debbie Hoffman first brings her mother to Oak Creek. "Hi there. Come on in. Would you like to hear the music?"

Ben, Julian, and I follow her into the activity room and pull three chairs into the circle. I glance around at the white-haired residents, all obviously much older than Julian. Yes, some slouch in chairs asleep, but others sing and call out the names of songs. Some even converse with each other. There is Doris Hoffman, from the film, in a lavender gym suit smiling and clapping, chatting with the plump woman beside her.

Julian walks slowly in his weird, jerky gait to an empty chair and sits down. He doesn't seem to notice the music. Immediately his head droops forward and he sleeps.

Soon Vickie appears, gesturing Ben and me to come to her office. As soon as I enter, she opens her arms and hugs me.

"Hard, isn't it?" she says. "It's really hard letting go. But we'll take good care of him."

My eyes fill with tears; I fight hard not to cry as I sign forms and fill out the necessary papers. Ben leaves to look around. Soon our business is over.

"Are you all right?" Vickie asks. "How are you doing? Don't worry, he'll be okay. I promise you—we'll take good care of Julian."

We discuss at length Julian's medications. "I'd like to see him off drugs," Vickie says. "People usually come here over-medicated. But we can handle behavior that families and day care centers can't tolerate." She explains that they like to see people's real personalities. "We can always add meds if we need to."

"Julian looks over-medicated," she repeats.

We decide to take him off Mellaril and see how he is. I am relieved. Now we can determine which of these new disturbing behaviors might be due to Mellaril and which to Alzheimer's. I am to call his neurologist and have him fax Vickie the new instructions.

Finally it is time for Ben and me to leave.

"When shall I come back?" I ask softly. In the film, Debbie Hoffman was told not to come for four days.

"Oh, leave him a day and come on Saturday," Vickie says.

"But you told Debbie Hoffman to stay away four days." I quote the film.

"People are different," Vickie says. "Some higher functioning people need more time to adjust. If they see their families too soon, they'll want to go home. But for Julian, it probably doesn't matter. You could come tomorrow as far as he's concerned. It's you I'm worried about, Ann."

Vickie looks straight at me.

"Go home and rest. Don't you worry. I promise you. He'll be fine."

Ben and I return hesitantly to the dining room where Julian is already sitting at a table with five others eating lasagna. Women in blue shirts pass around bowls of lemon pudding.

I walk up to Julian and lay my hand on his shoulder. "Hi, Darling," I say. "Did you have a good lunch? Here comes your pudding."

Julian never looks up.

"Eat your dessert, Julian. And I'll come back later. I'll see you soon. I'll come back later." I avoid saying the word, "goodbye."

And Ben and I turn away from Julian and walk out the front door.

A rush of emotions runs through me: guilt, relief, decisiveness, reluctance, pride, sadness. But mostly, a great wave of release.

I have found good people to care for Julian. I can no longer care for him on my own. It is no longer healthy, definitely, for me and most probably also for him. I feel a strong pull towards a new free life, just as I simultaneously feel the glue between Julian and me stretch and stretch and stretch and finally snap apart. Like pulling two ends of Antar's Silly Putty...pulling, pulling, stretching the sticky, tan plastic thinner and thinner until the final strand of connection snaps.

Something feels severed as I walk out of Oak Creek. I am crossing over a bridge. Rather, I've driven through a dark tunnel and am coming out on the other side.

"I'm glad Vickie said not to come tomorrow," I tell Ben as we drive back to Palo Alto. "I am exhausted."

"Let's do whatever you want today, Mom," Ben says. "Go out to lunch. Go for a walk. To a movie. You decide. I'm not going home until tomorrow."

Driving back across the bridge, we re-hash the morning, agreeing that Julian's departure has gone as well as it could. I feel pleased with myself. No regrets over what I told Julian. I tell Ben about our morning cuddle, but don't take my eyes off the road, and Ben grows strangely quiet. He may have been crying. He tells me later that he has a good feeling about Oak Creek, today being the first time he has seen it.

~

Back in Palo Alto, we eat lunch at the Fish Market, followed by a walk along the bay lands. I feel free, and exhausted, but I don't want to go home. I'm glad Ben came down to spend this day with me, glad for his companionship, his endorsement, his concern and support. We go to an early movie, then dinner, simple activities which I've been deprived of so long. Ben talks of literary events in San Francisco he and Greg will invite me to. Maybe I will join them next summer if they return to Cadiz?

Around ten, we drive home. The kids are asleep and Karen stands by the kitchen sink bent over the dishes. Beiçola, in his white uniform, has just returned from teaching his Capoeira and samba class. Both look at us anxiously as we walk in.

Over cups of tea, Ben describes in detail our arrival—and departure—from Oak Creek. Karen and Beiçola listen quietly as Ben tells his impressions. Mostly I feel too tired to talk. Vickie was right; I'm grateful that I don't have to go back tomorrow.

Entering my study, I collapse on a chair. I consider sleeping alone in our king-size bed, but I don't dare even open the door to our room. I don't want to look inside. I couldn't bear to see the empty bed, so I undress and lie stiffly on the narrow couch in my study. This long-dreaded moving day is over, but the feel of Julian, the look of Julian, swirls around me as I thrash about trying to get comfortable before sinking exhausted into a fitful sleep.

~

The next morning I wake around eight, flooded with thoughts of Julian.

Did he sleep last night? Did he wander the halls? Did they hug

him and talk to him as they promised they would? Does he feel abandoned? Does he understand that I put him away? Is he mad at me? Does he miss me? Might he possibly feel cared for and safe?

Lying alone in my study, the house throbs with Julian's absence. No Julian slowly eating his morning cereal. No Julian to dress, undress, take in the car.

Thirty-six years we slept together. Yesterday's cuddle remains tattooed onto the surface of my skin in all the places where his body touched mine, so warm and familiar, yet oddly, subtly, unresponsive.

Will I clear out his drawers and closets as if he had died? Will I clean his office near our bedroom and claim it as mine? Or will I wait until he really dies?

It's as if he had died, this ghastly departure. A mini-death, though it's not actually so. No Julian to dress and feed this morning. No Julian here. No Julian.

Only myself.

First Visit

ON SATURDAY MORNING, water drips off the rain gutters into a puddle outside my window. Loquat leaves hang clean and slick from last night's rain. White patches of sky backlight the branches.

It's six A.M. I've lain in bed awake for hours after another restless night, eyeing the clock from midnight till dawn. All this week I have slept badly. Funny. Since Julian is gone, I expected to sleep better, sleep off the exhaustion from the crescendo of care I have put out. But I am anxious, fretful.

In just a few hours I will visit Julian for the first time. How will I find him? Happy to see me, like when I picked him up from day care all this past year? Will he run towards me as soon as he sees me, his face lighting up? Will he hug me, kiss my neck and say, "Oh, it's you?"

Or will he be angry and sad-faced? Will he grab my arm and mutter, "Come on, let's go?" Will he cry? Will he hate me for what I have done? Will he still know me?

It's been forty-eight hours since Ben and I drove away from Oak

Creek. I have never left Julian this long since he's been so confused. Will his lack of time-sense help? Maybe he won't know how long it has been. He is used to my coming and going, used to being in the day care crowd. Maybe it doesn't matter anymore who puts on his shirt or sets a bowl of oatmeal before him. Maybe it doesn't matter if it's a professional caregiver instead of me.

Karen feels he doesn't know her, says it could be anybody's hand that leads him to the car or drives him to day care. Maybe now that he lives away from the house, gone from the intimacy of my daily touch, maybe he will lose his awareness of me too. Maybe the closeness we shared in our daily duet of dressing and undressing, showering and shaving, will fade away. Maybe he will no longer know me!

But perhaps he'll be better. He is off all drugs. Yesterday he stopped the Mellaril and Buspar. Maybe he will improve. Maybe his rapid decline these past two weeks—crawling on the floor, his jerky gait, his groping along walls like a blind man—was due to the Mellaril. God, I hope so, but I'm prepared for this not to be.

Soon I will get dressed and drive an hour across the bay to see him. Visiting a board and care center will be oddly familiar, for I have visited my father in many hospitals, convalescent units, and nursing homes. But now it's Julian, my husband Julian, in a dementia care center. My head understands these words, but my pounding heart needs to catch up.

~

Heart thumping, I push open the heavy front door and step into the pink carpeted hall of Oak Creek. Elderly residents mill about. A bent man shuffles back and forth, two women sleep on a bench, heads lolling to one side.

And there's Julian, jerking along, in his twitchy, puppet-like gait. Is he slightly better?

He walks in my direction, not yet aware I am here. For a few seconds I watch him, head down, moving in slow motion, spaced out in a world of his own. Not only is he like these demented others, he actually looks worse off than most.

When he gets closer, I call, "Julian, Julian, hello, Julian."

A flicker of a smile...brief, fleeting...then it is gone. He smiled, yes, I'm sure of that. I hug him, but he's stiff and unyielding. His

lips make a muted kissing sound, definitely a kiss, but not planted anywhere.

Then a gush of unintelligible words pours out, a flood of gibberish. Not in response to anything I say or ask, but a torrent of words, as if he wants to tell me something important. I understand nothing. He talked like this before we increased the Mellaril, which silenced him.

Has he improved, two days off meds? Is he filled with "things to tell me?" Maybe he is trying to explain what has happened since I left. Maybe he is furious that I did this to him. Maybe he is telling me how terrible he feels, or that he is okay.

All my interpretations are just that: projections and guesses. I'll never know.

I hug him close and try to sound cheerful.

"Julian, hello. I'm so happy to see you. Let's take a walk."

I take his hand and we stroll down the hall, past his room and around a corner where a bench is set in an alcove. We sit down and I stare at him, struggling to figure out how he is. His face is blank, revealing no expression that I can read.

"Are you okay?" I ask. "I want you to be safe and cared for." I don't dare say "happy."

He gives no answer.

"Do you want some sweeties? I brought you candy."

I fish in my purse and hand him a small bag of his favorite licorice. The stiff plastic bag crackles. He fiddles with it but can't open it. I reach in and slip a licorice in his mouth.

"Mm…good. Lovely, lovely," he says. The first words I have understood.

I pop in another, then another. Then I hand him the open bag and he reaches in and pulls out a piece.

"May I have one?" I ask, testing his comprehension. "May I have a piece of candy?" I extend my hand. "I want some licorice."

Slowly, carefully, he closes the bag, meticulously folding down the top and rolling it into a tight package. He starts to put it in his pocket, but I take it, drop it in my purse.

Laying my hands on his cheeks, I stick my face close to his, and kiss his nose.

"I love you," I say. "You're a wonderful man."

No smile this time, as there was the last night before he left. Is he mad at me? Does he not understand? Is he exhausted from the strain of adjusting to this new place? Is he punishing me, the way a two-year-old ignores the mother who just returned after a weekend trip?

"Transfer trauma," they call it in books. Dementia patients often decline when they move, I have read, and even after they adjust, they often do not regain skills they have lost. Or, as my friend Charles warned me, is this a sign of Julian disconnecting and pulling away?

Charles suggested when we last talked that Julian might deteriorate rapidly once he was placed. I am his "life support system," Charles said, his "lifeline to himself." Just as removing respirators and feeding tubes hastens death, so removing the intimacies of our life together might hasten his decline.

This sad responsibility presses on me. It is like taking a terminally ill man off a respirator, Charles said, removing life support and "letting nature take its course," which, theoretically, I think I approve of.

"Let's go for a walk," I tell Julian, as nothing is happening here on the bench. I desperately want some sign from him that he is all right.

I will come to realize a few visits later that I need to calm down. I must let Julian be, not wish for "something to happen," not expect him to respond. But I don't understand yet how to visit.

We go into his room to get his parka, which I slip on him, enjoying the familiar task of zipping it closed. It isn't really cold outside, but perhaps the jacket will signal that we're going for a walk. He seems comfortable in his old blue coat.

I take his hand and we walk back and forth across the patio. Am I imagining that we are walking quicker? Yes, his walk has improved; he stands straighter. His hips aren't jerking. I increase the pace, walking faster until he tires and slows down.

We stop before an aviary where gray mourning doves flutter down from a high branch to the ground near our feet. Their flapping wings make a whirring sound, but Julian doesn't blink or even see that sixteen birds just flew inches in front of us.

"See the birds, Julian."

He stares straight ahead.

"See the trees, Julian, the beautiful trees."

I persist. Outside the wooden fence enclosing the patio, oak trees and willows grow up the hillside. Dark branches reach over into the courtyard, moss covered, still dripping from last night's rain. He doesn't look up. But neither had he seen the egrets, sunsets, or marsh grass on our recent bay lands walks.

"The trees are beautiful, Julian."

It is hard to let go of needing a response from him.

Then I grip his arm and march back and forth across the patio singing, "You take the high road and I'll take the low road...," a favorite. We've sung this for years; as recently as last week he joined in humming the last line..."the bonnie, bonnie banks of Loch Lomond."

But when I come to the words "me and my true love will never meet again," I break down and sob. I can't sing. Hot tears spill down my cheeks. I try not to let Julian see them.

Inside the activity room, a man plays "Let Me Call You Sweetheart" on an electric guitar. Residents sit on rose-colored vinyl chairs around the room, most slump forward, heads drooping. Some look up and clap; a few sing. I lead Julian to a chair and push him down. He stands up. He sits down. He stands again, giving no response that he even hears the music.

Later, as I stand at the front desk asking a staff person how he is doing, Julian wanders off. A forlorn figure, stooped and gray, he shuffles down the hall away from me, groping his way along the wall. He looks a hundred years old. Reaching the glass door at the end of the corridor, he stands there, rubbing his hands on the glass.

Is he mad because I am talking to someone else? Is he tired from the strain of sustained interacting? Or is it neither of these, but rather his poor, plaque-filled brain telling him to keep on moving?

The caregiver, a young woman in a royal blue shirt, says, "Julian's doing fine."

"How do you know he's doing fine?"

"Well, he smiles in the morning. He's cooperative when we dress and undress him. He doesn't fight or resist his shower. He eats his meals."

I listen in silence to this low-level list of criteria.

"Don't worry," she says. "He's fine. We'll take good care of him."

I nod and peer into the dining room. Time for lunch. Residents sit quietly around tables as plates of food are set before them...a

roomful of white-haired men and women with advanced dementia. Julian sits among them, head drooping, sound asleep. I shake his shoulder but he doesn't wake up.

"Goodbye, Julian," I say. "You eat lunch and I'll see you later."

His eyes never open and I leave.

Third Visit

THE THIRD TIME I enter Oak Creek, I resolve to just observe Julian before saying hello. Right away I see him standing in the dining room, walking slowly, lifting his right hip, swinging his leg around in his odd, jerky gait. *That* isn't better.

Alone, moving in his own fog, he jerks slowly across the room until a caregiver in a blue shirt (they all wear blue shirts) goes to him.

"Hi, Julian. Hi, Julian," she says. "Smile, smile." She takes his hands and swings them from side to side until Julian manages a faint grin. The caregiver sees me and starts to bring him over, but I motion her to stop and she leaves Julian standing alone in the room's center, dazed.

I can't stand seeing him like this. I rush over and he actually smiles as I approach. Again, a flood of words gushes out, real and invented, gibberish with the intonation and inflection patterns of true speech. I hear the word "German," clearly. He repeats "German," which is embedded in nonsense syllables.

I hug and kiss him, put my face close to his, relieved that he is responding again. Maybe the Mellaril is leaving his system. Maybe his transfer trauma is easing.

Today he smiles a lot, no doubt about it, and answers more questions too:

"Do you want candy?"—"Yes."

"Do you want more?"—"Give me one."

"I love you."—"I love you too."

"You're a wonderful man."—"You're a good girl."

"You're a great guy."—"You're a funny dingy."

He reaches into the bag and removes two licorice bits, then folds the bag carefully and slips it in his pocket, just as he meticulously folded napkins and toilet paper at home.

Outside, he stands up straighter and walks faster. Hand in hand we stroll across the patio where I sing familiar songs, hoping he'll join me.

"Daisy, Daisy, give me your answer true. I'm half crazy over the love of you."

"From this valley they say you are going. I shall miss your sweet face and bright smile."

"You are my sunshine, my only sunshine, please don't take my sunshine away." As I sing this last line, my voice chokes. I never noticed how many songs I have sung mindlessly for years are about love and loss.

Julian hums along. Not just on the last line, today he hums soon after the song begins: the Israeli national anthem, "HaTikvah," "God Save the Queen," "Hava Nagila." Again we pause before the aviary but he looks down at his feet. Sixteen doves sit on two branches, but I say "See the birds" only once. I am also making progress.

Inside the dining room, residents sit in a circle as the activity director tosses a green plastic balloon to each person, who then bats it back. When she throws it to Julian, he catches it, holds it a minute, then pushes it away. Three times he catches and throws the ball. Hooray! Yesterday he only held it. Yesterday it bounced off his nose and he never even blinked.

A visiting ritual is evolving: walk the halls; sit on the bench and eat licorice; hold hands on the patio singing; pause to hug, look into each others' eyes and kiss; enter the activity room, stand there briefly, then leave; go into his room. Repeat the above. There is not too much else to do.

Finally I leave Julian sitting in the activity room, slumped in a chair.

"Bye," I say. "I have to go baby-sit Rasa." I avoid saying the word *home*. "I'll see you later."

Do I imagine that he looks away? That he looks sad? Or is he simply tired now from the strain of connecting? Is he glad to sink back into his Alzheimer's fog and not have to fight his way back into reality?

By the time I reach the front desk, his head hangs to one side and he's asleep, like half the others. For some reason, today, I feel better leaving him.

At the desk, a cheerful caregiver tells me again, "Julian is doing just fine." He's cooperative, eats well and is "so sweet." Yes, he crawled a bit, but they don't care.

I drive home through rounded hills covered with new spring grass—past a chestnut horse standing by a fence, past six black goats.

What do I really want for Julian? What do I want for myself? First I felt so strongly the need to hang on to him, for him to be "better," to be "okay." But as days drag on, I must practice letting him go.

"It's over. He's finished," I remind myself.

But I have felt this before. Our married life together is certainly finished. Maybe it's better for him to withdraw, fade away and slip more totally into his fog? Maybe it protects him against the pain of facing where he is now and what he's become.

But these are just guesses. Others at Oak Creek, like Doris Hoffman in the Alzheimer's film, seem cheerful enough. Several people there actually seem happy.

"Some think they're in a hotel," a caregiver told me. "Others believe they're on a cruise ship."

Maybe Julian will perk up once the Mellaril leaves his system, once he adjusts to his new surroundings. Maybe he'll have yet another period of his odd little version of "happy." Or, maybe he'll continue to withdraw.

I arrive at the toll booth for the Dumbarton Bridge, halfway home. The uncertainty of what will happen to Julian is exhausting, but whatever happens, I must get ready now for Julian soon not to know me. But how in the world do I prepare for that?

Fourth Visit

ON THIS EARLY, dark February evening, I visit Julian at a new time: after dinner, wondering what life is like around Oak Creek at night. In the television room, residents lounge in armchairs staring at a sitcom, some dozing, some chatting with a neighbor. On a bench in the lobby, a white-haired man and woman hold hands, leaning their heads together, eyes closed. It is like a cozy scene from a geriatric dorm.

Alone in the empty dining room, Julian stands unbuttoning his shirt. The shade of red is unfamiliar and I gasp; the shirt is not his. It feels important that he wear his own clothes. Too much of his identity is already gone. But when I see the label, I realize the shirt is inside out. It does belong to Julian.

Julian fumbles with the buttons, which are difficult to manage since they are inside the material, yanking at the top button until it tears loose. Then he pulls at the second.

"He's been taking his shirt off all evening," a blue-shirted caregiver explains. Since the caregivers don't wear name tags, I don't know anyone's name. But this is a smiling young caregiver with wavy brown hair who is always friendly.

Julian walks a few steps in his lurching, jerky gait, still fiddling with the buttons. I move towards him, lean against a nearby table and call, "Julian. Julian. Hi, Julian."

He doesn't look up, does not see or hear me. Just last week he noticed me across a room. Now, he doesn't.

I walk to him, stick my face close to his. "Hi, Julian. Hi, Julian," I say louder.

His eyes stare blankly at the floor.

"Hi, Julian. Hello. How are you?"

Finally his eyes lift and meet mine, but it's a vacant stare. Slowly a faint hint of a smile forms. I hug and kiss him. His lips purse; he kisses back. I take his hand and slip my other arm around his waist to begin our now-ritualized walk up and down the halls. As we move, he stands straighter and picks up speed. The jerkiness eases but he's back to his stooped shuffle. We march down the hall and back. It is dark outside, too cold to go out. Residents and caregivers stroll about in the bustle of the evening bedtime routine. With others so close, I feel too self-conscious to sing and I have no licorice. Julian slows down. I can't think of anything to do.

"Are you tired?" I ask.

"Yes, yes."

"Do you want to sleep?"

"Yes."

A heavy-set caregiver overhears me. "We put him to bed at seven yesterday," she says. "And he slept till eleven."

I'm relieved to hear he finally slept. "It was like that at home," I

tell her. "He only stayed in bed from seven to eleven. Then he was up all night. It's good to put him to sleep early."

The caregiver holds out his navy and white-striped pajamas.

"Would you like me to undress him?" I ask, suddenly longing to touch him.

She hands me his pajamas. "Sure, if you want."

In room six, his roommate, George, a handsome, lean man with sandy-colored hair, sits in his underwear pulling on pajama bottoms, looking like a perfectly normal man getting ready for bed.

"If you wire it to the antenna, it'll work better," George tells me. "I've arranged for the maneuvers and the transfer of the whole operation."

Speaking in wonderful sentences, George is always planning and arranging business operations.

"You've taken care of everything," I say. "Now you can rest."

Slipping between the sheets, George lies on his back under the covers. I put on Julian's pajamas while George prattles on.

"That's great that you arranged things," I say. The room feels cozy, a little like two roommates in a college dorm, only no books are in sight and Julian never converses with George.

An attractive, muscular man in his early seventies, George is pleasant, talkative. When I first saw him, I never dreamed he was a resident. I figured he was a visitor, like me. His cheerful flow of speech seemed normal until I heard the looseness of thought, the non-sequitors, the lack of logic, even though his sentences sounded perfect. Responsive and appropriate, George looks swell, he just doesn't make sense.

A few years back, Julian also gave this impression. For quite a while he could "pass as normal" in casual exchanges. What I'd give now for Julian to return to that state, even though I was frustrated and angered by it at the time. Who put George here, I wonder. He still seems capable of "normal life." But what do I really know of his impairments and what constraints his family has? Perhaps he lived alone; perhaps there was no one to care for him.

"You look tired, darling," I say to Julian, who stands near me in his striped pajamas.

"Yes, yes," he says.

I pull back his bedspread, wondering how to get him in bed,

when a caregiver comes in, pushes him down, lifts his legs, swings them around, and shoves him down on the pillow. One-two-three. Rougher than I would have, swifter too. But Julian is down. She puts his clothes in his dresser and flicks off the light.

Julian rolls over on his side, face towards the wall, his gray hair on the clean white pillow. I pull the sheet up around his ears and bend to kiss his whiskery cheek. His eyes are closed; he's already asleep.

"Goodnight, darling. See you later." A wave of tenderness floods me. "Bye, George. Sweet dreams, you guys." I pause at the door to watch Julian sleep.

Back in my car, the dashboard clock reads 6:55. Red taillights before me and headlights approaching are the only lights on the pitch black freeway.

Seeing Julian asleep in his bed has somehow comforted me. The first three nights, he paced all night, caregivers told me, and never slept. How much of his state is due to exhaustion, bewilderment, utter fatigue? Will he adjust? Will he ever be better? By "better," I mean return to where he was a few weeks ago: smile more, be more responsive, enjoy something besides licorice.

A week ago, I imagined we would go out for ice cream, eat dinner in restaurants, walk in a park. I never dreamed he would plummet like this.

"Let go, let go," I tell myself. "Let him be however he is. Stop needing him to respond." My task now is to keep saying this long goodbye, keep letting him go.

At the same time, I must not abandon him. I cannot, will not, dump him and disappear. But what do my visits mean to him? Does he know that Ann, his wife of thirty-five years, has come? Surely he doesn't register, "My wife put me here and only visits one hour a day." I doubt if he has enough cognitive ability to be mad, blame me or feel resentful.

But do my visits help? Do they help him feel on some primitive level that he is not abandoned? Is my touch comforting, familiar? Does he enjoy my voice, my hug, my kiss? If no cortical memory trace exists recording a visit, does my presence influence how he feels?

Whizzing down the freeway, I move over to the fast lane, and remember reading as a psychology student that institutionalized in-

fants deteriorated from lack of stimulation and touch. People in nursing homes who are not visited decline more rapidly, I have also read.

The toll booth for the bridge appears, the demarcation between Julian's new life in the east bay and my new life in the west. Rolling down the window, I hand over my dollar, then speed across the Dumbarton Bridge.

It is important to visit, I decide, regularly and often. Julian might improve once the Mellaril leaves his system, once he becomes rested, once he grows less stunned from his sudden transplant. Besides, *I* need to visit. I need to see him, touch him, give him a kiss; I am not ready to distance myself and leave.

~

Back in the house, the children, already in pajamas, lean over the hamster cage watching "Antara" race around her exercise wheel, her tiny legs a blur of brown.

"Gramma. Look, look...Antara's running," the children cry, as the wheel squeaks faster and faster. Lifting the hamster out of her cage, they hand her to me. I hold her silky, quivering body in the palm of my hand and stroke her soft fur. Another day in my new life ends. I am home.

Five, Six, Seven, Eight

FIFTH VISIT. After lunch: the dining room is crowded with thirty-five residents sitting at tables eating dessert. Only Julian is standing, not going anywhere, not doing anything...just standing.

But he looks better, his face less waxy, less drawn. He seems rested, handsome even in his olive-green corduroy pants and the new plaid shirt my sister gave him for Christmas. I scrutinize his posture and movements before going in.

Seeing me, he smiles and points his index finger, just as he did when I used to pick him up from day care. More smiles today. Some little exchanges:

"I love you."—"I love you too."

"You're a wonderful man."—"You're a good girl."

"Do you want to walk?"—"Come on, let's go."

Outside, hand in hand, he stands straight and walks briskly back and forth. Back in the activity room, he actually sits down and holds a bean bag which a staff person gives him, but he has no idea that he is to toss it into a hoop as the others are doing.

Suddenly Julian seems tired. We go into his room and he sits on George's bed, looking like he needs to sleep. When I take off his shoes and glasses, he lies down and I fluff a pillow under his head. His eyes close and he drops off to sleep, resting sweetly on his side, hand cupped under his cheek. I tiptoe out, feeling for the first time that he is less of an alien transplant, that he looks more like he belongs here.

~

The next day, Ben comes down from San Francisco and he and I take Rasa with us to see Julian. It's Ben's first visit, my sixth, and Ben is nervous. He has phoned nearly every night to inquire how Julian is and I have reported each nuance of his dad's behavior and the swings in my mood. I have prepared him, told him not to expect a response, not to expect Julian to know him.

I explain that I am trying to learn to let Julian go.

When we enter, Julian is wearing tan cotton pants and a peacock blue shirt, his hair freshly washed and combed. Standing tall and walking smoothly, he looks terrific as Ben hands him a chocolate.

"Mm...lovely," Julian says, responding to the candy, but not exactly to Ben.

Rasa, her legs gripping my waist, head nestled on my shoulder, stares wide-eyed from the safety of my neck as residents drift towards her. This beautiful child attracts people as if she is a bright light in a dark room.

Clustered around us are several curious residents: a tall, smiling man who only mumbles, named Barry; a white-haired woman with a soft Irish accent named Maureen; and Fred, knees permanently bent, his body stooped at the waist, each speaking to Rasa in the exaggerated inflections adults use when speaking to toddlers. A plump woman named Irene, makes clucking noises and waves. Doris Hoffman, wearing a pale blue sweat suit, strolls by and chucks Rasa under her chin.

By now, I know many residents and greet them by name, and I introduce Doris and Ben.

"Doris, this is my son. He lived in New York," I tell her, knowing from Debbie's film that she lived there too.

"New York...Brooklyn...Queens...the Bronx. Wasn't that great?" Doris says, grinning and chucking Ben under the chin, just like she did Rasa. "Twenty-three...eighty-seven and sixty-two."

"Brooklyn. I lived in Brooklyn. Did you live in Brooklyn?" Ben surprises me by falling right into the jolly, nonsensical patter I also have learned. "Eighty-seven and sixty-two...yes, yes."

Then we head outside where I am thrilled to watch Julian walk normally, as I am still haunted by images of him crawling around on the floor. On the patio we meet Julian's roommate, George, and I introduce him to Ben, who listens attentively as George relates the latest business plans, "changing the entire operation to maximize profits."

"You've got great ideas for improving the office," Ben agrees.

Back in the activity room, a man plays stand-up bass, singing "My Wild Irish Rose," as we all sit down, Rasa cuddling on my lap. Mesmerized by the music, she nods her head in time to the beat. The plump woman, Irene, whom we met in the hall, sits next to me jabbering away to Rasa, punctuating her comments with clucks, telling me about her great-grandchildren.

Julian is at his best today: many smiles, more responses, his walking perfect. He doesn't really engage with Ben or Rasa, but he seems comfortable, back in his body, aware of his surroundings. He notices other people, points at one man, talks gibberish to another. We leave him sitting at a table, waiting for lunch.

Driving home, Rasa sleeps in her car seat while Ben and I review the visit: how good Julian looks, how well he walked, how "alert" he seemed. We call him alert and the staff calls him alert, though any stranger would label him a walking zombie. It's all so relative.

Ben and I laugh merrily over our encounters with Doris, George, and Irene who emerge now as distinct individuals, funny and interesting, no longer a blur of "those demented others." Each is a person with a history as complex as Julian's, each deserving our respect. The sun shines clear and bright as we drive home and phone Jeff in New York to tell him how much better Julian is and how much we enjoyed our visit.

~

Since I am babysitting Rasa today, I take her with me again to visit Julian. Naturally, I expect to repeat yesterday's upbeat visit, but I should know better. In this disease, nothing stays the same.

Julian looks good when I enter, wearing tan corduroy pants and his rust-colored shirt. Somehow seeing him in familiar clothes reassures me and I always notice what he's wearing.

But today his face looks sad, his mouth pinched, set in a grim line. He comes to me, but he doesn't smile. He keeps saying, "Come on, let's go. Come on, let's go."

My heart sinks. Does he want to go home? Does he want me to take him out of here? Or does he mean he wants to keep on walking the halls? He seems restless, never stops moving, not comfortable and relaxed like he was yesterday.

"Come on, let's go," he demands. I get only a few smiles and just one kiss. He keeps pulling my hand.

Again the mumbling man, Barry, plump Irene, and Maureen with the Irish accent all gather round to admire Rasa, but Julian doesn't look at his granddaughter. He never even notices she's here.

Outside in the patio, I feel pulled in opposite directions: Julian wants constant motion; Rasa wants to stand and watch the birds. Julian seems remote, angry, annoyed. If these are my projections, I'll never know.

~

Julian has been at the dementia center ten days now and I've made seven visits in a row. They merge together in my mind. The differences between them grow more subtle, perhaps reflecting my moods more than his.

What difference does it make really which shirt he's wearing or whether we walk the right hall first or the left? Who cares how many times he smiled? Yes, there is a small range of fluctuations, of improvement and slips. But after yesterday's wonderful visit, today I feel low.

I ask Vickie why he is walking badly when for the past few days he walked so well.

"It's probably the disease." Then Vickie adds, "But he isn't crawling."

Yes, but I want his gait to improve now that he's off the Mellaril; I fantasize phoning his neurologist to tell him Julian is better. I *am* still

attached: to Julian improving, to his becoming cheerful like Doris Hoffman, to his being happy to see me.

Let go, I remind myself. Stop dwelling on the details of each visit and making visiting Julian the top priority of each day.

Probably Julian has lost track of time; how often I see him no longer matters. Still, I hang on to Julian by a silver, gossamer thread, which is pulling, pulling, stretching, stretching. Our connection is so thin, so fragile, maybe it already exists only in my mind.

～

Julian stands straight and tall when I arrive for my eighth visit. For the first time, he recognizes me and walks right over, taking my arm, hooking it over his and leading me, yes, leading me, down the hall. He doesn't wander aimlessly. He marches me to places: down this hall, out this door, back in, as if he is showing me around.

In the dining room, he smiles at the activity director, takes her hand and kisses it. He catches the green ball twice and throws it back, then bats it with his hand.

But the next time, he just holds it, suddenly forgetting what to do. He holds it for several seconds, then drops it on the floor. The activity director smiles. "See...isn't he better?"

Julian isn't wearing his glasses. When I ask about them at the front desk, the receptionist says sheepishly, "Oh, they've been missing since yesterday. He must have taken them off, laid them down and someone else picked them up. It happens around here. Tomorrow we'll do a room search."

As she explains, Irene walks by wearing two pairs of glasses. Apparently, she has picked up a second pair and put them on top of her own. The outer frame looks like Julian's.

"Look at that!" I exclaim.

"Oh, Irene...could I please borrow your glasses?" the receptionist asks.

Irene removes the outer pair and cheerfully hands it over. How skillfully the staff handles potentially explosive situations.

"You have to have a sense of humor around here," the receptionist says.

Outside, Julian walks briskly, smoothly, no jerking, no twitches. Today he decides to explore the area behind the aviary, walking over uneven redwood chips with no problem. Then, he straddles the

white handrails that parallel the ramp to the door, like a big gray-haired kid climbing a jungle gym in the park.

At lunch time, I take Julian into the dining room for lasagna and green beans. Feeling thrilled with his improvement, I rush to the front desk to tell the staff what good shape he's in, and then decide to check on him once again before leaving.

But he has fallen asleep over his plate, his fingers red with lasagna sauce, his head hanging forward. His glass is knocked over, and milk has spilled onto his plate and trickles off the table. Shrugging my shoulders, I smile and head towards home, my first eight visits over.

A Fragile Ledge

THE NEXT WEEK I check out books on tape from the library for my drives to Oak Creek: *The English Patient*, *To the Lighthouse*, *Remains of the Day*. Before each trip I buy a *cafe latte*, sip coffee and listen to a good story driving there and back, turning the two-hour drive into two hours of "reading." Unlike my dutiful visits with my father, visiting Julian is becoming a pleasurable part of my week. I *want* to see Julian.

Another week goes by, of increasingly satisfying visits. No longer distinct, they merge and fold one into the other, like swirling chocolate batter in marble cake.

Some days Julian wears his tan corduroy trousers or his olive-green ones, sometimes his blue shirt, his plaid or his rust-colored velour one. Always he is clean, his hair shampooed, his cheeks smooth.

Each day for the past week he smiles when he sees me, recognizing me from across the room. I no longer need to stick my face inches from his and repeat, "Julian, hi, Julian, Julian, hello, how are you, Julian" before he even lifts his eyes to see a face before him, much less know it's me.

This past week, I'm sure he knows me. "Annie," he says at least once each visit. "I love you" or "you're a good girl" or "let's go this way" or "I have to pee."

Taking my hand firmly, he pulls me to where he wants to go. We walk quickly, at a normal pace, down the three hallways, back and

forth on the patio. He stands taller and once again I look up the familiar six-inch angle into his eyes.

He smiles often—when I speak, when the staff directs cheerful remarks to him, and when we go outdoors into bright sun.

Julian doesn't know where his room is, or that George is his roommate, but he wanders freely, up and down the halls, in and out the four different doors. While a room full of people sit listening to a man play Mozart on a cello, or a woman singing old show tunes, Julian walks outside, oblivious to the activity programs. He stands during meals, the staff tells me, so they seat him near the wall where he's less likely to get up. Often he reaches and grabs other residents' food.

But Julian seems content, striding the halls, opening and closing bedroom doors. The staff smiles and talks to him as they pass; he gets lots of attention. I revel in his voice saying "Oh, Annie" and singing with me "Hava Nagila."

Julian is where he needs to be. Off Mellaril, cared for by kind, attentive staff, Julian is, unexpectedly, thriving; and, freed from the grind of daily care, I can come and be his friend.

Today, standing outside the aviary, pressing our bodies together in sunshine, he looks handsome, "normal." When we kiss lightly on the lips, he throws back his head and laughs.

A young staff person washing windows nearby looks at us and smiles.

"It's like being a teenager with nowhere to go," I joke. "In high school, I necked with my boyfriend in cars."

Now Julian and I steal kisses wherever we can. Humorous, yes, but the topic is important. Married nearly thirty-six years, the desire for physical contact doesn't disappear overnight.

Am I crazy kissing Julian on the mouth, hugging him tightly, pressing against him? But I need this closeness. I enjoy it and he does too. People with dementia still need physical contact. Maybe it contributes to their sense of well-being.

The heart connection between Julian and me still beats strong. There he is, his smiling sweet self, dressed in his green plaid shirt, his clean corduroy trousers, looking fine. He smells of shampoo and shaving cream. His body feels firm as we hug—not romantically, certainly not seductively, not sexually—but a great deal more than

the hug of mother and child, or the casual embrace of siblings or friends.

I have lain with this man, rolled and tumbled, known him in all places and he me. Over thirty-five years we've been intimate: loved, fought, quarreled, caressed, confided, whispered, shouted, played, delighted and comforted each other. Here he still is: his body handsome and familiar, his mind turned to mush.

"I love you," I tell him, taking his face between my hands, looking deep in his eyes, so there is no mistaking me. "I love you so much."

A wide grin spreads across his face, his body relaxes against me.

"A good girl," he says, trailing his fingers through my hair. His touch is gentle. Tears blur my vision. Of course he knows me. He is still a person, a good measure of Julian's essence still beats inside.

What does it mean to love a man with advanced dementia? I am young, healthy and strong. At fifty-eight, God willing, I have lots of living left. Already, just in the past two weeks, I've gone to movies, a play, dinners and hikes with friends. What am I doing feeling such deep affection for a man who can barely bat back a green balloon?

When it's time to go, I say quietly, "Julian, I've work to do. See you later." Never do I say, "I'm going home." He doesn't cling to me, follow me to the door or in any way protest my departure as I feared he would, like the woman at the dementia unit I visited who kept crying, "I want to go home!"

A month ago, I feared our life was over. Now I savor this tenuous reprieve. Like mountain climbers making a dangerous descent, roped together, Julian and I rest momentarily on a fragile ledge, with dizzying glimpses of the abyss below.

Valentine's Party

SUNDAY MORNING I put on my only red blouse. It is almost time for my first Oak Creek family event, a Valentine party.

Wanting to visit Julian before it starts, I arrive twenty minutes early. There he is, milling about the foyer—handsome, smiling, dressed in a teal blue shirt and gray corduroy trousers, his hair freshly combed. He comes right towards me, pointing his finger: his way of saying "Oh, I know you."

Arm in arm we stroll the halls as visitors arrive. Through the doors to the dining room, I hear musicians warming up, clarinet scales pierce the air. Wives, husbands, sons, daughters, and grandchildren fill the entrance area, embracing loved ones midst the bustle of greetings, the cheery commotion before a party.

"Each month we have a family gathering," Vickie told me that long ago day (only two weeks, really) when Julian was admitted, and Debbie Hoffman told me on the phone she never misses their parties.

As the door opens, residents and families flow into the large dining room decorated with red paper streamers and cardboard cupids. White plastic cloths cover the tables, shiny red hearts strewn about. A jazz band—drums, clarinet, bass and piano—belts out familiar tunes.

Julian and I sit near the piano player, where I survey the jolly scene. Residents are dressed up for the occasion: women in necklaces and earrings, a few men in sport coats. Instead of the usual jogging suits, some women wear pantyhose and dresses.

Beating my hands on the table in time to the music, I watch Julian, who hardly notices the band. No head wagging, no finger snapping as he used to do at day care. But he sits next to me and applauds whenever a song is finished.

I lean over to him attempting conversation: "Do you like the music, Julian?" "Isn't the clarinet nice?" "Soon we'll have cake."

No response. But we sit together in the festive room listening to the cheery sounds. Occasionally he stands up and I try to get him to dance, but he just stands still holding my hands. I can't get him moving to the beat, as not so long ago he could do.

~

The band plays, "Let Me Call You Sweetheart," and every time they sing *"I'm in love with you,"* tears mist my eyes.

Ridiculous: crying over this corny song at this simple party. But unsuspected emotions boil to the surface and spill out: sadness at Julian's lack of responsiveness, happiness sitting beside him, seeing him looking so well, disbelief that he is actually living in a dementia center, joy at the intense connection I feel holding his hand. In some odd way, we are still a couple, even here at an Alzheimer's care center.

Little dramas play out. At the next table, petite Debbie Hoffman leans towards her mother, Doris, chatting and laughing, looking like any daughter and elderly mother having a little tea-time chat. Though Doris's language makes no sense, she engages animatedly in the give-and-take of conversation, nodding, answering, rattling off her beloved numbers.

Across the table, an auburn-haired woman sits next to a bent, ancient woman with similar features, trying to get her to open the brightly wrapped gift she has brought. "Open it, Mother," she urges. "Open your present." But the older woman's face is blank and she stares at her plate. Finally the daughter tears off the paper and pulls out a soft white sweater, but her mother won't touch it, won't even look at it. Disappointment washes over the daughter's face, but she lays the sweater on her lap, gently takes her mother's hands and simply holds them.

Next to Julian, two balding men sit on either side of the man they call "Pop," waiting for caregivers to serve plates of cherry cheesecake and vanilla ice cream. Julian's face lights up as he is handed a cup of hot cocoa with whipped cream.

"Mm, lovely," he declares sipping it eagerly.

Children run about, spill their cocoa, munch cookies, as at any family holiday gathering. As the band plays and we eat our cheesecake, suddenly, thin "Grandpa" walks towards us, pointing to Julian's beard. Leaning over, he declares, "That man needs a shave!"

"What, Alan? You don't like my husband's beard?" I laugh.

Life goes on here at Oak Creek. Each demented person, so limited, so impaired, is at the narrow constricting end of life, but each is special. Each retains shreds of connection to families only dimly remembered and perceived. Many residents sit with family, but many, too many, sit alone.

One small dumpy woman hunches motionless across from me, her face still, her eyes blank, never moving except when the cheesecake appears. Grabbing at her piece, she shoves gooey bits into her mouth, blobs dropping onto her blouse. She has no visitor. I try to catch her eye to say something, but she never looks up.

Suddenly a staff person stands near her, grasps her hands and pulls her to standing. This gentle, blue-shirted caregiver smiles and begins slowly shifting her weight back and forth to the music's beat.

The older woman stands rock still, like a petrified lump as the caregiver continues swaying and humming. Slowly the woman begins to move, almost imperceptibly at first, weight first on one leg, then the other, until she is actually moving in time to the music and a faint smile creeps across her wrinkled face.

At three sharp, the band stops playing. Musicians put their instruments into black cases, the party is over. Folks drift from the dining room. Small children run about the halls begging permission to go outside to "see the birds," just like Rasa.

While Julian wanders aimlessly, I "chat" with Doris Hoffman, who points her finger at my face, smiles broadly and announces, "Twenty-seven, thirty-two, ninety-eight...and wasn't it lovely!"

Then I introduce myself to Debbie, thanking her for talking to me on the phone a few months back. She looks at me, her eyes soft and filled with compassion. She asks how it's going. I tell her that Julian seems to be doing okay, but I get weepy as I speak. She reassures me that Oak Creek takes excellent care of the residents, and acknowledges how hard it is to get used to seeing a relative here.

Gentle Maureen drifts by holding three paper plates, and in her soft Irish accent, complains, "I had five boys...and they never helped me with the dishes...."

In the hall George walks past, conveying his current plans for "improving the administration and management techniques." He is so much higher functioning than Julian that it must be hard sharing a room with Julian.

Residents mill around, stroll up and down, unusually active for this time of day. An excited energy lingers, as when guests leave after a child's birthday and the kids are hyped on sugar and need to calm down.

Julian wanders about, not seeming to notice my departure. My last sight of him is the back of his blue shirt receding down the hall. Now I drive home alone across the bay, emotionally drained.

Simple as the party was, Julian still has minimal semblance of a cheery life. It amazes me that so many times I've felt his "life was over"; I am astonished to see that it isn't yet. Reduced, yes. Drastically simplified, yes. But emotional and rewarding still.

If only I can open myself to catch these fleeting moments, savor and cherish them, press them firmly into my heart.

Lake Chabot

BRIGHT SUN SHINES after days of rain. Thick white clouds roil above steep hills, lush with new grass. My car pulls into Oak Creek's driveway.

Julian's been here three weeks. I have lost track of how many times I visit. What I know is that I look forward to seeing him and feel good when I leave. How could I have foreseen—in the depth of my sadness and the trough of his decline—that I would ever again feel good?

Julian is wandering around the dining room as I enter, wearing a dark gray cable knit sweater that is not his. Standing quietly in the doorway, I gesture to the caregiver to leave him be as I like watching him a while unnoticed.

He stands in back of Doris Hoffman who sits at the table finishing her lunch. Putting one hand on her shoulder, he reaches over and grabs her pie.

I just stand there, waiting to see what will happen, what the staff will do, but they don't do anything. Like me, they watch as Doris swats Julian's hand and turns back to her dessert.

Then Julian approaches a tiny white-haired woman in a pink sweat suit and lays his hand on her thigh. The staff keep their eyes on her, but they don't intervene. The woman in pink pushes Julian, ordering "go away." Next he spies Fred's plate of lasagna still on the table. As Julian reaches for it, Fred yanks the plate from him, muttering "son of a bitch." Amazing how, like pre-school children, they often can settle their own conflicts.

"Julian likes to eat other people's food," a young staff person in a blue shirt tells me, laughing. "But he never hurts anyone. Most folks here can take care of themselves."

Taking Julian's hand, she brings him to me as his face breaks into a huge grin. I will see this delight three more times in the next half hour: when I return from the bathroom, when he returns from the bathroom, and when I approach after getting his coat.

"Oh it's you...you!" He has no memory that he's already met me. Instead, he has four times the pleasure, greeting me each time as if it's the first.

Arm in arm we go outside onto the patio where Julian jabbers

away, long enthusiastic sentences I can't understand. Often he looks into my eyes and smiles sweetly. When I take his face in my hands and kiss him on the lips, he throws back his head and laughs.

"You are a wonderful man," I tell him. "I'm so proud of you." Pleasure sweeps over him, his eyes light up.

We stride briskly back and forth in the sun. He walks well, fast, normally. No more jerking, no twitch. He joins me in humming almost all of "Tumbalalaika," "Bonnie Bonnie Banks of Loch Lomond," "You Are My Sunshine," and two Yiddish tunes. Not the words, but the melody, right on pitch.

Vickie appears on the patio and we chat about the beautiful weather, how well Julian's doing.

"We just love him here," she says. "He's so sweet, so happy."

We both gaze at Julian who is cheerfully climbing over the white metal rail near the door.

"Why don't you take him out today?" Vickie suddenly asks.

My mouth hangs open as I stare at her, surprised by these words.

I had imagined taking him to restaurants and parks before he came here, hoping to continue shreds of normal life, just as I'd taken my father on outings all those years he lived in assisted living homes.

But Julian was in such dreadful shape when he arrived, there was no point in an outing. He never knew where he was. A lake, a forest, a sunset—none of it mattered. He didn't notice anything, and he walked slower even than my old father.

After the Mellaril wore off, I considered taking him for a drive, but I worried he might protest coming back.

"Go on." Vickie urges me. "Take him out."

"But what if he doesn't want to return?"

"He'll be fine," she reassures me.

"You've been right about a lot of things," I say.

~

Soon Julian is sitting in the passenger seat of our car, cheerful and happy, normal as can be, just like in old times. I can't believe he has been in Oak Creek nearly a month. I play a Jewish tape and Julian smiles at the music as I drive to Lake Chabot, a nearby regional park.

The lake lies in a narrow canyon with steep wooded hills rising on both sides. Mallards and Canada geese waddle about the sandy

bank. We pause, hear them quack and honk, and Julian smiles. For months before he came to Oak Creek, he never responded to anything I showed him.

Hand in hand we walk along the wide path on the lake's south side watching red, white, and blue flags flap from high poles attached to the boat dock. Sun glistens on the water, tiny sparkles of light. Oak trees, pines, and madrone cover the hillside, and Julian and I turn our faces to the hot sun.

"Lovely, lovely," Julian says.

I can't believe the joy I feel: Julian and me, walking silently beside the lake. Julian and me, hand in hand, the sun on our faces, a cool breeze in our hair. Content, once again outside the dementia center, doing something normal. Who would believe it?

We reach the first bench and sit for a few minutes gazing at sparkling water, my head nestled on Julian's shoulder. Reluctantly I stand up and turn back towards the car. Life has suddenly opened a little: we can go out. Vickie was right. Another fleeting pause in Julian's decline, another unexpected pleasure. I vow to grab it. I will take him out whenever I visit: return to Lake Chabot with a picnic, bring the kids for a barbecue maybe, take longer hikes on the lakeside path.

Happiness fills me as I drive Julian back to Oak Creek. But as we pull into the driveway, my face grows tense. What if he doesn't want to leave me? What if he refuses to go in the door?

But Julian slides out of the car and bounces back in. It's almost snack time.

"Hi, Julian, you're home!" A caregiver gives him a hug. "Come on in and have an apple." Julian laughs, takes her hand and follows her to the dining room.

Julian is home.

Art Group

THE NEXT SATURDAY MORNING, I climb the stairs to a loft in a converted warehouse where I've been invited to an art therapist's studio for a day of self-expression through art.

"It's not about painting a good picture," my friend Connie assures

me as we walk down the hall. "You don't have to be an artist," Eileen adds. "I can't draw a thing."

Still it is with trepidation that I enter the spacious room, bearing the salad I've brought as my contribution to the pot luck lunch. Three brick walls are painted white; wide high windows flood the studio with light. In the tiny kitchen area in one corner, the leader sets out coffee and an assortment of teas, while Connie cuts up melon and Eileen lays cinnamon rolls on a colorful hand-painted plate.

I am no artist. I'm verbal, linear, concrete. My hands don't make or fix things, sew or handle tools. I stopped drawing when I was ten and have avoided arts 'n' crafts ever since.

But I feel comfortable in the "check-in time," when eight women settle themselves on a couch and armchairs and listen intently as each tells how she feels today and what is going on in her life. A woman in a mauve sweat shirt with a picture of an otter and "Monterey Aquarium" on it talks of marital problems. The woman curled in the armchair sipping tea describes struggling to find meaningful activities now that she has retired, a third tells about her son who is abusing drugs.

When my turn comes, I tell them, "My husband's had Alzheimer's for six years and has just moved to residential care," explaining how badly he deteriorated, how last month I had to place him in an Alzheimer's center.

The women look at me with sorrowful eyes.

After the check-ins, we disperse to begin two hours of silent work, rummaging around a counter covered with water colors, collage materials, paints and clay, before taking our supplies to some quiet spot. Without thinking, I head straight for the clay. My hands need to hold and grasp something heavy.

Yellow and red bricks of plasticene lie in large packages. When I break off a yellow chunk, it feels cold and hard. Kneading it with my fingers, I stretch, pull, squeeze and push as slowly the stiff dough warms and softens enough to pinch a shape. A knob of a head emerges from the yellow lump, then a neck, back, two legs and feet. The faceless figure stands on thick yellow legs. I pinch off two smaller pieces, roll them into fat snakes, fashioning arms.

Bending the figure forward at the waist, I attach the snakes to

each shoulder. The arms hang straight down, like a gorilla, like Julian on Mellaril...standing motionless in a trance, arms dangling uselessly.

Shaping the legs, I then create a spine, broad shoulders, a narrow waist. Totally immersed in my work, I never even glance at what others are doing. This figure absorbs me, satisfies me. It is Julian on Mellaril: stooped, expressionless, unresponsive, stiff. I press his feet firmly onto the table. He stands slouched and still, looking exactly like I saw him those last sad weeks at home.

Next I pull another chunk of cold yellow, working it until it becomes yielding and warm. A thick roll this time, a pinch at one end for a neck, a small lump for a head, two curved legs. This figure lies on the table: it is Julian curled on his side, asleep.

A red piece of plasticene forms a shorter figure: me, identical to the yellow Julian. I press the red figure against the yellow, pinch them together along their entire length. Smoothing their bodies together, I run my finger along the seam where yellow meets red, feeling Julian curled around me in bed that last morning. My back recalls his familiar warmth as we lay together that last time.

I feel his heat and our hot attachment, relive the searing rip when my body left his, as I peeled myself from him before taking him to residential care. Rolling a thick yellow arm for Julian, I fold it over the red me. The plasticene figures lie quietly snuggled together on the table.

Next, I make a new yellow figure, taller, standing erect. His arm is outstretched to greet me when I visit him at Oak Creek: Julian off drugs.

His finger points. "Oh, it's you, it's you!": the sure sign of recognition. My clay shows the miracle of his improvement: Julian off Mellaril, awake again, walking normally, standing straight, smiling, laughing, most of all, knowing me.

A tall yellow figure and a short red one emerge next, a couple standing side by side. The red one's head rests on the yellow shoulder. One red arm encircles his waist, the other holds his hand. They walk together...me and Julian...strolling around Oak Creek...up and down hallways, back and forth across the concrete patio, holding each other, hugging, pressing against each other...our joyful connection.

Finally I grasp a red chunk of plasticene, intending to make one last figure. "What to make of me?" I think as I soften the dough.

"Time's up," someone suddenly says. "Finish your work."

No time to form the last figure. No time to decide how she should be, what she should be doing.

"What to make of me?" The question throbs as I plop down the red lump, a thick vertical blob of plasticene with no shape at all.

As the other women put away paints and brushes, I set my figures on a narrow board: the yellow, stooped Julian, crushed by Mellaril; Julian and me lying together; his new erect, drugless state; our lively walks arm in arm around Oak Creek; and last, the thick red unshaped lump of me.

I gaze at the figures. My hands created these forms with no thoughts, no words. But my body remembers it all. Here they stand, testimony to what has happened.

～

After lunch we gather again on the sofa and chairs, where each woman presents her work. Others comment, exclaim, pose questions, say what interests and impresses them.

When my turn comes, I place my line of figures before the group. Pausing, I take a deep breath, then nervously explain. The women stare at the plasticene forms as silence descends. No one says anything and I feel uncomfortable in the growing stillness.

Then, one by one, each woman's eyes lift and catch mine, holding eye contact for a long time. They smile and slowly nod. I sit in the silence, my hands resting in my lap, flooded by an enormous sense of accomplishment and release.

Red Lump

THE PLASTICENE FIGURES now stand on my desk. The red lump, especially, captures my eye. It's about three inches tall, squeezed slightly at the top suggesting a head. Pinches in the middle hint at a torso. The heavy bottom sticks solidly to the board.

The question I asked at the art group hangs in the air, as formless as ever: "What to make of me?"

～

This is what I talk about with Dr. Norman at our next meeting. Not having seen her for several weeks, I first recount recent events: how Julian has improved, how he is cheerful and smiling, how he kisses me and sings songs, how I take him to walk around a lake.

"It's pretty weird," I tell her. "But I'm so glad to see him. I look forward to going. I'm genuinely happy to be with him. We actually have fun together!"

Dr. Norman watches me and nods: her cue to say more.

"I can't explain, but I love being with Julian. He's all love—a big, gray-haired bundle of affection, like a tail-wagging puppy, like a wiggly toddler, full of hugs and tickles and body-squirming grins."

Dr. Norman nods again, re-crosses her legs.

Tears leak from my eyes.

"He's gone, but not gone. It's like he died, but he hasn't. He'll never return home. I should clean out his closet and toss papers from his desk, like any widow. He's never coming back. But unlike a real widow, I can go see him. I know where he is. His hand feels wonderful in mine. I enjoy his hugs."

I go on to describe how well Julian looks, how fast he walks, how the Oak Creek staff thinks he is "such a sweet man."

Dr. Norman listens and finally asks, "And how about you? How are you?"

For a minute I am silent. It's easy for me to talk about Julian, tell others how he is, describe what has happened. It is much harder to talk about myself.

"I'm okay," I say slowly. "I live on different levels. How am I? The answer depends on what hour you ask."

Dr. Norman nods, cueing me to continue.

"I move on with my life, do lots of things, movies, meetings, dinners, hikes with friends. Every weekend I am busy. I continue my work with PFLAG—Parents, Families and Friends of Lesbians and Gays. I still answer their information line and visit schools with the speakers' bureau. I have just accepted a new term on the board."

I pause. "So it's not like I just sit around and cry. I hardly ever cry, in fact. The kids fill my house with noise and clutter. I'm rarely alone in an empty house. But...."

I search for words to describe something vague, something inchoate.

"I feel like I felt before I met Julian...tentative, uncertain. I'm not used to being in the world as a single woman. I've been part of a pair for thirty-six years. I married at twenty-two. While I was never a totally dependent, mousy type, I leaned on Julian. We divided life's tasks."

Issues I felt as a young adult have re-surfaced, I say: insecurity about whether people are interested in me, uncertainty over what to say.

"I go out in the world," I tell her. "But half of me is gone."

A wave of sadness floods me as I picture the plasticene figures I made in the art group—the yellow and red couple lying together.

"I'm learning how to move in the world alone and make my own life. I never really had to do that."

Dr. Norman reminds me that much of what I do—PFLAG work, hiking and writing—has never involved Julian.

"But he's still often THE TOPIC," I explain. "He's what I think about, what I talk about...even what I write about!"

"Can you write about something else?"

"Yes, but not now. I don't want to."

Dr. Norman looks at me quizzically.

"Is there something wrong with that?" I ask. "Is it unhealthy for me to feel so attached? To still find Julian interesting? To still enjoy being with him?"

"I'm wondering the same thing," Dr. Norman says nodding.

But I feel criticized by the brevity and neutrality of her remark. Maybe she thinks I'm weak to continue talking and thinking so much about Julian.

"But he's only been in Oak Creek five weeks," I protest.

She says nothing more. I want her to understand the sparks of life that remain in Julian, how profound this is to witness, what I am learning about dignity at the end of life.

"I want to go on writing about Julian," I say. "He's still very much there. How can I explain? I feel deeply attached to that essential love we still share."

I recall severely retarded, autistic children with whom I worked when I was a speech therapist, who needed to move to institutions. I remember parents who clung to shreds of "intelligence" their kids may have shown, to isolated islands of higher functioning, like Julian

whistling and tying his shoe. I think of families who devoted their lives to caring for a severely damaged child.

"Yes," says Dr. Norman. "But it becomes unhealthy if being so attached prevents those parents or other family members from fulfilling their own lives."

Carefully I consider her answer.

"You know," I say abruptly. "I had a birthday last Sunday, March third. I turned fifty-eight, the age my mother was when she died."

Dr. Norman straightens up in her chair.

"So you have no map," she declares. "No roadmap for being an older woman."

"I rather think my life is over," I say, but not in a depressed way. "I've had a full life: I've loved and been loved. I've worked and traveled, have children and grandchildren. I have many friends... but...," my voice trails off.

"You've no map," she repeats.

No map. No plans, I agree, picturing the red lump of plasticene sitting on my desk and imagining nothing for it. I haven't the faintest clue what shape that red lump might take.

"I'm not a person who easily makes big decisions or five-year plans," I say. "I never have. I'm not the type to say, 'Oh, I think I'll move to Oregon...or go back to school...or change careers.' I tend to let things evolve. I'll just have to wait and see."

Expectantly I look at Dr. Norman hoping for some sign from her, some nod of approval, or frown of disapproval, but she sits, quiet and still.

"I'm learning to trust myself and my intuitions," I say. "And go with them. I don't want to decide anything now. I don't really want to do anything different.

"People ask me, 'Well, what are you going to *do* now?'," I tell her. "Or they say, 'Well, you must be relieved to have time to yourself.'

"I hate to hear that! I feel like when I was young and was asked what I planned to do after college. That sinking feeling, when I hadn't a clue. I've never really made plans for myself far ahead of time. For better or worse, I'm the type who rather lets things happen."

Our hour is over. Dr. Norman doesn't respond to what I just said. I feel uneasy, imagining that she disapproves, but I'm smart enough to know this is my own discomfort, my issue to grapple

with. She says nothing, just stands, opens the door for me and smiles.

Walking to my car, I picture the thick hunk of red plasticene sitting on my desk across from my computer, knowing it waits there, pliable, ready to be formed, whenever I am ready to shape it.

Whack!

EARLY SATURDAY MORNING I pour fresh coffee into the filter and listen to my phone messages.

Suddenly: "This is Oak Creek. Please call as soon as possible. It's about Julian."

Coffee grounds spill from the funnel as I hurriedly dial Oak Creek's number.

"Hello. This is Julian's wife. I just got a message to call."

Pause...then a woman's voice says, "Oh, yes. Just a moment. I'll get the supervisor."

My mind races over possibilities: he's broken his glasses. They've changed his room. He slipped out the front door?

A new voice comes on the line.

"Hello, Ann. This is Rachel. Julian's all right," she begins. "But last night we had to call 911 and take him to the emergency hospital."

My heart leaps to my throat.

"What happened?"

"Don't worry. He's okay. He has a cut on his forehead that bled a lot. Paramedics came and took him to emergency. No stitches even. They cleaned him up and brought him back. He slept till eight. It's nine now and he's fine."

Rachel explains that Julian was awake last night as usual. He was wandering around at four A.M. and suddenly went into a resident's room. The man whose bed was near the door woke up and whacked him over the head with his cane.

"Oh no," I cry. "Is he really okay?"

"He's acting just like Julian, smiling and cheerful, wandering around, talking. He ate a good breakfast."

"You're sure? He's not scared? Upset? Does he have a headache? Shall I come?"

"He seems fine." Rachel's voice is reassuring.

"I wasn't planning to come today. But if he needs me, I will."

"No, he's all right. We just wanted you to know."

"I'll come tomorrow. Thanks for calling."

I replace the receiver. Karen, Beiçola, and the children have already left for the Capoeira class in Berkeley, and there's no one around to tell. While my breathing returns to normal, I finish making coffee. But I begin to wonder, how many staff people are there at night? How well does Julian sleep? What if he goes into someone's room again? I decide to call back and ask.

The familiar voice answers the phone.

"Rachel," I begin. "I was thinking...what actually goes on at night?"

"Well, two or three staff people are on the night shift. They do room checks, take people to the bathroom, change diapers. Some residents are up, too. One or two, maybe four. Julian is almost always awake."

Memories of my sleepless nights come rushing back: Julian prowling the house, dismantling the bed, removing plugs from sinks. "What does he do?"

"Oh, he wanders around," Rachel says, "talks a lot to the staff and follows them around."

"But if he follows staff into residents' rooms, how can you prevent something similar from happening again?"

"I'm sorry," she says. "It's just one of those things. It happened so fast. We'll watch him closer from now on."

"I'm not mad," I say. "I just want him to be safe...you know..."

My voice sticks in my throat. An unexpected wave of emotion hits me, tears leak from my eyes.

"I'm sorry," I mumble. "I didn't mean to cry. I'm not really upset...it's just...I'm not used..."

"It's hard letting a loved one go." Rachel's voice is soft. "You have a wonderful family."

"Thank you...thank you...it's hard...hard to put Julian in residential care...I..."

"Julian's such a sweet man," Rachel continues. "He's happy here. He's adjusted well."

"But how can you tell?"

"Well, he smiles and sings. He kisses our hands. We really like having him here."

"I'm relieved to hear this." Managing to control my voice's tremor, I ask, "Do you have time to talk a bit? Tell me more about Julian. What does he do all night?"

"Well, he just walks around. We put on his slippers and robe and he talks for hours. Sometimes he curls up in a chair and tries to sleep. But when we try to take him back to bed, he resists. So we just let him stay up."

"He was up all night here at home, too," I explain. "I couldn't make him sleep. No sleeping pills worked. I'd find him in the morning—with freezing feet, standing forlornly in the middle of a cold room. He urinated in corners and wastebaskets. My house smelled like a neglected bus station."

"We take him regularly to the bathroom," she says. "He's no trouble at all."

She describes how cooperative he is when they dress and bathe him. Only he's very sensitive to temperature changes. He resists undressing for fear he'll be cold.

"We wrap a towel around him before he steps in the shower," she says.

"I feel so relieved," I say. "You're so patient and kind."

"This is the best job I've ever had," Rachel suddenly announces. "I've learned so much here. It's like going to college."

I sit down in a kitchen chair and focus intently on what she says. I don't even know who Rachel is, this kind voice on the other end of the line.

"Alzheimer's is a tragedy," she explains. "A terrible disease. Yet everyone here is special. No matter how out-of-it they look, they have moments of connection and these moments are beautiful. They're what keeps me at this job."

A lump forms in my throat. How can I tell her how grateful I feel?

"I know, I know," I manage. "I have incredible moments of connection with Julian. He's so impaired, but he's so emotionally with it. Most people don't understand. It's hard to explain."

"My job is spiritual," Rachel continues. "I feel I'm doing God's work. I'm uplifted, enriched. I'm a better person for knowing people with Alzheimer's."

I stretch out my legs, rest my feet on the table and listen hard to Rachel's words.

"Thank you for taking such good care of Julian." My voice catches again in my throat.

Rachel calls to tell me Julian got hit on the head and went to the hospital, and we end up talking about her job's spirituality. Relief floods over me. Julian is appreciated and cared for by wonderful people like her.

"Julian's a very special man," she says. "Don't worry. He's fine."

Hanging up the receiver, I pour hot water into the filter. Delicious coffee smell fills the air. I take a mug outside into the bright sunlight that floods my morning garden, where a black squirrel scurries up a redwood trunk and a robin hops across the grass. Perching on the ledge of the wooden vegetable box, I drink my coffee and survey the young tomato plants encircled by the wire cone they will climb in the coming months. Julian is fine, despite his bash on the head.

Suddenly, I feel enormously grateful for my freedom—and for Julian being in a place where people not only care for him, but value him too. A man with Alzheimer's whacked Julian's head with his cane…it's almost amusing. But Julian's okay; I'll see him tomorrow. I sip my coffee, stare into my garden and slowly begin planning my open, free day.

Red Lump Returns

FLAT. LOW. SAD. Life stretches out blandly before me. Returning home from a perfectly fine morning, I feel irritated at everything I see: kitchen counters covered with jars, bowls, pots, cereal boxes. Plastic Power Rangers, stuffed rabbits, naked Barbies strewn across the carpet. Julian's study piled with his books and papers, and my father's boxes.

In general, I've made my peace with Karen and Beiçola about their sense of order conflicting with mine, but today I feel annoyed at the clutter.

The kids' bedroom—their domain, not mine—is a mess: clothes piled on the dresser, drawers a jumble, the desk top covered with un-nameable junk.

Storming through the rooms, I search for Rasa's bottle. It's my afternoon to baby-sit and she is cranky from a three-day cold. Thick gooey blobs of mucous bubble from her nose.

I want to put her down for a nap, but I can't find her bottle. Not in the dishwasher. Not on the messy countertops. Not in the family room, not on the floor. She's filled her second dirty diaper and has poured soup down her just-changed clothes. I scoop her up more harshly than I've ever done and plop her in bed handing her *Pat the Bunny* and a toy telephone.

"Stay there!" I order and stomp back to the kitchen to tidy up.

Damn this house. Damn the mess. Karen's not home enough to keep order. Swooping up newspapers for the recycling bins and dirty cups for the dishwasher, I mutter to myself: Karen should keep things more tidy, Beiçola should clean the garage.

The litany of complaints continues: the kids' toys should be orga- nized. They can't play when nothing has a place. Their minds will grow cluttered. Montessori was right, children need orderly envi- ronments to feel calm and secure. The children are learning bad habits by this disorder.

Why doesn't Rasa have her own bed? Why doesn't Karen put the children to sleep earlier? The bedtime hassle drags on for hours. Antar's table manners are terrible. Celina interrupts and drops her underpants on the bathroom floor. The garage is a disaster. And Julian's study is a total mess. I can't even walk in that room, much less work there.

I throw cups in the dishwasher and stack the laundry.

But as I sit fuming and folding, I know the messy house is not the problem. We can fix that, pick up more, run a tidier ship. The prob- lem is me, how I feel about my life: aimless, disoriented, un- centered.

Early this morning I had a tantrum about my clothes. Scheduled to speak on a PFLAG panel at a high school about prejudice against gays and lesbians, I couldn't find anything appropriate to wear. This sweater was too dark, this one too wintery. These pants too tight, these had no matching top. No shoes to wear with these trousers. Tearing sweaters and blouses off hangers, I threw them on the bed in disgust.

At seven-thirty I summoned Karen.

"I've nothing to wear!"

Karen was rushing around trying to get the kids ready for school, and she looked at me silently with forced patience and a tight smile.

"How about this?" She held up a blue velour top.

"Too heavy. Too dark."

"This?"

"Too tight in the arms."

"This blouse looks nice."

"My bottom's too fat. I can't tuck it in."

"How can I help you, Mom?" Karen answered, giving me a look which said I know you're in a bad mood, I'd like to help you, but I can't, and besides I'm late for work.

She returned to the kitchen. Flicking on TV, I listened to the weather report. Hooray. It would be overcast and cloudy with temperatures in the sixties. I could wear wintery clothes: black pants, matching shoes, and a loose sweater which fit.

The homophobia workshop went well. I was one of five speakers—a lesbian teacher, a gay Stanford student, a lesbian senior from Berkeley, the father of a lesbian daughter, and me. The questions were great, the discussion lively. I felt excited and pleased, until I stepped back into the house.

Now I'm home and Beiçola has rushed out to teach his class, my turn to stay with Rasa. What's happening anyway? Grumbling about a messy house? Criticizing Karen for how she raises her children? The kids have been the same for the past six months and I haven't felt like this.

Only yesterday I had a wonderful Sunday with Julian at Lake Chabot, canoes and kayaks drifting across glistening water, joggers and bikers crowding the path. New spring grass covered the surrounding hills, and Julian was full of kisses, his eyes lighting up every time he saw me, caressing my hair, running his fingers along my cheeks. "You're so lovely," he said over and over. Every time I looked at him, he smiled.

Julian has a new bedroom, too. After his whack on the head, Vickie moved him down the hall, far from the man with the cane, and away from George, who needs a roommate who can talk and relate. So Julian's room is now just off the lobby, where staff can keep a closer eye on him, the second bed vacant for now.

Given the situation, things couldn't be better. But what is the situation, I ask myself, folding Rasa's tiny blue jeans.

Now that Julian is gone, my life is supposed to be easier. I can sleep at night. My time is my own. I'm free to come and go as I like. I don't come home to an empty house. Far from it, sometimes I could do with a little solitude and silence. But I'm basically glad the kids are here. On the outside, my life is "normal."

So what is wrong?

I have lost my center. I feel aimless, uncertain. For six weeks now, since Julian left, I have felt okay. I've been busy. I haven't cried, haven't been depressed. But today, for some reason, everything soured.

I am "okay." I'm "comfortable." I'm "passing time." But I don't know anymore what my purpose is. What can I wrap my life around? What is my meaningful work? Old questions, familiar questions that haunted me for years, before Alzheimer's, before cancer. Those existential questions that I never had to ask for the six years when I cared for Julian and knew my purpose; I had meaningful work.

Now Julian is gone. I no longer define my life by his needs, stealing an hour here or there for myself. I am as free as any woman my age, and that's just it. What am I free *for* ? What is it I want to do?

Like a new widow, or a new divorcee, an open life stretches before me. How shall I fill it? The red lump asks again: what is to become of me, this odd, curious kind of widow?

Easter Sunday

ON EASTER, I walk with Julian beside Lake Chabot, passing families sprawled on blankets, batting volleyballs over nets, serving picnics from food-laden tables. Radios blare Mexican music, and every table and plot of grass is covered with friends enjoying this bright day.

Julian and I stroll around hand in hand. Too hot for our usual four-mile walk, we simply amble through crowds, taking in smells of barbecued chicken and ribs. Kayaks and canoes rock on the lake's blue surface.

Julian's face is all smiles.

"Lovely, lovely," he declares. "I love you, darling. I love you, my darling."

He gazes into my eyes, pauses, turns toward me and softly caresses my hair, kisses my cheek.

"You're lovely, lovely."

Then come strings of gibberish, long streams of unintelligible talk. A flood of invented words embedded in phrases with normal English intonation and inflections.

"The mandiblation tagurras," he says, like a professor delivering a lecture. "Fagarree tookooma. Ederol mepontias. Padamee eleral and hagation exteral."

"I guess so," I answer.

Sometimes a whole nonsensical paragraph pours out, sometimes a short question. I respond with a vague remark and Julian seems satisfied. To look at us, you'd see an affectionate middle-aged couple, a second marriage, maybe, or a new romance, judging from the kisses, hand-holding, and hugs. If you didn't speak English, you would never know from the sounds of our talk that we weren't having a real conversation.

And sometimes we do actually have a realistic, albeit simple, exchange.

"Do you want to go in the car?" I asked Julian in Oak Creek's dining room when I arrived. "Do you want to go for a ride?"

"Goody, goody," he said, jumping up and down three times like an excited toddler.

"Would you like an ice cream?" I ask him now.

"That would be lovely, lovely," he says.

As we rest on a bench outside the Marina Cafe overlooking the boat dock, Julian suddenly sticks his ice cream into his pocket. An Asian couple sitting next to us holding a white long-haired Maltese puppy with a blue bow on each ear stares at Julian.

I remove the Haagen Dazs from Julian's trouser pocket and hand it to him. Without tearing off the paper cover, he takes a bite, as the couple continues to stare. I take it from him and tear open the package folding down the paper to expose the stick. As I hand it to him, he grabs, not the stick, but the nutty chocolate.

"Mm, lovely," he sighs.

By now his fingers are covered with chocolate. The couple stops talking and stares open-mouthed.

Turning to them I explain simply that my husband has Alz-

heimer's disease and lives in a residential center nearby. Their faces soften and we begin discussing their dog: his age, his hair care, how often they change his bows, while Julian happily finishes the ice cream. After I wipe his sticky fingers, we continue our walk.

Leaving the cafe, we head around the lake's south side, where the path is crowded with kids riding bikes, and parents carrying toddlers and pushing strollers. On the muddy banks, men doze in plastic garden chairs beside little stands holding fishing poles, and farther out, black-necked Canada geese drift lazily. Arms around each other's waists, Julian and I stroll along, often turning towards each other to kiss.

"Darling, my darling," he says looking adoringly at me.

His declarations make tears fill my eyes.

"Don't," he says suddenly, clear as can be. "Don't make me think it's not all right."

I stare at him, through a teary smile. "It *is* all right, Julian. You're a wonderful man."

"Boogia boogia boogia," he says pressing me to him.

"Boogia yourself." I punch his shoulder, amazed at the insights coming from this damaged man.

We walk past clumps of oak trees and Raccoon Cove where fishermen flick their lines into the lake. I am filled with joy at this bright day, the gift I've been given of more time with Julian.

～

Julian is like a man resurrected out of a coma. Now that he is off the heavy doses of Mellaril and lives in a simple, structured environment designed for his needs, he is less anxious, and has actually improved. I wonder if I should have placed him sooner, but I wasn't ready. To my great surprise, here I am, blessed with this sunny, smiling, cheerful man, blessed with his ongoing affection. I love and am loved, even still. We're on a narrow plateau, I know, and time is fleeting. Any time he can lose his grip and slide further down the slippery Alzheimer's slope into non-knowing.

But for now, we walk hand in hand singing "You Are My Sunshine," "Clementine," "Molly Malone," "Red River Valley" and "Dayenu," from last week's seder, the first Passover in thirty-six years I didn't share with Julian.

"I'm happy you're happy," I tell him. And I truly am.

Julian turns towards me and grins.

"Boogia boogia, boogia," he says, his beard rough and scratchy on my cheek.

Out to Lunch

ENTERING OAK CREEK the week after Easter, I immediately spot Julian standing in the dining room, wearing a forest green velour shirt that's not his. Finding him in someone else's clothes still shocks me, but the shirt is clean, fits him and matches his faded green corduroy pants.

Renee, the activity director, holds a plate of cantaloupe slices, trying to hand Julian one, but he glares at her, shouting, "I don't want any. No. Fuck it. I don't want it!"

Catching Renee's eye, I grimace an apology for Julian's language. In over two months here, I haven't once heard him curse.

"I'm sorry," I mouth.

"Never mind." Renee laughs. "I've been called everything in the book. You can't imagine what comes out of the sweetest, nicest people. I don't take it personally."

I am nibbling a melon slice when Julian finally notices me, his face lighting up.

"Oh, it's you. I love you, I love you!" He bounds towards me, folding me in a fierce hug.

Embarrassed by Julian's affection in front of residents who may feel lonely and may not get visitors, I lead him out of the dining room, away from the staring eyes.

"Oh, I love you so-o much!"

"I love you too," I whisper.

"We love watching you two meet," a staff member smiles.

Julian's greetings are so exuberant, and I understand that his inhibitions are gone, his sense of timing, of what is appropriate to do where. Not wanting to deprive Julian, or myself, of these affectionate encounters, I'm learning to accept them as they come.

"Would you like to go in the car?" I ask Julian in the lobby.

"Goody. Goody."

"Shall we go to the lake? Go for a walk?"

"Lovely. Lovely," he says.

"I'll bring him back in time for lunch," I tell a caregiver, as I open the front door to the cold air outside.

"Oo, coldy, coldy." Julian shivers, buttoning the top button of the strange green shirt.

Inside the car, balalaikas and violins blare from the tape deck and Julian claps loudly. "Boogia boogia," he says, followed by, "The odderol estofenay surpasses the akalany. Is the mackinee offeraldee paralaba?"

These last words are definitely a question.

"Well, I'm not sure," I answer.

"Kadolee inoover palam tookkofen."

"I guess so," I say. Seemingly satisfied, Julian caresses my arm. Keeping my eyes on the road, I tug gently at his beard, and soon we're at the entrance to Lake Chabot, where we go regularly now, each time I visit.

"Hello," Julian calls out cheerily to a stocky man approaching us on the path. "Hello there," he waves to a woman jogger.

"Ach, Barooch Ha Shem, Barooch Atah Adonai, Melach..." He begins some Hebrew blessings which dissolve into a stream of Jewish gibberish, Hebrew syllables with Yiddish inflections, both languages he used to speak. *"Oy gevalt,"* he says, pleased with himself.

I smile at him and we kiss many times. Often he looks at me, pure joy all over his face.

"Och, I love you so-o much!" he declares.

This outpouring of affection is a gift. Julian can't put on his seat belt or wipe his bottom, yet he's not angry, sad, hostile, or scared. Given Julian's situation, he couldn't be in a better mood. No longer on heavy psychotropic drugs and living in a supportive environment designed for dementia patients seems to be exactly what he needs. He is flourishing in the attention and care he receives, and, off drugs, he is more alert and communicative. I'm grateful for this precious time.

For half an hour we stroll along the lake's rippling gray water until I ask, "Are you hungry?" and we head for the car to return for lunch.

～

Back at Oak Creek, residents fill the dining room as caregivers serve their noon meal. Against the far wall, Newell, Verna's husband,

watches intently as plates of hamburgers and potato salad are hand-
ed out. I'm still not used to seeing Newell here. He just arrived last
week, after Verna, encouraged by Julian's good adjustment, finally
made the dreaded decision to place Newell, too. Ironically, Vickie
put him in the empty bed in Julian's room, so now Newell and
Julian are roommates, though I doubt they know it.

As I stand looking for a free chair for Julian, Renee calls out,
"Ann, would you like some lunch?"

Why not, I think. The staff has invited me many times to stay for
lunch and I never have, so today, for the first time, I sit down hesi-
tantly at one end of a long table, with Julian on my left and a tall
muscular man on my right. A white-haired couple sits opposite me,
the ones that always hold hands in the lobby. The woman wears a
purple silk blouse, her nails polished, hair nicely cut and blown dry,
looking like a well-groomed woman dining at a restaurant. No one
speaks. The crowded room is oddly quiet, devoid of chatter that
you'd expect in a restaurant of this size. Only the cheerful quips of
the staff:

"Hi, Newell. Here's your hamburger."

"John, are you hungry?"

"Margaret, sit here."

"Sit down, Bob, sit back down. Your lunch is coming."

Julian is thrilled I am here, grinning at me, reaching out often
and patting my hand.

"Boogia, boogia, boogia," he declares. "Boogia, boogia!"

Hoping he'll quiet down, I pat his shoulder as his "boogia's" ring
out at our otherwise silent table.

Suddenly the woman in the purple blouse glares at Julian and
snaps, "Shut up!"

A pang of hurt hits me. I glance to see if Julian has heard, but he
keeps on eating. Then I regard him through her eyes, shoving baked
beans in his mouth with his fingers, mumbling nonsense. Obviously
she would never choose to eat lunch with a man like him.

"Just shut up!" she roars again. Not everyone thinks Julian is cute.

Her companion, his gray hair shorn in a crew cut, and a blue an-
chor tattooed on his forearm, takes her hand and pats it.

"He can't help it," the man gently explains. "We have to be
patient."

My eyes widen at this exchange. This man is usually asleep when I see him, slumped in an armchair. I had no idea he could even talk, much less express so compassionately the dynamics around the table.

"Well, he's damned annoying!" the woman mutters as her friend continues patting her arm.

"Boogia, boogia," Julian persists. "I love you, oh, I love you!" he shouts, oblivious to what the woman just said.

Wondering what to say, I chew my hamburger, feeling I should rescue the situation and start a conversation. After all, that's what people usually do over lunch. The tall man across from me sullenly picks at his bun.

"Bob, how's your lunch?" I try. "Are you enjoying your hamburger?"

He looks at me, but doesn't reply.

"Barbecues are nice, don't you think?"

Bob stares at his plate. This conversation is going nowhere.

Now Julian is scooping up potato salad with his fingers. I hand him his fork, but he ignores it and continues picking up chunks of potato.

"Lovely, lovely." Looking at me, he repeats: "I love you so-o much!"

I direct a few comments at the couple, but both ignore me, so I try Bob again. When I mention his name, he looks up, but no exchange develops. I am here, really, to visit Julian, so I focus on him. He's eagerly grabbing strawberry ice cream in a paper cup, frozen hard. After eating his entire meal with his fingers, he suddenly picks up a spoon and begins scraping the ice cream.

"Mm, lovely," he croons, totally absorbed in enjoying his food— just as he immerses himself in music.

Soon I'm handed dessert, but I am still moping over that woman saying Julian was "damned annoying." Oddly, despite the obvious reasons for her comments, I feel hurt, even if she has dementia. I want everyone to love Julian and think he's cute. Obviously they all don't.

Recalling his days at home, not so many weeks ago, I remember he drove me crazy standing six inches from my face, pouring out streams of gibberish.

This woman sees Julian daily, hears him jabber nonsense, watches him grab food with his hands. Her neat hair, polished nails, and good language show she is quite aware. She has every right to express how she feels. Just as Julian's inhibitions are gone, so are hers. He can't inhibit his love declarations and nonsense syllables any more than she can inhibit her annoyance.

As Renee explained this morning when Julian swore, "I just let it roll away. They won't remember later what they said. So why should I?"

Good advice: letting go and not holding grudges.

My first lunch at Oak Creek is over. Against the wall, Newell still sits devouring the last of his ice cream, and I go over to him, touch his shoulder and say hello. He looks up and smiles. He seems to have made a smooth adjustment too. Verna says Oak Creek is rather like day care, only you stay overnight.

As Julian leaves the table, I follow him into the empty hall where he takes my hand and kisses it, throwing back his head, laughing. His hand softly strokes my hair, tenderly, his blue eyes blazing with affection.

When a tear slips out and rolls down my cheek, Julian stares at me with a worried expression.

A feeling person still lives midst the short-circuited connections in his brain, beneath the damaged mess of tangled neurons. Occasionally astounding insights burst forth through the snarls of his dementia, precious gifts to catch and cherish.

"Don't *cree*," Julian says, clear as can be: "I'm okay. Really, I'm okay!"

And deep in my heart, I believe he is.

Part IV: May 1996–April 1997

Lifeline

"As if through a stethoscope…I hear my life force roar: loud and persistent."

Rainy Day

DARK CLOUDS HANG in a slate gray sky when I arrive at Oak Creek to visit Julian, a cold May wind stings my cheeks. Obviously I can't take Julian to the lake; I'll just have to stay with him here.

Inside, I find him standing in the "barber shop," a warm little room near the front door, bouncing around, jabbering away as Vickie puts eye-liner on a beautiful Japanese woman with lovely white hair just blown-dry. In the second chair, Rachel, the caregiver who told me her work was "spiritual," shaves the thin man they call "Grandpa." Petite, with a fine-boned face and gentle hands, she laughs and jokes with him. Two other residents sit watching the cheery scene, smells of shampoo and shaving cream fill the air.

"Boogia, boogia, lovely, lovely," Julian chants.

"Boogia yourself." Rachel tugs playfully at Julian's beard, then spies me. "Look, Julian, look who's here."

Julian keeps looking at her, kissing her cheek.

"Well, I'm not the only one he kisses." I laugh.

"Julian, look. Look over there." Rachel spins Julian around to face me.

"Oh, it's you, you. I love you, I love you." His face breaks into a huge smile. "Oh, it's so nice. Good, good. Oh, I love you!"

He clasps me to him, kissing my neck. "Oh, you've come." People look on us kindly, and I no longer mind his public displays. I'll take all the kisses I can get.

A tall, stooped man whom I knew before at Julian's day care strides towards me. "Come on, let's go," he demands.

Bob is the tallest man I know. Stony-faced, subdued on Haldol, pacing restlessly near the front desk, he grabs my hand, pulling me towards the door, while Julian tugs me in the other direction declaring his love. "Come on, let's go," Bob insists.

Suddenly, as if he is an admirer cutting in at a dance, Julian taps Bob on the shoulder, clears his throat, and says, "Pardon me, sir!"

"Did you hear that?" I call to Rachel. Winking at her, I add, "Two men haven't competed over me in a long time."

Bob tows me with a strong grip as Julian kisses my neck, and I laugh nervously, not knowing how to stop Bob. Rachel quits shaving "Grandpa" and heads towards us.

"It's okay," I tell her. "I'll take them both for a little walk." Rachel returns to the barber chair, but I know she is watching in case of trouble.

"Let's go, Bob. Come on, Julian." I maneuver Bob around, our backs to the door, and, with Bob gripping one hand and Julian the other, we proceed down the hall.

"How are you, Bob? Good to see you. I like your shirt."

By now I know he never speaks, except for "come on, let's go," but I need to say something, and it is awkward ignoring Julian's affections, especially intense in the fresh moments when I arrive. Squeezing Julian's hand, I sneak it to my lips for a secret kiss.

We walk down the hall to a door which opens on to the fenced back yard. Rain splatters on the glass. "No, no. Coldy, coldy." Julian pulls me the opposite way with no intention of going out, while Bob stands solid by the door.

"Let's go this way, Bob." I manage to steer him around. Haldol makes him manageable; without it, he'd be out and away. The three of us shuffle back towards the barbershop, where Rachel rescues me, taking Bob's arm. "Come, Bob. Let's see if morning coffee's ready." She whirls him around and leads him towards the dining room, enabling me to escape.

But where can Julian and I go? It is definitely too wet to go to the lake; if we stroll the halls, we'll just keep meeting Bob—and Barry and Maureen. Sometimes I like hanging out with residents, but today I want to be alone with Julian. It's not fair for him to have to share my attention. This time is his.

We are standing in front of Julian's new bedroom, number seven, the one he now shares with Newell. Ironic that they should be roommates. Julian followed Newell to day care, then led the way here.

Impulsively I open their door. Twin beds with flowered spreads. Two identical nightstands, closets locked, so residents don't remove each other's clothes. Framed pastel prints of spring flowers over each bed.

Newell's dresser is covered with Easter cards and family photos of him and Verna, while on Julian's stands a photo of him and his three brothers, beside a plastic cube with pictures of our children when they were young. Julian's carved soapstone Buddha, on his Stanford desk for twenty years, sits there too. The day he moved I grabbed these items, simple markers of who he had been, but I doubt he even sees them.

The room is clean and spare, like an inexpensive motel. Standing together by Julian's bed, I feel suddenly weary, desperately needing to lie down. I lead Julian to his bed where he stretches out on the flowered spread with no trouble at all and I lie down next to him. Rain drums on the window. Julian is quiet, eyes closed, relaxed and still, and I snuggle up to his familiar warmth. We haven't lain together since the morning he left, four months since that last sad, chaste, fleeting cuddle.

No talking. No thoughts. Just our bodies—lying together taking a nap, feeling so normal. I rest my head on Julian's chest, then wriggle to fit it onto the slope of his shoulder. His arm instinctively comes over me; my hand lies on his belly, rising and falling. He smells of shaving cream and toothpaste. A thought occurs to me: slide my hand lower, but I don't dare.

Raindrops patter on the roof, trickle down the window. What if someone comes in? Is this okay, I wonder, us lying together on his bed in an Alzheimer's center? But why not? Who cares if a caregiver enters? The staff wouldn't mind, nor would Newell. If Newell wandered in, he would dash briefly into the bathroom and wander back out. So I relax into the heat of Julian's body pressed against mine.

A crazy thought: to undress and lie together under the covers, skin against skin. Nonsense. But maybe one day we could go to the house of a friend who lives nearby and spend some time alone together. What might happen? Pushing away these thoughts, I lie quietly, savoring the rise and fall of Julian's breaths, his scratchy beard on my forehead. Then sadness floods me. Look what we've come to: sneaking a cuddle in a dementia center. Blinking against waves of grief over our lost, lusty, interesting life, I close my eyes, my breathing slows....

Julian moving off the bed wakes me and I glance at my watch; we've slept half an hour, a delicious stolen interlude. For a moment,

just waking up, I feel like after our quick little naps at home. But then I see clearly where we are.

Not yet lunchtime. What's there to do now? I go to Julian and lead him to the window. Sitting on Newell's bed, we watch large raindrops slide down the pane, see the wet, dark cement walkways and the jasmine climbing the fence, washed to deep green.

I begin humming a melancholy "Shalom Haverim" and Julian joins me. Slowly, we hum together, drawing out the high notes. Then I move on to livelier tunes: "Raindrops are falling on my head" from *Butch Cassidy and the Sundance Kid*, songs from *Oklahoma!* My mood shifts, we sing louder. Soon we are laughing as we belt out song after song. When we start "Waltzing Matilda" we stand up, now face-to-face in dancing position—my right hand on his shoulder, left hand on his back. We start to dance; I lead, he follows. Then I hum Glenn Miller's "Blue Moon" and we press together as if we're in a high school slow dance.

At the end of each chorus we throw back our heads and laugh, kissing often. An immense sense of well-being washes over me before I glance at my watch, shocked that it is nearly noon.

"Time for lunch, Julian." Reluctantly I open his bedroom door and lead him to the dining room, where he immediately begins eating lasagna, never noticing me leave.

~

Driving home, along slick freeways, I ponder this hour with Julian, dancing and singing together. I love and am loved, even still. We have surely communicated intimately, despite the terrible damage done to him by Alzheimer's, despite the fact that he lives in a dementia unit and can barely talk. Some essential Julian is still present, intensely alive. We are deeply connected, though I still struggle to accept him as he is, and am still learning to let go, not to need him. In my visits, I try just to be there. It is hard to explain, but when I can join him in the present moment—no words or thoughts of past or future, no regrets, no expectations, and no fear—that moment is fine.

My freeway exit appears. As I hum "Raindrops are falling on my head," tears sting my eyes, a confusing mix of love and loss, and leaving the wet freeway, I drive up Page Mill Road towards home.

Lifeline

THE NEXT SATURDAY morning in May, I wait with sixteen caregivers in a rustic lodge for the Family Caregiver Alliance retreat to begin. The large wood-paneled room is filled with men and women of all ages, each of us caring for a wife, husband, or parent with Alzheimer's, Parkinson's, or stroke.

We have come for the weekend to reflect on the meaning of caregiving. What does it mean to us? What space is it taking in our lives? What will we do when it is done?

"The primary task of caregiving is letting go," the retreat leader begins. A gray-haired woman wearing a boldly-painted scarf over a lavender jogging suit, Bonnie stands before a stone fireplace while we caregivers sit at long tables facing her.

The room is quiet, everyone intent on her words.

"You are all asking," Bonnie continues, "when will my pain end? Some pain ends at placement, some at death. Some pain extends even beyond. What can we do to end our pain?"

Tears glisten in the eyes of every caregiver. Last night as we introduced ourselves, enormous pain accumulated in the room: some care for a family member at home; some are thinking of placement. Others, like me, have just placed a loved one in residential care.

"We need to tell the truth about caregiving," Bonnie says, "how awful it can be. We must acknowledge this before we can get real respite or relief."

My shoulders sink with a sigh that echoes around the room.

Bonnie then passes out long sheets of white butcher paper and tells us to make a time line of our life on the sheets.

"Start with your birth," she says. "Draw a horizontal line across the paper. Then mark the age you think you'll die. Mark significant losses. Mark your years of caregiving. Show clearly where on your lifeline you are now."

My body stiffens, nameless emotions choke my throat. On the table, colored markers lie in a box as I stare at the challenging blank paper. I'm scared to begin. Slowly I pick up a black felt pen and draw it across the paper from the left side to the right. On the left edge I print: "Born 1938."

Easy enough. But now what?

I have no idea when I'll die. Will I live a normal lifespan, reach seventy-five, maybe eighty? Or die young, like my mother, dead from colon cancer at fifty-eight, exactly the age I am now? The chance of breast cancer recurrence is a possibility, though, for the past eight years, I've been healthy and lucky. Where on this line shall I mark when I'll die?

Thinking positive, I draw a vertical slash on the far right edge, labeling it: "Died: 2013, age 75."

With two entries now on both ends of my line, I quickly divide the line into thirds, writing "age 25" on the first mark, "age 50" on the second.

Then, picking up a red pen, I make a thick red mark just beyond "age 50" and write, "ME NOW: 58." Entering my life's last third, I'm relieved to see the long empty line stretching off to the right.

Over the first third, I draw a parenthesis spanning "birth" to "25" and label it "childhood/growing up." Pondering my uneventful, comfortable youth, I see no significant losses here.

Around the "25" mark, I list: college, marriage, speech therapy degree, births of three children, work. Drawing a second parenthesis spanning 25 to 50, I label this period "adulthood/family life/career."

Then I estimate where on my lifeline "32" would fall, the age when I lost my mother, and I write in black ink, "Mother dies." Until her death, the first two thirds of my life were relatively easy, with no major hardship or loss.

But now I come to the divider: age fifty.

Under "50," I write, "breast cancer—mastectomy," as images of cancer treatment flash by. In the narrow band between 50 and 58, my pen flicks rapidly up and down: just before 50, I write, "49—Father's neck cancer;" then "50—my breast cancer;" "51—chemotherapy;" "52—Julian's Alzheimer's diagnosis;" "53—Father's three-month hospitalization." On it goes. Between 53 and 58, I mark so many dark lines there is no room for them all.

During these five years, Julian and my father rapidly declined, Julian mentally, Daddy physically. His mind sharp, my dad lived with a failing body while Julian grew more and more childlike, his body healthy and strong,

At 54: Julian lost his driver's license, and with it, his independence, his increasing dependence on me more intense. At 55:

Daddy's cancer re-occurred—more neck surgery, a second tracheotomy. At 56, Dad broke his leg in a car accident, which, because of diabetes, would not heal. More marks for his two vascular surgeries, the long hospitalizations, the many times he moved to a new apartment, each medical crisis and move requiring my sister's and my ongoing help.

During this period, Julian suffered too many losses to even record.

Seeing them on paper, I am stunned that so many losses fell in the last eight years. No wonder I feel depleted. My chest tightens, crushed by the weight of Daddy's operations, hospitalizations, and long convalescences woven through Julian's relentless decline.

Breathing deeply, I draw another black line and write: "Father's death—1995," just seven months ago.

Then I mark "Julian—residential care," three months later: February 1, 1996. Four months have passed. Shutting my eyes tight still won't stop the hot tears.

The space between age 50 and 58 is massed with hard times, but heavy caregiving is clearly over. Even though Julian needs me, my life is no longer dominated by constant caring for him at home. In the thick of it, I couldn't imagine caregiving would ever end, but now, an empty line stretches off to the right.

My heart pounds with excitement and fear. I don't know what to put in this next section, any more than I knew how to shape the red plasticene lump. Between 1996 and 2013, I draw a large question mark.

Suddenly Bonnie's voice interrupts my thoughts. "Bring your papers into the living room," she says.

Rolling my butcher paper, I feel exhilarated at the open expanse of life before me, and relieved to escape the challenge of what to write on the long empty line.

"Our focus for the rest of the weekend is from this day on," Bonnie says as we gather around her. "What do I want to do? Who do I want to be, from now until I die?"

Bonnie then directs us to make a list of ten goals for the time remaining in our life, however short or long. "Be wild, dream, let go, put anything down," she says. "But also write five practical goals that you could accomplish in the next month. And one immediate

action, that you can do tomorrow. You have five minutes. Ready, go!"

Pens scratch, people scribble feverishly. The wild part of my list is easy: go more often to the mountains, travel with friends, visit Alaska, even if I am afraid of bears.

The immediate part requires more thought. Fun outings with grandchildren, one at a time. Be more serious about my writing.

"Write down something concrete that you can do tomorrow!" Bonnie reminds us.

But "be more serious about my writing" is not a concrete action. To write more, I realize, I must clean Julian's office. If I cleared out Julian's and my father's things, I could work there in peace, away from the noisy family, and Karen and Beiçola could use the spare room which is now piled high with my papers, books, and Daddy's junk. But I am paralyzed around this task.

In the retreat's last hour, each caregiver shares out loud the one concrete action that we promise to do tomorrow. When my turn comes, I hear myself say, "I promise to call a professional organizer on Monday to help me clean my husband's office and clear out a free space for me to write and do my work."

And I know exactly whom I'll call: my friend, Amanda, who works as a professional organizer, helping people clear out junk from their lives and arrange their space.

Feng Shui

THE NEXT THURSDAY after the retreat, the doorbell rings promptly at nine. When I open the door, there stands Amanda, holding a stack of large collapsed cardboard boxes, wearing a tan fisherman's vest with many pockets. Straight black hair frames her serious face. As I mumble words of embarrassment over my mess, she walks right in, following me first to my study, then Julian's.

"Hmm," she grunts, surveying my problems. The desk and bed in my study are covered with papers, bills, catalogues, PFLAG materials, totally out of control, while Julian's office is filled with his papers, books, and twenty-seven years of clutter. Julian's study is where I threw my father's things after he died, and where I now toss everything I want out of sight.

"We can't move your things into Julian's office until we move his things out." She states the obvious. It sounds so simple, but I have been paralyzed around this task. Why haven't I done this?

In Julian's office she assembles the boxes and opens a garbage bag. Producing five index cards and a marking pen, she writes: "JULIAN, DADDY, GOODWILL, RECYCLE, THROW AWAY."

"Macro-sort first," she declares, taping each sign to a box. I feel ashamed, silly. I am fifty-eight years old with a master's degree from Stanford. Amanda is young enough to be my daughter. Do I really need to pay her to label a box? From the nearest pile, Amanda lifts the top paper, scans its contents and throws it into the appropriate container. I begin picking up papers too. It feels good to put each paper in its new place. But every time I hold a letter or photo, waves of emotion flood me.

"Look at this," I murmur, showing her my father's report card from junior high.

Amanda pays no attention. "Put that here," she orders. No sentiment, no nostalgia allowed. She is clearly not interested in memorabilia.

A dispassionate macro-sort is just what I need. On my own, I would stop to read each letter, gaze wistfully at photos, weep a bit over Julian's notes. I would get confused over how to arrange the papers, would become overwhelmed and pick up paper clips.

Amanda keeps me to the task. "Throw away? Or Goodwill?" she snaps.

Suddenly Rasa appears, adorable in her tiny jeans and flowered shirt, her black curly hair pulled into two little bunches on top of her head. She holds out her finger. "Gamma, I have a spinto," she says.

Amanda never looks up. I follow her cue and continue sorting papers.

"Gramma's working," I say. "Go find your Daddy."

Rasa stares at me, eyes wide, lower lip quivering. I don't usually talk like this, and she runs away. If Amanda weren't here, I probably would stop and take out the splinter.

Seven boxes cover the carpet. Now we see that our categories don't work. The Julian macro-category will not contain all his papers, and we find other things defying the divisions. So Amanda

tears the sign from the box, turns it over and prints: "JULIAN—SCIENCE," then another, "JULIAN—PERSONAL." She makes new labels, "PHOTOS" and "ANN—MISCELLANEOUS," and assembles new boxes. We keep "DADDY" and "GOODWILL." The "THROW AWAY" label remains taped to the plastic bag which is rapidly filling.

Amanda slashes through piles—tossing papers in boxes, handing me whatever she is uncertain about. But I feel terrible throwing out Julian's things. He is not dead. An enormous resistance hangs over me, as if I am erasing his presence, pushing him more completely out of our house. This was *his office* for twenty-seven years and I feel guilty taking over his space.

Be logical, I tell myself, tossing stacks of manila folders. Julian will never need these papers; there is absolutely no need to keep his professional files. The kids won't read them and neither will I. Now that Karen's family lives here, they need an extra room, and I need a private work space, a quiet place to write. Wouldn't Julian want me to do this?

I decide to keep Julian's published material for Ben, Karen, and Jeff, who may want it one day, especially Jeff. Every scrap of paper with Julian's handwriting, I also keep, hundreds of scribbled notes: tasks to do, words he wants to remember. Somehow I cannot toss these sad reminders of Julian's decline, but I throw away everything else.

With Amanda beside me, I grow bolder: hurling Julian's files, scientific reprints and papers into the recycling box, holding in mind the image of a tidy workspace, a clutter-free desk for my computer and printer, PFLAG files standing neatly in metal dividers, my Navajo print hanging beside the window.

Boxes grow heavier. Amanda carries bulging plastic bags to her car, saying she will drop them at the dump. She hauls away Goodwill boxes. Space expands. Suddenly, for the first time in two years, the light oak surface of Julian's desk appears, the swirling grains of wood, beautiful.

Now, Julian's bookshelf is empty, six white shelves awaiting my books. But his books lie dumped on my bed. I have nowhere to put them, as the shelves by our bed are already full. So Amanda and I begin sorting Julian's books, even though three years ago, when he left Stanford, I already gave away hundreds. These remaining volumes

contain chapters he wrote, or were written by colleagues and friends, or are books he collected on Israel, meditation, and Zen, which Jeff has told me he wants.

Amanda and I create more categories: books to give to Julian's colleagues, students, and Friends of the Library; books for Jeff, and books to keep. Each one I hold in my hand, struggling with my urge to keep it, resisting the thought that I will read it one day.

"Make space!" Amanda keeps me to the task.

Soon, seven bags of books are destined for the library; another three to Julian's research associate. The books I decide to keep stand dusted on the nightstand; labeled boxes are stacked by my bed.

That the boxes will stay there for another three months, I don't yet realize. But no matter, the main job is done. Julian's stuff is out of his office, which now stands empty, waiting for me to move in.

Amanda and I stand proudly by the boxes as she looks at her watch: twelve noon. In just three hours we cleared Julian's office, even though his presence still hangs in this room which has always been his private refuge. Though I am eager to move in, I feel a lingering sense of betrayal. But the caregivers' retreat made clear that I must move on; Bonnie, the retreat leader, would endorse these actions. For me, clearly, moving on means moving in.

Slipping her pen in a top vest pocket, Amanda carries the final garbage bag to her car. "Call me if you need help with micro-sorts," she says, and drives away.

Like a psychic plumber, Amanda has unclogged the energy flow in our house. No more do we have an unused room, and I am eager to settle myself in this clean new space.

Suddenly I imagine Julian giving me his blessing. Even with Alzheimer's, he supported my trips to the mountains, understood my need to get away alone. Never hanging on me, he endorsed my growing independence.

Excitement builds; I can't wait to move my books, computer, files, pictures, and manuscripts into my new office. A surge of energy swells. I will like working in here, and understand why Julian loved to secret himself in this small cozy room. Feeling Julian's pat on my bottom, I hear his voice, in his cute Scottish accent, cheering me on: "I'm proud of you. Go for it, Annie."

Shots of Clarity

A CAFE LATTE in my Toyota's cup holder, the last tape of *The Great Gatsby*, over the bridge and up the freeway to Julian. I plan to spend the morning with him on my way to volunteer at a respite camp later this afternoon.

This Friday morning in early June, I find Julian sitting on the bench by the front door dressed in corduroy pants and a peacock blue shirt, his feet bare, his caregiver kneeling before him tugging on his socks.

"Hi, Ann," she says. Julian never looks up until I stand in front of him calling his name, then he breaks into grins.

"I love you. I lo-o-ve you!" he exclaims, kissing my lips. His hair feels damp; he is obviously just out of the shower.

"Can you wait a minute?" his caregiver asks.

Sitting on the bench beside Julian, I watch her clip his fingernails, hear him laugh at the clipper's tickle. Streams of gibberish pour out, as if he's glad I'm here and has lots to tell me.

Soon we're out the front door approaching our car.

"Goody, goody," he exclaims. "Da ga, da ga, da ga. Diddle piddle diddle. Poddle moddle."

He's in a great mood, caressing my hair as I open the car, gazing at me, his face close to mine, smelling of toothpaste and shampoo.

Suddenly he looks deep in my eyes. "Oh, I feel just like myself," he declares. "There's no difference. I just love you!"

Amazed, I stare at him. After four months in residential care, these unexpected shots of clarity still startle me, allowing peeks into his reality, into what is left of his tangled brain.

When I punch the tape deck button and a Yiddish song bursts forth, Julian shouts, *"Oy gevalt!"* and claps in time to the music all the way to the lake.

At Lake Chabot, as a cool breeze hits our skin, he delivers his usual comment, "Oo, coldy, coldy," while buttoning the top button on his shirt and pulling up his hood. Each time we walk in the sun, he will remove his hood and unbutton his shirt, covering up again whenever the path leads into shade.

"Wow!" he declares staring at a bank of orange sticky monkey bushes growing up the hill. "Wow!" he repeats, facing the lake.

Today's exuberance spills over me. This outing is not how most people view visiting an Alzheimer's patient. Perhaps Julian is not typical. Why is he so responsive today, when so often he appears oblivious and blank? Health professionals ponder why Alzheimer's patients fluctuate so in their behavior. But whatever the reasons, I'll continue to do whatever I can to encourage Julian's sense of well-being.

Hand in hand we stride past cattails at the water's edge, past the fallen log where turtles sun themselves. Whatever song I begin, Julian quickly hums the tune. If I abandon expectations of meaningful exchange, and don't sink into the greater gloom of all that is lost, these moments feel fine. Emotional connection is what I value most in friendships, and it's amazing how, in our odd little way, we have this still.

Laboring up a steep hill after walking an hour, I puff, "I'm getting tired," and Julian looks at me with a worried expression.

"Are *you* tired?" I ask.

"No."

"I am. I'm tired."

"That's okay." His reassuring words pop out. "You'll be all right."

Even in this diminished state, he can occasionally be sensitive and aware. Back in the car, we sing more Hebrew songs as we return to Oak Creek. "How about staying for lunch?" a staff member asks me again, as I deliver Julian to the patio where they eat on Fridays. Glancing at my watch, I see I do have time.

~

It's hamburger day, when the cook barbecues outdoors. Although I'm volunteering at the respite camp later today, I don't have to be there until two, and since I live with five vegetarians, the grilling meat smells mighty good. So I sit beside Julian at a picnic table with his first roommate, George, and Irene, the woman with twin granddaughters, across from us, and a balding man with a cane named Felix at the end.

"May I join you?" I speak directly to each one. "I'm Ann, Julian's wife." I have talked many times with George and Irene, but never to Felix.

Our plates arrive and Julian eagerly scoops up baked beans with his fingers, while George, Irene, and Felix silently chew their burg-

ers and eat potato salad neatly with forks. Though I have eaten lunch here several times, I still am uncertain what to say.

"I love hamburgers," I try, but it's a weak start. "Good barbecue."

No one replies, and I'm thinking what to say next when George says, "The organization is well-managed. But they'll have to reorganize the materials. It definitely needs to be done."

Across from me, Irene jumps in, "Yes, the girls are in the islands. Twin girls. Little ones. Hawaii. It's great over there."

Grabbing onto a meaningful word, I add, "I've never been to Hawaii."

"Joanie and Bill were there—in Honolulu," Irene answers, swabbing a blob of catsup which fell from her bun onto her flowered blouse.

I have no idea whom she is talking about, but Irene rambles on in full sentences as if I knew them well, while George discusses "war and invasions."

Julian silently picks up one bean at a time between thumb and forefinger. When a bean falls on the table, he lifts it carefully, his little finger curved in the air, like a Victorian lady sipping tea at a tea party, reminding me of his mother in Scotland.

While Julian is the only person at our table eating with his hands, at other tables, residents feed themselves at all levels of skill. One white-haired man wearing a bib shovels bits of a bun into his mouth with both hands, half of it falling on the table. Next to us, a caregiver tries to spoon potatoes into a woman's closed mouth, saying, "Open your mouth, Millie. Open up."

At the end of our table, Felix, a distinguished-looking man with meticulous manners, the one who whacked Julian's head with his cane, cuts his hamburger neatly with knife and fork.

"Have you ever been to Hawaii?" I politely try to engage him in conversation, having no idea if he can talk. But I am learning to assume everyone can.

In a slight German accent, Felix answers softly, "No, I never have," before resuming his silence.

Irene, George, and I chatter on, taking turns speaking, one of us beginning when another stops, asking and answering questions, the pragmatic forms of conversation. Irene and George speak grammatical sentences with good vocabulary, though I have no idea what we are talking about. Our "conversation" has no logic, no topic that I

can find. But I have learned, from years with Julian, how to carry on a satisfying conversation that is about nothing. Julian eats steadily while Felix, also quiet, listens, yet I sense he understands.

The camaraderie around this table feels oddly rewarding. George and Irene seem as content as if we were having a mature talk. Only information and content are gone. It can be interesting, and often amusing, hanging around dementia patients once you give up on logic and give yourself over to this new way of relating.

It is as if you enter a strange land, with the rule "Abandon all logic, ye who enter here" written over the gate. This lunch seems like good preparation for my eight-hour volunteer job at the respite camp, which lies ahead.

As caregivers bring watermelon for dessert, I stand up, ready to go. It's easier for me to leave Julian at the table, than if he follows me to the door.

"Excuse me, but I have an appointment," I say. "Thank you for having me to lunch. Goodbye, George. Bye, Irene. Goodbye, Felix."

Julian looks at me frowning.

"I have to go, Darling." I ruffle his hair. "I'll be back later," the words I said when Julian was home. Here at Oak Creek, I always leave Julian with "I'll be back later," never goodbye.

But he leaps up ready to come with me. "I'll go too." Tension hangs in the air at the moment of leaving.

"Here's your dessert. Sit down," I say, maneuvering him back in his chair, handing him melon. "I'll be back soon."

Julian shoots me another mysterious marvel of dementia.

"Okay, Sweetie, I'll be waiting," he says, clear as can be. "Don't be long."

I leave Julian drinking his pineapple juice, his little finger arched delicately in the air.

Pay Back

AFTER LUNCH AT Oak Creek, I drive an hour east to a lodge where the Family Caregiver Alliance respite weekend is starting. Julian came to this camp last year, but this time I come as a volunteer buddy, instead of an exhausted caregiver wife.

Soon I find myself on grass outside a brown shingled building, playing volleyball with three men in wheelchairs.

The net hangs low, the ball large and soft, like a big balloon. When it comes my way, I bat it to Robert, sitting near me in his wheelchair; if I get the height and angle right, Robert can slam it over the net.

"Way to go, Robert," I yell.

"Nice shot," another volunteer shouts, likewise setting up balls for two chair-bound men on the far side of the net.

Also on their team stand a lanky, white-haired woman and a robust man wearing a straw hat. Though they are over eighty, they hit the ball well, make cheery comments, their Alzheimer's still in the early stages.

Here I am, starting an eight-hour shift at this respite camp, which Julian attended twice when I felt desperate from the grind of caregiving, hoping to offer something back for the relief I got when Julian came here.

Running to the net I set up balls for Robert, then dash for hard hits to the back court. Robert began this game sitting stiff and grim-faced in his wheelchair; now he grins broadly each time he swats the ball.

"We've got a real system going here, Robert," I shout.

Altogether six men are in wheelchairs, one has a wooden leg, one a gastrostomy, three are diabetic. Some had strokes, others have Alzheimer's or other forms of dementia. Many campers walk okay, but need help dressing and in the bathroom. A few wear diapers.

When Julian came to camp, I had no idea of the complex planning behind this weekend.

Beth, the organizer, pairs each "camper" with a "buddy" who volunteers for an eight-hour shift. We are to "hang around" with our camper, help them feel comfortable, be their special friend. Since one buddy hasn't shown up, I am assigned two campers: Robert, a soft-spoken African-American man, who had a stroke seven years ago, leaving his right side paralyzed, and Shirley, a skinny, gray-haired, lively woman with Alzheimer's, who is in constant motion, chattering non-stop.

As I helped Robert's wife unload his suitcase just an hour ago, she poured out instructions. "Here's his jacket and a box of Depends.

He doesn't usually wear them, but just in case. And he needs help getting to bed."

"Don't worry," I said, her anxiety bringing back the apprehension I felt when I delivered Julian to camp. "We'll take good care of him. You have a good weekend. Do you have special plans?"

"Dinner with friends," she said. Such a simple act, which most people take for granted, but for caregivers, going out can be hard, if not impossible, to arrange.

As campers arrived, their buddies greeted them and escorted them to their rooms, each family's face showing apprehension mixed with relief.

"I'm so tired," sighed the wife of the Alzheimer's patient with the wooden leg. "I don't know how much longer I can go on."

"I've never left my husband," another said.

"We're going to the wine country," a daughter and her husband announced, giving me the telephone number of their hotel. "But don't call! We haven't been away without Mother for three years!"

The joy I felt having two weekends alone without caring for Julian comes rushing back, plus, the pleasure of knowing he might have a good time too. Now I glimpse the detailed planning behind this venture, suddenly realizing I don't even know who Julian's buddies were.

The volleyball game over, I push Robert's wheelchair into the lodge, where campers, buddies, and staff gather in a large circle for lemonade and the afternoon program. We are to tell our names and something special about ourselves.

Most campers seem so nervous and confused, I wonder how they'll ever introduce themselves. But Beth holds index cards filled out by families, giving personal information about each camper— occupation, interests, place of birth. In the most nonchalant manner, Beth encourages campers in their labored attempts to speak, elaborating on a word they might produce, extracting a meaningful phrase out of a stream of disjointed thoughts. New campers begin to relax.

Sitting between my special buddies, Robert and Shirley, I wink at Beth, give her a thumbs up sign. What a marvel she is: orchestrating this meeting in such a jolly, natural way. Soon we are all singing "I've been workin' on the railroad...," and suddenly it is time for dinner.

At the evening gathering, Karaoke singers appear, lugging huge black amplifiers, TV monitors, and microphones. Before long, everyone is clapping, singing, acting silly. Volunteers dance lively polkas with elderly campers. A retired psychology professor with Alzheimer's dances wildly to rock music, reminding me of Julian when he could still dance.

I "dance" with Robert, standing in front of his wheelchair, holding his hands. At first I feel awkward and imagine he does too, but soon we get into it, vigorously swinging our arms in time with the polka, then I push his wheelchair in merry circles, hand him a tambourine which he jangles and shakes. My other buddy, Shirley, who sits alone day after day in her son's apartment, is ecstatic to be in the midst of all this commotion.

"I'm so happy," she shouts. "You gotta be with people. People! People!"

The dancing over, I push Robert's wheelchair outside, down a paved path to the "bunkhouse," where the men in wheelchairs will sleep, other buddies pushing their campers, too. The night is cool. Dark shadows of pines stretch across the path, a butter yellow moon begins its ascent.

In the bunkhouse, six men in wheelchairs sit in a tight circle, waiting for the night staff to help them to bed. For many this is their first time away alone since they've been disabled; a slight awkwardness hangs around us. I perch near Robert on the arm of a sofa, quietly listening.

"Where were you in Europe?" one man asks Robert, who in the introductions said he had been a captain in World War II. Most of these men, in their seventies and eighties, served in the military during the war, and they discuss where they fought.

Gradually their talk deepens. "When did you have your stroke?" a man asks Robert the more relevant question. "And when did you have yours?" Robert asks back. The conversation turns to what now unites them, what is really on their minds.

"People stop noticing you," Robert tells the group. "People I thought were friends suddenly aren't there."

"Yes. It's so hard to get around," says a stocky man in a plaid shirt, shifting in his wheelchair. "I get so damned frustrated. I used to make furniture and fix things. Now I can't do a damned thing with

this useless arm!" An hour earlier this man stood on his good leg and twirled me around.

"People let you down," Robert adds softly.

How privileged I feel to be in this bunkhouse, witnessing intimate talk springing up between men who this afternoon were strangers. I wonder if Julian felt like this when he came to camp, though he couldn't have verbalized his feelings.

"You are all courageous." The words jump from me. "I admire your resilience, your strength."

The men sigh and grow quiet. In the silence, something rich and meaningful passes between us, a current of understanding flows around. Though I am able-bodied, young, and female, I feel deeply connected to these brave men.

We share a similar suffering. For six years Julian struggled with letting go of his life as a quick-witted, capable man, also feeling rejected and useless. A memory comes of him two years after his diagnosis, crying, "No one wants to talk to me anymore." For six years I helplessly watched him slide from competence to residential care.

Finally the night staff arrives to get the men ready for bed; my shift is over.

"Goodnight, Robert. Have a great day tomorrow." Not finding words for what I feel, I stumble around an ordinary good-bye, swallowing back the lump tightening my throat. Shaking his hand, I manage, "It's so nice to meet you."

Robert is wheeled away. I watch his chair disappear into the bathroom, then leave the bunkhouse, heading up the path to my car. I came to this camp to give something back. Little did I guess that from volunteering I would so richly receive: witnessing the power of the human spirit, and the importance of emotional connection, no matter what state the body or mind is in. I feel connected, too, to the wide world of caregivers, who day after day, care for loved ones, a gargantuan job largely unappreciated by others, unless you've been there.

From shadows drifts the soft hoot-hooting of an owl, the huge yellow moon swelling up behind the pines.

Hiking

IN EARLY JULY, a friend and I rent a cabin in the mountains near
Lake Tahoe, where Julian and I came for years. Alone today, I leave
my car at a cow camp trailhead and hike along a muddy path, push-
ing through mule ears and fragrant lupine reaching nearly as high as
my waist. The air is sweet, and the trail follows a noisy stream where
water tumbles over rocks and wild gardens grow along the bank:
daisies, pale blue lungworts and bunches of yellow and purple flow-
ers whose names I don't know.

After ten minutes, my stiff hips loosen, the dull ache fades away.
My pack, holding a water bottle, sandwich, and windbreaker, hangs
lightly on my back, my floppy hat shades my face.

The trail climbs steeper now, out of the woodlands, headed to-
wards switchbacks crisscrossing the bowl that slopes down from the
ridge. I am as alone on this hillside as that solitary juniper off to my
right.

Gravel crunches under my boots as I pass tiny pink phlox nestled
against glistening granite, and marvel at swaths of magenta paint-
brush covering the bowl, more flowers here than I've ever seen.
Small dark birds swoop and dart between pines, juncos, maybe, or
swallows.

One brown bird lights on a willow just a few feet away, so close
that without binoculars I see his crimson head and breast, his brown-
streaked wings: a Cassin's finch. Stunning, brilliant, he perches for a
moment on the branch before me; then suddenly, he's gone.

As I start up the switchbacks, my legs feel heavy, my boots slip on
sliding rocks. Heart pounding, I must stop every few minutes to
catch my breath.

I hate walking these switchbacks so slowly. But I'm hauling twen-
ty extra pounds accumulated this past winter from stress eating: in
the hospital cafeteria as my father lay dying, in bakeries eating past-
ries with Julian, filling up time before going home and putting him
to bed.

Higher on the switchbacks I gasp for air, my pulse throbbing in
my throat. Above the tree line, I gaze at the hillside before me, pale
green with huge patches of magenta and orange, and far below, the
brown barn at the cow camp, with tiny cars parked by the trailhead.

Just last September I hiked here with Julian, as we have done for the past eight years. But by then I could not have managed Julian alone. Ben and Greg came with us, and our good friend Joan. I could never have driven with Julian, cooked and cared for him, hiked with him, slept with him, talked to him—by myself. But I needed one more trip together to our beloved mountains, correctly guessing that trip would be his last.

I did the driving, while Greg planned meals and cooked. Ben and Joan took turns walking with Julian, singing with him to keep him moving. Apprehensive with every step, Julian was fearful if he had to step on a rock or cross a stream, nervous if he stood by the lake's shore. He wouldn't climb over a fallen log, enjoyed no view. We had to drag him up mountain paths, holding his hand on every trail.

Still we managed to have fun. Photos show a smiling Julian poised between Ben and me, arms slung over each other's shoulders; Julian in his navy parka sitting on a granite boulder golden in the setting sun; Julian and me dancing to a Beatles' tape in the pine-walled cabin.

Ten months later, overweight and out-of-shape, I huff up these switchbacks alone, remembering when I last saw Julian five days ago in his care center. On my way here, I stopped to visit, and took him to a cafe for coffee and cake.

Happy, silly, full of kisses and jingles, he never noticed the packed car, never saw the duffel bag or ice chest. He never asked where I was going and, though it felt sneaky and dishonest, I only said, "Bye, Darling, love you. See you later," as I left him sitting along the wall in the dining room near white-haired folks sleeping and slouching, the music therapist pounding "Goodnight, Irene" on the piano.

Now I'm climbing the last switchback just under the ridge, past tall monument flower spikes pushing out of the rocky slope. With each step, my boots slip backwards on gravel, my breath comes in short gasps.

Suddenly I reach the crest, where a huge panorama spreads before me: jagged volcanic peaks ring the green expanse of Meiss Meadow below, pitted with small blue lakes. Wide snow patches cling to the ridge's north side, and turning south, I scan the huge bowl I have climbed, locate the tiny brown speck of the cow camp barn. Up on this ridge, the wind howls fiercely, blowing off my hat,

making my hair whip my face, leaving me shivering and exposed.

I am utterly alone. Unexpectedly, tears sting my eyes. Julian is dithering around in Oak Creek, where he now lives. My husband, my life companion, is gone. What has happened to our old life? Grief floods me, a single sob sticks in my throat. I miss him. I want him, as he used to be. Maybe I've idealized him, forgotten his faults, minimized our quarrels and fights. But I long for him whole: bright, smart, capable. I need to talk to him, want him to hold me.

Images come of hiking together young in our marriage, when our lives lay open before us, passing gray-haired couples wearing jeans, parkas, and packs. That was my goal: growing old together, becoming a gray-haired couple still hiking mountain paths.

Yesterday, a solitary woman descended the trail from Lake Winnemucca as I hiked up. Stout, with bowed legs, she looked sturdy and strong. Blue shorts exposed heavy thighs lumpy with varicose veins, and her broad smile revealed crooked teeth with spaces between them. Carrying a ski pole, she paused and jammed it into the ground to brace herself, then looking straight at me, beamed and said, "Isn't this glorious?"

Shivering here on this blustery ridge, I pull my parka from the pack and zip it up, before heading back down the trail. Walking easily now, no puffing, no pounding heart, I lurch down the steep path, wind ruffling my hair, the low western sun warm on my face.

On the descent, my thoughts about Julian feel less anguished. As though from a high ridge, I scan the panorama of thirty-five years together: the variegated, richly-colored, complex sweep of our marriage. Julian seems smaller now, occupying less space. He is like the beautiful finch that perched momentarily beside me, brilliant, in full view, and then flew away.

Suddenly I stumble. My boot slips on a loose rock and I slide down to one knee, an agnostic Jewish genuflection. My back is wrenched, my kneecap smashes on gravel. Slowly pushing myself up, I stand for a moment, assessing my body as the stinging on my knee eases, my backache fades. I feel okay again. Thinking of yesterday's woman, I decide to bring a ski pole next time I hike.

My eyes lift and scan the trail ahead: the intense orange paintbrush, purple lupine, and yellow mule ears even more glorious in the slanting light of late afternoon sun.

Dinner Party, Solo

BY MID-AUGUST, tomatoes, eggplants, and cucumber vines spill out of the new raised beds I had built in my garden where I tore out the old privet hedge. Apple tree branches bend low, heavy with small green fruit, yellow coriopsis and purple salvia showing off brilliantly against rock roses.

Because the garden has never looked better, I decide to have a small dinner party. Not a dinner party exactly, but I invite three friends for a barbecue.

Near the redwood picnic table menacingly looms my new gas grill, which I have never used. Ben and Greg convinced me to buy it for the Fourth of July, so we could barbecue hamburgers, and since then, for over six weeks, it has stood, untouched.

Karen, Beiçola, and the children are away today at a Capoeira event, so the house is quiet and tidy for a change: a perfect time for guests. I haven't had anyone to dinner for a year. I've planned a simple supper: salmon, corn, and eggplant—all done on the grill. Three close friends, who know me and Julian well, are coming.

Happily I set five mats and five silverware settings on the round table under the umbrella—green cloth napkins, daisies, candles, the works. The table looks cool and inviting. Pitchers of iced tea chill in the fridge, also a platter of veggies to dip into hummus, and I will do all the cooking when they are here.

The doorbell rings, and in walk our good friends, Ruth and Bernie, hair wet, just out of the shower. Only yesterday Bernie went with me to visit Julian, whom he hadn't seen for months.

Driving Bernie to Oak Creek, I warned him that when we entered, residents would come to him, talk, and might act strange. But I needn't have warned him. He regularly visits his retarded son, Steven, who lives in a home for handicapped adults; Bernie knows what residential facilities are like.

The minute Julian saw Bernie, he rushed over, hugged and kissed him, declaring, "Oh, lovely, lovely!" Not embarrassed at all, Bernie was cool, hugging Julian, kissing him back. There they stood, two gray-haired, middle-aged friends, two aging professors, who met in 1970 in an anti-Vietnam War demonstration, holding each other in a long embrace. I know Julian recognized him. "*Oy Gevalt,*" Julian said.

Later, the three of us walked by Lake Chabot, holding hands, Julian in the middle, singing loudly together and whistling. An old left-wing Jew like Julian, Bernie launched right into the songs Julian and I sing, Yiddish and Israeli tunes, and "Los Quatro Generales" from the Spanish Civil War.

"I haven't sung so much in years," Bernie laughed on the drive back.

"Singing is what Julian and I do together," I said. "It's how we connect."

Bernie told me about watching Steven play basketball in a special league for handicapped adults, and how he takes him to Stanford football games, which are Steven's passion. He stays connected to Steven, while simultaneously letting him go, as I am learning to do with Julian.

But pain still hangs beneath our surface acceptance.

"Once I spoke to a Stanford psychology class on having a retarded son," Bernie explained. "Suddenly I broke down and cried. I didn't realize how much pain still runs deep down."

Now Bernie and Ruth stroll around the garden admiring my new plants; they haven't been here for months, haven't seen all the changes. Then I shove the instruction manual for the gas barbecue into Bernie's hands.

"Here, you're a professor of engineering, read this."

A twinge of helplessness hits me as I ask for Bernie's help; I meant to read the instructions and master the grill myself before this dinner, but it's easier just to ask Bernie.

"I should have…," I begin to explain.

"No problem," Bernie interrupts my protest, settling into a garden chair with a glass of iced tea and the manual while Ruth examines my tomato plants, comparing them to hers.

Soon my buddy Eileen appears in the garden, holding a cheese board. "Oh," she says. "Suddenly I felt so sad walking in the door knowing Julian wouldn't be here." Her husband, Joe, died four years ago, and Eileen and I spend a lot of time together, going to movies and out to dinner. Wiping her eye, she arranges crackers and brie on the board.

The four of us sit around the table under the white umbrella sipping cold drinks and nibbling hors d'oeuvres as the air cools down,

shadows stretch across the lawn, and crickets begin their twilight song. The garden is quiet, beautiful, and I feel calm and relaxed here with my good friends. Our talk is easy, no alcohol even, and we're drunk, spaced out in this delicious summer night.

Eileen lights three candles set in square glass containers, while Bernie and I tackle the barbecue. As he reads me instructions, I push a button and turn a knob on the front panel to start the grill, a job so simple, I could easily have done it alone.

Wrapping the five salmon steaks in aluminum foil, I place them on the grill, adding five ears of corn in their husks, then split Japanese eggplants, just picked from the garden, and brush them with oil.

It's dark now, so I can hardly see the grill. A heated discussion begins over how long the fish should cook and how many minutes before we turn the corn. When we finally open the foil and remove the corn husks, we see that all the food is burned. The charred black ash coating the fish, corn, and eggplants makes everyone laugh.

"We should have turned it sooner." "The gas was too high." "You need to oil the fish."

But no matter. Once you scrape off the charred coating, the food tastes swell. "Let's pretend we're camping," I say.

As we begin to eat, Eileen suddenly says, "There are five place settings and we're only four. Was someone else coming?"

Blood rushes to my cheeks as I realize I bought five salmon steaks and five ears of corn, and set out five plates, assuming five people were eating.

"Well, look at that," I say, feeling foolish and whisking away the extra setting. "I just assumed five."

No one says anything, but we all know why: Julian's presence is as strong as his absence. For thirty-five years, I've counted the number of dinner guests, and automatically added two.

After dinner, we sit in the balmy air, lingering over mint tea and peach cobbler, watching the candles flicker as crickets chirp louder and the garden grows dark, our talk rambling and easy.

Finally Bernie looks at his watch, announcing, "It's midnight," and my friends prepare to leave. I hug them goodnight and blow out the candles, flooded with an enormous sense of satisfaction.

For years I believed Julian was the dominant attraction and that

friends gravitated to his personality and witty talk. Now I feel odd, tentative, without him. But I have had a successful, solo dinner party. I can have friends to dinner and resume a normal adult life. Now I know how to light my barbecue, and I understand that I just need to turn the fish a little sooner.

Yoga

THE NEXT WEEK in Yoga class we're supposed to lie in corpse pose, *savasana*, but I fidget on the blue foam mat, my muscles tight, my lower back arched off the floor, my skull pushing up my chin. This is not deep relaxation. My neck feels pinched and I can't let it release and flatten.

My mind races, one thought after another swelling up, grabbing my attention. I need to make a budget. Why were there only forty-two dollars in my checking account when the bank balance came? I must call Goodwill to collect the junk I threw in the garage after my cleaning session with Amanda. Will the recycling truck take cardboard boxes or do I need to collapse them? Do I have any Hawaiian-looking clothes to wear on Sunday to Oak Creek's luau?

The Yoga teacher's melodic voice penetrates my mind's chatter. "Breathe. Stay with your breath. If thoughts come, return to your breathing."

I have heard these words a thousand times. I know this already. Usually I sink eagerly into the sky blue mat, surrender my body to poses and release my mind to simply following my breath.

But today it's not working. My back hurts, my neck is stiff. I'm getting old and arthritic. I should call a rheumatologist and ask about the pain in my hip.

"Think about space." The teacher's voice breaks through. "Space in your body. Relaxing is about making space."

I try to focus on my breath, inhale, exhale, and my back sinks a little towards the floor.

"Space has no weight, no boundary. We can move into space...."

Sara's voice is soft and soothing. Focusing on my vertebrae, I breathe into the tightness in my back, try to open up my spinal column to give my poor crushed cervical discs some space.

I think about my garden and the vegetables I planted in the new

space that opened up when I tore out the hedge. I think about the space in my life now that Julian is gone.

"Breathe into the space," Sara says.

Maybe I don't have to fill the space of Julian's absence. Maybe it's not a "hole" or a "void," but rather, a beautiful open space for me to expand in.

My lower back rests now on the mat, my neck flatter, my body heavy, my muscles relaxed. I lie face up, eyes closed in corpse pose. *Savasana.* I am here, now, opening the space.

"Stand slowly, for the sun salutation," Sara says.

Rolling over, I pull myself to standing, but my back still hurts. I have no strength in my legs. Watching the teacher's supple body, I feel stiff, and judgments return: I'm old, arthritic.

"Let whatever you feel be okay," the teacher says, but already I'm filled with criticism. My legs are weak. I come out of poses long before others in the class, some even older than me. I imagine them competent in their professions. What a joke. I don't even know them, have no idea who they are or what they do. This is turning into a dump-on-Ann day.

My sun salutation doesn't go smoothly. I raise my arms and arch my back, but when I bend forward to touch the mat, I must bend my knees. I can't keep them straight, can't swing my right leg back. I can't do "wedge pose" because my arms wobble. I have no upper body strength, can't maintain dog pose as long as others. I can't...I can't....

Sara's voice drifts back in, interrupting my thoughts. "Whatever you feel is okay." Exactly the words I need to hear.

We end class with "warrior pose," which I suggest when Sara asks what pose we would like to do. My legs stand far apart, balanced and braced. For the first time today, they feel strong. My arms stretch out straight from my shoulders. My right leg bends at the knee, the left leg extended. I stare at my right hand. Stretch. Stretch. Energy flows down my arm and out my fingers.

"Warrior pose," says Sara. "A strong pose, projecting us out into space, the space of our work."

In warrior pose I finally feel good.

"Let whatever you feel be okay," Sara's voice returns.

Then, for the last two minutes, we do something new.

Lying on our backs, Sara directs us to put a thumb on each ear,

index finger on our eyes, third finger on our nostrils, fourth and fifth fingers on our upper and lower lips. Each finger presses an opening on our face. It's amazing to do something I have never done before. We are to close each opening on our face, press in our ears, close off our eyes, "listen to our inner sounds."

My inner sounds roar in like a speeding train, drowning out thoughts. I hear my heart: pumping, pumping. I hear blood swooshing through arteries. As if listening to my heart and its pathways through a stethoscope, I hear my life force: loud and persistent.

Pump, pump. Pump, pump. Swoosh. In the background, muted surf rolls in and recedes, as if I've held a giant sea shell to my ear, silencing self-deprecation and judgment. My body, like warm Jell-o settling on the mat, quivers to stillness, and I lie, absorbed, focused, peaceful, listening to my life force roar and the loud surges of my beating heart.

Oak Creek Luau

ON A BRIGHT SUNDAY morning in late August, I enter Oak Creek just in time for the family luau. Paper flowers are taped on walls, tropical fish mobiles dangle from the ceiling, and residents are dressed up fancy—women in blouses, men in colorful shirts, each wearing a plastic lei around their necks.

Julian runs toward me, a red lei bouncing on his chest. "Oh, it's you, you. I love you! I love you," he cries, pressing against the white cotton pants and flowered blouse I finally found in the back of my closet.

Visitors watch us, smiling, as Julian throws his arms around me and lifts me off the floor, with surprising strength. Milling about with husbands, wives, sons, daughters and grandchildren, residents wait for the dining room to open. A muted anticipation fills the air and I wonder if the residents sense a party is about to happen.

The activity director, Renee, dashes by in a light blue, flowered halter dress with a long skirt, two carnations in her hair, looking hot and frazzled.

"We've been cooking since seven this morning and we're not quite ready. We have to de-bone the residents' fish."

Amazed that Renee is removing bones from thirty-five fish fillets, I wait with Julian near Newell and Verna, who looks elegant in a long flowered *muumuu*. "I found this in my attic." Laughing, she confesses, "I haven't worn it for thirty years."

The four of us look like two ordinary couples at a regular party, except that both men are in their second decade of Alzheimer's. When I first met Verna at a support group six years ago, I never dreamed our husbands would one day be roommates in a residential facility. A pang of longing shoots through me: I wish Julian and Newell were normal. If only this party were at Stanford, or Lockheed, instead of Oak Creek Dementia Center.

Every so often Julian fingers the red lei around his neck and asks clearly, "What the hell is this?"

In the television room, Debbie Hoffman squats in front of her eighty-nine-year-old mother, Doris, who sits on a vinyl chair along the wall, talking animatedly, though I know Doris's language makes no sense. But Debbie has learned how to enjoy their conversations. Debbie's partner, Frances, leans on the arm of Doris's chair and snaps their picture.

When the dining room doors open, Debbie motions for me and Julian to join them, and we settle ourselves at a long table covered with a blue plastic cloth decorated with shiny bits of colored confetti. Picking up avocado chunks with his fingers, Julian tears into his salad. "Mm, good," he says.

A band begins playing Hawaiian songs—a woman on piano, a man on bass, and a man strumming an electric guitar, who smiles at me. This guitarist often entertains at Oak Creek and knows the residents well. Fixing his eyes on Julian, he suddenly stops "Lovely Hula Hands" and launches into "Ha Tikvah," the Israeli national anthem, which he always plays especially for Julian and Doris Hoffman during his music sessions.

Julian is thrilled, throwing open his arms like a professional singer and humming loudly, right on pitch. Visitors at other tables look puzzled, wondering what happened to the Hawaiian music. Doris wags her head from side to side, and Debbie, Frances, and I laugh, while Verna winks from the adjacent table.

The next time I glance at Doris, she has picked up her napkin and pinched it in the center, holding it vertically, the top half flopping

over while her other hand bats it back up. Each time the napkin flops, she bats it, hilariously laughing a gap-toothed grin.

"Twenty-seven, forty-three and wasn't that good?" Doris declares, batting the napkin, enjoying herself thoroughly while Debbie, Frances, and I grin at each other.

Then Doris takes the napkin and puts it in her hair, like a giant bow, making us double over, clutching our stomachs. Debbie and I make bows out of our napkins, putting them in our hair too, while Frances snaps pictures and Julian remains oblivious, engrossed in his salad.

Getting sillier, I hold my bow under my chin: a bow tie. Debbie imitates me and Doris bursts out laughing. Then she puts her napkin under her nose, like a huge white moustache. Somehow she scrunches up her nose and upper lip so the moustache stays in place. Giggling like third graders, Debbie and I make moustaches too, and Doris, Debbie, and I sit with huge white moustaches under our noses, but it is hard to keep our moustaches on when we laugh. Frances keeps snapping pictures while Julian reaches over and grabs my avocado.

Residents at the next table, dementia patients with Alzheimer's, stare at us, wondering why we are making so much noise and look so peculiar.

"We're being silly." I feel the need to explain. "This is the silly table."

Smiling blue-shirted caregivers bring our lunch: fresh baked salmon covered with creamy dill sauce, rice pilaf, green beans, sweet potato. Doris scrapes off her sauce and removes dill from her fish, speck by speck.

"She hates dill," Debbie explains, but by now Doris is also removing all the green confetti from the table decoration.

As we eat our meal, Debbie, Frances, and I begin more serious talk.

"Have you read Sherwin Nuland's book *How We Die?*" I ask.

"Years ago, but I couldn't finish it," Debbie says. "Too despairing. Too grim."

"I just read the Alzheimer's chapter," I say, "and learned a lot. I agree with his description of the 'long torturous decline,' but I disagree when he calls Alzheimer's 'death without dignity.'"

Doris and Julian eagerly devour their meal, while Debbie and I look at them, our eyes moist with tears: they are so impaired, yet very alive and present.

"There's plenty of dignity in this room right now," I say softly. "Only you have to learn how to see it."

"People think dementia robs folks of dignity, but they confuse incontinence with dignity," Debbie continues, nodding towards Doris, Newell, and other residents who wear adult Depends. "Incontinence isn't undignified, it's just incontinence."

"Two-year-olds in diapers aren't undignified," says Frances. "Why are eighty-year-olds?"

"It's surprising how pleasantly life can go on in a good dementia center like this," Debbie says. "It doesn't have to be terrible."

"Their life isn't over." I glance at Julian, absorbed in picking up rice grains with his fingers, my voice quavering. "Horribly different, drastically limited, but not yet over."

~

Around the room, visitors sit by husbands, wives, mothers and fathers; I feel weepy seeing these family groups, and united with them in our common struggle. But some residents sit alone wearing the ridiculous paper lei, and I wonder if they realize no visitors came for them.

"I feel so sad for the residents with no visitors." I nod in the direction of one ancient woman silently picking at her sweet potato, and at skinny "Grandpa," whose eyes stay fixed on his plate.

"You know," Debbie whispers, "more than half the people here never get visitors, and some of their families live nearby."

"They're afraid," I offer. "It's too hard to see people deteriorate like this."

"They won't, or can't, come," says Debbie, "because a dementia center seems too threatening and depressing. It evokes too many fears."

"Maybe some adult children feel scared this may one day happen to them," I suggest. "Maybe children of Alzheimer's patients fear inheriting it, while spouses don't."

"That may be," says Debbie. "But I'm a daughter. And some spouses stop coming too."

We look in the direction of one hunched old woman sitting

alone, whose husband deposited her here and never comes. It's hard
to feel gracious towards families who don't visit when you come
regularly, though intellectually I understand that some people may
feel angry at their demented relatives, about events or disappoint-
ments from the past. I understand, too, that younger people are
busy with children at home and their demanding careers. But
still....

Just then, a blue-shirted caregiver wraps her arms around this
solitary woman, hugging and rocking her as she refills her glass with
sparkling cider.

"They should just get over it!" Debbie quips.

"Many people feel their relative doesn't know them," I say, "and
doesn't remember the visit. They think their visit doesn't matter, so
why bother to come."

"Visits are valuable, remembered or not," says Debbie. "Visits
have meaning in the contact that takes place."

"Yes, but it takes time to learn this," I say. "I had to learn how to
come here without getting depressed. Seeing Julian with all these
old people wandering, muttering, drooling, or slouched over
asleep, made me so sad. And when he didn't respond.... It took me
weeks to understand this place, and how to visit."

I look into Debbie's eyes. "You know, watching you with Doris
has taught me a lot."

Too much talking. Julian wants my attention and reaches over,
pulling me to him, kissing my ear. Frances photographs our faces
cheek to cheek, then I snap pictures of Debbie and Frances hugging
Doris.

Dessert is served. Digging into their coconut pudding, Julian and
Doris smile happily while fishing out banana slices and dropping
them on the table with the confetti.

~

When the band stops playing, Julian and I wander out onto the sun-
ny patio where Doris, Debbie, and Frances sit under a green
umbrella, chatting with other families. Verna and Newell stroll
by, Newell stretching out his arm, greeting everyone he passes. He
extends his arm to Julian, who doesn't respond. I doubt if Julian re-
alizes that Newell is his roommate, but I think Newell knows.

Verna and Newell walk away towards the aviary to see the mourning doves, while Julian and I, arms slung around each other's waists, march back and forth across the patio, humming together "Ha Tikvah," which in Hebrew means "hope."

Double Date

ON A HOT SEPTEMBER morning, just after Labor Day, Julian and I sit in the back seat of Verna's Camry as she drives us and Newell to Lake Chabot. Both Verna and I visit three times a week, and we sometimes drive to the lake together.

Newell's favorite Mormon Tabernacle Choir tape, a hundred voices singing "Rock of Ages," fills the car. The tense muscles of his face relax, his anxious look softens. A former engineer at Lockheed, Newell played saxophone, sang light opera, loved music all his life.

Diagnosed with Alzheimer's five years before Julian, Newell hasn't uttered a word for half a decade. Now he smiles and "hums" along with the choir, a muted monotone, his only sound.

In the back seat Julian claps loudly, as if he wants to speed up the tempo of the hymns, and I reach for his hands to quiet him.

~

At Lake Chabot gatehouse, Clifford, who collects parking fees, waves and greets us in his mechanical voice. Pressing his electrolarynx to the collar of his tan uniform shirt, Clifford buzzes, "Hello there! Beautiful day, isn't it? How're your husbands?"

Clifford's laryngectomy requires him to project sound with this device, yet he talks cheerfully to all who pass, the perfect welcome to Lake Chabot.

Helping our guys out of the car, we smear sunscreen on their noses and place visored caps on their heads. But Julian yanks his off, annoyed that I have done something for him that he can do for himself.

"No, no!" he grumbles, putting the hat on backwards so the visor hangs down his neck, making him look like a cool, geriatric teenager.

Handsome in a plaid shirt and navy shorts, Newell stretches his arm towards me, fingers grazing my face, his way of greeting.

Marching down the road under a cloudless sky, Verna grabs Newell's hand and I grip Julian's. Buff-colored grass sways on the hillside, and on our left, Canada geese glide on the lake's glistening surface.

"La-la, la-la." Julian's high-pitched song begins in loud falsetto.

This falsetto marks the newest sign of his decline. Weeks have gone by since I have heard his normal pitch, and I hate losing even his sound.

Then, suddenly, clear as can be, his voice drops to its natural register, and, throwing his arms around me, he declares, "Wonderful. It's wonderful!"

Then, he jabbers as he has done for the past six months, "You know, I've been thinking we should...."

But each phrase trails off, going nowhere. The few real words dissolve into gibberish, melt back into his falsetto song. Each time he begins, my hopes rise: maybe he will complete this phrase? But each ends in verbal mush, and though I should be used to it by now, I am not.

Throwing open his arms to the hot September sun, he repeats, "Everything is wonderful! Everything is wonderful!"

Julian's joy is a mysterious blessing.

⌒

Strong and quick, Newell strides along, almost running, while Verna clings to his hand, afraid a mountain bike will crash into him. Breaking free from her grip, he dashes into the small wooden outhouse beside the path, then quickly emerges and runs ahead to wait for us on the next bench.

Although Newell has had Alzheimer's for fifteen years, wears diapers and can't speak, he does many things Julian cannot. He knows they share a room and that his bed is near the window. Until recently, he played solitaire: building up on aces according to suit, descending from high cards, alternating black and red, acts of genius compared to Julian's primitive skills. Newell balanced his checkbook and played simple tunes on the piano long after he could no longer talk. Even today, if you hand Newell six napkins, he will place one before each chair at the dining table; if a fork is missing, he will get one from the counter. Well brought up, and still a genteel man, Newell positions himself on the street side of the sidewalk when walking with Verna, and holds open doors to let women enter first.

Alzheimer's robs its victims in such different ways, and grants them curious little islands of enduring skills.

Down the path marches our odd quartet: Newell dashing in and out of privies, stretching his arm to passing joggers, Julian wandering into bushes humming his loud falsetto.

Embarrassed over Julian's high-pitched "la-la's" when hikers pass, I sometimes start "Clementine" or "Oh, Susannah," so they see just a couple singing together. Or, I might call, "Hello there," to help them not fear Julian's weird ways.

A woman in jeans with a Yorkshire terrier tugging on a leash calls "Good morning" and shakes Newell's hand. Tears fill Verna's eyes as she says, "People have no idea how good their greeting makes me feel."

A green park truck honks and drives carefully around us, two park rangers waving hello.

"Trail angels," Verna calls them—people who choose to work near bay laurels leaning onto the roads, people who feel nurtured by the rounded hills. People who accept Julian and Newell being here, and welcome them.

Besides Lake Chabot, there are few places we can take Newell or Julian. These healthy, able-bodied men cannot be cooped up, sentenced to life imprisonment in a nursing home just because their brains have shriveled, memories destroyed by neural tangles and plaques. We can't leave them to live out their remaining days in a dementia center with elderly residents shuffling and mumbling, groping their way along halls.

Newell and Julian *need* to go outside, or so Verna and I think; they need to be in nature, to smell bay laurel and eucalyptus, not just Lysol, feces, and carpet shampoo. The staff might say most residents are okay staying in Oak Creek. But people take their *dogs* to parks and walk them!

Maybe the truth is that *I* need to see Julian beside Lake Chabot, do something "normal" with him and enjoy these remaining shreds of ordinary life.

Occasionally Verna and I take them to Burger King for a hamburger and fries, but that is like chasing after two giant two-year-olds who spill their cokes and smear catsup on tables, and now even this is getting too hard. Sometimes I drive Julian to a small coffee

bar in a shopping center, where we sit in the back. But Julian sings loudly in his new falsetto and there is no quieting him now, no hiding his weirdness.

So Verna and I treasure coming to Lake Chabot. Here, Julian and I slip our arms around each others' waists. From time to time, he kisses my neck, nuzzles my hair, says, "You're a good laddie."

When I answer in an exaggerated Scottish accent, Julian blurts, *"Oy gevalt."* When I switch to Yiddish phrases, he giggles again.

Newell walks faster, Verna running to keep up, and they shrink to two small figures far ahead of us on the road. Ambling slowly, I sing: "From this valley they say you are going…, Oh, Susannah, oh, don't you cry for me…, Come and sit by my side if you love me…, …the cowboy who loves you so true…," Julian humming along.

On the bench where the road curves, Verna and Newell wait for us to catch up. When I gesture for Julian to sit, he sees only the steep drop down to the water. Anxiously, he pulls back. When he finally sits beside Newell, I stand behind him, my hands on his shoulders, restraining him lest he stand and lurch down the bank. Verna opens her pack, hands out ginger snaps and Gatorade.

"What do you think about buying a bench and donating it to Lake Chabot?" I voice the thought that recently came to me.

"Great idea! I love it!" Verna points to where the road skirts a little promontory jutting out into the lake. "A new bench might go there. There are some long distances between benches."

When the green park truck passes again, we hail the rangers. "Can we buy one of these benches?" we ask. "How much would one cost?"

The ranger says it is certainly possible; Verna and I decide that we will donate a bench, and write down the phone number to call.

As our guys munch ginger snaps, I open a touchier subject.

"It isn't over for me," I say. "Friends think since Julian is gone from the house, that I'm free, normal again. But I'm not."

Married over fifty years, Verna says quietly, "I know…."

"It's odd, isn't it?" I say, "feeling connected, at the same time alone."

Verna nods, grows silent.

"Julian is so full of life, no matter how weird and demented he looks from outside."

"Newell, too." A vigorous woman in her mid-seventies, Verna consults with state and county agencies supplying services for the elderly, and gardens, swims, plays tennis.

"Finding satisfaction takes time," I say, recalling the story she published in a local newspaper describing their golden wedding anniversary, when she brought Newell to the lake and fed him cookies, holding all the memories from their long, shared life.

"I'm seeing a counselor," Verna confides, "who suggests visiting less often and building a more separate life. But it's hard," she says, "reducing my visits from three times a week to only two."

"I'm starting to come just twice a week, too," I say. "After seven months at Oak Creek, Julian doesn't seem to miss me between visits. He's happy to see me whenever I come."

∼

Back at the car, Julian settles in, but Verna can't position Newell on the front seat so she can fasten his seat belt. Explanations, commands, gestures—all fail. We can't be late for Oak Creek's lunch; frantically Verna pushes Newell's shoulders, but he is a big man, sitting solid.

A baldheaded jogger in shorts and tank top witnesses our struggle and stops beside us. "Can I help?" he asks. Overcoming pride, Verna agrees, and the man shoves Newell over.

"Another trail angel," Verna says as he jogs off and she buckles Newell's belt.

"Oklahoma" plays on the tape deck as Verna drives back, Julian clapping, Newell humming.

Soon Verna and I will eat lunch at Oak Creek where the staff will seat the four of us at one end of a table. Julian and Newell will eat with their hands and grab other people's food. Accustomed now to tablemates who drool and stir their food into mush, Verna and I will chat with each other, as wives often do on double dates.

"...sit alone and talk...and watch a hawk...makin' lazy circles in the sky...,"Verna and I sing, driving back to Oak Creek.

A Good Man

THE NEXT MARCH, I arrive at Oak Creek for my bi-weekly visit. Hard to believe it is thirteen months since Julian moved here, more than one hundred thirty times I have driven across the bay to see him.

In the dining room, the man from adult education plays "Swanee River" while a few residents beat time with rhythm sticks or rattle gourds, conspicuous against the majority who slump and doze, the scene I am used to.

Against the back wall slouches Julian, in his new tan corduroy trousers, fast asleep. No longer does he recognize me from across the room, so I squat in front of him and, as I clasp his hands, his eyelids lift, his blue eyes staring blankly off to one side.

"Hi, Julian. Hi, darling," I say. "Julian, it's me, Ann."

These days I must speak a while, let him hear the sound of my voice before he responds. How much longer will he know me? Slowly, his stare shifts into a smile and he touches my cheek; for now, seven years into his Alzheimer's, he clearly does.

Leaning on the arm of his chair, I listen to the piano player pound out "Molly Malone," a song Julian likes, and he hums loudly, right on pitch. While the teacher collects rhythm instruments, I whisper in Julian's ear, "Do you want to go in the car?"

He stares at my face struggling to understand. "Kee? Kee?"

"Do you want to go in the car? We can drive in the car."

"Enda kee, enda kee?"

"Yes, in the car. We can drive in the car to the lake."

"Yes, yes," he says, jumping up and down like an excited toddler.

It's been months since I heard Julian ask questions or request clarification. Exchanges like this, where he listens, tries to understand and responds, disappeared long ago. Yet today, we enjoy this little chat, the inconsistency of his language totally baffling.

Half Irish jig, half hippy free style, Julian dances, as I lead him across the room and out the front door. Stepping into the sunny driveway, he turns his face, like a sunflower, towards the light.

"Oh, it's good. Wonderful, wonderful!" he declares, basking in warmth. "I'm so happy."

And when I open the passenger door, he slides right in, like a

normal man, as if he knows how. Today, for some reason, he does not stand beside the door, completely puzzled as to how to enter. He does not crawl in on his hands and knees, baffled as to how to sit on the seat, nor does he step in backwards, unable to turn around. The sun's heat has somehow warmed his synapses and he sits down properly as I pull the seat belt across his chest, hear the buckle click.

Driving to the lake, I say, "Hello, Darling. I'm glad to see you."

"La, la, la, la-la, la." Julian begins the sounds he hums all day, from the minute he opens his eyes until the minute he closes them. He is only quiet, the staff tells me, when he is asleep or eating.

"La, la-la, la-la...."

Today's tune is unrecognizable, but it's a change from "Oh, Susannah," which he hummed constantly for the last six weeks.

"La la-la...do you know...," he suddenly sings, "...the ever wonder...la...la la...nevertheless...I've been thinking...la-la...."

This is new: inserting sentence fragments into the "la-la's" of his song. Maybe words are stored in his brain somewhere near music? Maybe melodies trigger expression of his thoughts, or, are the words just random firings of his neurons? I'll never know, but I do know that inserted into his songs are bits and pieces of sensible-sounding phrases.

"La la...I want to tell you...."

My hopes rise. This time, will he say something meaningful?

"La la la...," his song continues. He never completes the message he begins, though his words suggest he is still here enough to try.

Waving a cassette before his eyes, I ask, "Do you want to hear music?" He doesn't see the tape, so I place it in his hands. "Jewish music?"

Though he rarely answers, I still offer choices, because sometimes my question inflection elicits a response.

Julian stops singing. "Sure. Why not?" he answers clearly.

When "Tumbalalaika" blares from the speakers, Julian exclaims, "Oh, lovely, wonderful," clapping and humming with all the songs on both sides of the tape as I drive to the park.

Any familiar music, played on the piano or tape recorder, or sung by me, can dominate Julian's internal song. But in any silence, his own song returns.

Six years ago, just after his diagnosis, terrified of Julian being

A CURIOUS KIND OF WIDOW

unable to speak, we talked endlessly about his increasing language problems. I tried encouraging him to think of himself as a smiling Buddha, an image he admired. For years a small Buddha statue sat on his desk at Stanford, the one that's now on his dresser at Oak Creek; Julian took up meditation, attempting to quiet his then fiercely active and anxious mind.

But Julian never slid into contented silence; instead, he vocalizes constantly. Maybe his singing, even without words, reassures him at some primitive level that he is still himself. No silent Buddha, as long as he makes noise, Julian is here.

⁓

Out of the car, we stroll towards Lake Chabot, where Julian and I have come twice a week for almost a year. Black cormorants dive into sapphire water, disappear, then resurface. Spring grass covers the hills, poppies and wild iris surprise me along the path.

Often I stay quiet while Julian hums, but sometimes when he pauses for breath, I loudly begin a song he knows. If I sing something lively and quick, or slow and solemn, Julian joins me, his voice quality mirroring the song's mood. Without words, our duets touch cheerful, sad, mournful, wistful feelings, Julian's voice full of expression.

When I sing "me and my true love will never meet again..." sweetly, mournfully, tears leak from my eyes, and Julian's. Humming "Eli, Eli," a hauntingly beautiful Hebrew song, a prayer to God, slowly, each note full and resonant, I am flooded with intense peace, and believe that Julian feels peaceful too.

⁓

Now the road crosses the gully where bay laurel trees arch overhead, forming a cool, leafy tunnel, the air thick with their pungent smell. There, we face each other, his hands stroking my hair, his kisses sweet.

Sitting on a wooden bench, Julian resumes his la-la song. A wave of affection floods me, and I speak loudly over his humming, directly into his ear, "Julian. Listen. Listen to me."

He smiles, but he can't stop singing.

"Julian. Listen, listen. I love you."

Suddenly he stops. "Me too," he says clearly.

"I'm proud of you, Julian. You're a good man."

His face breaks into a huge grin. He takes in these words, I know. I look hard, directly into his eyes. "You are doing a wonderful job."

"You too," he says. "You too."

Julian's Birthday

TODAY IS JULIAN'S BIRTHDAY: he is sixty-six. He's been at Oak Creek nearly fifteen months. It probably doesn't matter to him what day I visit, but it matters to me.

Stopping at the front desk, I get the sign-out book and write Julian's name, my name, and the date, April 15, 1997.

"It's Julian's birthday," I tell Vickie, who sits across the counter writing in patients' charts.

"We celebrated all the April birthdays last Sunday." Vickie looks up from the folders, "with a chocolate sheet cake and candles."

"That's so nice. I didn't know you celebrate residents' birthdays." Leaning my elbows on the counter, I wait to hear more.

"We carried the cake to each person and sang 'Happy Birthday'."

"Did they understand it was their birthday?"

"Well, no one blew out the candles," she says slowly.

"Do you think Julian realized the cake was for him?"

The telephone rings and Vickie answers it without responding, but I already know the answer.

When she hangs up, I announce, "Julian won't be here for supper tonight. I'm taking him out to a Chinese restaurant."

But Vickie says, "Wait. I have to tell you something." Worried that something is wrong, I stare at her.

"Julian got a haircut today. You may not like it. It's a little short. A new staff person cut it. But we explained to her how he normally looks." Vickie adds, "It won't happen again."

"That's okay," I sigh, relieved this is all that's wrong. "He's had short haircuts before."

Just then Julian wanders towards the desk, his hair shorn so close to his scalp that pink skin shows through the stiff spiked hair. It stands a quarter inch, like a Marine recruit's, except that Julian is no muscled twenty-year-old. He shuffles in front of me, humming

to himself, eyes staring off into space. Suddenly he looks old, decrepit, silly, yes, *senile*. Senile: a word I have never used to describe him.

Now I see that his beard has been mowed off too, his thick, wiry gray beard, which makes him look like a professor or a rabbi, is shaved away. He looks, not like an academic with a well-trimmed beard, but like a grubby, unkempt old man, the way others probably see him. Maybe my children view him this way; maybe it's partly why they find it so painful to come, and visit so rarely. Gray stubble pokes out from his sideburns, extending under his chin and down his neck, the skin of his jaw pale through the prickly hairs.

I haven't seen Julian's jaw for twelve years, since 1985, on our last sabbatical in Washington, D.C., when he did a research project on men with testosterone deficiency. A memory comes: lying in bed on a Sunday morning, sun streaming through our bedroom window, splashing over the flowered quilt. Suddenly a man appeared at the door carrying a tray with steaming mugs of coffee and a plate of toast.

"Breakfast is served, Madam," the stranger said.

I looked up, saw this clean-shaven man standing with the tray and a folded dish towel over his arm, as if he were a waiter in a fancy restaurant. For several seconds, I stared at the man approaching the bed, before I recognized Julian.

His upper lip was blotchy red; his jaw looked small, underslung. I was used to dark curly hair, a thick moustache and bushy brown beard, so much a part of his persona. He seemed to have lost his character, an intellectual Samson without his strength. I hated the wimpy appearance his smooth jaw made. Not like a professor or scientist, he seemed a shy, ineffectual man.

All that day I asked him, "Are you angry? Are you upset?" He looked so different, his whole gestalt changed. I couldn't understand what he was feeling, couldn't read his facial expressions.

"Why'd you shave it off?"

"Just to try something new," he said. "Sabbaticals are opportunities to experiment with being different."

But when he looked in the mirror, he didn't like it either, and we both decided he should let his bushy brown beard grow back.

"Yes, Julian's hair is awfully short," I tell Vickie. "Let his beard

grow back. I like it longer." If only growing his beard might bring back some of his strength.

Now Julian stands next to me smiling and singing unrecognizable tunes. No more "Oh, Susanna," "Clementine," or "HaTikvah," which he sang endlessly for months. Now his "song" is an invented refrain, repeated in an eerie high pitch, his new falsetto. At times, he vocalizes unintelligible words; other times he produces real words, but they make no sense. Occasionally an understandable phrase still appears, "It's you, it's you...."

We exchange pecks on the cheek, where stiff hairs scratch my lips. His face feels like rough sandpaper, his head covered with prickly stubble with nothing to grab, run my fingers through, tug or caress.

Suddenly Julian says clearly, "Come on, let's go."

I stick my face in front of him, and we kiss, a quick pucker and release. Watching us, Vickie smiles.

Suddenly Julian stops his song and in the silence, I grab the chance to say, "Would you like to go in the car? Ride to the park?"

He stares at me, struggling to understand; it's harder to elicit a response from him now.

"Shall we go in the car?"

After a long pause, he finally says, "Yes, yes," and I am relieved to get an answer. At times I can occasionally capture his attention, by asking a question exaggerating the inflection of inquiry. Though he probably does not comprehend the words, I feel he understands that we are about to do something nice together and I wait for him to agree.

"Shall we walk by the lake?"

"Yes."

"Go out for dinner? Have dinner together?"

"Yes, yes, yes."

I have learned how to elicit these "yesses." Hearing them makes me feel as if we are having a little chat.

In the shady driveway, Julian buttons his top shirt button and pulls up his collar. Then, moving to sunlight, he basks in warmth. "Oh yes, good," my sunflower says.

Beside the car door, I hug him. "It's your birthday. Today is your birthday."

He stares at me with a quizzical expression, clearly trying to understand, but it's as if I am speaking some totally foreign language.

"Happy Birthday to you…," I sing, and by the third line he joins me. We hum it through to the end and repeat it twice more before I open the passenger door and buckle him in. Maybe he does not realize it is his birthday, but he recognizes the song and sings it joyfully.

Driving to the lake, I play his favorite Yiddish tape and Julian, as always, claps to the music, humming along. "Oh, it's beautiful," he exclaims between songs, looking at my face, smiling, caressing my hair, pulling my right hand off the steering wheel to kiss it.

Yes, Julian is growing worse. Yes, his perseverative songs are reduced to a few invented lines repeated over and over. Yes, there is less language, less awareness, less recognition.

But in many ways he acts as he has for the past year, singing, clapping to music, still affectionate. Ever since he came off the Mellaril, and adjusted to Oak Creek, he has rested on this plateau, staying much the same, without much noticeable decline. Though this level will fade, and God, it will hurt when he no longer responds, for now, he does, and I savor each connection I get.

Getting out of the car, Julian shivers in the breeze, and I help him into his blue parka. Hand in hand we cross a field where knee-high grass waves in the April wind. Yellow mustard covering the hillside, the bold azure sky, wild iris along the path: beauty everywhere I look.

Together we sing our shrinking repertoire: "Tumbalalaika," "Clementine," "Red River Valley." Occasionally Julian slips back into his falsetto la-la tune, but when I sing loudly into his ear, he returns to our mutual song, back on normal pitch. From time to time he kisses my hand, or slips his arm over my shoulder, actions I cherish.

Now we walk beside Lake Chabot where a green-headed mallard and his brown speckled mate glide near the bank. So natural in the animal world for the male to be flashier, more colorful, attract more attention. So it seemed for years with Julian and me, but now Julian's brilliance has dimmed.

"On the bonnie, bonnie banks of Loch Lomond…," we sing together, as passersby stare at us, some with puzzled expressions, others smiling and waving hello.

In these moments, I am filled with joy for how happy Julian still

is. These days I rarely feel despair, rarely feel sad entering Oak Creek, where I am used to the hunched, shuffling old people wandering the halls, one of them my husband.

Like Julian, I am also, oddly, content. After thirty-six years of marriage, at age fifty-nine, the exact age Julian was when he was diagnosed with Alzheimer's, for some strange reason, I feel at peace.

Why, I ask myself, as we march down the road. Julian's decline has dominated the past seven years, giving me time to say this long, slow goodbye. I have had time to gradually learn how to take over his share of our marriage's divided tasks. Had time to tell him I love him, and that I appreciated his companionship and devotion, while acknowledging our hard times as well. I've had time to plant, nurture, and grow a life without him. Not exactly a life without him, for he is still very present, but I have my own satisfying life separate from him.

Thumbing through old journals these past weeks, I've read descriptions of our fights and struggles in the late nineteen seventies and early eighties. So much time I wasted blaming Julian for my unhappiness. I wish I'd learned sooner that I needed to build a more satisfying life for myself, apart from Julian and the kids.

Julian and I walk faster, down the slope that dips into a shaded glen. Since he has slipped back into his eerie high-pitched "La-la-la-la, la-la-la-la," and I can't get him to sing with me, I sink deeper into my thoughts.

From where I now stand, here's what I've learned: to accept Julian just as he is. To stop looking to him to satisfy my needs and "make me happy." To have my own fulfilling work. To accept responsibility for creating my own sense of satisfaction and peace. To believe that I am capable and worthy. To silence my gallery of harsh, judgmental critics. To tune increasingly into what I want, instead of trying so hard to please others. I can do this now. I have learned to pick up and cherish the many blessings in my life.

Had I learned this sooner, Julian and I would have enjoyed more loving times, and the children would not have witnessed the often angry scenes between us.

Now, walking along Lake Chabot with Julian, our long, rich life flashes before me. We are long past youthful hopes and promise, and mid-life disappointments. Today's contented feelings I have strug-

gled towards and earned. Our early love has come full circle. We've arrived back at the intense, easy affection we had for each other when we began.

Julian and I reach the mile marker post, and rest on a bench facing the lake before turning back. Late afternoon sun glistens on the water, shooting arrows of light into our eyes, and across the lake, oaks and bay laurels stand in dark shadow on the opposite shore. When I hand Julian a butterscotch, he deftly unwraps the paper and pops the candy into his mouth.

"Mm...lovely," he says.

"It's your birthday," I repeat. "Your birthday."

He looks at me quizzically, wrinkling his brow, and I place a second butterscotch in his mouth. "You're a lovely one," he says, caressing my hair. "Lovely, lovely."

I stroke the side of his head, startled again by the prickly stubble, then begin another round of "Happy Birthday." This time Julian quickly joins in, right on pitch. When we reach the last line, "Happy Birthday, dear Julian, Happy Birthday to you," he adds a little coda, "boom-boom-boom-boom," a few notes of a fancy ending to our song.

We sit on the bench holding hands, my head resting on his shoulder, both of us squinting into the blazing orange disk of the setting sun.

Savoring Chocolate

"A circle of redwoods curves around us...their rust-colored bark fire-scarred, beautiful and enduring."

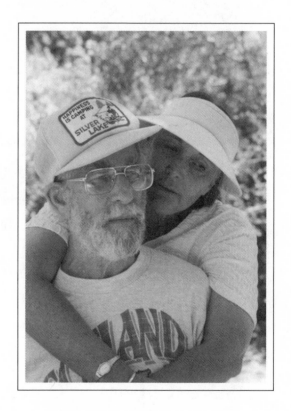

A Sense of Home

ON FEBRUARY THIRD, ten months after Julian's birthday, the telephone wakes me. It's six A.M. The pounding rain of the past three weeks still drums on the roof, pine branches scrape against my window. Ignoring the phone, I start to roll over, but who would call so early if it weren't important? So I lift the receiver.

"Hello, Ann?" It's Vickie from Oak Creek. "Everything's okay. Julian is fine, but..."Vickie always starts her calls this way.

"Oak Creek is flooded. Since two A.M. we've been moving everyone out. Julian's on his way to Cedar Creek, another Alzheimer's center close to you in Los Gatos."

Images of waking up and evacuating thirty confused Alzheimer's patients like Julian leap to mind.

"What happened? Is everyone all right?" My questions pour out.

In a calm voice, Vickie says that at 1:30 this morning, the night staff noticed water seeping under the front door. When they looked out the back, the creek behind the property had flooded, and four feet of water sloshed outside the dining room. The staff called the fire department, who ordered everybody to leave.

"The day staff rushed in to help," Vickie says. "We put residents' clothes over their pajamas, and they sat quietly in the television room while we threw their things into plastic bags. We acted calm, so they stayed calm. Most went to Walnut Creek Dementia Center here in the East Bay, but Julian and a few others went to Los Gatos."

I'm dying to ask more, but I know Vickie must call other families. "You're terrific! Bless you," I say. Julian is probably okay, but picturing him and his Alzheimer's buddies being whisked off in the slashing rain to some strange destination brings tears to my eyes. They will never understand what is going on, and how will the caregivers manage to move them?

At seven-thirty I go into the kitchen, where Karen is zipping

Antar and Celina into their parkas, ready to drive them to school, and I tell them what's happening. "Call me when I get to the office," Karen shouts, hustling the kids out into the rain.

By eight o'clock, I can't wait any longer, and phone the Los Gatos dementia center where Julian is headed. But the vans haven't arrived, although the trip should take less than an hour. Relentless rains are causing major damage all over the Bay Area, and on the television morning news, reporters stand before giant maps showing that three freeways Julian's van should travel on are flooded.

At nine, I phone Cedar Creek again. Yes, they just arrived, and are eating breakfast. "Shall I come? Maybe I could help, you know, calm Julian down," I suggest. But I'm told firmly I should not visit until this afternoon, and I can picture the chaos that must surround ten Alzheimer's patients entering a strange dementia center in a storm.

By noon I can't resist another call. Now it is all right for me to come. Windshield wipers swishing back and forth against the rain, I cautiously drive south, towards Cedar Creek, the center that hadn't yet opened two years ago when I was desperately searching for places for Julian. Inside, a kindly woman at the front desk directs me to him—Room sixteen.

In a bedroom similar to his at Oak Creek, I find my husband rolled in a bedspread sound asleep. The spread's white lining faces out, so he looks like a giant caterpillar in a white cocoon. These days when I visit Julian at Oak Creek, he wanders the halls carrying a fluorescent pink "CAUTION: WET FLOOR" sign tucked under his arm. He is so fond of this sign, I wonder if it feels like his briefcase. But now Julian is obviously exhausted, so I let him sleep and search for other Oak Creek refugees.

First I meet Maureen, the slender woman whose sons never did housework, her hair mussed, her eyeballs red from fatigue. "Maureen, hello," I smile, putting my arm around her. "I'm happy to see you!"

"I don't know where I am," she whispers. "I'm so confused. I don't know where anything is." Patting her shoulder, I answer, "This is a new place. But you'll be all right. You have friends here to help you." Looking unconvinced, she manages a faint smile and drifts away.

Next, skinny "Grandpa" shuffles towards me, unshaved, dark circles ringing his eyes. "Hello, Alan," I call. "Oh, Alan, I'm so glad to see you."

"How'd you know my name?" He can't believe someone here knows him.

"Well, I know you from...from your old neighborhood." I am uncertain how much to explain.

"What is my old neighborhood?"

"Castro Valley."

"Yes, I live in Castro Valley, but this isn't Castro Valley!"

"This is Los Gatos. You'll go back to Castro Valley soon."

"But I don't want to be in Los Gatos. I want to be in Castro Valley!"

"I know, Alan. But you're okay. You'll go home soon."

Apparently satisfied, Alan, too, shuffles down the hall.

In the large activity room residents play a loud game of bingo, a rather high-level game few Oak Creek residents could manage. "G twenty-two," an activity director calls out, "N forty-one."

Near the wall Larry hunches next to Mona, patting her hand, one arm around her shoulders. Larry is the man who last year told his lunch companion she had to "be patient" with Julian's jabbering. Today, I'm glad to see him comforting Mona, a beautiful, shy woman, who never speaks.

Crouching before him, I ask, "Larry, how are you doing?" Without lifting his head, his bloodshot eyes look up. "I don't know anybody here," he whispers. "It's so noisy." "Yes, and you must be tired," I say, as his eyelids shut. "Relax. You can rest now." How clearly our gang expresses their feelings, but I'm relieved that they all seem okay.

Rachel and Margo, two caregivers from Oak Creek, bring Alan into the room, sitting him down beside Larry. Both red-eyed and looking exhausted, Rachel and Margo describe their harrowing ride, driving a van full of confused Alzheimer's patients through the stormy night.

"They were okay for two hours," Margo tells me. "Then they all fell apart. Julian sang frantically, Larry kept yelling at Julian to shut up. The roads were flooded, blocked with detour signs, and we got lost. But we made it."

Rachel says that when the staff woke the residents to dress them, they explained they were getting up early to go on a trip. Most cooperated, but Alan protested, "I don't want to go on no trip!"

Laughter and tears come together: the patients' plucky resilience and the heroic devotion of the staff.

Returning to Julian, I sit beside the white cocoon, and soon his eyes open. "Hello, Sweetheart," I say as he stares at my face, before lifting my hand to his lips, giving it repeated kisses. Then he stands, hugs me, and arm in arm we explore the strange, new hall.

When I hum "Loch Lomond" and Julian joins me, his voice melodious and relaxed, I am relieved. The tone of Julian's singing is his emotional gauge, right now telling me Julian is fine.

~

For the next three days I visit Los Gatos daily, walking the halls with Julian, trying to comfort our gang whose families can't come. Thrust on each other abruptly, the four groups adjust: refugees and regular residents, Oak Creek and Cedar Creek staff who manage their demanding jobs midst all this commotion.

An Italian man from Oak Creek, who forgot English and speaks only Italian, wanders the halls crying, "*Mi casa, mi casa.*" Julian's anxiety manifests by constant loud, tense singing.

One noon in the dining room, a woman, tired of so many strangers, shouts at Julian, "You don't belong here! Just get out!"

Julian, who understands little language and rarely speaks, glares at her and, to my amazement, sternly answers, "No! I won't!"

Bless them all for their candor.

Five days later, the rain finally stops, the creek recedes, carpets dry out and the evacuees are driven back to Oak Creek, where the staff has spent hours cleaning and preparing for their arrival. As they walk through the door, each resident is greeted with "Welcome home," each one hugged and kissed, tears streaming down the faces of residents and staff, as well as the grateful families who watch.

When the Italian man arrives, he kisses the wall and bursts into tears, crying, "*Mi casa, mi casa!*" And Julian walks in, picks up *two* pink "WET FLOOR" signs, tucks them under his arm, and once again patrols his halls, cheerfully singing.

I learn a lot from this flood experience. To the Alzheimer's refugees, Oak Creek is clearly not just a "dementia care center"; it is

their home, which they sorely missed. I also learn that the staff doesn't just wash and dress the residents, they truly love them.

~

That night, at home, the children in bed, I sit at the kitchen table shoving aside crayons and plastic Power Rangers to help Karen fold the laundry, while Beiçola puts Capoeira flyers in envelopes for a mailing.

"Julian seemed so relaxed back in Oak Creek," I tell them, "like he was happy to be home after a trip. Heart-breaking as it was to put him in residential care," I say, "Julian's home is clearly no longer here, but across the bay, in Oak Creek."

Karen and Beiçola exchange silent glances. I suspect they are thinking about their own move, which they've been discussing for months. It's time they moved to a home of their own. We all know this. But moving out is complicated. They must find affordable housing, schools and work. They are considering living in a village outside Rio de Janeiro near Beiçola's mother, to let the children learn Portuguese and experience life in Brazil.

"Next year at this time, we probably won't be here," Karen reminds me.

No one says much. Rolling up the kids' socks, I nod quietly, thinking about the shifting sense of home, how the location of "home" changes throughout our life.

Karen piles Antar's clean shirts on Celina's jeans, while Beiçola continues folding flyers. It's hard to picture my big house without this active, noisy family. I can hardly imagine the emptiness their absence will bring, though part of me longs for a tidy, quiet adult environment. What will it be like, living alone? But we do know it's time to move on, time for each of us to develop a new sense of home.

Karen puts jackets and lunch boxes on the table, and I carry laundry into the bedrooms, getting ready for tomorrow.

Moving Mandala

ON NOVEMBER ELEVENTH, just two weeks after Karen, Beiçola, and the children finally moved to Brazil, I again climb the

stairs to the warehouse loft where the art group meets, my head buzzing with emotions surrounding my daughter's leaving.

Walking down the hall to the studio, scenes of their departure fill me, and I wonder what will emerge from this morning's session. About every two months these eight women get together, and I'm amazed at what tumbles out while silently working with art materials. I set down my cobbler beside the salads on the kitchen counter, greet my friends, then take my tea straight to an armchair and nestle in, eager for check-in.

"My kids just moved to Brazil," I blurt when my turn comes, "and I feel jangly and unsettled."

The women quietly listen, sipping their tea.

"They lived in my house for over three years," I rush on. "It was good being together during Julian's last days at home. We were a big noisy family. Even though the house was messy and chaotic, I was glad for their company after he moved to Oak Creek."

The group listens hard—no questions, no platitudes, or advice. Their attention, plus the time limit of brief check-in's, forces us to focus, find what's most important, discover what's pressing.

"But it took them many months to actually leave. Moving to Brazil was a complicated decision, arranging work and the children's schools. For months Karen and Beiçola vacillated about Brazil. Now they're in a small village outside Rio near Beiçola's family, and I'm alone in my big house, which is both wonderful and terrible. It's a big change...."

My voice trails off. The women watch me, nodding; then the woman beside me begins her check-in. Pressure builds in my chest, and I can hardly listen to her as scenes from the past weeks bubble up and flood me.

If only I could draw or paint, I moan to myself, as we disperse after check-ins to choose materials. Bringing a large sheet of watercolor paper and a box of Crayola pastels to the table, I consider drawing some of the scenes that bounce through my head, or painting an abstract rendition of my swirling emotions. But I have no idea how to start.

Impulsively, I dump apples and oranges out of a large bowl, turn it upside down on my paper, and trace around it with a purple pen, drawing a huge lavender circle.

A mandala comes to mind, a beautiful, decorative mandala. I muse, putting the fruit back in the bowl. Picking up the purple pen, I find my hand dividing the circle into seven sections, like pie wedges. But, it is not colorful designs, but words, that come.

Around the perimeter of the wedge, from nine to eleven, were the pie a clock, I print the words *Leaving for airport*. In this wedge I scribble, "Hurry up! Where are the tickets? We're late! Where's Antar's backpack? Will fifteen boxes fit into the car?" The phrases radiate out from the center, parallel to the section dividers.

The next wedge between eleven and noon, I label *After airport, after visiting Julian*. More words come: "I'm all alone. Boo hoo! Nobody loves me. Not a soul in this world knows, or cares, where I am!"

The wedge from noon to two gets called *Entering the dark, empty house*, and becomes filled with: "Well, this is it! Silence! A dark, empty house. No sign of life! So this is how my life is going to be?!"

Then the wedge called *Seeing their mess* gets covered with scribbled phrases: "What a damned mess they left! If they were renters, I'd never return their cleaning deposit!"

Cleaning frenzy follows, containing the lines, "Seven plastic bags, stuffed with trash, off to the dump! Huge box in garage—throw all their useable stuff there! Remember Amanda's dispassionate macrosort! Don't get emotional over Lego pieces and bits of Barbies!"

Then a larger wedge, wider, straddling the space between five and seven, were this a clock. This wedge is entitled: *Waking up next morning in my house alone*. This space has more room to write in and holds sentences written horizontally, neatly, across the paper, easily read. "Quiet...blessed quiet," the top line says. Then, "Ah...I can think...whew! The sun streaming in through the family room window—beautiful...I can drink my morning coffee and read the paper in here." Then, "I crave order, clean surfaces, attractive objects to see."

The last section completing the circle is another large wedge between seven and nine, entitled *Now What?*

Colorful question marks fill this space, red, green, magenta, turquoise. I become enthralled making question marks, cheerfully make more question marks, and more, large ones, small ones, in a rainbow of hues, until the entire wedge is filled with squiggles ending in dots.

Unlike the red plasticene blob that perplexed me two and a half years ago, when I first came to the art group, these question marks feel exciting.

More color seems needed: I peel the wrapper from a turquoise pastel crayon and lay it on its side, rubbing it around the outside of my circle, covering all the space to the paper's edge, so my word-filled mandala hangs in a sky of bright blue.

When I back away from the table and squint, the circle appears like a flashlight beam seen head on, the written lines like light rays radiating from a center source. Or, like a huge eyeball iris, looking out, witnessing my story.

After lunch, when the minestrone and Merlot are finished and cheery chatter calms down, we move again to the sofa area to share our work. One woman brings a huge cardboard covered with tissue paper, feathers, and loops of yarn. Another holds a watercolor painting of her last night's dream. When my turn comes, I display my paper.

"Moving Mandala," I announce, proceeding to read the title of each labeled wedge.

Then I read the quotes inside each section, changing my voice, exaggerating expressions, so they sound like character lines from a play: "Where are the tickets...nobody loves me...so this is how it's going to be...the damned mess...bags to the dump...ah...blessed silence."

Coming to *Now What?*, I spontaneously snap out answers to the question marks: "Buy a new couch, paint the family room, wash Rasa's scribble off the wall, stay home and write in my quiet mornings, have friends to dinner."

The women laugh and burst into applause, as I set down my mandala, the whole layered story of the kids moving out condensed on this page.

Driving home, I realize these question marks feel different from the blank line I drew in the caregiver retreat. They are questions: beautiful, bright, open, vibrant questions, not to be feared.

Thinking back to February's flood, when Julian was evacuated, then returned to Oak Creek, I see I'm developing a new sense of home. I have never lived alone. After high school, I lived in a college dorm, then rented an apartment with friends; then I married;

thirty-five years later, when Julian left, Karen and her family were with me.

Now is my time to live alone, and make that good. After three years of sharing the house with a noisy, young family, much as I love them, it's time we moved on. Karen and Beiçola, likewise, are creating their sense of home, for now, in Brazil.

Pulling into my driveway, I envision how inviting the family room will look with a new couch and comfortable armchair, a good reading lamp. And I decide to order a cord of wood to burn in the fireplace for the coming winter.

Sad Little Visit

SIX MONTHS AFTER Karen, Beiçola, and the children moved to Brazil, Beiçola returns to California on Capoeira business, and drives out with me to visit Julian.

"I'm so happy to see you," I tell my son-in-law, whizzing up the freeway towards Oak Creek, "and hear how you are."

Karen and I have talked briefly just a few times, as they have no telephone, and she must call from a public phone booth down the road from their house, where long lines of people wait outside, shouting if she talks too long.

"The kids are the first foreigners to live in the village," Beiçola begins. "Kids crowd around Antar every time he plays soccer or rides his skateboard. His Portuguese is pretty good."

"He's so bold. I thought he'd adjust fast," I say. "And the girls?"

"Well, Celina is shy. She understands more Portuguese, but rarely speaks. My mom talks to her constantly, and she's beginning to answer."

"Celina wrote that her mosquito bites are like silver dollars!"

"Mosquitos love Celina, that's for sure." Beiçola laughs.

"It's a pity you couldn't get a telephone," I say. "Without a phone line and email, Karen can't do the free-lance reporting she wanted to do."

"That's Brazil!" Beiçola says. "Things rarely happen as you plan."

"Adjusting to a small village must be hard," I say. "But it'll be a great experience."

"Karen's interning now at the Associated Press in Rio, hoping for a job," Beiçola explains. "Meanwhile, she's teaching English in a local school. If she can't get regular work, we may have to re-think our decision. Maybe even return to California."

The car hurtles up the freeway towards the San Mateo bridge, past rolling hills where Herefords graze on new March grass, past clumps of purple lupine, past a thin, solitary heron standing motionless beside the road.

"How's Julian?" my son-in-law asks, sitting in the passenger seat snacking on corn chips.

"You'll find him very changed," I say. "He's much less responsive. Weaker, less predictable. For nearly three years he was pretty stable. I took him twice a week to the park. He could easily walk three or four miles. But these days, I never know if he can even get in the car."

"What's been happening since Karen and I left?" Beiçola asks.

"Well, he's had three grand mal seizures," I begin, explaining that seizures are not necessarily part of Alzheimer's disease, but do occur in about ten percent of Alzheimer's patients. "With each seizure, Oak Creek called the paramedics who took him by ambulance to the emergency hospital. He's on new drugs, to control the seizures. First the dose was too high. Then too low. Then we had to change medications."

"Maybe the drugs are making him weak," Beiçola suggests.

"Maybe. But it's hard to tell what's Alzheimer's and what may be a drug reaction."

"Remember how he improved after you stopped that other drug? The one he took before he moved to Oak Creek."

"Sure I do," I say. "He needed sedating, so we could manage him at home and day care. Looking back, he was overdosed on that Mellaril. That was too strong a drug for him then. But now he needs this drug to prevent more seizures. And I've found a good neurologist near Oak Creek whom I trust."

Out the car window as we drive over the bridge, San Francisco Bay stretches glassy blue in both directions.

"I'm glad you're coming with me today," I tell Beiçola. "Maybe you can help me take him to the lake."

The March sun shines bright after weeks of blustery days, when a

cold wind shook the trees and Julian would never step outside. "Coldy, coldy," he used to say months ago, seeing the leafless branches bob up and down, watching drops of rain slide down the glass. These days, he utters no words. But his body language—hunched up shoulders, his scowl, turning away from the door—says it all.

"For weeks I haven't walked with Julian," I tell Beiçola. "Last Sunday at the St. Patrick's Day party, he was grumpy and irritable. The visit before that I couldn't get him out of the chair. He was sleeping behind the reception desk when I came, in a maroon desk chair on wheels near the telephone, as if he were a new employee dozing on the job."

I tell Beiçola the whole story: how hearing my voice, Julian opened his eyes and smiled, but refused to stand up. When I took his hands and tried to pull him to standing, the maroon chair slid towards me on its wheels. First I found this comical, Julian also thought it funny. Each time I pulled him, the chair rolled and he laughed. Julian rolling along in the chair caused two passing caregivers to laugh too, and they eventually tried helping me pull Julian up. But there was no moving him.

Stubbornly, he sat in the chair, ignoring our entreaties and resisting our tugs with all his strength. Fifteen minutes later, three of us finally pulled him to standing after I braced the chair wheel with my foot.

"When I did get his coat on and maneuvered him out to the car," I tell Beiçola, "I decided it was too risky to take him alone to the park. But I hoped we could at least take a ride down Palomares Canyon."

But Julian stood by the car door and wouldn't, or couldn't, get in. Despite my explanations and shoves, he remained fixed and rigid by the door, unable to get onto the seat.

"I just gave up," I continue, "and brought him back in Oak Creek where we shuffled up and down the patio." A far cry from the walk by Lake Chabot I hoped for, and not even a cheery ride in the canyon, a second best.

"So I'm really glad you're here today. It'd be great if we could get Julian to the lake."

During the three years that Julian has lived in Oak Creek, he has usually recognized Beiçola, even after he stopped greeting him with

"big chief," even when months passed between visits. The signs grew subtle: brief eye contact, followed by a fleeting smile, sometimes a quick hug, a reaching out of his hand, indications that I call "recognizing." I wonder how their meeting will be today?

~

Inside Oak Creek, we find Julian slouched in the chair nearest the door, slumped over asleep. Beiçola goes to him while I hang back, for Julian can't handle relating to two people at the same time. It takes all his energy to focus enough attention to be aware of one.

So Beiçola greets him first, waking him gently, then handing him the bag of Licorice All-Sorts we have brought. Sitting next to Julian, he smiles, in his thick Portuguese accent says, "Hello, hello there. How're you doing?"—allowing Julian time to sense his presence.

But then he gestures for me to come see Julian's hands, which are folded in his lap, stained brown and foul-smelling. I snatch back the licorice and fetch Rachel, the caregiver who told me, when Julian first came to Oak Creek, that she was doing "God's work."

Rachel brings warm wash cloths and sits by Julian, taking his hand in hers, wiping his fingers gently, so gently. He doesn't pull away or resist, as he often does when I clean his hands after lunch, smeared with lasagna sauce or meat loaf gravy, using cold water, trying to get the job done fast. Slowly, lovingly, Rachel wipes his hands.

She makes several trips to the bathroom returning with warm cloths, washing, caressing, each brown finger. Her thin body sits poised on the arm of his chair, long dark hair framing her intent face. Julian relaxes into her hand massage, absorbing the contact and comfort Rachel brings to God's work.

Watching Rachel floods me with gratitude for her kindness, for all the loving care Julian has received daily from the caregivers here at Oak Creek, for over three years.

When his hands are clean, Rachel suggests that Julian shower, as his pants need changing, and a complete shower is easier than a diaper change and wash. So Julian is whisked off to the bathroom, and while they are gone, I tell Beiçola that Julian became incontinent when he was hospitalized after his first epileptic seizure.

"I doubt I'd have managed at home as long as I did if I'd also had to change his diapers," I say, full of respect for family caregivers across this land who handle this odious chore I was spared.

Soon Julian is returned to us in a fresh green jogging suit, his hair and beard still damp. "Hi, darling, how nice you look," I say, laying my hands on his shoulders, but he frowns, and when I try to kiss him, he growls, pushing me away. No smiles today, no hug or kiss, these greetings to which I am addicted.

"I'm sorry," I tell Beiçola. "He doesn't seem to be in a great mood."

"Nobody is in a good mood every day," Beiçola says. "He deserves to be grumpy sometimes too."

When I try handing Julian a licorice, he won't, or can't, grasp it, so I slip it directly in his mouth. Mechanically he accepts the little black square and chews away; instead of his usual "lovely, lovely," just "mmm," or even a smile, he grimaces.

"Maybe he expected chocolate," I tell Beiçola, optimistic, searching for some logical explanation besides relentless decline.

Judging from Julian's behavior, there's no point trying to walk at the lake, so we struggle to put on his parka and take him outside on the patio.

Julian's face is a terrible wooden mask giving no response, no recognition. Shuffling along, indifferent to his surroundings, he leans to one side, scraping his tennis shoes along the cement. He appears much as he did three years ago, over-dosed on Mellaril, and over-dosed last year on Dilantin, which turned out to be the wrong anti-convulsive drug. This time I fear it is not drugs, but Alzheimer's advancing.

One eye is fully open, but the other squints to the right, as if he hardly sees. He is not wearing his glasses, and seems oblivious to my voice, my presence, my kiss, my touch, pushing me away when I try to caress him.

Beiçola and I trail behind him, watching him bump into picnic tables and the wooden fence. Julian is like one of those bumper cars at a carnival, moving forward until he hits an obstacle which knocks his course off to one side.

Seeing Julian slip down into this new next phase of non-knowing and non-responding brings tears to my eyes.

"It's hard for you seeing him like this," Beiçola says quietly, before asking the question I continually hear, "Does he still know you?"

"Until now, definitely, *yes!*" I answer. "But I'm afraid we're inch-

ing towards no." Today my spirits sink; as recently as three weeks ago, Julian gave me spirited hugs and kisses.

An ancient woman shuffles past, her body bent like a question mark, staring at the ground. Pulling away from thoughts of Julian, I ask Beiçola, "What are you thinking?"

"I'm glad I came today," he says, moving slowly beside me in his black Nike jogging suit, young and strong. "Seeing these old people makes me think about the meaning of a person's life, and how it can end. That woman was once an intelligent wife and mother who worked hard, and cared for her family. Look, this can happen to any of us."

Together we stare at slender, white-haired Maureen, wandering across the patio, the lively Irish woman I loved chatting with, the one with five sons who never did housework; but now Maureen is beyond conversation.

"Not only Julian has deteriorated in the past three years." I tell Beiçola about many residents who went to hospitals with pneumonia or strokes, and never came back. "Some stopped walking or eating, and moved to nursing homes. I saw one woman fall down and die right in the dining room," I say. "And ambulances come from time to time, taking somebody away. Then new residents, less impaired, take their place."

Today, facing Julian's blankness, I wonder which of these events might happen to Julian, and I begin to doubt what I have believed adamantly for three years about the importance of visits. Andrea, the new administrator who has recently replaced Vickie, also told me that most residents are rarely, if ever, visited, a fact I have made harsh judgments about.

But seeing Julian's blankness today, I better understand relatives who don't come, people who probably tell themselves that visiting makes no difference to a non-responding Alzheimer's patient. I have always believed it *does* matter, though today I'm less sure.

Beiçola strolls away to look at doves in the aviary, leaving me to approach Julian, who still does not kiss me or smile.

Slipping my hand gently through the crook of his elbow, I nestle it in his blue quilted parka pocket and sing, "You take the high road and I'll take the low road," my private gauge for how he is. Thank God, Julian begins humming our tune.

Julian also manages a few bars of "Clementine" and "You are my Sunshine." Not the whole song, certainly not several verses as he used to, just last month, but enough to let me know shreds of his essential self are still alive.

This visit won't end with me feeling up-beat over connecting with Julian. Instead I leave with a heavy heart, which I won't tell anyone about. Witnessing Julian's slow decline seems to be mainly my job, done mostly alone. Though he may have days when he will swing up again and be more vital, this is the direction in which we are headed. Outings at the park are numbered, if not already gone.

I hand Julian a pink Licorice All Sort, then a yellow, and finally a blue one, before taking him back inside. He gives no response to the little square sweets, just mechanical munching. Beiçola and I leave him asleep in the dining room, hunched down in his blue-quilted parka oblivious to the cheery chatter of the activity director setting up pins for a bowling game. She doesn't even try to hand Julian the ball or offer him a turn.

Beiçola sits quietly beside me in the passenger seat as I drive silently for an hour along the freeway towards home.

Savoring Chocolate

THE SECOND FRIDAY afternoon in mid-April, just a month after Beiçola's visit, two of Julian's ex-students rush into Oak Creek, eager to see him.

Brightly wrapped gifts for Julian's sixty-eighth birthday and a pink bakery box fill the back of my car, though I warned Marcia and Danusia driving over that he has deteriorated since they saw him on his birthday last year.

Marcia, his doctoral student in the nineteen seventies, scraped aside half a day from heading a research project in women's health, "because visiting Julian is so important," and Danusia, who nine years ago adopted an infant from India, left her child and a demanding job for this afternoon's trip. During Julian's last days at Stanford, and over the past nine Alzheimer's years, both colleagues have kept in touch.

"He might be aloof and silent," I prepared them. "He probably

won't know you." Describing Beiçola's dreary visit last month, I warned them that we might not go to the lake as we've done for his last three birthdays.

But Marcia and Danusia rush in joyfully and find Julian, with his curly gray hair, beard and glasses, shuffling near the front desk, alone in the hall.

"He still looks like a professor," Marcia says.

Without hesitating, Danusia runs over, hugging and kissing him, and immediately Julian smiles and begins whistling, his sign of good cheer. Their faces cheek to cheek, mouths puckered, Danusia and Julian whistle together.

When Marcia approaches, Julian can't shift attention from Danusia's face to hers, just as I warned them. Seeing Julian's confusion, they share fussing over him one at a time. Lastly I also approach, not knowing what response I will get. Last visit, he recognized me; four times before that, I wasn't sure.

But today, smiling and whistling, he seems in such good shape that I tell Marcia and Danusia we can try taking him to the park. So many times when I think I'll not be able to walk at the lake again, along comes another reprieve.

Spring has come today after weeks of rain, so out the door we march, and, despite my warning that he sometimes can't get into the car, Julian slips right in. Whatever the reasons for Julian's inconsistent behavior, I am grateful for today's good cheer, and off we drive to Lake Chabot, all four of us belting out Julian's remaining songs: "Loch Lomond," "Clementine," "You Are My Sunshine," and "Red River Valley," the last tunes Julian still hums.

"How about 'Happy Birthday'?" Danusia suggests.

"Let's save it for the cake," Marcia says.

In the park, Julian steps deftly out of the car and we head down the road, the sun warm on our skin, hills bright with new grass, yellow mustard and clumps of poppies.

Julian walks between Danusia and Marcia, holding their hands, humming, looking first at one face, then the other. I doubt if he is aware that they were his students, that they once worked in his lab. Certainly he does not know their names. But, always giving him the benefit of the doubt, I still believe he "knows them."

"We're probably familiar," Marcia says.

"He can feel we love him," Danusia adds. "He must surely sense that we care about him."

Both women stroll along, humming when he hums, whistling when he whistles, joining him in his la-la songs.

Acknowledged in these non-verbal ways, Julian responds at his best: laughing, hunching up his shoulders at the tickle of their kiss, whistling merrily in the bright sun, certainly not the glum, glowering man I saw last month. The fluctuations in Julian's behavior remain mysterious, not necessarily attributable to medication changes.

Leaving the road, we straggle up a leaf-strewn slope towards a picnic table set under a canopy of bay laurels, the air perfumed with their scent. The uneven ground is damp and spongy. Julian hesitates, starts back for the road, but Marcia grabs his hand, balancing the pink box on her other arm, and guides Julian up the steep hill while I spread an Indian madras cloth on the table, quickly setting out napkins and plates.

Then I coax Julian near one end of the bench and shove him down, but he can't swing his legs over. He doesn't know how. So I swivel his legs around so he faces the table.

Danusia sets a dark chocolate cake before Julian, and when we sing "Happy Birthday," Julian hums along, smiling broadly, looking so happy that we sing it three more times to prolong this moment, first clapping, then singing it fast.

Julian knows it's a party. Before a piece is cut, he reaches into the cake, double chocolate from the Prolific Oven, the one his lab always bought for special occasions. Lifting a gob into his mouth, his fingers get smeared with gooey frosting. Chewing, he closes his eyes and sinks into savoring chocolate, focusing as intently as if he were a wine taster assessing this year's new Beaujolais.

Summoning up whatever concentration is now required to bring forth a word, Julian inhales and pauses, then exhales, producing a loud, clear "Oh, good!"

As Marcia cuts him a piece and offers a fork, Danusia says, "I'll bet it tastes better if you use your fingers." Picking up cake with her hand, she adds, "People in India eat this way."

"Ethiopa and Kenya, too," I say, lifting a gooey piece with my fingers.

Soon all four of us are eating cake, licking chocolate frosting off

our fingers, just like Julian. We feel silly at first, but the cake is rich, sweet, and we joke, horse around, Julian happy and content, the centerpiece of our party.

Next Marcia serves different kinds of potato chips on three paper plates: sour cream and onion, barbecue, plain. Julian samples chips from each plate, but reaches most for the sour cream and onion, which are in the middle.

"He definitely knows which one he likes," Danusia observes.

"Yes, but is he choosing that taste or just the middle plate?" Marcia asks, ever the scientist.

So we conduct a little experiment by switching plates and, regardless of position, it is the sour cream and onion chips he loves. His sense of taste remains clear and strong.

It's present time: Danusia hands him a plastic lunchbox with painted butterflies, filled with Hershey bars and truffles; Julian immediately bites a truffle, closes his eyes and sighs. When Marcia hands him a small package and he tries to tear the paper, I am thrilled. For two birthdays past he made no attempt to open presents. But today he fumbles, ripping the paper, and knows it's for him.

From the torn tissue, he pulls out a navy blue tee-shirt with university crests under the word Stanford, and struggles to slip his arm into the sleeve. Unable to figure out how, he drapes the shirt over his baseball cap, which Marcia gave him last Christmas, making it look like an Arab head covering, a navy *kaffiyeh*.

I try to remove the shirt from his head, to put it on properly, but he tugs at it and scowls. The shirt is *his*. He wants it where it is. For the rest of the afternoon he wears his new blue shirt draped over his cap, the material hanging down and shading his neck.

Restless now, Julian stands, totters on the steep slope, then flops back down on the bench. Refusing to sit any longer, he lurches off downhill, Danusia leaping to guide him in case he falls. Marcia and I clean up, then join them on the road. Watching Marcia and Danusia hold Julian's hands, whistling merrily together, makes a lump form in my throat. They have not forgotten Julian, not written him off, but have found ways to be with him that are mutually rewarding.

In the car, Julian falls promptly asleep, his head leaning on the window, as I drive back to Oak Creek, where we arrive just before

supper. Residents gather in the dining room, but the air outside is so deliciously warm that we go to the patio and sit in white plastic chairs around a garden table.

Julian looks relaxed, content, his face peaceful, chocolate frosting smeared in his beard. His hands lie loose in his lap. A new woman I don't know strolls over and Danusia invites her to join us, bringing her a chair, chatting to her as if they are friends.

While Danusia laughs with the old woman, Marcia fusses over Julian.

Evening air and deep peace wrap around us. This simple moment is expanded by our rich past, so the moment is fuller than its surface appearance.

We must look so peaceful that a caregiver brings Julian's supper out to him: chicken soup and seafood salad, and we watch Julian eat, slowly, deliberately, until finally, it's time to leave.

~

Back in the car, we fall silent, each deep in our own thoughts.

"Thank you...," I begin, searching for words, "...for remembering Julian...making these birthday parties year after year. For being such loyal friends. I often feel very alone, still celebrating Julian."

"But we love him," both say. "And you too," Danusia adds. Marcia's and Danusia's kindness to Julian spills over onto me.

"My work is so demanding, so intellectual," Marcia explains. "But being with Julian is important. I never regret spending time this way. He reminds me how valuable it is just to be alive—to stop being wordy, to act silly, connect emotionally."

"We're coming next year too," says Danusia, "no matter what."

"I don't know if he'll still be in Oak Creek next year," I say. "He was fairly stable for nearly three years, but he's going downhill, especially since the seizures. You saw him at his best today, but he's unpredictable."

"How long can he stay at Oak Creek?" Marcia asks.

"As long as he can walk and eat by himself," I say. "They're very committed and keep residents as long as they can."

"And after that?"

"I'll look for a skilled nursing facility, probably on our side of the bay. I've signed "Do Not Resuscitate" forms, and no CPR, in case something happens suddenly," I tell them.

"Do people actually die from Alzheimer's?" Danusia asks.

"Yes, some," I say softly. "End-stage Alzheimer's isn't pretty. They forget how to swallow. There's often tube-feeding, malnutrition and paralysis, intubation and bedsores."

Danusia and Marcia grow silent.

"But those things may not ever happen. Most Alzheimer's patients die of other diseases, like heart failure, stroke and pneumonia."

"It must be so hard," Danusia says, after a pause.

"I decided not to put in a feeding tube if he stops eating, or do any drastic medical interventions," I say. "I'm trying to anticipate these end-of-life issues."

"Julian's had Alzheimer's such a long time," Marcia says from the back seat.

"Nearly ten years since his diagnosis," I say, remembering how they made lunch dates with him in the early Alzheimer's days, never knowing if he'd show up or find their office.

"And how are you, Ann?" Marcia asks. "Are you seeing anybody? Are you dating?"

"No...," I drawl out the word, "but I'm plenty busy. Writing and speaking to caregiver groups has become part of my work. I have hikes, trips, dinners, meetings, outings with friends. Next year, I'm considering signing up for a camping trip in Alaska.

"Surprisingly, I'm not lonely. I enjoy my independence. Several people I know, whose spouses had Alzheimer's, have met new partners. Some got married, and I'm happy for them. Who knows what the future may bring. But for now I take things day by day, though I'm open to whatever may come."

As I drive back over the bridge, we grow silent watching the sky fade from my favorite Crayola color, Prussian blue, to the color of the mourning doves in Oak Creek's aviary, pigeon gray.

"Visiting Julian is a gift," Danusia says softly, "reminding us to stay present and connected. Heart to heart, soul to soul."

Yes, yes, I nod, sliding a sticky finger into my mouth, licking off chocolate, just as Julian does, the taste of dark chocolate lingering, and I flick on my high beams to light up the freeway ahead.

Liquidambar

ON THANKSGIVING MORNING 2000, I wake up alone in my silent house. Sun streams through the window onto my new quilt, on Julian's physiology and meditation books, which fill half the shelves along the wall, on my favorite novels and poetry volumes standing beside them.

Sprawled in the center of the bed where I often wake up, even though I start the night on my customary side, I scan book titles: *Hormones and Behavior*, *Human Sexuality*, *Psychobiology of Consciousness*, books in which Julian has written chapters. Jeff likes to read them when he visits; they don't replace the adult conversations he never had with his dad, but they are expressions of Julian's intelligent thoughts, and Jeff's glad I kept them.

One morning when Rasa still lived here floats to mind: in her Pocahontas pajamas, she stood by the foot of my bed and pointed.

"That's Grampa's side," she observed. "I miss my Grampa," she said, at age four. "I wish he didn't have to live in that special place."

"Me too, honey," I said, explaining again that Grandpa has a sickness that makes him forget how to do things.

"Grandpa used to be a teacher," I told her, inviting her in for a cuddle. "But he forgot how to read. He forgot how to drive his car. He even forgot how to talk."

Rasa's eyes grew wide, thoughtful. "But he didn't forget how to eat," she declared. "And he didn't forget how to sing."

～

The house is quiet, so quiet, as I walk to the kitchen to make myself some Earl Grey tea. The Stanford graduate student I rent a room to is gone for the holiday weekend, but yesterday before he left, he helped me extend the dining room table, and I've added a card table to one end to make it longer.

Soon eighteen people will come for Thanksgiving dinner: Karen, Beiçola, and the kids, who are back from Brazil, living in an apartment just ten minutes away, and Ben and Greg with two of their friends. My friends, Bernie and Ruth, are bringing their son, Elliot, and his Brazilian girlfriend; and Beiçola invited two Capoeira masters visiting from Rio.

But I have plenty of time before they come. Greg and Ben are cooking the entire feast, and all I have to do is set the table.

Despite this crowd, at holiday times I often feel lonely: Julian's absence, and the silence around his absence, especially acute.

Smoothing down the longest cloth I own, I set out my mother's china, wine glasses, holiday napkins and tapered orange candles. Then I walk outside in my bathrobe, crunching dried leaves on the driveway, to the liquidambars that grow near the street, where I pick gold, maroon and amber leaves—perfect, unblemished—for our Thanksgiving table. Back inside, I carefully arrange them in the table's center, and set down small pilgrim and turkey candle figures, which have stood on our Thanksgiving table since I was a child. One pilgrim boy's head is melted away, and one turkey's tail, ever since some little person, unable to resist the temptation of their inviting wicks, lit a match and burned them.

~

By four, family and friends begin to arrive and soon the kitchen is crowded with people greeting each other, opening wine, pouring sparkling cider, laying out platters of cranberry pear relish and corn bread stuffing. Greg stands at the stove whisking his gravy.

"This year feels so easy," I exclaim to Ben, who is carving the turkey.

"You deserve it, Mom," Ben says. "You've paid your dues."

When we are all seated around the table, plates filled, ready to eat, Ben stands, wineglass in hand, and offers a toast.

"It's good to be together," Ben says simply, welcoming everyone. "This day is about the importance of family and friends, how beautiful it is being with people we love."

"Here, here," everyone chants, clinking glasses one against the other, while Beiçola translates Ben's words into Portuguese for the Brazilian guests.

"But, I want to say," Ben continues, "that certain people are not here, who should be. I just want to acknowledge my father, and say how much we miss him, how we wish he were here."

Silence falls over the table, tears fill my eyes. A few weeks ago, I described to Greg the lonely currents I feel at holidays; and he must have told Ben.

"So here's a toast to Julian," Ben says, standing at the head of the table beside me.

"Julian, to Julian," everyone says.

A rush of emotion prevents me from saying anything articulate about what I feel. Often I've considered making a similar toast at holiday meals, acknowledging Julian, but felt self-conscious doing it myself.

"Hey Ben...thank you," I stammer, thumping Ben's shoulder, and glancing at Karen, respectful of the Alzheimer's road my children also have traveled, wrestling with their own feelings of anger and loss. I am aware that the intense focus on Julian all these years greatly affects them, but I can only guess at their experience; they have their own stories to one day tell.

Laughter and talk follow Ben's toast...snatches of Portuguese and English...second helpings of Greg's stuffing...more creamed onions...recipes revealed. Rasa tells her six-year-old version of the first Thanksgiving in Plymouth, explaining why we eat turkey and pumpkin, Beiçola translating for the Brazilians.

At dinner's end, we move to the living room and lounge around a crackling fire, for pie and Ben's fabulous gingerbread roll with chunks of fresh ginger. Beiçola and the Capoeira masters set up conga drums and tambourines, and sing Brazilian songs, while the children run about, and the rest of us sprawl on the couch near the fire.

"How'd you and my dad meet?" Ben asks Bernie, as we sip coffee, and help ourselves to yet another sliver of pie.

And Bernie tells how he and Julian met as young Stanford professors in the late nineteen sixties, running away from the Oakland police at an anti-Vietnam war demonstration.

"We were peacefully picketing an induction center when suddenly the police began to charge," Bernie says. "They decided to disperse the crowd, and ran at us waving clubs and shields."

"We never knew that!" Ben and Karen declare, listening intently to Bernie's story.

"While the demonstrators were running way, Julian and I bumped into each other. We'd seen each other around Stanford...said hello...been friends ever since."

Bernie launches into tale after tale of his and Julian's political activity and escapades when they were both radical young professors in those years of unrest.

Questions fly from Ben, Greg, Karen and Bernie's son, now young adults in their thirties, roughly the ages Julian and Bernie

were then. Staring at Ben, I see Julian's intense blue eyes, a hint of his lips. There's a strong resemblance, but Ben's face is more muscular, more handsomely carved.

"Remember when Dad went with Karen and me to the Oakland induction center to protest shipping arms to El Salvador?" Ben says.

"I surely do," I say. "You and Karen were in high school and took a workshop on resisting arrest and 'going limp.' Dad and I pleaded with you not to get arrested."

Bernie and Ruth laugh as I continue, "And he drove you to Oakland to make sure that you didn't go limp. And what happened was that Julian and Ben got arrested, and Karen was furious that she wasn't arrested because she was a girl!"

I revel in the luxury of this reminiscing. Often people are reluctant to mention an absent loved one at a holiday gathering, fearing it will bring on sadness. But for me the opposite happens: I feel enriched, and our lives validated, evoking Julian's presence through stories.

Karen, Beiçola, the Capoeira masters, and the tired children go home around ten. I throw another log on the fire and we continue swapping Julian tales.

"Did I ever tell you about the time we got a phone call at two A.M. that a rat in Julian's lab was dying, some rat crucial to an experiment. And Julian jumped up, dashed into the lab and gave the rat mouth-to-mouth resuscitation!"

Everyone bursts out laughing.

When the laughter stops, I add, "I didn't kiss him for a month!"

"Remember the fancy academic gown Julian got when he received that honorary degree in the Canary Islands?" Bernie continues. "The yellow satin hat with fringe that looked like a lampshade?"

As he talks, I bring from the hall closet the black satin gown with lace cuffs and wide yellow satin hood, holding it up for everyone to see. Then I display the famous lampshade hat and swish its fringe.

"Five years after his Alzheimer's diagnosis," Bernie says, "Julian wanted to march in Stanford's graduation ceremony one last time, wearing his fancy robe and hat. So I marched beside him and held his elbow so he'd walk the right way. His robe with lace and the lampshade hat made him stand out in the academic procession. People came up to him and asked 'Where's it from?' Of course, by then he

had no idea what they were asking, and couldn't answer. He just smiled, with a twinkle in his eye, while I answered nonchalantly for him. No one ever knew he could hardly talk!"

After midnight, as the fire burns down, we carry plates to the kitchen and re-fill the dishwasher. Bernie and Ruth button their coats, thank Greg and Ben for the delicious feast, and take home a turkey leg wrapped in foil.

"When Jeff comes next month," Ben says, hugging me at the door, "let's all go visit Dad during Channukah and bring him *latkes*. It's been a long time since we saw him together."

Happiness floods me that this proposal is Ben's idea, instead of mine.

Now the family has left, the house quiet again, but filled with Julian's vitality and humor. Switching off lamps, I stretch out on the couch and stare into the dwindling fire, full of the richness of this Thanksgiving, filled with my blessings, the blaze gone now, but not yet out, embers glowing red hot, still giving off heat.

Mozart in D-Major

"...AND THIS HUGE GRIZZLY lumbered down the slope to where we were resting on the tundra. It halted about twenty feet away, staring at us. We could see its nostrils and curved ears, its shiny chocolate-brown fur...."

Sitting on a fallen log in a redwood park near Stanford the day after Thanksgiving, I tell my friend, Jan, about my grizzly bear encounter in Alaska, two months ago on a Sierra Club trip.

"I forgot everything I learned at the ranger's bear lecture in Denali," I tell her, "about what to do if we encountered a grizzly. I just sat there, frozen, praying it would go away and not charge."

Jan pulls a turkey sandwich from her backpack. "So what happened?"

"The friend I was with, Hanna, remembered that we were supposed to 'act big,' so we scrambled up, raised our arms high overhead and talked to the bear, trying not to threaten it. 'Hello bear,' we repeated words the ranger told us. 'Hello bear, we're humans. Just go away. You really don't need to come over here.'

"I felt terrified waiting for the bear's next move," I tell Jan. "Would it charge? Would it make a bluff charge and then stop? Or would it really charge, forcing us to drop on the ground, cover our heads with our arms and play dead, while it swiped us with a paw or took an investigating nibble?"

"Oh, my God," Jan laughs, taking a swig from her water bottle and settling herself against the log. A circle of redwoods curves around us, their thick rust-colored bark fire-scarred, beautiful and enduring.

"Well," I continue my story, "the bear stared and stared, and finally turned away, lumbering into a ravine. But our joy was brief. Then we realized we had to cross that same ravine to get back to the Savage River and return to the Sierra Club vans."

Jan pulls out a turkey drumstick and a rice cracker. "And...?"

"So Hanna began singing a Hebrew song, *'Shalom aleichem, heivenu shalom aleichem,'* which means we bring you peace. We shouldered our packs, zipped our parkas and sang 'Shalom Aleichem' loudly as we ventured into the ravine. Thankfully, the bear emerged down by the muddy trail, crossed the gray, stony, braided river and disappeared into the distant rocks."

Laughing at my tale, Jan gnaws on her drumstick and says thoughtfully, "You didn't have to wait for Julian to die to start having adventures, did you?"

Puzzled, it takes me a moment to remember our hike in this same redwood park over five years ago, when she first offered me the Sierra Club hiking schedule and I shocked myself by saying I'd do that after Julian died.

"No," I answer softly. "Julian's still at Oak Creek, God bless him, quieter now, but still affectionate and very alive. In February, he'll have lived there five years. Imagine!"

~

After lunch, Jan and I sling on our packs and stride up the soggy trail past rain-washed ferns growing at the base of towering redwoods, swapping stories of our Thanksgivings.

I tell her how happy I feel that Karen, Beiçola, and the children are again in California after six months in Brazil, living nearby, but not *in* my house. And Ben and Greg also moved closer to be near Ben's new job at Stanford. I remember my tough, isolated Thanks-

giving six years ago, when Julian was in such dreadful shape, the last Thanksgiving that he was home.

Jan and I grow silent. Images swirl in my mind, for although I am no longer part of a couple the way I used to be, I am part of a big, busy family.

How happy Julian would be to read Karen's front-page articles in the newspaper and to know that Ben is an assistant dean of students at Stanford, ironically working in a staff study in the same Green Library Julian worked in and loved.

Jan walks faster now, disappearing around a bend. The forest is silent, except for the occasional screeching of a jay and rustling of dry leaves as some little creature, less fierce than a grizzly, scrambles through brush.

Last Sunday's Thanksgiving lunch with Julian floats to mind, our fifth Thanksgiving at Oak Creek. Tables covered with green cloths... yellow chrysanthemums in vases, sparkling cider, a man playing hymns on the piano, and my darling Julian dressed specially in his khaki Dockers and a long-sleeved blue shirt, hair and beard freshly-trimmed, still looking like a professor.

Sitting beside Julian, I watched him pick up salad with his fingers, carefully placing bits of olive on the plate's rim, lettuce leaves falling unnoticed on table and floor, a maroon bib keeping his shirt clean.

"Isn't this the pits?!" the wife of an Alzheimer's resident said to me sadly.

Across the table, Verna cut up Newell's turkey into tiny pieces, and softened his stuffing with gravy, as he has difficulty swallowing and sometimes chokes. Newell looks older, thinner, frailer after his bout with pneumonia and month-long stay in a convalescent hospital last spring, and since another stint in a nursing home for a recent infection. He can't stand up by himself now, and needs help walking.

No more double dates at Lake Chabot. Our last trip replays itself, Newell just back from the hospital, walking unsteadily. Verna and I took Newell and Julian for "just a short walk"—hoping to reach the bench we'd bought in their honor.

Ahead of us, I saw Newell droop, fold over, bend forward, gripping Verna's hand. Clearly, she needed help to support him. But Julian and I were behind them, Julian stepping slowly, deliberately.

Tugging Julian, I tried to urge him faster, to catch up with Verna, but there was no hurrying him. Seeing Newell crumple, I dropped Julian's hand and ran to help. But as I propped up Newell, I looked back to see Julian lurching off the road down a brushy slope towards the lake, about to fall.

Newell was doubled over, unable to walk, Verna not strong enough to support him alone, and Julian was staggering down a steep bank towards the water. Just then a trail angel appeared, in a ranger's uniform. He helped Verna drag Newell to the car while I rescued Julian. That was the end of our Lake Chabot dates.

Now, a caregiver sometimes puts Newell in the car so Verna can take him for drives, playing music he loves, grateful when he lifts his head and manages to smile. In a week, Oak Creek will start pureeing his food. Both Verna and I realize his days at Oak Creek are probably numbered.

Gazing around Oak Creek's Thanksgiving, I watched Doris Hoffman chatter away to Debbie, and Debbie's partner, Frances. Doris has been here eight years now, three longer than Julian. Weaker, slower, slumping more, much less verbal, she still grins and chuckles when she's awake, still points her finger at me, saying, "Twenty-two, ninety-six and wasn't that great?"

Seeing families with their loved one still makes me tear up. New residents, surrounded by families I don't yet know, lingered over pumpkin pie, some less impaired and even younger than Julian. For five years he was the youngest one here. Most of the folks I befriended when Julian first came are now gone: "Grandpa," Maureen, and Larry, to nursing homes, hospitals or death. With a shock I realized that, except for Doris Hoffman and two others, Julian is now one of the veteran residents.

Walking around a bend of the trail, I find Jan leaning against a fire-scarred redwood trunk, watching a yellow banana slug under a fern, and we resume hiking together. "It's nice walking quietly," she says. "What were you thinking?"

"About the last time Julian and I went to Lake Chabot," I say, "just before his last seizure. I managed to take him alone to the lake, and we actually walked all the way to the bench Verna and I bought. We sat on it and shared an orange."

"How's Julian doing?" Jan asks, her voice soft.

"Ever since the last seizure, he's gone downhill. I can't take him anymore to the lake, but sometimes we still go for drives in the car. He's less responsive, more subdued. I have to pull him out of a chair. Some days it takes three people to get him standing and walking; other days he manages fine. He can still whistle and hum four songs. Still enthusiastically eats his food. Still loves chocolate."

My last visit, two days ago, plays like a movie through my mind: Julian sitting in the little music room the new administrator set up, asleep in an armchair, listening to Mozart. Kneeling before him, I wiggle his knees, saying, "Julian, hello darling, hello Julian."

Slowly, his eyes open, staring off to one side. "Julian...hello...it's me...I'm happy to see you." His blue eyes shift, finally focus on mine. Pausing, he inhales, "Oh...good!" he manages, in his regular voice. His hands, clenched in his lap, won't open to receive the Hershey's kiss I've brought, so I pop it into his mouth, and he chews, silent again, closing his eyes, savoring chocolate.

Perched on the arm of his chair, I comb my fingers through his hair, massage his shoulder. Impaired as he is, just sitting close and touching him fills me with comfort and familiarity. The way he relaxes and sighs tells me he feels this too.

Pressed together, we listen to both sides of the Mozart tape, quartets in D-minor and D-major. Maybe it's from Julian that our musician son Jeff gets his deep love of music; Jeff will come from New York next month to see him, will bring him a Yiddish tape, will join the family as we take Julian *latkes* and Channukah candles. Violins and cellos chase each other, and from time to time, Julian unfolds his hands, and in time to the cello, gives several loud claps.

"What happens next?" Jan asks.

"Right now he's okay. He'll stay at Oak Creek as long as they'll keep him. When they no longer can, I'll place him in a skilled nursing facility closer to home."

The words come out easily now, resolutely, without the anguish of previous years.

"Will moving him to a nursing home be as hard as placing him at Oak Creek?" my divorced friend asks, pointing out some trillium, whose long tapered leaves will support lovely white flowers in spring.

"Hard, yes, but not as hard. The worst time was deciding to move

him out of our house, breaking up our thirty-five-year marriage, grieving and terrified about life without him."

I tell her that Verna and I started visiting nursing homes last week, and figuring out how we'll pay for the increased fees, which will probably be between five and six thousand dollars a month. Not that we need a nursing home now, but we want to be prepared ahead of time. We don't want to make this important decision in a crisis.

"But you know what?"

"What?" Jan asks, knowing what breaking up a long marriage is like. In nearly the same year, we both lost our mates—she to divorce, me to dementia—though today, after our hike, she will go home to her new boyfriend with whom she is happy.

"I'm doing just fine. I'm planning new trips: hiking in Death Valley this spring to see the wildflowers, and the Grand Tetons next June, where there'll probably be more grizzlies."

Jan suddenly starts to laugh. "Remember after I got divorced and Julian got Alzheimer's, when I fixed my watering system and you set up your answering machine...alone?"

"We've come a long way, buddy," I say.

Beyond tears, beyond anguish, sadness lurking but no longer dominant, my love for Julian still beating strong, I slap my hand against my friend's, giving her a high five, as we stride down the trail, my heart wide open, alert, confident, ready, I hope, for whatever comes along next.

~

Epilogue

IN OCTOBER 2001, after living in Oak Creek's care center for nearly six years, Julian shuffled to a stop. He could no longer rise from a chair. He began choking on food. Oak Creek staff could no longer care for him.

So Julian moved to a skilled nursing facility near our home, where he slipped downhill over the next three months. After battling several rounds of pneumonia, our family decided on "comfort care" and arranged for hospice.

Up until his last days, he smiled when tapes of Beethoven switched to bagpipes. He still managed an occasional wink. Julian died peacefully on December 31, 2001, at age 70, listening to Mozart and Jewish music, his family around him.

An autopsy confirmed Julian's diagnosis of Alzheimer's disease made twelve years before, marking the beginning of this long journey. It was a journey he traveled with courage and grace, and surprising moments of joy.

I've been so good at twelve years of your dementia:
greeting you in the care center with hearty hugs,
driving you down roads shaded by sycamore and live oak,
wandering hand-in-hand by the darkening lake,
singing Yiddish tunes when all your words dropped away.

Good at slipping the spoon into your eager mouth,
placing pureed peas on your tongue, watching
your Adam's apple rise, then sink, the little gasp.
Staring into your wide eyes fixed on mine, cerulean and clear,
feeling your hot hand press my fingers to your lips.

Good at summoning family when your time had come,
calm before their frightened faces. Good at lighting the candle,
caressing your bearded cheek, humming rabbis' *nigunim*,
counting between slowing breaths, until your dear chest lay still.
It's letting go of you I'm not so very good at.

August 2002